MAIDEN USA

MAIDEN USA

mediated youth

Sharon R. Mazzarella
General Editor

Vol. 3

PETER LANG
New York • Washington, D.C./Baltimore • Bern
Frankfurt am Main • Berlin • Brussels • Vienna • Oxford

Kathleen Sweeney

MAIDEN USA

Girl Icons Come of Age

PETER LANG
New York • Washington, D.C./Baltimore • Bern
Frankfurt am Main • Berlin • Brussels • Vienna • Oxford

Library of Congress Cataloging-in-Publication Data

Sweeney, Kathleen.
Maiden USA: girl icons come of age / Kathleen Sweeney.
p. cm. — (Mediated youth; v. 3)
Includes bibliographical references and index.
1. Teenage girls—United States. 2. Mass media and teenagers—United States.
3. Self-perception in adolescence—United States.
4. Sex in popular culture—United States. 5. Popular culture—United States. I. Title.
HQ798.S94 305.235'20973090511—dc22 2007008717
ISBN 978-1-4331-0208-0 (hardcover)
ISBN 978-0-8204-8197-5 (paperback)
ISSN 1555-1814

Bibliographic information published by **Die Deutsche Bibliothek**.
Die Deutsche Bibliothek lists this publication in the "Deutsche
Nationalbibliografie"; detailed bibliographic data is available
on the Internet at http://dnb.ddb.de/.

FSC
Mixed Sources
Product group from well-managed
forests, controlled sources and
recycled wood or fiber

Cert no. SCS-COC-002464
www.fsc.org
©1996 Forest Stewardship Council

Cover photo: ©2003 Rhiannon Marino, age 16, *Eugenie*
Cover design: ©2007 video.text
Author photo: ©2007 Kate Hagerman

The paper in this book meets the guidelines for permanence and durability
of the Committee on Production Guidelines for Book Longevity
of the Council of Library Resources.

© 2008 Peter Lang Publishing, Inc., New York
29 Broadway, 18th floor, New York, NY 10006
www.peterlang.com

Printed in the United States of America

Table of Contents

Acknowledgments

I would like to acknowledge all the Brave New Girls who have inspired me during my teaching artist residencies and presentations at Reel Grrls, Seattle; Garrison Art Center, Garrison, New York; University Settlement, Beacon, New York; DIA: Beacon, New York; Children's Media Project, Poughkeepsie, New York; the Ophelia Project, Poughkeepsie Day School, New York; and Girls Incorporated projects in Los Angeles and Indianapolis, as well as the many bright voices I have encountered in my lectures at schools, colleges, and universities.

Special acknowledgment goes to Eliss Maehara, Tenzin Mingyur Paldron, Moira Flanagan, and Lori Damiano, who have taken their Tech Girl skills to new levels of expression since I met them as teenagers.

I would like to thank the educators and innovators in this field who have dialogued with me and in some cases co-created programs combining technology, media literacy, and creative practice: Malory Graham of Reel Grrls, Deborah Aubert of Girls Inc., Maria Marewski of the Children's Media Project, and José Blondet of DIA: Beacon, along with Mike Gersh and Mark Lyon of Beacon High School. The conversations, travels, exchange of media lore, and video editing sessions have been expansive.

Thanks as well to supporters and fellow enthusiasts of Girl Culture along the way: Emily Keating and Lois Dino of the Jacob Burns Film Center; John Knecht of Colgate University; Mara Alper of Ithaca College; Teresa Foley of

Pittsburgh Filmmakers; Roberto Arevalo of the Mirror Project; Toney Merritt of Film Arts Foundation; Patricia O'Neill of Hamilton College; Karen vanMeenan of *Afterimage*; and Christine Tamblyn of San Francisco State University.

Conversations with friends, colleagues, and mentors have been invaluable to the evolution of *Maiden USA*. Special thanks to Catherine Allport, Bonnie Bainbridge Cohen, Cathy Banks, Michael Belfiore, Beth Biegler, David Birn, Felicity Campbell, Laura Cirolia, Jeff Davis, Elizabeth DeLabarre, Amy Dul, Annie Finch, Linda Ford Blaikie, Francesca Genco, Mark Greene, Cat Guthrie, Kate Hagerman, Tal Halevi, Jeanine Harmon, Alexandra Hartman, Edie Hartshorne, Deborah Hedwall, Carol Houlighan Flynn, Genessa Krasnow, Irina Leimbacher, Leah Lococo, Kody Janney, Cait Johnson, Wendy Kagan, Robin Kahn, Annie Kyrkostas-Schlegel, Jonathan Lilly, Erin Maile O'Keefe, Claudio and Jean Marzollo, Amy Matthews, Aline Mayer, Mary Clare McCauley, Fidelma McGinn, Kimberly McKeever, Laura Meiselman, Carolynn Melchert, Toney Merritt, Julie Metz, Josephine Monter, Fiona Otway, Purva Panday, Sue Peehl, Lynn Perry, Lucia Ramirez, Bonnie Schiffer, Trace Schillinger, Cornelia Schulz, Cathy Silverstein, Sara Topitzer, Yvette Torell, Jennifer Delilah Trammel, David Trend, Trinh T. Minh-ha, Kathleen Tyner, Carl Van Brunt, Betsy Weiss, Elaine Wells Baker, and Erika Wood, who have provided me with countless inspirations, as have many other filmmakers, artists, writers, researchers, scholars, and cultural theorists.

Special acknowledgment goes to Tom and Jami Sweeney, DB and Ashley Sweeney, Kate and Scott Salvato, Kitty and Bill Andrews and Martin and Virginia Marino for their invaluable support over the years.

Kudos to Sharon Mazzarella, who invited me to give a multimedia *Maiden USA* presentation at Ithaca College in 2001 and is the enthusiastic editor of this *Mediated Youth* series for Peter Lang.

This book is dedicated to my daughters, Rhiannon and Finnavar, who showed me the way to Girl Culture, and to my husband, Jeffrey Marino, who has always been there for the girls.

Prologue

Maiden USA: Girl Icons Come of Age began as a curatorial project of films and videos by teenage girls entitled "Reel Girls/Real Girls," which premiered at San Francisco Cinematheque/Yerba Buena Center for the Arts in 1998. An article, "Maiden USA: Representations of Teenage Girls in the 90s," analyzing the rise of teenage girl protagonists in contemporary independent films and documentaries appeared in the Winter 1999 issue of *Afterimage*. This research served as the basis for a video installation and lecture at "Summit 2000: Youth, Media and the New Millennium," a global conference held in Toronto in 2000. Since then, the project has evolved through a number of artist residencies, including three NEA-sponsored artist residencies at Reel Grrls, Seattle, a digital media program for girls taught by women filmmakers, and a series of lectures, workshops, and multimedia presentations about and in collaboration with teenage girls across the country.

The Graduate Faculty at the Department of Interdisciplinary Arts at San Francisco State University, where I completed my Master's degree in 1996, encouraged me to expand my creative practice to include a social or mentorship role, which ultimately extended beyond the production of video art about Female Icons and identity to include mentoring teenage girls in the art of Seeing Like a Camera. While mainstream media critique at first seemed an important piece of the mission, far more crucial became the urge to inspire girls to move beyond the exclusive Diva track of dream careers as Actresses and Models to the power of looking through the lens as a director, cinematographer, or media artist.

The multilayered evolution of *Maiden USA* as a book has included eight years of collaborative multichannel video installations, video poetics, writing and storyboarding workshops, PowerPoint presentations, and research for several published essays. Through my hands-on work with teenage girls, I have become an *aficionado* of Girl Culture. Beyond Mean Girls, Teen Moms, and Girls in Peril, my collaborators have introduced me to manga and Bikini Kill, *Buffy the Vampire Slayer*, *The Ring*, and Regina Spektor, all of which has enriched my perspective on the many definitions of "performing girl." My Maiden USA media collaborators have proven far more savvy and resilient than many "girls-in-crisis" parenting books would intimate. Since I began researching this book, women directors have brought us *Bend It Like Beckham*, *Whale Rider*, and *Lost in Translation*, featuring new Icons of Teenage Girlhood. Mainstream media has been transforming and will continue to change as more and more girls and women continue to produce media and forge careers in the field. This book presents a creative world of reinterpretation that is empowered and cross-pollinated, an exploration of an artist's interaction with girls that has become one part cultural theory overview, one part curatorial project, and one part improvisational riff. What has emerged is a deeper understanding of Maiden USA Icons and a dynamic ongoing digital collaboration with Real Girls and Reel Girls.

In addition to my work as a videomaker, writer, and educator, my role as the parent of two young daughters on the cusp of the new millennium intensified my interest in the topic of girls empowerment, and sometimes brought painfully close to home the issues of eating disorders and cutting, self-esteem and self-criticism, gossip, and clique violence. My research into the changing media images of teenage girls in this "Decade of the Girl" in print, Hollywood, pop music promotion, and independent media has been enhanced, and at times robustly challenged, by my own daughters. Through them, I have experienced Sims, Club Penguin, Friendster, MySpace, Facebook, and an iPod soundtrack for more road trips than I could ever have imagined. What I found in watching, listening to, and observing 1990s and 2000s media in the context of living and working alongside Real 1990s/2000s Girls was surprising, energizing, at times disturbing, but also extremely inspiring. This era has given rise to narratives, characters, and concepts of Girl Power that reach beyond Britney and Christina's early Lipstick Lolita sell-out of sex appeal. By the year 2000, so many Icons of teenage girlhood began to appear in mainstream and independent media offerings that it now comes down to an issue of choice, selection, and filtering. New Icons of Girlhood are there for the framing, and Millennial Girls are absorbing aspects of these role models as they formulate their own identities.

While I was initially motivated by fear of this "girl-destroying" global media machine, hands-on work with teenage girls in high schools, museums, media art centers, and colleges against the backdrop of real-life engagement in conversational,

rite-of-passage, creative, art world, and consumer life as an active parent of two daughters has brought me into contact with a generation of Millennial Girls who are savvy, strong, intelligent, and motivated. While some girls may indeed be endangered, this work has shown me that more emphasis must be placed on the stories of those who succeed by giving voice to their perspectives on Girl Icons and identity and believing that even glitches in personal narratives can be re-edited and re-framed. Given the proper Geek Girl tool belt, which includes the language of media literacy, anyone can become a Super Girl.

The good news is that despite a sketchy national curriculum for media analysis in public schools, media literacy programs have been emerging through local chapters of the Girls Clubs of America, Girls Incorporated, and the Girl Scouts of America, as well as empowerment programs, arts enrichment programs, and filmmaking programs for girls across the country (see Chapter 11, "Girls Make Movies: Out of the Mirror and Behind the Lens" and the Appendix). A great deal can be done by parents and educators to take up the media literacy slack of American public education for children and youth of all ages by critiquing tabloid celebrity, consumerism and naming powerful Icons of influence in daily conversation. With the availability of inexpensive digital cameras and the increasing presence of editing software on computer systems, videomaking has become not only an affordable enterprise but a necessary one that can even be cultivated at home.

Insulating girls from mainstream media is a limited enterprise, but providing them with a vocabulary to name and demystify the images on billboards, grocery store magazine racks, and in conversational vernacular gives them a powerful skill set. Even when parents limit exposure to commercial television or movies, the racial, gender, and social class stereotypes must be navigated or Big Brother becomes the consumerist teacher. My daughters still joke that I can't "sit back and relax and enjoy the movie" without dissecting the underlying scripts at play, or read a fashion magazine without discussing photo retouching, freaks-of-nature bodies, and anorexia. However, after years of "watching together" with a critical eye to naming stereotypes and analyzing filmic and fashion narratives, both of my daughters are extremely well versed in the vocabulary of Dumb Blonds, Valley Girls, Amazons, Cyberchicks, Warrior Women, and the wide range of visual roles, both new and retrograde, for girls and women. They are aware of the potential toxicity of fashion magazines and are savvy about the uses of Photoshop in creating two-dimensional fantasies of beauty. They have also learned to make films and take photographs and to talk back to mainstream media by asking as many questions as possible. While much of my career has been devoted to working with teenage girls in alternative educational settings, a great deal of the most potent media literacy impact has taken place in my own living room.

Given the persistent imbalances in the gender and racial make-up of the most powerful mediamakers in the world today, multicultural girls need a complete media skill set so they can begin to chart career goals to influence the images appearing in a popular culture still predominantly produced by white men. At this point in time media literacy must extend beyond critique to actual digital image-making skills. Learning digital discourse through filmmaking and editing has become a language girls must master in order to be fully literate in the 21st century. While the star system of teenage girl celebrities appearing on billboards and screens across America provides seductive eye candy, girls need to be encouraged to locate the power behind the camera. With the rise of digital technologies and the multimedia Internet platforms YouTube, MySpace, and Facebook, they now have access to an extensively networked public platform for exhibiting their digital productions on-line.

Like many other youth media arts professionals, I have been invited as an artist-in-residence to public schools as well as media art centers, private schools, colleges, and art museums, which places me outside the mainstream, though simultaneously in dialogue with mainstream image systems. For some girls, contact with individuals from outside their educational institution can open a window to new career options and new forms of self-perception. My educational work with teenage girls involves an active dialogue with pop culture and contemporary art, which provides an entry point to a common vocabulary. Manipulating and dialoguing with pop imagery assists in the acquisition of power over images that shape and inform collective identities and values in America and beyond. Digital cameras are potent tools for gaining mastery over the jump cut universe of visual messages embedded in our visual terrain. Framing the world in close-up becomes a step toward self-awareness, a way to transcend the spillover of celebrity culture. It is the aim of this book to provide a guide to analyzing and embracing New Girl Icons as potential power beacons for Real Girls everywhere and to highlight the work of Girl Media Mavens creating the next generation of cultural narratives, Icons, and images Made in the USA.

* * *

Please note: I have taken the liberty of capitalizing the words "Icon" and "Maiden," as well as the names of those Icons in popular culture throughout the book, but I do not generally capitalize the words "iconic" or "iconography." You will see examples of this throughout the text, including Lipstick Lolitas, Amazon Athletes, Brainiacs, Supernatural Girls, etc. I also include copious references to films and television programs. In general for films, I will include the date of release and director's name in parentheses the first time a title is mentioned to avoid redundancy. For television, I include the dates of production and the original broadcast production channel. A list of all films mentioned in the book is included in the Appendix.

Introduction

Visual history provides moments when representational taboos lift and boundaries are never the same. The mid-1990s marked a time when pop cultural depictions of teenage girls shifted forever in America, breaking open possibilities for definitions of the words Female, Femininity, and even the "F" word, Feminism. Welcome to the land of Maiden USA.

As global media transitions into the new millennium, teenage girls have become pop culture's Lipstick Lolitas, as well as Amazon Athletes, Demon Slayers, Brainiacs, and Superheroines. Who are these Nymphets and Super Chicks entering our consciousness in growing numbers over the past 15 years, and how do real girls navigate their impact in the process of defining themselves? *Maiden USA: Girl Icons Come of Age* analyzes recent changes in American Female Icon-making, which includes a collection of emerging, powerful, and often contradictory images of teenage girls. This rise in Girl Power, Young Hollywood Diva, and Warrior Girl narratives has been influenced by the contributions of independent women directors, Asian and Latin American media trends drawn from anime and tele-novelas, changes in social taboos linked to Anita Hill and Monica Lewinsky, Title IX gender equity in sports, and the increased accessibility of gender-equalizing digital media tools.

For decades, Hollywood's coming-of-age genre was dominated by male narratives such as *Rebel Without a Cause* (1955, Nicholas Ray), *Summer of '42* (1971, Robert Mulligan), *American Graffiti* (1976, George Lucas), *Diner* (1982, Barry Levinson), *Fast Times at Ridgemont High* (1982, Amy Heckerling), *Rumble Fish* (1983, Francis Ford Coppola), and *Stand By Me* (1986, Rob Reiner). In these classics, teenage boys act out, cop attitudes, perform bonding rituals involving cars, lose their virginity without consequences, and explore the language of reckless abandon.

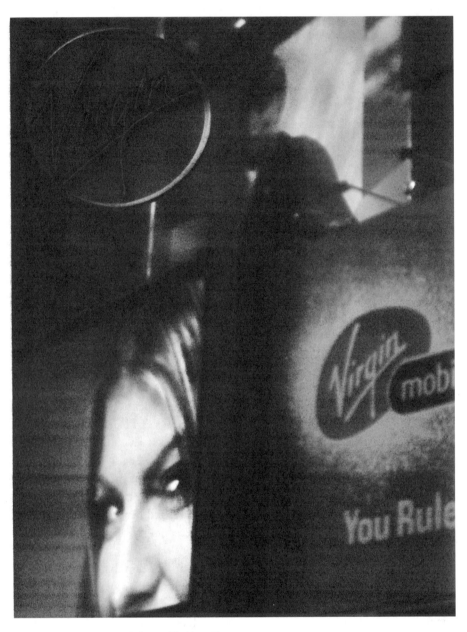

1.1 "Virgin Times Square" ©2007 Kathleen Sweeney.

The young women in these boy movies classically take on the roles of Girlfriends, Sisters, Sidekicks, or Objects of sexual fantasy. The 1990s produced its share of boys coming-of-age dramas and comedies, including bad boy parties such as *American Pie* (1999, Paul Weitz and Chris Weitz), with mindless sequels spinning off into the 2000s. Though Cheerleaders and Alpha Girls, Nerds and Sluts still populate these beer brawl comedies, even in these films the roles of the girls have changed and expanded.

With the exception of token legends of power such as Dorothy's witch-conquering, heel-clicking shoe scenes in *The Wizard of Oz* (1939, Victor Fleming) or gender-crossing Velvet Brown's victorious horse race in *National Velvet* (1944, Clarence Brown), the Teenage Girl in popular culture was a passive helping noun linked to Daddies, Brothers, and Boyfriends. Catapulting beyond the role of the Girl-Next-Door, Teenage Girls entered the high-intensity spotlight in the 1990s and continue to make Diva headlines in the new millennium. In the late 1980s with the black comedy *Heathers* (1989, Michael Lehman) teenage girls began to emerge as front-and-center protagonists of narratives in popular media that drew in adult audiences. The subsequent success of the independent features about teenage girls launched at the Sundance Film Festival such as Allison Anders' *Gas Food Lodging* (1991) and *Mi Vida Loca* (1993), Peter Jackson's *Heavenly Creatures* (1994), and Todd Solondz's *Welcome to the Dollhouse* (1995) encouraged Hollywood producers to open their coffers to the teenage girl tale, turning tinseltown into teenseltown.[1]

Until this shift, the Girl Icon did not exist as a persistently active noun in American visual vernacular. At this point in millennial pop culture, the coming-of-age narrative is no longer exclusively male terrain. Even Cheerleaders left the sidelines to take center stage in Hollywood high school dramas such as *Bring It On* (2000, Peyton Reed). By the late 1990s, mainstream media consumers, apparently ready for girls' coming-of-age stories, bought tickets in droves, proving that the "girl hook" could bring in significant adult audiences.

Maiden USA zooms in on a diverse offering of Girl Icons spun by popular culture since the 1990s. What does it mean to come of age against the backdrop of *Teen People*, Girl Power, Geek Girls, and Riot Grrls ... more girls, gUrls, and grrls than popular culture has imagined before? *Maiden USA* peers through the visual barrage of teenage girl-centric storylines in print ads, television shows, and films and questions its impact on the emerging identities of Real Girls, covering issues of agency and voice in an era of Queen Bees, Tennis Amazons, Teen Moms, and *Buffy the Vampire Slayer* (1997–2001, WB; 2001–2003, UPN). Forget about slumber parties. Magic, supernatural powers, and a constant need to slay demons have kept teenage girl heroines multi-tasking at maximum speed. While previous incarnations meant ultimately giving up a Tomboy persona to be defined as a young woman, storylines now feature girls entering adolescence without giving up

their magical powers, athletic prowess, or braininess. In fact, in *Buffy the Vampire Slayer*, *X-Men* (2000, Bryan Singer), and the *Harry Potter* series (2001–2003, Chris Columbus; 2004, Alfonso Cuaron; 2005, Mike Newell; 2007–2008, David Yates) adolescence is posited as the timeframe when special powers manifest to be honed and developed. Tame TV girls of the 1960s and 1970s like Gidget, Marcia Brady, and Laurie Partridge have been effectively karate-kicked off screen, except in Nick at Night retro syndication. And forget about the split personality of *The Patty Duke Show* from the mid-1960s. The Tomboy is now united with the Beauty Queen.

While the term "Girl Power" itself may have worn thin through over-marketing by groups like the Spice Girls, the concept has not proven a fleeting fad, but has proliferated and taken many forms since the early 1990s. Children growing up in the millennial era have accepted archetypes of female superstrength as definite possibilities in the special effects universe. Millennial Power Girl Icons persist and multiply in the public imagination with each new round of publications, animations, and feature films. Clearly "You Go, Girl!" has been obeyed at exponential speed. The sheer numbers of Girl Icons in the visual marketplace marks a significant representational shift. Part of the success of teenage girl narratives is due to the crossover appeal of these characters, who attract adult viewers as well as teen and tweenage ones. The special effects action film series *Spy Kids* (2001–2003, Robert Rodriguez) and the full-length animated feature *The Incredibles* (2004, Brad Bird) are examples of media offerings now marketed to the entire family. Apparently, mainstream writers and producers have grasped that female viewers want to fantasize about heroics just as much as the guys. And they are no longer satisfied to be rescued by Superman. Lois Lane just isn't the same!

Alongside the emergence of Super Girl Heroines, another discourse has arisen since the 1990s about Endangered Girls, Victims of clique violence, masterminding Mean Girls, Teen Moms, and Abducted Girls, which has simultaneously spawned a publishing, educational, and workshop industry of psychological and parenting discourse geared toward "saving girls." These languages of rescue have caused parents and educators to question the impact of media images on girls' body image and social behaviors and have contributed to funding media literacy, media making, and self-esteem programs throughout the country.

ICONS OR EYE-CONS?

Since the organizing focus of *Maiden USA* is on naming and analyzing Icons of the Maiden in American Pop Culture, it is important to begin to define some core terminology before segueing into the various chapters. The purpose of this book is to stimulate a media-literate dialogue about Icons of Girlhood. Part of that

dialogue exists in the written and spoken word, but another part exists as a postmodern visual dialogue via digital media production, which is where girls (and women) can creatively own these Icons to revive, reshape, and remake them in their own image, thereby adding to the pantheon of Girl Icons available to our media vernacular. As we shall see from the plethora of examples described in *Maiden USA*, millennial media has produced many new Icons of Girlhood.

So how do we define the term Icon? Derived from the Greek *eikon*, meaning "likeness, image, portrait," the word Icon first referred to religious paintings of saints, including Jesus, Mary, and the Holy Family, which served as spiritually inspirational symbols. Every aspect of these paintings held special significance, including the specific minerals chosen to grind into pigments, along with hand gestures, objects, and sight lines. In semiotic terms, an Icon is a sign, a signifier of layered meaning. Iconography, literally "image writing," is, by extension, the study of the meaning and interpretations of Icons. The symbol systems embedded in current Pop Icons of Girlhood have moved beyond the uniquely religious domain of candlelit cathedrals to the electronic and lamp-projected surfaces of cinema, television, print media, and the Internet. A polytheistic form of paganism known as celebrity worship is part of Pop Icon culture. Pop Icons are powerful meta-cultural concepts which provide gateways to our fantasy versions of our selves. In this way, Pop Icons are dense, focused layers of cultural association which fuse and concentrate into a code representing an ideal, a role model, an identity-by-proxy. But not all of these identities are laudable or powerful, especially when applied to the lives of Real Girls.

While religious Icons served their purpose as spiritual keyholes into the lives of saints and gods, some Pop Icons work a little differently on human consciousness. An Icon in these terms can sometimes be what I call an "Eye-con," an image scam that must be navigated and brought to awareness by analyzing and naming its syntax, just like a stereotype. If you have the opportunity to visit an adolescent girl's bedroom, you will likely find the walls covered with Pop Icons in the form of Celebrity posters, both current and retro, fashion magazine pages, as well as photographs of themselves and their friends. These images contribute to an expression of visual identity which involves careful editing and selection. Nothing is random on these Image Walls, which serve as an individualized pantheon of Icons, a collage drawn from multiple media sources toward the creation of a persona, the performance of the Teenage Feminine. The walls provide a canvas on which to dialogue with popular culture.

One of the initial functions of media literacy involves separating the visual wheat from the chaff. But what are the deeper meanings beyond these Icons as Symbols? An Icon, while sometimes an image to admire and revere, can, in pop cultural celebrity terms, serve as a con game for the eyes, a seduction, a ruse to

grab attention through a neuro-linguistic shortcut. This kind of Eye-con taps a repository of instant associations that lead to assumptions, reductionist categories, often at the unconscious level. An Eye-con proceeds from a process of seduction that produces a blissful simplicity of attraction that becomes its own mystery, its influence. Why do we fall in love with these images? Why are we drawn into their mysterious power? What complex system of hypertextual association inspires our infatuation with an Icon?

Accepting that no publicity-free utopia exists for millennial adolescents or millennial anybody means that we have no alternative but to become vigilantly media literate and so acknowledge the visual media choices we make in private spaces and observe the influence of those images imposed upon us in public spaces. Media literacy involves recognizing the Eye-con scam, reading between the lines of the text, those stories and myths underlying the image as given, and naming the Icons that embody power and agency for girls and those which encourage eating disorders or premature promiscuity. This type of analysis provides a narrative, a context for the images that hold us in thrall. What do we watch and why (as opposed to mindless channel-surfing)? What do we see by chance, and where do those images reside in our nervous systems and memories, influencing our choices, assumptions, and conversations? Media literacy involves consciously reading and making media, aware of the artistry and the skill sets, the tropes and the scams, and the intricate structures of image construction.

The most dangerous Eye-cons take place when we are utterly unconscious of their influence, when images are designed to evoke responses of desire for a time, place, relationship that is fictitious and possibly addictively pernicious. Eye-cons set us wanting the unattainable through a form of impossible promise. Within this system of the Eye-con are Girl-cons, the naming of which is another part of the *Maiden USA* discussion. Girl-cons are Icons of girlhood which posit girls as inevitable Victims. Girl-cons are also those paedo-porn[2] Lipstick Lolitas seducing a collective gaze with sexy come-ons. These Girl-cons are images of lost innocence packaged as instant celebrityhood. *You too can possess her. You can be young like her. You can be mysterious like her. You can own her.* Many girls take on this "make it as a Diva" fantasy as part of their passage into womanhood.

Girl-cons are also anorexic adolescent models selling a form of starvation beauty that has become even thinner in the 1990s and 2000s. If we are in on the con game through conscious iteration of the selling machinery at work, and begin to perceive Eye-cons and Girl-cons as products, then we are playing along, not yanked on a chain leading us to levels of dissatisfaction fed by consumerism. We are making conscious choices, choosing to enter a fantasy rather than being led through a smokescreen of half-truth titillation. Media Literacy involves naming the Girl-con then looking beyond her manufactured seduction to alternative role

models that have appeared alongside her as other forms of Girl Power. But first the Lipstick Lolita and Model Citizen confection Icons must be named in all of their glittery allure. Aspects of the Icon involve calling upon stereotypes as well as archetypes.

As the Guerrilla Girls have noted, "Stereotypes are living organisms, subject to the laws of cultural evolution: They are born, they grow, they die and or change to fit the times. They have an umbilical connection to language: They gestate in popular culture and are born in everyday slang."[3] How does a teenage performer make it to Iconic status? How does an image, a face, a personality become a part of the collective zeitgeist? Certainly each Girl Star is linked to a publicity machine, as in the case of Disney Corporation's Tween Machine, with its multiple platforms from which to launch young celebrities and a cable network to advertise new tween "products." But some reach a status beyond mere celebrity in public consciousness to become enduring cultural Icons, such as Elvis, Marilyn Monroe, and Madonna. In this way, they become metaphors, verbs and nouns, to conversational discourse. A common set of Icons links us to a collective reference system. Many pop stars have ephemeral life spans as objects of collective scrutiny and interest, and this is one of the great mysteries of collective popularity. While the majority of Tween and Teen Stars rampantly represented in the 1990s and 2000s will no doubt meet the fate of the *Teen Idol* syndrome, where stars burn bright then disappear from public view, some will enter the collective vernacular as enduring Super Girl celebrities and cultural Icons.

Some celebrities become Icons to such a degree that their personalities transcend the characters they are portraying and they find it impossible to blend into the storyline of a film. This is true of 1990s career celebrities Britney Spears and Paris Hilton. Their stage and screen presence is cultivated and sustained in the salacious realms of the tabloids. They are professional celebrities whose primary talent lies in attracting publicity rather than acting, singing, writing, arts, design, or athletics. In high Warhol style, these Girls produce and perpetuate only their celebrity. Celebrities who become Icons in the cult of personality can act as vampires to a narrative film, drawing attention away from the very storyline. Icon personalities such as Madonna's are hard-wired to draw light from every available source, at times draining meaning from the narrative. On the stage of pop music, this larger-than-life persona can be mesmerizing. Those who are actors first, personalities second (including Cate Blanchett, Kate Winslet, Claire Danes) come to the spotlight in a different way; their success and fame elevates them to Icon status but their roots remain as actors. Their craft involves dissolving into their roles, sacrificing the self to the art of illusion.

Characters can also become Icons that transcend the actor's name, as in the case of Buffy the Vampire Slayer, whose iconic status transcended that of the actress

who played her, Sarah Michelle Gellar. Forget that Buffy is a character in a television show. In many ways, Sarah Michelle Gellar is Buffy the Vampire Slayer for the rest of her public life, thanks to syndication and DVDs. The same is true for teenage actress Emma Watson, whose multi-year contract with the *Harry Potter* franchise ensures that her fans will know her as Hermione. Many of the Maidens of the past decade have become single names, losing the link to paternity of any kind. Their single-name status cues into their iconic status, as in the case of Madonna or Cher. Britney, Christina, J. Lo, Alanis, Buffy, Sabrina—all single-named characters/ entities, conjuring an instant allure of intimacy so grand it elevates our consumer status in relation to them. We "know" them, don't we? After all, we call them by their first names.

MAIDEN USA: AN OVERVIEW

The first chapters of *Maiden USA* are as much about analyzing imagery as addressing gender imbalances in image-making industries that contribute to the perpetuation of Girl-cons and stereotypes. Following this Introduction, Chapter Two, "No Secrets, No Taboos: The Wild West of Millennial Girlhood," sets the cultural timeframe for the emergence of New Girl Icons against the backdrop of changing social mores. Some of these changes have impacted teenage girls in positive ways, including the changes in the "dreaded taboo" of menstruation, the emergence of the language of sexual harassment, and the lifting of sexual abuse secrets via confessional television programs such as *Oprah* (1986-?, HBO/Harpo Productions). This chapter explores changing definitions and representations of teenage girl desire and examines the persistence of The Slut as a socially stigmatizing Icon for girls.

With the emergence of cable television, which began in the 1980s and exploded in the 1990s, the search for viewers has led to the launching of loss-of-virginity narratives in the early stages of young female performers' careers. This provides the basis for Chapter Three, "Lipstick Lolitas: The New Sex Goddesses," which extends the discussion of broken taboos in the 1990s to include the use of underage teenage girls and the lure of their virginity to sell magazines, CDs, and movies and to launch their careers as the new generation of Sex Goddesses. Sexy teenage soap operas in the style of *The O.C.* (2003–2007, Fox TV) and *One Tree Hill* (2003–2007, WB) invade prime time, pulling in both teenage and adult viewers. Marketing teenage starlets as "hot and wanting it" to an older male gaze became commonplace by the late 1990s in *Esquire* and other men's magazines. This sets the stage for a discussion of the Collective Gaze, with reference to Laura Mulvey's seminal 1975 essay "Visual Pleasure and Narrative Cinema."

Chapter Four, "Reigning Tweens and Alternative Tweendoms" examines the marketing world invention of Tween culture, a term that has served to speed up childhood with programming and product lines geared to consumerist notions of girlhood, often by marketing child starlets who by age 18 end up as post-Lolitas on the cover of *Rolling Stone*. This discussion includes early childhood's Barbie and Disney Maidens as part of the young girl's worship of the Teenage Girl Icon. In addition to covering the need for critical analysis of programs and products geared to this demographic, the chapter ends with a discussion of a series of films by independent directors such as of John Sayles' *The Secret of Roan Inish* (1994) and Hayao Miyazaki's *My Neighbor Totoro* (2005 [1988]) and *Kiki's Delivery Service* (1995 [1989]) as tween stories providing alternative visions of girlhood.

Chapter Five, "Mean Girls in Ophelia Land," discusses Girls in Crisis scholarship as a 1990s phenomenon that has contributed to bringing attention to girls and has engendered an entire parenting and self-help industry geared to girls' self-esteem. The profusion of teenage girl-centric visual media in the 1990s and 2000s has been accompanied by a wave of psychosocial critiques inspired by Mary Pipher's bestselling *Reviving Ophelia: Saving the Selves of Adolescent Girls* (1994), inspired by Carol Gilligan's *In a Different Voice: Psychological Theory and Women's Development* (1982) and the American Association of University Women's 1991 study "Shortchanging Girls, Shortchanging America." Along with *SchoolGirls: Young Women, Self-Esteem, and the Confidence Gap* (1994) by Peggy Orenstein, *Reviving Ophelia* set a nation's eye on teenage girls and self-esteem, which has led to national discussions about teenage pregnancy, gender inequities in education, and sexual harassment. Post-*Ophelia* books about teenage girl self-esteem, identity, and subterranean social languages include Joan Jacobs Brumberg's *The Body Project: An Intimate History of American Girls* (1997), Rosalind Wiseman's *Queen Bees & Wannabes: Helping Your Daughter Survive Cliques, Gossip, Boyfriends and Other Realities of Adolescence* (2002), and Rachel Simmons's *Odd Girl Out: The Hidden Culture of Aggression in Girls* (2002). With some best-selling books translating the "girl crisis" into the Mean Girls phenomenon in the 2000s, the teenage girl Icon continues on in the active public imagination as a once-subterranean force that has come to the surface with more power than ever estimated. Despite the claims of girls being "troubled" and "in trouble," which has sent Baby Boomer parents to Barnes & Noble and Amazon in droves, girls have clearly become front-and-center subjects. The spotlight is illuminated; girls have the power to hold our attention.

Chapter Six, "Out of the Gender Box: Title IX Amazons, Brainiacs and Geek Girls" explores Gender Bender narratives which have begun to blur previously black-and-white definitions of Male and Female Icons in our culture, and ways in which Girl Characters are using their bodies, voices, and minds to

extend beyond gender stereotypes, setting trends, and defending themselves in new and exciting ways. This chapter looks at the role of Title IX in forging an appreciation for Superstar female athletes launched as teenagers with the dignity and finesse of Venus and Serena Williams; the influence of Brainiac characters along the lines of MTV's deadpan *Daria* (1997–2001), HBO's Meadow Soprano of *The Sopranos* (1999–2007), and Claire Fisher of *Six Feet Under* (2001–2005); and the gender and racially groundbreaking *Akeelah and the Bee* (2006, Doug Atchison). Beginning with an overview of the girl in horror movies from the screaming victim to the menace of *The Ring* (2002, Gore Verbinski), this chapter also looks at the role of girls' voices in promoting the culture of hot trends.

Chapter Seven, "Supernatural Girls," extends this discussion further with an analysis of the 1990s–2000s emergence of Teenage Action Chicks with special powers. These included the WB's *Buffy the Vampire Slayer* (1997–2003) and ABC's *Sabrina, the Teenage Witch* (1996–2003), who were soon joined by Rogue of the *X-Men* series (2000, 2003, Bryan Singer; 2006, Brett Ratner); the martial arts maven Jen-Yu of *Crouching Tiger, Hidden Dragon* (2000, Ang Lee); wand-waving Brainiac Hermione Granger of the *Harry Potter* franchise; gadget whiz Carmen Cortes of *Spy Kids*; and force-field-wielding Violet of *The Incredibles*. Even the Disney Channel, launching pad for Lipstick Lolitas Britney Spears and Christina Aguilera, made way for *Kim Possible*, an Emmy Award-winning animated series about a Super Girl Cheerleader Math Whiz who fights evildoers to save the world that debuted in 2002.

Add to these the girl heroines of Hayao Miyazaki's animated features from his Studio Ghibli, who are becoming better known to American audiences due to recognition at the Academy Awards for *Spirited Away* (2002, Best Animated Feature Oscar Winner) and *Howl's Moving Castle* (2005, Best Animated Feature Oscar Nominee), and the allegiance of Pixar's John Lasseter. Miyazaki's catalogue of films for older audiences center on remarkable girl characters whose magical encounters lead them to explore and expand powers of their own; they include *Nausicaa of the Valley of the Wind* ([2005] 1984) and *Princess Mononoke* (1997). Miyazaki's young heroines must face a series of tasks and challenges in a journey of self-discovery that ultimately involves service to the greater good, providing a definitive contrast to the Slackers and Gossipers of Reality TV.

Chapter Eight, "Grrls vs. Womyn: Generation Blending," looks at the culture of "Performing Girl" that has emerged from the girls' movement to impact the culture of adult women as well. This chapter marks a linguistic foray into the fluidity of the term "girl" as it applies to many aspects of female culture, bridging generations as a sign not just of the "cool" and the "hip" but of sociopolitical movements as well. This chapter explores the linguistic play inherent in the terms "Girlie" and "Girl Power" and discusses "Girl Culture" as a pop cultural link to humor and wordplay in

Third-Wave feminism. The "girling" of American culture has influenced the Art World via the Guerrilla Girls and Cindy Sherman's performative photography, as well as pop culture through the Spice Girls and Madonna's "Girlie Show."

Chapter Nine, "The Girl Gaze: Women, Hollywood, and Sundance," profiles the rise of girls' rite-of-passage narratives directed by women directors, with reference to Professor Martha M. Lauzen's "Celluloid Ceiling" studies about women behind the scenes in the Hollywood industries. This chapter briefly charts the rise of independent filmmaking; the growth of the Sundance Film Festival and the opening up of teenage girl narratives directed by Alison Anders, Leslie Harris, and other early 1990s pioneers; and the adult female interest in the teenage girl protagonist in literature which has provided the basis of many screenplays featuring girl heroines. Breaking the barrier to female protagonists carrying narratives beyond a traditional Sidekick or Helper role, these films have contributed to new perceptions of the teenage girl subject in American media. The Sundance Film Institute and Sundance Film Festival have provided a development platform for many award-winning "indie films" about multicultural teenage girls in the new millennium, often with women at the directing helm. Unexpected hits *Bend It Like Beckham* (2002, Gurinda Chadha), *Real Women Have Curves* (2002, Patricia Cardoso), and *Whale Rider* (2004, Niki Caro) have tapped into the climate of multicultural awareness of the late 1980s and 1990s, moving us toward the beginnings of a more diversified media environment of alternative voices and perspectives. Many independent narratives now include a teenage girl as a pivotal character to boost marketability.

In addition to examining many incarnations of the Young Feminine playing on the flickering billboards and computer screens of images offered for a price in the new millennium, *Maiden USA* includes a chapter on girls' self-representation in the digital era. Chapter Ten, "Girls Make Movies: Out of the Mirror and Behind the Lens," discusses the emerging field of girls media making. This chapter profiles several national mentorship programs designed to assist girls in interpreting gendered Icons and the consumerization of desire by producing their own digital media, thus giving voice to Digital Girls. These initiatives provide proactive venues for getting the Girl Gaze out of the inverted mirror of beauty and behind the lens where they can ultimately influence the kinds of images seen on the billboards and websites of popular visual traffic. This chapter weaves interviews with teenage filmmakers and twenty-something Indies who began making media in their teens to provide a forum for media-literate and technologically savvy young women poised to speak from their experiences as digital natives. These girls are not endangered; they are a new breed, fluent not only in media critique but in technical production as well. Unlike many mass-market books, which focus on naming Girlhood as a social problem, *Maiden USA* looks to these forms of media literacy and media activism as visual doorways to the construction of Girl Power and Girl Identity in America.

The concluding chapter, "iCelebrity and Evolving iCons," briefly discusses the significance of user-friendly digital web pages on the Internet networking sites Friendster, MySpace, and Facebook, which have opened new means of self-representation for girls and a possible antidote to the thrall of celebrity culture. iCelebrity self-portraiture on the Internet has grown exponentially since the early 2000s as the fever of the networks has spread across college campuses and high schools, and YouTube has become an unprecedented channel for free distribution of digital media. This chapter briefly opens the door to the growing applications of these venues and their significance to Girl Filministas in the years ahead.

In an effort to stimulate and support the efforts of new media makers, *Maiden USA* includes an appendix of films, texts, and websites about girls and technology, women directors, girl-centric narratives in print and media, and contact information for youth media organizations such as Listen UP! and national filmmaking programs for teenage girls.

PERFORMING GIRL IN OPHELIA LAND, LOLITA LAND, AND BUFFY LAND

Overall, *Maiden USA: Girl Icons Come of Age* exposes the contradictions of a visual landscape of teenage girlhood where wealthy teen celebrities define "youth success" as excess and partying and "regular girls" are often seen by the news media as troubled or in trouble. The ultra thin body of the Teenage Girl-Woman often serves as a Model Citizen with the fresh face and the "new look" against which women and girls measure standards of beauty. That she is a long-limbed, bony anomaly of nature is often beside the point; her ubiquity in Image land makes her a Princess of the Desired Norm. The teenage girl's own body falls under the scrutiny of a self-directed, comparative gaze, a gaze that alternately identifies with the Maiden Models of popular culture and rejects them wholesale as objects of fakery and consumerism. Since the Lipstick Lolita aspect of the Maiden continues to wield clout as a substantial on-the-arm consort of the mass media power structure, it is important to name her as a Girl-con of many guises.

It's essential to acknowledge that pop culture's celebrity rites-of-passage *have* become accelerated catwalks into womanhood, with more and more girls encouraged by unmediated media to give up their slumber parties to board the fame rocket ship, even through proxy celebrity worship or by adopting an Alpha Chick persona on a cell phone. With the rise of Reality Television, "everybody" can theoretically become a Diva. Being front and center means that girls, no longer invisible, often no longer dress like kids; they have in some cases become "mini women" with perfect hair, outfits, and nails. No longer hiding in their bedrooms rebelling against

"the 'rents," many teenage girls seek a level of physical and academic perfection that is impossible to maintain. With teenage Celebrity Girls waxed and sheathed as the cultural Icons of beauty, power, and wealth, while "regular girls" are often presented by well-meaning PBS documentaries and through parenting publishing industry as in danger, it is easy to forget that there are many more exciting, interesting, intelligent, creative, and brave Girl Icons in the media marketplace as well. As Starlets or Teen Moms, Mean Girls or Abduction Victims, teenage girls have risen on the collective radar, but so have Supernatural Girls, Amazons, and Brainiacs. Beyond pop cultural references, a wider spotlight can locate girls who create their own languages and images and project a kind of leadership that involves teamwork rather than backstabbing.

While plenty of Neo-Lolitas were introduced to the visual marketplace as pre-legal sex symbols in the 1990s and 2000s with first names like Britney and Paris, a diversity of identities is there for the viewing as well. It all depends where the lens of focus leads, which is part of media literacy, a concept threaded throughout the book as a combination of media critique and creative practice, which names and dialogues with powerful Icons appearing in the visual vernacular of our daily lives. Media literacy is literally the act of "reading and writing media" as a language with its own complex grammar and symbol systems. Reading media involves critique and analysis, while writing media involves production. Increasingly, for children and youth, media literacy takes place at home, in school, and in after-school enrichment programs and is parent, student and educator-driven. For adults, it's an ever-evolving visual Spam filter that must be tweaked and recalibrated throughout our lives. Given how much time girls spend consuming media, it is worth examining the type of Icons they absorb and venerate as their identities are forming.

Choice remains an operative and important concept for parents and educators selecting media for children and adolescents and in determining how many hours to spend watching it. The sheer volume of selections has been aided by mail order DVD services such as Netflix, which carries enough foreign, independent, and Hollywood titles to satisfy the fantasies and desires of female and male viewers interested in a diversity of Girl characters. Accessibility is no longer quite as challenging. Career Girls, Geek Girls, Cyber Chicks, and the mothers of girls are consuming feature films and television shows about powerful Girl Heroines alongside their daughters, making Girl Power a highly profitable industry. But Girl Power means more than just buying Barbie a pink convertible. It means reclaiming the original power of girlhood often lost in the increasingly multi-tasked process of becoming a woman. With childhood an ever-fleeting phase in our extended lifespan, we as a culture are continually looking to the youth category for rewired metaphors and symbols of creative passion.

The 1990s and 2000s have in many ways become the decades of Girl Power and Girl Consciousness. *Maiden USA* is a book about an evolving pantheon of Made-in America Icons who have come of age as undeniable representational forces over the past 15 years. The many guises of Girl Power and Girl Identity in the 1990s and 2000s have elicited much debate about the definitions of childhood, adulthood, and gender roles. The purpose of this book is to expand discourse about this new generation of Maiden Icons and to inspire discussion about ways for Real Girls to navigate their own identities, fantasies, creative output, and career goals against the backdrop of current and retro Girl Iconography. What is playing on the big screens and iMovies of the popular imagination? Are they Pop Star Lolitas, Warrior Girls, New Goddesses, or Victims of Vanishing Childhood? Are these Icons self-made empowerments or manmade confections?

While widespread concern about the "endangered lives" of teenage girls has been articulated on the bestseller lists, *Maiden USA* looks to the continued and expanded presence of Girl Power Icons as an undeniable resource for the new millennium. These Supernatural Power Girls, Title IX Athletes, Brainiacs, and Individualists have actually occupied as much screen time as the over-sexualized waif-maidens of backlash media. It's not just a question of where we look but how we look/gaze and what we claim of importance as viewers. New vocabularies continue to name girl-on-girl bullying, low self-esteem, cutting and eating disorders, but more discussion is needed to acknowledge the significance of this brave, raw power of possibility represented by Maiden Icons of energy, magic, wisdom, physical strength, demon-slaying and digital self-portraiture.

Maiden USA: Girl Icons Come of Age emphasizes current Girl Power Icons as "media models" of great value to girls in articulating their own styles and vocabularies of cultural production, shifting the perspective from girls as Victims of American culture to girls as proactive creators and trendsetters. This is essentially the difference between the screaming Victims of classic horror movies and Buffy the Vampire Slayer, who kicks "undead vampire butt" to save the world. *Maiden USA* moves beyond the discourse of social "epidemics" of drowning Ophelias, robot-cold Mean Girls, and Teen Moms by focusing ultimately on the Girls, Grrls, and gUrls—both teenage and adult—who are successfully tapping the cultural power available to them through digital technology to create the newest versions of female image making. *Maiden USA* posits Girl Power beyond cliché as a force of collective creative potential.

No Secrets, No Taboos: The Wild West OF Millennial Girlhood

The 1990s marked a time of eroding boundaries around social mores and strictures, a blending of soft-core porn aesthetics with definitions of Model Beauty, and an era of exposed secrets, scandals, and explicit bodies in mainstream media. It also marked a moment for an opening up the possibility playing field for definitions of Female, the Feminine, and Girlhood. Growing up Female in the context of this timeframe of blurred distinctions between the sexes and about sex in general represents a Wild West of freedom, possibility, and yes, lawlessness. In fact, since the Internet emerged in its nascent mainstream form in the mid-1990s, it has remained a kind of unregulated Digital Wild West. This is the era of Napster, porn pop-up ads, and innocent searches based on key words like "Girl" leading to dark corridors of the porno universe. (As I discuss further in Chapter Eight, "Grrls versus Womyn: Generation Blending," this blurring of the word "Girl" with sex industries continues to pose challenges.) Yet this lack of regulation also paved the way for shareware, chat rooms, blogs, social networking sites, MoveOn. org and Wikipedia.

This chapter looks at some of the pros and cons that have resulted from the lifting of strictures which repressed teenage girls in previous decades and examines what some of these shifts might mean for them in terms of their nascent body image and sexuality. The change in representational and verbal taboos has at times spelled excess and a loss of mystery around youth-based sexuality, but has also expanded representational potential for definitions of adolescent female body

2.1 "Vinnie's Tampon Cases" ©2005.

image. While land-based boundary crossing has been part of the global politics of both the 19th and 20th turn-of-century eras, our most recent millennial expansion has had much to do with the amplification of virtual landscapes fueled by our imaginations, technologies, and media.

The Wild West of Millennial Media culture has its parallel in the westward expansion of the late 1800s, when gender roles opened to include enduring Girl Icons embodied by sharpshooter Annie Oakley, Willa Cather's young, strong-willed heroines facing harsh terrain in *My Antonia* (1918) and *O Pioneers!* (1913), and the adventuresome Laura Ingalls Wilder of the *Little House on the Prairie* books (1932–1943). As we know, Cowgirls never go out of style. Teenage girls living during the Wild West of the 19th turn-of-the-century era, when lithographs still provided the majority of newspaper imagery and live theatre was the pop culture of the moment, could not have imagined the virtual, multimedia Wild West of the 1990s and 2000s. Being a Wild West Girl like Annie Oakley meant shooting skeet while riding backward on a horse, not baring your midriff in *Teen People* magazine. Just as brothels dotted the Western landscape of 1800s mining towns, shantytowns, and borderlands, so virtual prostitution has been part of the millennial Wild West Show.

During the 1990s many representational taboos dissolved in mainstream media, blurring Low Culture and High Culture, children's and adult programming, and raising issues about media's influence on the health and well-being of young children, adolescents, and adults in terms of addiction, violence, depression, and a host of issues linked to self-esteem. The loosening of previously strict prohibitions regulating depictions of sexuality, homosexuality, menstruation, and plastic surgery set the stage for a complete unzipping of the mainstream Maiden Body. The shift away from some of these cultural taboos has been liberating for teenage girls and women, particularly with regard to "The Menstrual Curse," and changes in sexual mores have brought some new freedoms. But confusion has emerged as well for adolescent girls exploring their sexual identities against the backdrop of a Teen Celebrity culture of highly seductive packaging, a style of marketing deemed inappropriate for teenage or tweenage imagery less than a generation ago. Some of these changes in the realms of the forbidden have meant big business for the entertainment, sex, and plastic surgery industries, with questionable benefit to the emerging identities of Real Girls. Despite advances in discourse, career options, and representations, girls and women are still navigating the definitions of sexual and political power linked to the Female Body.

A blending of factors including the explosion of media content and subsequent points of view has influenced modifications in public attitudes about menstruation, sexuality, age of consent, homosexuality, and revealing fashions. Many phenomena have contributed to the mainstreaming of soft-core pornographic imagery in print

and television advertising and in broadcast and theatrical programming, as well as the movement toward more liberal attitudes about the Body, homosexuality and bisexuality, and multicultural points of view. A tempering of FCC (Federal Communications Commission) "decency" regulations under President Reagan in the 1980s[1] combined with intense competition for broadcast and theatrical viewers with the arrival of cable television's hundreds of channels. The increase of cable outlets, the rise of the Internet, and the demise of the network supremacy in television have combined with FCC deregulation to create a constant search for "virgin terrain" in media. Just as Westward Expansion was fed by a search for virgin terrain, so media content in this expanded outlet arena continues to seek the unseen, the untold, the unheard-of. And not all of this search is about deflowering Virgins through the power of the puerile gaze, though sometimes it is. (This phenomenon will be discussed more fully in Chapter Three, "Lipstick Lolitas.") In addition to progressive perspectives, which have changed attitudes relating to shame, the Independent Film Channel, Sundance Channel, and PBS programming, as well as mainstream television, have introduced audiences to gay and multicultural values and perspectives, which have in turn influenced mainstream media offerings and provided us with Latin American, Asian, and African-American Heroines as well as unusual, arty, brainy, and Super-Powered Girls.

Changing notions of privacy and a therapy-influenced shift toward the "talk show confessional" opened the floodgates of subject matter for public perusal. The 1990s breakdown of taboos in mainstream media coincided with the Anita Hill/Clarence Thomas hearings, which introduced the term "Sexual Harassment" to the American vernacular. The Lewinsky/Clinton scandal, which blurred semantics about oral and consensual sex, overlapped with the airing of childhood secrets and abuse on shows such as *Oprah*. Subsequently, the rise of Reality TV brought forth a seemingly endless supply of publicity seekers willing to expose themselves in any number of shocking ways. Reality TV has provided extended adventures in taboo-breaking as a means of enticing viewers jaded beyond measure by channel surfing, pre-recording, fast forward and rewind ability, as well as multiple viewings of videos and DVD through rental and ownership. Grabbing market share has often meant titillation to draw in viewers at any cost to what used to be known as "good taste." Owing in part to the ennui of an affluent "we've seen it all" era, this trend for "new new new" definitions of audacious, crass, gender-bending, social-bending behaviors draw Attention Deficit Disorder channel surfers to view activities that are often beyond proportions of aesthetic taste. Is it camp? Is it carnival? Is it endless spectacle? As Susan Sontag asserted in "Notes on Camp," "The relation between boredom and camp taste cannot be overestimated. Camp taste is by its nature possible only in affluent societies, in societies or circles capable of experiencing the psychopathology of affluence."[2] All of this has meant that for better

or worse, the closets of American secrecy have been flung wide open. Under the Big Top of Real Stories by Real People, the circus of baroque exhibitionism has been playing ever since, and many of these exotic performers have been Teenage Girls.

Global media's digital eye is capable of reaching to the farthest corners of the earth into previously hidden mysteries, as well as broadcasting programs and images into previously private sectors of the world where media did not penetrate. While a great deal of this reach is invasive, some of it expands our awareness of our role as global citizens. Breakthroughs in visual and informational terrain which expose previously held secrets-as-taboo have provided language and political clout for disenfranchised girls and women, as in the case of the emergence of Sexual Harassment language.

ANITA HILL, SEXUAL HARASSMENT, AND FIGHTING BACK

In 1991, Anita Hill, an African-American lawyer and professor at the University of Oklahoma, provided testimony against Clarence Thomas, then an appointee to the Supreme Court by President George H. W. Bush, paving the way for women to come forward with their own stories and class action suits against men who had sexually harassed them in the workplace. Even young girls and women who watched these proceedings from the periphery witnessed a changed playing field for their future or current places of employment, school and college campuses, and street lives. The language of Sexual Harassment provides a means for turning these situations around to a new forum for female empowerment by naming what had been a subtle, imminently deniable form of female oppression. When behaviors can be named and identified, acknowledged and debated in a court of law, they officially emerge from the closet of inchoate sexual politics.

During the hearing, Hill alleged that Thomas had sexually harassed her in the workplace through the use of coarse language. According to her testimony, she began working for Thomas in 1981 as his assistant at the U.S. Department of Education after graduating from Yale Law School in 1980. It was during this period that the alleged sexual harassment took place, which included the infamous reference to a pubic hair on a can of Coca-Cola. To those who believed the legitimacy of Anita Hill's claims or opposed the Thomas nomination on other grounds, his appointment represented a defeat. Yet, the Hill-Thomas controversy had other long-term consequences beyond Justice Thomas' life term on the Supreme Court. From that point forward, awareness about sexual harassment heightened considerably. According to Equal Employment Opportunity Commission filings, sexual harassment cases more than doubled, from 6,127 in 1991 to 15,342 in

1996. As of 2003, filings remained in this five-figure range. Over the same period, awards to victims under federal laws nearly quadrupled, from $7.7 million to $27.8 million.[3]

Following the Clarence Thomas hearings, thousands of women came forward to report abuses in the workplace, including the military, where, as a decided minority, they were often afraid to break the rules of encoded obedience to superior officers. In 1991 the Navy Seals Tailhook incident, in which 83 women and 7 men were assaulted during a symposium at the Las Vegas Hilton Hotel,[4] became national news. This kind of power abuse was clearly no longer acceptable. Women began to have legal recourse to seek retribution if their legal rights in this regard are violated. Owing to the gray area of many Sexual Harassment trials, charges are often dropped, but the fact that these cases can now be brought forward for verbal as well physical charges has much to do with the language introduced at the national level by Anita Hill. In the same way that Rosa Parks' refusal to site in the back of the bus changed the course of the Civil Rights Movement in America, Anita Hill's refusal to keep quiet about her former boss marked a historic shift in power for women and girls in the workplace and in schools. What followed in the wake of the Anita Hill testimony were debates over Date Rape, Acquaintance Rape, and other forms of Sexual Harassment, which have provided legal terms for protecting adolescent girls and women.

While commentator Camille Paglia questioned the subsequent policing of sexual practices in America as a form of censorship in her 1994 bestseller *Sexual Personae* and her essay collection *Vamps and Tramps*, the shift in power had taken place. Women were becoming vocal about the subtle languages of sexual politics. Katie Roiphe, in her 1994 book *The Morning After: Sex, Fear, and Feminism* argued that date rape was an over-exaggerated case of female victimhood, with women abdicating responsibility for their own seductive innuendos, alcohol, and drug use.[5] Roiphe's claims denied a previous era in which women who were date-raped and abused had no recourse to legal protection. While the politically correct police certainly could take these new terminologies to extremes, along with the newly strident terminologies of gay culture and long-sought multicultural awareness, the tools of sexual vocabulary/sexual agency available to women and girls had changed. Men and boys are now on notice that the "old boys/bad boys club" can no longer operate in the same way, not even at the annual Christmas party or the eighth grade dance.

Teenage girls are beginning to find ways to defend themselves against hallway harassment in school as well. In her 2006 Women's eNews article, "Teens Meet Harassment in High School Halls," Liz Funk documents ways in which high school girls are fighting back against sexual harassment by peers as well as male faculty. According to statistics, 83 percent of girls and 79 percent of boys will face

some form of in-school harassment during their lifetime as students, "from sugges-tive comments to inappropriate touching."[6] All schools are now required to have policies to deal with Sexual Harassment, a far cry from the pre-Anita Hill era, when perpetrators usually got off scot free unless there was clear evidence of physical violence. However, with linguistic etiquette eroding owing to pop song lyrics filled with the words "Bitch," "Whore," and "Slut," blurred semantics mean that girls who react to these monikers are often accused of being "uncool" and "oversensitive" and boys are often ignorant of these repeated terms' deep impact. Etiquette loss aside, girls do not like these words applied to them and do have the recourse to seek out correctives. Yet in any era, this takes courage.

At filmmaking initiatives like Seattle's Reel Grrls, Sexual Harassment has often served as the subject for Public Service Announcements produced by teen-age girls. In one such PSA from 2003, the girls turned the tables on the boys, whistling at them, pinching their rear ends, knocking into them in the halls as a boy's voice-over says, "I feel used." Here a role reversal in video drives the subject home.[7]

When taken to extremes, the languages of Sexual Harassment can seem like an end to spontaneous flirtation. But this language emerged to empower girls and women to speak up and find assistance when their personal safety is at risk and access to free speech is being denied. Date Rape and Sexual Harassment law and language is designed to protect those who are assaulted and in danger of being silenced. Millennial teenagers and Gen X commentators are interested in reclaiming sexuality from the realms of victimhood, which is an aspect of Girl Power. According to another report on Women's eNews, young women are using the power of the gaze combined with the network of the Internet to deter sexual harassment on the streets of Manhattan.[8] In response to lewd, on-the-street come-ons, these young women are snapping pictures of the perpetrators with their cell phone cameras, then posting their images on blogs in a campaign called "Holla Back NYC."

Without the debates of the early 1990s, the language of self-defense for harassment and date rape would not exist. While the debate continues, and few agree on the precise definitions of terminology, the avenue for recourse when necessary is now in place. What is clear is that boys as well as girls face harass-ment and bullying in school, so these policies provide a support structure to both genders.

Another highly proactive, girls-driven response to the possibilities of abduc-tion and date rape is a 45-minute "how-to" video, *Just Yell Fire*, which was co writ-ten by 14-year-old Dallas Jessup and 15-year-old Catherine Wehage, sophomores at the all-female St. Mary's Academy in Portland, Oregon. A black belt in Tae Kwon Do, Jessup co wrote and starred in *Just Yell Fire* with Wehage as a response

to news stories of girls being abducted, particularly one incident captured on a mall surveillance camera that ended in a girl's murder.[9] With the encouragement and support of the girls' mothers, extended families, and communities, what began as a home video-style school project became the professionally produced fictionalized narrative starring Jessup and Wehage. *Just Yell Fire* serves as a how-to for girls to escape abductions and protect themselves from date rape using Filipino Street Fighting techniques, including eye-gouging, ear-pulling, and groin-slapping. The project attracted the pro bono attention of several Portland film professionals, including director Takafumi Uehara, as well as professional actors Josh Holloway and Evangeline Lilly from the popular series *Lost*. In an effort to expand knowledge of the ten techniques demonstrated in the film, it is available for free download on the website, www.justyellfire.com, which has had more than two million hits. Dallas and Catherine have appeared on *The Montel Williams Show*, *Good Morning America*, and *Eyewitness News* and have received national coverage in *People*, demonstrating that a sizeable audience exists for alternatives to the Victim Icon.[10] The title underlines the crucial component of a girl's voice as a weapon of self-defense.

With critiques of over-policing on college campuses, it takes a memoir such as Alice Sebold's *Lucky*, published in 1999, to set the record straight about the differences in gender when it comes to late-night forays across campus. As an 18-year-old freshman at Syracuse University, Sebold survived a brutal rape attack by a stranger in a passageway during a late-night walk from the library to her dorm. She was not drunk or flirting with anyone. Because she survived the assault and was not murdered, the police considered her "Lucky." Political correctness and "rape hype" aside, it's still girls who have to navigate this possibility of sexual harassment taken to the most violent extreme. One of the keys of success to Sebold's testimony, however, was her assertion of virginity at the time of the incident.[11] Defense lawyers still use the brand of sexual promiscuity as a means to turn juries against women in a court of law.

MONICA LEWINSKY, ORAL SEX, AND THE SLUT

While Sexual Harassment dialogues have clarified policies of protection against sexual bullying, one major news scandal of the Clinton presidency blurred definitions of sex, virginity, and the nature of sexual relationships. When Monica-gate broke in 1998, Oral Sex became a national topic. As a news-driven subject of daily conversation, acceptable notions of "sex talk" shifted at dinner parties, at work, in mixed company and on the networks. As White House intern in 1995, Monica Lewinsky began a relationship with the President that continued

into 1996. Her confidante, the much older Linda Tripp, recorded Lewinsky's telephone conversations about the affair and then turned the tapes over to Independent Counsel Kenneth Starr, who used the evidence as the basis for initiating impeachment proceedings against the President.

Though President Clinton apologized to the American people in August 1998 for his "inappropriate" relationship with Lewinsky, he maintained that he did not commit perjury when he had denied its existence. Since the relationship involved only oral sex, not sexual intercourse, it was not, in his opinion, a "sexual affair," "sexual relations," or a "sexual relationship." Though he was acquitted, the damage to his presidency was done. The scandal provoked national debate about definitions of consensual sex, oral sex, and sexual relationships that continues to cloud concepts of virginity among millennial teenagers. Did Bill have sex with Monica or not? Oral sex is not sexual relations? Many of us said, "Come on, Bill, get real." But teenagers growing up in the context of these blurry sexual semantics have put oral sex (as in female on male) into the land of contradictory definitions. These days, some girls still call themselves "Virgins" even if they have performed oral sex. While technically, they have not engaged in coitus, they have had "oral intercourse," which renders them far more sexually experienced than the word "Virgin" implies. In a diner scene complete with a phallic banana visual in 1995s *Clueless* echoes this social strategy. Cher's best friend Dionne explains, "My man is satisfied, he's got no cause for complaints, but technically, I am a virgin. You know what I mean."[12]

Are we a culture of tricky lawyers, duping our own better judgment with word play? In the wake of this scandal, oral sex has come to be treated like a seemingly casual activity, akin to "making out." According to a 2004 study published in *Pediatrics*, teenagers who watch sex on television are twice as likely to engage in sexual activity at an earlier age.[13] Pop cultural messages signalling one-way Oral Sex as a strategy for girls to keep a boyfriend and still remain a Virgin, are worth discussing, dissecting, and questioning.

In May 2004, Benoit Denizet-Lewis published an article in *The New York Times Magazine* entitled "Friends, Friends with Benefits and the Benefits of the Local Mall," which introduced a concept to adults that had been circulating among millennial youth. This latest sensational thread was the result of research Denizet-Lewis conducted through youth Internet sites. Posing as a teenager himself, the author gained the confidence of several teens who were willing to meet with him to be interviewed, even after he revealed his identity as a journalist.[14] In the "friends with benefits" set up, teenagers have casual, consensual sex without commitment, similar to the "Love the One You're With" philosophy of the late 1960s. Do these arrangements benefit boys or girls or both? Denizet-Lewis suggests that the girls are not getting a fair deal.

As scholar Rhonda Chittenden points out in her article "Teen Oral Sex: It's Sensationalized," girls

> describe using oral sex as a way to relieve the pressure to be sexual with a partner yet avoid the risk of pregnancy. Some believe oral sex is an altogether risk-free behavior that eliminates the worry of sexually transmitted infections. There is a casualness in many teens' attitudes toward oral sex revealed in the term "friends with benefits" to describe a non-dating relationship that includes oral sex. In fact, many teens argue that oral sex really isn't sex at all, logic that, try as we might, defies many adults. Most pointedly, teens' anecdotal experiences of oral sex reveal the continuing imbalance of power prevalent in heterosexual relationships where the boys receive most of the pleasure and the girls, predictably, give most of the pleasure.[15]

Despite the upfront casual message, girls who perform oral sex on multiple partners still become known as Sluts. One aspect of the Lewinsky scandal was very clear: Monica came on to Bill Clinton and he said yes. Monica was not a victim of sexual assault. She was a consenting adult who wanted a relationship with the President. What happens when a young woman is attracted to a powerful man and willingly engages in an unequal sexual relationship? That she accepted it on his terms was part of her downfall; that he accepted her advances was his. While Monica may have been a victim of the media circus that followed, Clinton did not sexually assault her; she made the first move. Yet in many ways she became a partner in a "Friends with Benefits" deal that did not benefit her beyond a cameo on Reality TV and as 1999 cover art on *The New Yorker* as the newest version of the Mona Lisa.[16] And yes, she was the "other woman," which is often spelled S-L-U-T.

Madonna's public persona of the 1980s and 1990s has done much to make The Slut seem cool and powerful, a woman in control of her desire, cashing in on her own sexuality as a savvy business person. Through her live performances, "Like a Virgin" and "Pappa Don't Preach" song lyrics, audacious fashions, and come-on dance videos, she brought sexy underwear out of the boudoir to the level of visible accessory, meaning seeing bra straps became cool, not an "oh-my-god" panic hit. The conflation of Catholic iconography with overt sexuality hyper-charged the simultaneous controversy and popularity of her music. Academia has devoted pages to her impact as an American Icon, her role as AIDS advocate, and Female Pioneer.[17]

Despite Madonna's impact on popular culture, which has extended into the 2000s, The Virgin has remained a tricky and often "wink wink" term for girls to uphold, just as The Slut persists as a complex and contradictory identity to navigate. Emily White's 2002 book *Fast Girls: Teenage Tribes and the Myth of the Slut* deals with the lingering mythologies of The Slut in our culture. As she points out,

> To talk about the high school slut is another way of talking about America, and just as America is a vaporous notion, always shifting, always full of new believers and new contradictions, so

too the high school slut archetype dissolves at certain points, becomes almost imperceptible. Some people swear they can see her clearly, others swear she was never there at all.[18]

Through interviews with hundreds of women, White examines the impact The Virgin-Whore polarity has on the socialization of teenage girls. In her analysis of high schools, White correlates boys' use of pornography as a sex education source with the prevalence of "Slut lore" on campus. Through interviews with hundreds of women across the country, White concludes that it is often teenage boys who initiate Slut mythologies by bragging about encounters that may or may not have occurred. Once the boys have initiated these pernicious rumors, it is often what she describes as "girl tribes" who put the ostracization of The Slut into action.

The cruelty assigned to girls' tribes is very much linked to the fear of being outcast by boys' tribes, and it is the very oppositional line drawn by The "Virgin/Slut" paradigm that can slice through the girls' circle of community. In her interviews with young women recovering from their history as The School Slut, White discovers that their own "boyfriends" often started the rumors as part of male bravura, exaggerating "how far they went." Girl tribes seize these bragging tales and use them to assassinate a single girl's character, turning her into the ultimate outsider. As she notes, "Girls manifest a verbal and physical hostility toward the slut that is remarkable in its focused intensity."[19] Yet who calls upon girls to police one another in this way if not the contradictory culture in which we live? Being placed in the time warp of a pernicious conundrum of "Do It/Don't Do It" and "You're Sexy/You're a Skank" obviously evokes a deep rage and hostility in girls, which emerges in the scapegoating of The Slut.

The irony of adolescent boys' use of the term Slut, often bandied about in bravura style, belies an unrealized desire for a relationship beyond their physical readiness or development. In early middle school, girls enter puberty sooner than boys, so the Slut moniker could be termed a wannabe form of 6th or 7th grade boy envy, as girls mysteriously embody abilities beyond their reach. As I recently began telling girls who run into this kind of pernicious labeling as young as 12, "S-L-U-T is just a projection of a boy's L-U-S-T with the letters mixed up." Through the word Slut, the confused, more immature boys find verbal power to replace their lack of sexual prowess. Not only does it confuse, embarrass, and mortify the girl, it serves to divide the entire girl community. Through this single word, the boy penetrates the circle of girls, slicing it into bi-polarized halves. In Emily White's research many of the girls designated as Sluts in sixth or seventh grade had no more sexual experience than their peers, yet the power of this branding during the period of sexual identity formation and its ability to ostracize a girl from her female community meant that by high school, she often became "available" to many boys,

fulfilling a destiny played out for her in a single highly charged label.[20] Girls who talk back against the labeling need not accept the falsehood of its destiny.

In *Girl Culture*, a large-scale book of photographic anthropology, Lauren Greenfield provides interviews with some of the girls appearing on the pages. Nkechi, a Nigerian immigrant living in Los Angeles, expresses the contradictory over-sexualized messages of popular culture and the persistence of judgments against girls who attempt to openly embrace their sexual freedom.

> Pop culture says, "It's all right to have sex with all these guys. No one's gonna look at you differently." But I know from being around my brothers that when a girl has sex a lot with different people, [boys] don't want to be with you. At Crenshaw [High School], girls that went around sleeping with people were put on a "senior hit list" and made fun of. It wasn't cool to be a "ho." All their popularity was gone after that. So you'd try to keep yourself off that list.[21]

While some girls are resigned to navigate this double standard, other girls are still looking for ways to rebel against it, which is where media making can serve a social cause and provide a forum for girls unable to express their rage freely in their communities. Through Public Service Announcements (or PSAs), mini-documentaries, and social issue video art, girls can creatively spin the standards of conduct that hold them in place and fragment their sense of wholeness as human beings. Since girls are constantly navigating double standards in the ways teenage performers behave and they have more narrow parameters permitted for their own expression of desire, creative outlets are paramount.

GENDERED DISCOURSES OF DESIRE

Gendered double standards play out frequently in popular culture. Michael Jackson made crotch-touching a staple of his live performances and dance videos in the late 1980s. While accepted at the time as part of his stage persona, it was never a career stopper. When Roseanne Barr made an obscene gesture during her performance of the national anthem at a San Diego Padres game in July 1990, she was denounced. The message was clear: women touching themselves in public is verboten. And while public sexual displays remain outside the realm of socially accepted behavior and public decency, the double standard of public response to these two situations belies a persistent double standard toward overt acknowledgement of male and female desire and to the definitions of individuals' relationships with their own bodies.

Part of sexual development involves an exploration of masturbation, more widely accepted for boys than girls. Sex Education classes refer to "nocturnal emissions," or involuntary orgasms in males, but not involuntary orgasms in adolescent

girls. Teenage boys are assumed to have an inherent need "to let off some steam." Sex Education language for girls, on the other hand, focuses on the possibilities of sexually transmitted disease, sexual violation, and teen pregnancy. Rarely does female desire enter into the discussion, even as an unconscious urge.

The male "need" for genital "release" as taught links to the unconscious, to sleep, to a "he can't help himself" equation that in heterosexual relationships names girls as the gatekeepers of sexual relations. Boys are encoded as unable to control themselves; girls are taught that not only *can* they control themselves, but they *must*; it's part of their job description. If they don't control themselves and their boyfriends, they will end up pregnant and it will be their own responsibility to resolve.

Post-Lewinsky and the blurring of semantics about what constitutes the sex act, "Good Girls" will masturbate their boyfriends or provide oral sex to "help them" channel their desire with the assumption that they remain intact Virgins in the process. Teenage girls do not have a codified outlet for their desire without risk of being ostracized as weird, dirty, or Sluts. The issue of a girl's reputation remains much more strictly codified. While guys are sometimes jocularly labeled "man-whores" for sleeping around, it is mostly in a joking code among girls as a warning not to expect much in terms of commitment from them. Promiscuous Guys are not judged, ostracized, or whispered about, they're just the roosters in the henhouse, strutting around.

Many American schools are vigilant sites for conformity along gender lines. As White reminds us, "Like the fear of witches that led to the burning of young women at the stake in 1600s Salem, the slut story relies on the notion that there is something insidious in the slut's existence and that if she is not ostracized, her poisonous influence will spread."[22] The fear of being outcast serves as a potent form of censorship that often prevents girls from exploring their own desire and their own narratives of self-expression. Creating a persona outside the norm carries the risk of being outcast unless that unique identity manages to imprint as a purveyor of "Cool." Then the "arty" personality becomes a trendsetter, but this requires a core resiliency and a willingness to take risks, which have not been qualities encoded by consumerist America. In *Fast Girls*, Emily White cites Janis Joplin as a classic "slut personality" who eventually annihilated herself with drugs and alcohol despite her extraordinary gift as a blues vocalist modeled on Bessie Smith. Janis Joplin was iconic in her bravura and her success at operating outside the norm. An American original, she still serves as an inspiration to teenage girls who discover her. But originals often have to pay for their uniqueness in adolescence with scars carried into adulthood about never really "fitting in." The America pull toward "rising above," "getting ahead," and "making creative breakthroughs" expresses itself in an admiration of celebrity and fame. Yet the conformity urges of the group mind run at powerful voltage to counter messages about talent and inventiveness. We applaud

and admire our Joplins and Einsteins, but almost all biographies report difficult childhoods for those who are different, who follow their genius desire.

In order to dismantle The Virgin/Slut polarity of our continued double standard culture, the gendered discourses of desire need to be examined. And sexual desire marks only one part of personal passion leading to creative and career-based manifestation. If boys are allowed passion, and girls must still suppress it, how does this translate into realizing their most audacious dreams linked to other forms of passion? "Boys will be boys" allows them to shoot for the moon, while girls must be "responsible." Though the judgments are lessening, and freedoms for girls expanding, The Slut vocabulary remains a censoring device for female passion. Until Girls' Desire has a voice in the culture of Sex Education, girls will continue to grapple with this paradigm which accepts boy desire as "natural" and girl desire as linked to her role as a Daughter of Eve. Since girls bear the burden of an unwanted pregnancy, the culture may have an unconscious need to maintain The Slut Myth to prevent more teen conceptions. Knowledge is power, however, and girls with more access to birth control and an understanding of female sexuality beyond the charts and diagrams of clinical biology will be more prepared to articulate equality in their sexual relationships.

With more women writers, creators, and directors producing plays, films, novels, and art exploring aspects of female desire, the collective eye has begun to recognize and accept diverse expressions of female sexuality, even adolescent desire. The taboo word "Vagina" entered the cultural lexicon with Eve Ensler's enormously successful *The Vagina Monologues*, an Obie award-winning one-woman show and best-selling book based on interviews with more than 200 women which explores the "ultimate forbidden zone" of female sexuality. Initially performed in the late 1990s at the Cornelia Street Café in New York, by 2001 the play was staged at Madison Square Garden with readings by celebrities including Melissa Etheridge and Whoopi Goldberg. Since then the play has been performed by Kate Winslet, Julia Stiles, Alanis Morissette, and many others. Despite controversy due to its discussion of masturbation, lesbian sex, and rape, the play has toured the country and been performed on hundreds of college campuses. Drawing on the success of the play, Eve Ensler spearheaded V-Day, a global movement to stop violence against women and girls.[23]

Several recent films have explored aspects of female desire, breaking new representational ground. Tamara Jenkins' 1998 Independent feature *Slums of Beverly Hills* tells the quirky story of Vivian Abromowitz (Natasha Lyonne) struggling to grow up in a family of lower-middle-class nomads who move from one temporary address to another just to remain in the prestigious Beverly Hills school district. Their father Murray (Alan Arkin) supports the family mostly by soliciting handouts from his wealthy brother, Uncle Mickey (Carl Reiner). Jenkins' original,

semi-autobiographical script explores Vivian's bourgeoning interest in sex, including her loss of virginity to the local pot dealer Eliot (Kevin Corrigan) and her own experiences with a vibrator-produced orgasm. In a rare scene shot from the neck up, the viewer watches the teenage girl's experience of pleasure in a filmic moment that is non-pornographic, not even soft-core, though undoubtedly part of its "R" rating. It's evocative of Vivian's experience of self-awareness and rebellion. Few films deal with a girl's exploration of self-driven desire; most focus on the loss-of-virginity moment with a teenage boy, teenage pregnancy, or an act of sexual violence. Compare the R-rating of *Slums of Beverly Hills* with an R-rated Bad Boy adolescent movie like *American Pie* (1999, Paul Weitz), which features Jim (Jason Biggs) in a pants-down scene fornicating missionary style with his mother's recently baked apple pie. The entire premise of *American Pie* is the loss-of-virginity pact made by the four main male characters at the onset, a quest pursued throughout the film. Kirby Dick's 2006 documentary *This Film Is Not Yet Rated* discusses the moral philosophies behind our current rating system, comparing the ways explicit sexuality and explicit violence are rated. In particular, prolonged female orgasm onscreen will usually bump the film's rating to R or, in the case of Kimberly Peirce's *Boys Don't Cry*, to an NC-17.[24] The documentary, itself rated NC-17 for graphic sexual content in sample clips from feature films, provides an exposé of the current inconsistencies and gender, racial, and hetero-centric biases of the ratings board.

The problem of voyeurism remains when adults attempt to penetrate the realms of teenage sexual discovery, even as psychological, academic, or journalistic investigation, Independent feature, or Hollywood narrative film. Over the past 15 years, popular culture has been peering into the "first-time" bedroom and backseat scenes of teenage sexuality in ways that are at times exploitative, at times refreshing, and sometimes truly breakthrough. Magazines such as *Life* and *The New York Times Magazine* have featured photo spreads on the "inner lives" of teens, which include photo spreads of their bedrooms. One such issue presented "Being 13: A photo album of impressionable, streetwise, sentimental and very young adults" including the photography of Lauren Greenfield, Eve Fowler, Catherine Opie, and others.[25] In a more exploitational vein, the March 1999 cover of *Life* featuring 19-year-old Katie Holmes of *Dawson's Creek* carries the text "The Secret Lives of Teens: Real teenagers around the country tell us their private thoughts on sex, drugs, parents and more. Their answers may surprise and shock you."[26] While these photo essays seek "intimate knowledge" of teenage American psyches and are not necessarily sexualized, the focus on "penetrating" youth secrets undeniably attracts adult readers.

The Loss-of-Virginity episode in teenage dramas *Buffy the Vampire Slayer*, *Everwood*, and other network and cable shows has been pivotal to the storyline, providing many lead-up and after-the-(f)act episodes. As Kate Aurthur notes in

Salon.com, "Since 1991, when Brenda lost her virginity with Dylan at the spring dance on *Beverly Hills, 90210*, teenagers have been having sex on television."[27] The loss-of-virginity script line provides a form of titillation programming that has made the prime time teen soap opera formula successful. With cross-marketing practices so effective, teenagers clearly aren't the only voyeurs to television's "first timers." So, while America has been peering in on the back seats and frilly bedrooms of "the girl's first time," the majority of these scenes do not usually show the girl's pleasure *per se*, but a moment of surrender in linear time, which brings us back to the discussion of female desire.

In *Fast Girls*, Emily White raises the point that until the Internet girls did not have privatized opportunities for viewing porn or erotica except for the occasional peek at *Playboy* or *Playgirl* magazine. "Although there has been much lament about the evils of Internet pornography, the fact is that never before have women so effortlessly been able to observe and access the pornographic imagination of the culture."[28] White points out that with the Internet girls now have access to an act of erotic looking once inaccessible to girls and dangerous to women when sex shops or X-rated theaters mostly populated by men were required for visual entry. While underage and child pornography remain the bottom-dweller scourges of this access and utterly inappropriate, teenagers are hungry for information about sex. As Ashley Grisso and David Weiss demonstrate in their research on chat rooms hosted on gUrl.com, the largest adolescent girls' site on the Web, the Internet can provide an environment for relatively anonymous and risk-free opportunities to ask questions and share information in a cyber peer space about aspects of sex and desire that transcend the barebones of Sex Ed biology.[29]

For sexual novices, chat rooms provide an alternative to the dangerous kind of Wild West provided by unregulated pornography, where images of dominance and misogyny accompany erotica. Because the majority of current heterosexual porn is constructed from a male fantasy perspective along The Virgin/Whore paradigm, there may be little for girls to glean from the demeaning scripts of power at play. Yet the fact that porn is so easily accessed on the Web and sometimes appears in pop-up ads means teenagers researching on the Web will inevitably come across the imagery. Peepholes are now available beyond taboos, and they must be navigated, regulated, and above all acknowledged. Luckily, more and more filters have been devised to keep the porn out of research requests by young children on Google and Yahoo! search engines. Is it possible to provide teenage girls and boys with accurate non-sexist information about female and male sexuality that includes love, touch, and caring behaviors in the definition of the erotic as well? This may be where shows like *Sex and the City* come in.

Sex and the City's arrival on HBO in 1998 provided an unprecedented visual landscape for female desire. Aimed at adults at its inception, this show, based on the

books by *The New York Observer* columnist Candace Bushnell, gained a relatively small but significant population of teenage girl viewers. During its six-year run, *Sex and the City* served as a sex education manual for many teenage girls, who often watched with their mothers.

> Once considered a show for single women and gay men, it has blossomed into a comic fantasia about love in the Big Apple that is enjoyed by straight men, lesbians, women in their 70's and 80's, and finally, teenage girls. Unlike the current glut of youth-oriented entertainment, "Sex and the City" is not courting a young audience. It's tucked away on premium cable, with a "mature" warning preceding each episode. And maybe that's part of its appeal. By HBO's own figures, girls ages 12 to 17 make up only a sliver of the audience—93,000 out of more than 6.6 million viewers—but those numbers don't reflect the show's cultural impact on that age group.[30]

While the viewer numbers may seem small compared with the adult viewership of HBO, DVD rentals and purchases of the series, as well as re-edited re-runs on TBS and other cable networks means that *Sex and the City* will continue to reach teenage girls. The fact that a program packed with information about female orgasm, safe sex, and sexual relationships told from a woman's perspective continues to exist in syndication long after the final 2004 episode "An American Girl in Paris (Part Deux)" aired, means the impact of the program continues.

The sexual escapades of these four "liberated" New York City career girls—Carrie Bradshaw (Sarah Jessica Parker), Miranda Hobbes (Cynthia Nixon), Charlotte York (Kristen Davis), and Samantha Jones (Kim Cattrall)—raise many important issues for women and girls about relationships, sexuality, career, motherhood, and extended adolescence in the context of high fantasy, high fashion scenarios. Except for Charlotte, three of the four women characters begin the series as commitment-phobes. By the end, they are all in committed relationships, as if their second adolescence is finally over. Yet the fear of not finding a man and the focus on "the hunt" for teenage girl viewers is out of context to their youth and the years of possibility ahead of them. Their biological clocks are not ticking and they do not need to be anxiously trawling the dating waters.

Sex and the City signals an era of permissibility not only for adult women to explore looking with desire or sexual fantasies but for teenage girls to consider doing so as well. Sarah Hepola quotes Michael Patrick King, an Executive Producer and writer for the show: "The idea that there's a show with the word 'sex' in it that even teenage girls, whom it's not designed for, would want to watch together makes it healthier than sneaking your father's Playboy alone."[31]

The first two seasons of *Sex and the City*, written and directed mostly by women, included Indie directors who made their mark in the 1980s and 1990s —Allison Anders (*Gas Food Lodging; Mi Vida Loca*), Nicole Holofcener (*Walking and Talking*, 1996), and Susan Seidelman (*Desperately Seeking Susan*, 1985). This set

the tone for a series that spoke to women as women, a key to its runaway success. Talented women writers Cindy Chupack, Jenny Bicks, Julie Rottenberg, and Elisa Zuritsky scripted many episodes, lending authenticity to the dialogue based on the stories published in Bushnell's original column. This show depicted an unbelievably loyal bond between the four women, a rare occurrence in a visual industry that relishes catfights and backstabbing. Not once do these women sleep with each other's boyfriends or gossip negatively about one another. They are an urban tribe bound together in the pursuit of love and career.

Despite the show's avoidance of the "F" word, feminism,[32] (the other "F" word occurs liberally) the depiction of four evolved career women exploring their sexuality in the relationship jungle of single womanhood in Manhattan broke entirely new ground. As a subscription cable service, HBO, unbound by the moral code of advertisers, accessed a level of creative freedom to explicitly explore women's perspectives on desire and pleasure. In syndication, this quartet of role models will continue to exert an influence on the sexual attitudes about single (albeit white) women. While Samantha reclaims her active expression of desire as an adjunct to her successful career, viewing it as her "right" to enjoy multiple partners without attachment just like a man, her friends respect her as a maverick of independence and business savvy. In the final season, however, she contracts breast cancer and loses her hair in chemotherapy, an ending disappointing to many who looked to her for liberation from the punishments meted out in Western culture to sexually promiscuous women.

Perhaps in a nod to the loyal teenage viewers of the show, writers included Episode 15, "Are We 34 Going On 13?," in which Samantha is hired by a 13-year-old to produce a party. The girls, so "experienced" at blow jobs and worldly wise to the point of 30-something ennui, one of them says, "I've been giving blow jobs since I'm 12 …,"[33] echoing exaggerated concerns and assumptions in adult viewers about young girls being more promiscuous than a previous generation. In the same episode, Carrie dates a comic book artist/store owner who still lives with his parents—they smoke pot, play video games, and ride a Razor scooter through Times Square. This aspect of the generational blurring inherent in *Sex and the City* may be part of the appeal for teenage girl viewers. Watching the show allows girls to cross into "adult" terrain through their Icons, Carrie, Miranda, Samantha, and Charlotte, a Fab Four quartet who often act like teenagers—hunting guys, partying, eating out, avoiding domesticana, providing a fantasy of urban liberation. It's the same dream girl fantasy that appeals to some grown women—unlimited access to glamorous friends, parties, gallery openings, houses in the Hamptons, and Manolo Blaniks.

In terms of sheer availability of knowledge, millennial teenage girls know far more about sex than previous generations. The dropping of taboos has meant more

skin visible and more information available through the Internet, and on shows like *Sex and the City*. But the inconsistency of the information, combined with mixed messages across various available forms of sexual drama and erotica, means we as a culture still have a long way to go in defining and allowing for the fullest expression of healthy female passion and desire.

COMING OUT BECOMES "IN"

In addition to its explorations of female desire and independence, *Sex and the City* explored homosexuality, following the debate around gays in the military in the first Clinton administration in 1992, bringing the rights of gays and lesbians front and center. Many public officials and celebrities were "outed," some voluntarily, some not. Madonna's support of gay culture throughout the 1980s, her appropriation of Vogue-ing in the 1990s, and her public flirtations with bisexuality contributed to the mainstreaming. This climate paved the way for gay narratives in movies and on television, often as a titillating, attention-getting device on teenage soap operas which include the WB's *Dawson's Creek* (1998–2003), Fox Network's *The O.C.* (2003–2007), and the Canadian-produced *Degrassi: The Next Generation*. Since it aired in 2001, this newest installment of *Degrassi*, which began as a PBS series in the late 1970s, has made the N network a favorite for 2000s teen programming, challenging the reign of the WB.[34] All of these examples have contributed to the expansion of gay culture into the mainstream, even in depicting teenage relationships. By the time Ang Lee's *Brokeback Mountain* won the 2005 Best Director Oscar for its portrayal of a love affair between two closeted bisexual cowboys based on a novella by Annie Proulx, Out was officially In.

What this climate has meant for adolescents navigating their sexuality is more opportunities for voicing their true identities, but no less confusion. In progressive schools and communities, "coming out" as a teenager has become a legitimate possibility. That the identity boxes have loosened marks a positive step, but sexual exploration has certainly become more complex and nuanced. While these changes clearly influence mainstream culture, the depictions of lesbian characters and gay male characters in teenage programming are often quite different. The longest standing teenage lesbian relationship and historically the first on prime time was between Willow (Allyson Hannigan) and Tara (Amber Benson) on *Buffy the Vampire Slayer* (1996–2003). When a stray bullet meant for Buffy kills Tara, Willow unleashes a red-eyed witch's wrath that is unstoppable as vengeance for her girlfriend's murderer. A committed lesbian relationship has yet to be repeated in the teen market. For a more thorough analysis of queer girls and coming out

narratives in media, see Susan Driver's *Queer Girls and Popular Culture: Reading, Resisting, and Creating Media.*[35]

With the exception of premium cable shows *Queer as Folk* and *The L Word*, which are geared to adult audiences, those shows for teenage viewers including *The O.C.* and the comparatively progressive *Degrassi* often situate the lesbian story-line as a "passing fling" or "exploratory relationship." The hype around 18-year-old Mischa Barton's 2005 lesbian kiss on *The O.C.* proved an obvious attempt at viewership grabs during the Nielsen ratings week. Though immediately after this episode, Marissa (Barton) breaks up with the "blond babe" bartender Alex (Olivia Wild), all the desired hype had hit the Internet with Quicktime versions of the Kiss madly circulating. Even Samantha (Kim Cattrall) on HBO's *Sex and the City* (1998–2004) explores a sexual relationship with Maria (Sonia Braga), a Latina artist, for several episodes, but ultimately decides she prefers men. The only long-standing gay characters on *Sex and the City* are men, like Carrie's confidante Stanford Blatch (Willie Garson).

Breaking new ground in depictions of teenage lesbian love and desire, *The Incredibly True Adventure of Two Girls in Love* (1995) by Maria Maggenti tells the story of a scrappy working-class white girl played by Laurel Holloman named Randy Dean (an obvious moniker for some action) who develops a crush on Evie (Nicole Ari Parker) an upper-middle-class African-American Alpha Girl. Randy is a social outcast who works at the filling station, while Evie travels with the college-bound in crowd in a subversion of stereotypes about class, race, and gender preferences. In Jamie Babbitt's 1999 comedy feature *But I'm a Cheerleader*, All-American Cheerleader Megan (Natasha Lyonne, the star of *Slums of Beverly Hills*) becomes confused by the disparity between her seemingly perfect life as the quarterback's girlfriend and her proclivity for taping pictures of cute girls in her locker and listening to Melissa Etheridge. The opening credits, interspersed with slo-mo images of beautiful girls doing flips, leaps, and hip sashays, provide a rare exploration in a film geared to a mixed audience of a female-to-female gaze of desire. Megan's distraught parents send her to True Directions, a rehab camp for gay youth, where Megan falls in love with Graham Eaton (Clea DuVall) and has to grapple with her parents' prohibition about coming home a lesbian. Babbitt's film considers the absurdity of mainstream notions about gender stereotypes as a female masquerade of "immunity" from homosexuality and also challenges assumptions about Cheerleaders being one-dimensional Hetero Babes. The movie is also discussed in Kirby Dick's documentary *This Film Is Not Yet Rated* as an example of an otherwise PG-13 style "teen film" awarded an R-rating owing to its depiction of girls' bisexual desire.[36]

The openness of general culture to the gay issue has meant that the current cli-mate for young gay people has changed, especially on college campuses, where gay,

lesbian, and bisexual alliances have grown in numbers since the 1980s. While gay bashing still occurs, advocacy has increased, along with a wider acceptance of gays in the culture at large. Celebrities such as Ellen DeGeneres and Rosie O'Donnell came out publicly in the 1990s, along with Jodie Foster, Elton John, George Michael, and many others, with no apparent damage to their careers, sending a general broadcast that it's "ok to be gay." In this more open arena, more teenage girls have opportunities to own their true identities. If it's okay to be gay, it's okay to be different.

THE CURSE IS LIFTING

As discourses of sexuality have gained some fluency, so have some discourses of the female biological body. In the climate of social change in the 1960s and 1970s, the young adult novel by Judy Blume *Are You There God? It's Me, Margaret* was published in 1970 to wide fanfare. For those used to the "little pink book" style of introduction to the biology side of sex education, its refreshing honesty on a girl's perspective about boys, bras, religion, and getting your first period ensured enormous popularity for the book, which continues in reprint more than 30 years later. Despite the fact that this book has been included on a list of "The Most Frequently Challenged 100 Books of 1990–2000"[37] by the American Library Association (a list which includes Maya Angelou's *I Know Why the Caged Bird Sings* and Mark Twain's *Adventures of Huckleberry Finn*), in 2005 it was included on *Time* magazine's list of "The All Time 100 Great Novels."[38] Millions of girls in America have read this book as preadolescents. Its infamy may be part of its continued success.

With the publication of *Our Bodies Ourselves* by the Boston Women's Health Collective in 1970,[39] a move toward self-knowledge about the body became an important part of feminism. Women and adolescent girls are now encouraged to learn the anatomy of their own bodies, rather than treating them as "engines under the hood" for their (once usually male, now increasingly female) gynecologist to look after. This "knowledge as empowerment" movement extended to many illustrated, colorful books for preadolescent girls preparing them for upcoming changes to their bodies, with more information than abstract anatomical charts.[40] But mainstream taboos—religious, social, and in menstrual product advertising—persisted until recently, enforcing a code that The Curse had to remain a girls-only secret.

In the classic horror film *Carrie* (1976, Brian De Palma), based on Stephen King's first novel, a terrible power is unleashed in the gaze of 16-year-old Southern girl Carrie (Sissy Spacek), kept ignorant of her imminent puberty by her fanatically religious and mentally ill mother (Piper Laurie). In an often-referenced scene, Carrie starts to menstruate in the shower after gym class. Not one girl offers sympathy or an explanation about what has occurred. Instead they viciously ridicule her naiveté with

a barrage of pads and tampons. A bewildered Carrie returns home to her mother, only to be blamed for her sinfulness and thrown into a closet. Talk about a horror scene.

As Shelly Stamp Lindsey suggests in her essay, "Horror, Femininity and Carrie's Monstrous Puberty," "Carrie's adolescent body becomes the site upon which monster and victim converge, and we asssume that a demon resides within her."[41] After being named Prom Queen, Carrie rejoices at her crowning. But when pranksters dump a bucket of pig's blood (a stand-in for menstrual blood) on her in a moment of seeming social glory, she becomes unhinged and wreaks havoc on the entire school. Pushed to the extreme, Carrie discovers that her passage into womanhood has given her a telekinetic power to move objects at will, a theme recurring in the storylines of mid-1990s Power Girl Icons Buffy the Vampire Slayer and Rogue of *X-Men*, whose superhuman gifts also emerge at adolescence. With close-ups on Spacek's eyes before each telekinetic act, the film posits the female gaze as a terrible force capable of hurricane-like destruction.

The initial impact of this horror film depended upon the primal dread of the menstrual taboo. Here DePalma links the notion of "the Menstrual Curse" with the supernatural curse imposed on victims of horror scenarios. While menstrual language has changed since the 1970s, *Carrie* is still considered a horror legend among many teenage girls who know it and cite it. The difference is that when teenagers discuss *Carrie* in the 2000s, the menstrual thread combined with Carrie's ignorance is seen as somewhat quaint and currently implausible.

When Whoopi Goldberg, playing a bored police detective in Robert Altman's *The Player* (1992), twirled an unpackaged tampon by the string, something dramatically changed in the language of representational taboo. Until that time, tampons had been seen on screen only in a horror film like *Carrie*. They weren't even shown in tampon advertisements. With this scene, menstrual imagery shifted from its unique occupation of the horror genre to the comedy genre. While unlikely that Goldberg's scene would recur in cinema, the fact that a tampon could appear an R-rated movie for general audiences meant that 1992 was a different era. In Amy Heckerling's 1995 Valley Girl classic *Clueless*, Cher (Alicia Silverstone) announces offhandedly, "I'm surfing the crimson tide,"[42] a reference simply absent from mainstream movies for teens or adults before the 1990s. Although part of known code phrases for menstruation which have included "having your friend," "a visit from Aunt Flo or Aunt Ruby," "seeing red," "needing band-aids," and "Code Red," these slang terms belonged more to personal "girl vernacular" than to the movies. The arrival of this kind of verbiage in popular films is another aspect of Girl Power. It's a sign that Western girls have been freed from an oppressive shame and dread. Naming is a form of power.

Another example occurs in Tony Goldwyn's feature film *A Walk on the Moon* (1999), based on a screenplay by Pamela Gray, which is set in 1969 at a Jewish family

camp in the Catskills during Neil Armstrong's moonwalk and the Woodstock Music Festival. In an early scene, 15-year-old Alison Kantrowitz (Anna Paquin) calls her grandmother urgently into the bathroom. She gazes briefly down, initiating the camera's path to her underwear, which momentarily reveals her first menstrual blood before the cutaway to her grandmother Lilian (Tovah Feldshuh), who greets the news with a traditional "Mazel Tov" slap in the face. In the next scene, Alison discusses sanitary napkins with her girlfriend in the drugstore when the camp lifeguard appears. The girls quickly kick the box of napkins behind them under the shelf, playing out the taboos of a previous generation. Despite Alison's admonition "not to tell Daddy" her newfound womanhood is announced over the community loud speaker. While this scene plays for laughs and Alison-identified mortification, it indicates, again, that menstrual taboos have changed. The glimpse of menstrual blood in this film becomes "natural," part of "light comedy," nothing like the horror of *Carrie*.

While scenes in *The Player* and *A Walk on the Moon* are clearly comedic, the shift in prohibition is noticeable. The 1990s conflation of reality and cinema means those previous unmentionables—including going to the bathroom and menstruating—began to appear as part of the "it's no big deal" discourse. In millennial advertising, while representation has come to include the once-unseen "sanitary products," blood itself never appears. With a loss of shadowy mystery and its implication of shame, advertisers in the 2000s place the emphasis on comfort, hygiene, and fashion, not on keeping the "deadly curse" from the boys.

This absence of angst has created a much freer mixed-gender social landscape for girls. A comparison of menstrual ads clearly demonstrates this. 1950s ads often depict a mother and daughter in the distance, their heads bent forward in private conversation. Characteristic of 1950s ads, which appeared only in "women's magazines," the page is replete with text, in direct weight with the images. The small type size requires a true peering in to read. For men, no doubt, this was the signal to "turn the page" if they happened to browse a female publication. Current ads feature large-type headlines and pictures of extremely active and social girls. By the 1990s, menstrual product print ads no longer focused on the shame aspect except as it related to fashion and the ways that tampons or pads might affect appearance. Postmillennial 16-year-old girls no longer live in dread of having tampons scatter on the floor, a theme found in 1970s ads. It's not a crisis anymore. Guys know about tampons. The focus of the 2000s advertising involves absorption and anti-leakage. Girls in tampon ads often wear white, the signal that they are clean and hygienic and leak-free. The same mysterious blue liquid seen in disposable diaper ads is used in brand comparison tests of sanitary napkins. In the 1990s pads developed "wings" to prevent "leakage," alongside the bizarre invention of pads for thongs. Shame shifted to fear of leakage. In a 2006 print ad for Tampax Pearls that appeared in *Seventeen*,

a genderless diver seen in the distance, hovers near a shark. The tagline: "A leak can attract unwanted attentions."[43]

Television menstrual product advertising has become even more overt in slots for cross-gender youth programming on shows such as *Degrassi: The Next Generation* (The N Network, 2002–2007). In the same way other advertisers grab viewers with "shock" techniques, menstrual product ads employ similar strategies. Some of the results are hilarious, some downright bizarre. Once tampons remained virtually absent from the scene, kept in product packaging displayed in a nice neat corner of the screen at the end of the ad. Now, tampons deal with drama. In a 2004 advertisement for Tampax Pearls, a young woman uses a tampon to plug up a rowboat leak, saving her otherwise clueless date from embarrassment. In a 2006 Kotex ad, a huge animated red ball floats through the otherwise spotless scene. Blood isn't mentioned, but the word "Period" is, as a punctuation pun. "Kotex. Period."[44]

A quirky online source for menstrual ad archives can be found at the Museum of Menstruation (MUM, as in "Mum's the word …").[45] German-born Henry Finley created the site after curating and operating the museum by appointment from his home for some 1,500 visitors from 1994 to 1998. Originally a relatively unknown website, it is now replete with—you guessed it—menstrual product advertising. The Museum has been cited in many alternative publications like *BUST*, as well as *The New York Times*, *LA Weekly*, *Chicago Sun-Times*, and has been featured on the BBC and on Comedy Central's *The Daily Show*, the hook to the story of course being "why would a man devote his life to such a subject?" Another instance of a man's involvement in what might be called the "Menstrual Liberation" movement is the creator of Vinnie's Tampon Cases. Vinnie manufactures a series of cartoon-decorated cases designed as an antidote to the angst his girlfriends experienced about their monthly cycle, a business which has grown in large part due to word of mouth. As Vinnie explains it in an online interview,

> My intention was to create a conversation that had never happened before: a man voluntarily asking a woman about her period. My hope is that with the basic facts about a woman's body, men can generate a greater respect and appreciation for women.[46]

Vinnie's Cramp Kicking Remedies and *Vinnie's GIANT Roller Coaster Period Chart & Journal Sticker Book* (San Francisco: Chronicle Books, 2002) feature the same Coney Island-esque cartoon style with information about menstrual awareness. In addition to a double-page rollercoaster spread for each month with removable stickers (the operative word here is "fun") the book contains recipes for herbal teas and PMS-relieving chocolate, a massage chart for foot reflexology, and book and website resources. His punch-out postcards are emblazoned with funny slogans including "Greetings from Cramp Camp … Send Chocolate!" Teenage girls in my circles have mentioned their appreciation of the cartoony humor of the tampon

cases, which some of them own. While some women and girls might object to the idea of a man tapping into the menstrual taboo to create a business (who makes money on tampons anyway?), the success of his concept provides a clue into the fact that social attitudes will shift only if both genders are involved in examining the taboo programming.

In 1997, Anita Diamant published *The Red Tent*, an unexpected bestseller focused on the transition from the matrilineal culture of the Ancient Hebrews emphasizing a women's support system based in menstrual lore, midwifery, and collective living with the transmission of wisdom from mothers and daughters rooted entirely in oral storytelling. Through the voice of the main character, Dinah, the menstrual (red) tent becomes a site for the rediscovery of a pre-patriarchal language that links mothers and daughters.[47] That this fictionalized account became so successful in the late 1990s indicates female audience readiness to accept historical fiction as a site for revising views on Women's History.

YOU TOO CAN LOOK LIKE BARBIE

As shame about the Female Body transforms at some levels, the emphasis on a conformist fashion world and cosmetic beauty continues to challenge girls' ability to free themselves from an obsession with physical appearance. Joan Jacobs Brumberg's book *The Body Project: An Intimate History of American Girls* provides an illuminating overview of the development of girls' mirror obsession since the last century.[48] Despite the fact that we laud teenage beauty as the real, unadulterated, unenhanced beauty in our culture, the plastic surgery industry would have us believe that more and more teenage girls and teenage celebrities seek plastic surgery and breast implants based on the desire to replicate a false beauty ideal, smoothed and retouched for nth-degree enlargement on mile-high billboards and gigantic screens. Given that teenage girls possess the youthful bodies and faces sought by many ageing women, the hyped suggestion that girls would choose such surgery in droves implies a disturbing trend indeed. Plastic surgery involves the construction of a manufactured self based on a teenage/youth ideal. The ideal in nature is real (unmediated, non-artificial), but ephemeral.

While plastic surgery among teenage girls rose less than in the general adult population,[49] the slight increases over the past few years have been aided in part by the mainstreaming of plastic surgery as an accepted beauty regimen of celebrities. Plastic surgery cable shows such as *The Swan* (Fox Network, 2004), and *Nip/Tuck* (FX Networks, 2003–) do not necessarily feature teenage girls but are certainly channel-surfed by them. These programs sell a mainstream illusion not only of radical plastic surgery as permissible but that the act of transforming an "ugly" self

into a celebrity beauty clone provides access to the ultimate happiness and success. Plastic surgeons in America have deftly interwoven the pop psychological terms "self-esteem" and "emotional maturity" into their websites and briefing papers, designed to be readily accessible to a general population, unlike the obscure medical briefs of a previous generation.[50]

Elective plastic surgery, a growth industry, has merged with self-help movement beliefs in self-transformation at the most superficial level: the physical surface of self. Teenage fashion and celebrity magazines have assisted in this effort, with widely publicized stories of "make-overs," including breast implants and liposuction. It was previously considered absurd for teenage girls to seek plastic surgery; even "nose jobs" were kept hush-hush. In certain conformist, moneyed sectors of America it's becoming more common—but certainly not epidemic—for girls to seek breast reduction or augmentation in addition to the perfect nose. Some individuals choose eye and nose surgery to reduce or eliminate "ethnic" features, a sign of how powerful the "white look" of conformity continues to be.

With the introduction in the 2000s of *Teen People*, *Teen Vogue*, *Elle Girl*, and *Cosmo Girl*, one pernicious side effect of this trend in gearing women's magazines to girls is that these "grown-up" magazines may be trusted because their mothers read a version of them too. Advertisements disguised as articles such as "The Teen Breast Implant Boom" in *Teen Vogue*[51] provide a level of "acceptability" through manipulation. Even the use of the term "boom" misleads, though this economics term belies the motivating factor behind such "articles." While teenage plastic surgery is certainly on the rise, the majority of the procedures continue to be rhinoplasty, with far more girls seeking breast *reduction* operations to relieve back pain from oversized breasts than breast augmentation. From 2000 to 2004, plastic surgery procedures in the United States increased 25 percent from 7.4 million to 9.2 million.[52] In 2004, 4 percent were performed on teenage girls, up from 3 percent in 2000. Ageing adults still seek far more plastic surgery than teenage girls. In addition, the *Teen Vogue* article (as well as all information about plastic surgery published on public websites such as www.plasticsurgery.org) lacks any critical awareness of the inherent dangers of implants or medical facts about the deleterious effect of implants on issues affecting a young woman's future health or ability to breastfeed, for example. The photographs of teenage celebrities Lindsay Lohan, Scarlett Johansson, and Eva Amurri accompanying the article in *Teen Vogue* visually imply that these naturally endowed young women may have had implants or condone them and that the size of their breasts links to their success as actresses.

What happens when young girls receive breast implants when the big chest fad ends and Twiggy again rules with the paparazzi? The article doesn't mention what it's like to do yoga with implants or what results when the implants leak into the bloodstream. According to this unsubstantiated article, 11,000 teenage girls

received implants in 2004.[53] The actual number posted on www.plasticsurgery. org is 4,000, up from 400 in 2000.[54] Using numbers falsely in this context creates an "everyone's doing it" buzz. The authors report that one girl received them as a graduation present, a reward for doing well in school … Hello? Who paid for this article? Plastic surgeons of America? Parents and educators need to flip through these magazines to give them the verbal one-two punch from time to time, to break the spell of the sugary fantasies presented on their pages. Yes, girls will be annoyed at having to wake up from the fog. Admire the styles, the celebs, sure, but parents and educators must out the "faux" articles.

Plastic surgery involves a reinvention of the self, the ultimate cyber-personality, a scientific high art form that defies nature, a quest for a plastic, clone-able, and repeatable beauty. Manmade. In this context, what is a real self? What is a false self? The whole notion of "plastic" surgery suggests the production of a more bendable, moldable, modifiable self, in many ways just like Barbie. Check out the women in the society pages or in the convertibles of LA. You will see her, again and again, perky and blond as ever. A doll modeled on real girls becomes the model for "eternal" girl beauty. In the final chapter of *Forever Barbie*, a history of a "living doll," author M. G. Lord interviews a woman who devoted sixteen surgeries to the pursuit of a Barbie body.[55]

Linking identity and image transformation to the superficial fix of plastic surgery marks a dangerous equation for teenage girls. While surgical makeovers may seem like a way to control the narrative of our lives, the rampant clone conformity of the post-surgery "look" glaringly presents as well. Changes at the level of breast implants and nose jobs and liposuction prove far more permanent than the term "plastic" would indicate. It is one thing to take a digital photograph and enhance it in PhotoShop at age 15. It is quite another to have breast implants.

The beauty industry already encourages girls to search for the perfect body, scrutinizing every inch of their skin, muscle, bone, and fat cells in a language of celebrity-based imitation, the performance of the feminine, which ultimately leads to consumer purchases of cosmetics, body care products, designer clothes, and so on. In parts of our culture, Fake is preferred over Fat. Fake Beauty more than Fat Beauty, Fake torpedo breasts rather than truly sensuous, voluptuous, and, yes, Fat-endowed breasts. Girls need to be able to separate Fact from Fiction and Fake from Real in representation.

The Dove Campaign for Real Beauty[56] has emerged in response to these trends. While obviously designed to sell Dove products, the campaign features more realistic multi-cultural women's curvy bodies in print and television ads. In addition, their website features a step-by-step "make-over" of a model for a print ad, including PhotoShop adjustments to her neck and eyes, a bold move for a company that manufactures soap and lotion. In 2006, Dove initiated the Dove Self-Esteem

Fund, which works with the Girls Scouts to develop educational materials targeting 8- to 10-year-olds and 10- to 14-year-olds to combat self-hatred. Is it possible to trust a corporation like this? This is, again, where media literacy comes in—to hone discernment. With slicksters in the advertising and plastic surgery industries prying into the "self-esteem" states of girls, knowing that teenagers often desire to "fit in" at any price, the next chapter, "Lipstick Lolitas: The New Sex Goddesses," looks at the difference between Icons of teenage talent and comportment and Eye-cons of sell-oneself trickery.

Lipstick Lolitas: The New Sex Goddesses

On an iconic level, global viewers have come to crave the Maiden, The Virgin, and the Young Amazon in the visual cathedral of popular culture, where we worship celebrities in a mythic interplay of desire, secret identification and homage. Teenage girls are not the only ones worshipping Maiden Icons of popular culture. Adults admire them as well, with male lust not the only motivator, though a primary one. Grown women navigate this new definition of collective youthful beauty, finding visual nourishment in a prefecund androgyny of teenage beauty that has become the fashion standard. High-fashion models now commonly begin their careers at the age of 14 or 15, often forgoing high school and college to take to the runway—a trend that became common in the mid-1990s.[1]

Since the prehistory of cave drawing, there have been Icons of the Feminine, just as there have been Icons of the Masculine. Folklore is replete with images of Nymphs, Nixies, Mermaids, Selkies, and Maenads, transitional Maiden beings with the power to lure men into the water. The cultural fascination with Mermaids, especially for little girls, has been amped up since the appearance of Disney's diminutive Ariel character. One of the most alluring images of Mermaids occurs in 2003 film version of J.M. Barrie's *Peter Pan* when Wendy approaches the beautiful blue Mermaids, only to be warned by Peter to stay away from their webbed claws and razor-sharp teeth.[2] Clearly, Mermaids are more mythically powerful than they might seem.

Statues of Maiden Goddesses of Greece and Rome were draped in diaphanous fabric wrought from marble, a marvel in its waves of artifice. Diana the Huntress, Persephone, Kore, Aphrodite, Nike the Goddess of Victory: all solid muscular girls

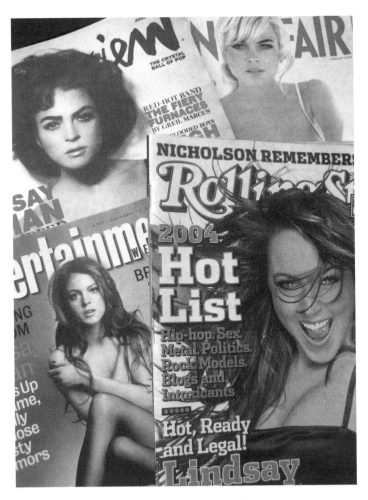

3.1 "Lindsay's Rite of Passage, 2004", ©2004, *Entertainment Weekly*, *Interview*, *Vanity Fair*, *Rolling Stone*.

immortalized in marble, inspirations for New York City's symbol of freedom in the New World, the Statue of Liberty. For centuries in Western culture, the term "Maiden" designated an unmarried woman, usually a Virgin at the blossoming, marriageable moment of beauty and potential before the childbearing years of adulthood. The word "Virgin," however, has had a fairly inconsistent set of meanings throughout Western history. According to Marina Warner,

> …in the case of the pagan goddesses, the sign of the virgin rarely endorses chastity as a virtue. Venus, Ishtar, Astarte, and Anat, the love goddesses of the near east and classical mythology, are entitled virgin despite their lovers, who die and rise again for them each year. Diana, the virgin huntress, goddess of the moon, who imposed a vow of chastity on her nymphs, appears at first glance to be an exception.… In the case of Artemis …and of Hippolyte, the Amazon queen, and of Athena Parthenos, the Maid, their sacred virginity symbolized their autonomy. … Elizabeth I was hardly entitled the Virgin Queen because she refused lovers … her virginity indicated she could not be subjugated or possessed.[3]

In the Christian Era, The Virgin came to symbolize a form of submission to God's will. Medieval and Renaissance painting and sculpture depicted the Maiden Princess in rescue by St. George and the Dragon and venerated The Virgin Mary in iconic profusion. Throughout the history of art, the golden-haired, lapis lazuli- or vermillion-mantled Virgin, a teenage bride of the Immaculate Conception, appears in multiple versions of The Annunciation, the visitation by the Angel Gabriel in which Mary is named the Vessel of God, accepting her role as the future mother of Jesus. Often, these words unfurl in a curvaceous gold-leaf banner emanating from the mouth of the Angel Gabriel into The Virgin's ear as she is impregnated by the secret of Logos, the Word of God.

While the Catholic Church subsequently tried to suppress the power of the Marion Cult, her image continues to dominate miracle folklore and legend into the third millennium, with annual reports of sightings in churches, on hillsides, sidewalks, in Latin America, Bosnia, Europe, Canada, Africa, and the United States. Obviously, the collective psyche has a need for the image of the Maiden. With Madonna's 1984 hit "Like a Virgin" replayed by teenage girls in the 1990s and 2000s, and books like Jeffrey Eugenides' 1993 novel *The Virgin Suicides* scripted and directed by Sofia Coppola in 1999 in a version replete with statuary and prayer cards, multiple meanings of The Virgin Icon have been at play in the collective imagination. The 2004 Indie hit *Maria Full of Grace* by Joshua Marston played with Catholic symbolism in the Communion-like images of Colombian Teen Mom-to-be Maria (Catalina Sandino Morena) looking up to receive a white tablet (which turns out to be drugs). The title itself echoes the first line of the Catholic prayer "Hail Mary, Full of Grace." The Sundance Film Festival's Grand Jury Prize film for 2006, *Quinceañera* (Richard Glatzer and Wash Westmoreland), features

a 15-year-old East LA Latina, Magdalena, who experiences a miraculous Virgin Birth. In December 2006, New Line Cinema released *The Nativity Story* directed by Catherine Hardwicke with holiday big budget fanfare featuring the young star of 2004's *Whale Rider*, Keisha Castle-Hughes, as The Virgin Mary.

There are many parallels between the Renaissance and our own era, in which the distance between childhood and adulthood is brief. While young women promised in marriage wedded as early as age 13 or 14, today's tween celebrities launch into their marriage with the adult world around the same age, if not earlier. In fact, despite the mid-20th-century arrival of child labor laws[4] and state-by-state guidelines for the age of consent in the United States, the delineation between childhood and adulthood has often been slim, especially for those in underprivileged classes. Even the now-ubiquitous term "teenager" came into usage in the United States after World War II. For the most part, age 18 is now considered the true age of adulthood in America (and most parts of Europe), when voting and other rights are accorded an individual, and adults no longer fear statutory rape charges for intimate involvement with a young person. With Teenage Girl Celebrities now marketed as millennial sex symbols, the time span of transition between childhood and adulthood provides a blip on the screen deemed worthy of a big cash-in.

Another commonality between the Renaissance and the current millennial era lies in the equal supremacy of the image or Icon and the written word, epitomized by the speed with which bestselling books, both fiction and nonfiction, adapt to the screen. This equal supremacy of word and image in millennial culture again calls for a balance of linguistic and inconographic literacy. What we hear equals in power to what we say; what we read as text equals in power to what we read as images. During the Renaissance, idealized female bodies adorned palaces and cathedrals in the high cinema of painting and sculpture, which, along with architecture, were the most highly evolved art forms of the time. In the Digital Era, the female form embellishes billboards, magazine covers, bus ads, and movie screens. We have reached a High Renaissance of the visual body. The mainstream American gaze falls for the Young Maiden, pre-woman, yet no longer a little girl. Like Virgin Goddesses of Ancient Greece, today's Maidens do not get married. Maiden USA of the 21st century synthesizes the male and female ideal; her hard body, not yet soft and fecund shows no signs of motherhood, yet she does possess defining curves that equate her with the female. Her power resides in her way-station definition. Still formless enough to accept the many scripts of desire written as a collective gaze of fantasy courses over her body, she is not yet fully woman in word. Millions watch, subconsciously or otherwise. She is possibility; she is virginal. Desire inscribes her body as we name her Celebrity, Teen Queen, Sex Goddess, Beauty Princess, Super Girl, Amazon Ace, Lipstick Lolita. They are all Maiden USAs.

In the 21st century, our gaze is the messenger of attention which names The Virgin in this current era of representation. She belongs to a landscape of Icons that describes Maidenhood as Maiden Form, Victoria's Secret Angel. Unleashed from the religious, church-based association of respect accorded The Virgin Mary Icon, some Maiden USAs enter the cult of worship as the new celebrity, the "It" girl, the hot commodity of style and wealth, eliciting an Annunciation of gossip whispered into the ear of tabloid readers, channel surfers, and bloggers. The tabloids banter in bold headlines, spreading rumors about the seductive wildness of certain Maiden USAs; their sex lives, boyfriends, managers, dysfunctional families. As cover art to magazines, as billboard drapery, this Maiden often looks out, catching our eye with a universal invitation to desire her and a headline that backs up the invitation.

MAIDEN FORMS

One of the biggest fashion statements to define the 1990s was the midriff "belly shirt," which often included a belly-button piercing. This look has come to define a moment in the 1990s when all was revealed in mainstream fashion, filtering down to clothes designed for little girls. Britney Spears and Christina Aguilera were among the Teenage Sex Goddesses of the 1990s photographed showing their midriffs, a style that by the mid-2000s was finished, though revealing clothes for teenage girls have continued. The eye on the girls had been established. Promotional posters for *American Beauty* (1999) showed the ribcage-to-hips bare torso of a girl, her hand resting on the stem of a red rose bud, beginning to open. Even Joan Jacobs Brumberg's book *The Body Project: An Intimate History of American Girls*, a 1997 critique of mainstream culture's overemphasis on physical appearance for girls, prominently features a bared, pierced midriff of an anonymous teenage girl on its cover. Although designed no doubt as a critical image, its eye-catching nature is part of the marketing inducing its purchase. A similar marketing strategy used the ambiguously erotic, yet rebellious, image of two "13-year-olds" sticking out their pierced tongues to promote Catherine Hardwicke's 2004 *verité* film *Thirteen*, discussed further in Chapter Nine, "The Girl Gaze."

The popularity of piercing and tattoos means that visible skin displays the artwork, even in the antifashion Goth look. On the one hand, this revealing represents a celebration of the Female Body, especially for women who spent the 1980s dressing for the gym and for the office, denying the female form as much as possible. Teenage girls and women in the 1990s achieved a level of physical comfort in acknowledging, accentuating, and celebrating the female form that has been

considered as breakthrough as the braless look of "sexually free" teenagers in the 1960s. However, with the lack of boundaries in the "looks" of womanhood and the blurred definition between tweens, girls, teens, and women, this type of sexualization as a celebration of adult female curves extended to fashions for little girls. Moreover, in a visual culture that includes illicit child pornography and sexual exploitation of children, often through portals on the Internet, questions have arisen about the "adultification" of clothing lines and advertising's images of youth. Inducing younger girls to be overly fashion conscious infiltrates the freely imaginative play space of their childhood. Guerrilla Girls, a feminist arts and media collective active since the 1980s (see Chapter Eight), have nailed the media on its role in promoting this new generation of stereotype, which I have named Lipstick Lolita, the Girl-con variety of Eye-cons discussed in the Introduction.

> Media-specific stereotypes leap across borders and cultures with terrific ease. For instance, young girls today in every part of the world and in every ethnic or economic substrata imaginable get bombarded via TV and the Internet with the Rock Starlet stereotype: a thin, young long-haired (usually blond) woman with her shirt way down to there to show her cleavage and way up to there to bare her midriff, grinding into a phallic microphone. Stereotypes like this have great power. In fact, psychologists are convinced that the projection of stereotypes leads to stereotyped behaviors.[5]

Today, tight-fitting Lolita fashions contain the otherwise chaotic unpredictability of adolescence in a sexy, womanly sheath. This image of adolescence is in direct contrast to the antifashion teenage Icons of the 1960s and 1970s, who, with their long hair, Afros, baggy tie-dyed shirts, bralessness, and bare feet rebelled against the clean-cut hi-fi cola ad kids of the 1950s. Adolescence is a time of chaos. Despite attempts to contain adolescent girls as preternatural Beauty Queens and objects of desire, the tabloids cover the New Lolita exploits in barhopping wildness and unbridled shopping sprees. This wildness and the animal nature of their partying feed the image of their sexual availability and often include a reference to "partying with older men,"[6] providing another meaning to the term Daddy's Girl.

Sexuality and sexual exposure have become increasingly public domains of viewership. Eroticism is front and center on the grocery line—no delineation exists between a private erotic space and public spaces. Through the cleavage of teenage girls and shirtless guys on magazine covers in the grocery aisles, we have no choice but to navigate sexual images at unexpected, once-mundane moments of our lives. In addition to sexual imagery, we have tabloid gossip in our viewing space, violent war reportage, and fear-based storylines to contend with, and not just when we choose to open a newspaper, flip open our laptops, or turn on the television. Magazine displays at the grocery line are only one example. Airport television screens broadcast CNN or Fox News in waiting areas, where the only way to filter in relative "silence" is through an iPod.

Erotica was once a privatized arena that one chose to enter. By purchasing *Penthouse* or *Playboy*, renting X-rated videos, or frequenting sex clubs, mostly male consumers entered this realm by choice. *Rolling Stone* and *Esquire* magazine covers featured on general newstands now frequently highlight sexy young women—Lipstick Lolitas—in poses once aligned with *Playboy*.

What does all of this oversexualized content in our image stream do to our collective psyches? Are we spent, numbed out before our time? What does this barrage of Sex-itas mean for teenagers navigating their nascent sexual identities? Does this contribute to the early onset of puberty in American girls? Questioning our intake is part of an awakening that guides our gaze and helps us to construct filters of navigation that assist with processing our overloaded pop culture image banks, where images enter an unconscious reservoir of our memory banks, influencing our behaviors and attitudes at the subtlest levels. Pulling back to overview provides a perspective on just how much accelerated cultural transformation has taken place in media streams since the 1990s.

Collective desire for the teenage female body was once the taboo domain of films such as *Lolita* (1962, Stanley Kubrick), about a middle-aged college professor obsessed with a 12-year-old "nymphet," based on the novel and screenplay by Vladimir Nabokov. Since the late 1950s when the novel originally appeared, "Lolita" has become a type, a noun of public discourse. Her image as the Sexy Schoolgirl, a staple of pornography as iconic reference, plays into the construction of Lipstick Lolitas of the 1990s quintessentialized by Britney Spears, who even wore a schoolgirl outfit on the cover of her first album. As the Guerrilla Girls point out, "Lolita became a stereotype: a seductive adolescent girl, a nymphet ready to have unlimited sex with older men. Do an Internet search under Lolita and up pops an endless barrage of porno sites."[7]

In 1962, controversy accompanied Kubrick's film to such a degree that he changed Lolita's age to 14 and reedited many scenes to provide a "suggestion" of what is explicit in the novel. As Stephen Metcalf points out in *Slate*,[8] the original shock value of this highly crafted piece of poetic prose, about the corruption of a young girl by her supposed stepfather, has not evaporated. Unlike *Lady Chatterly's Lover* by D.H. Lawrence and *Ulysses* by James Joyce, both banned when published, *Lolita* still has the power to shock as an artfully accurate portrait of a depraved mind. Adrien Lyne's 1997 remake of the film stirred up the old controversy, with many religious groups boycotting the film due to the explicit nature of the sex scenes between Jeremy Irons as Humbert Humbert and Dominique Swain (then aged 15) as Lolita. Lyne had trouble finding theatrical distribution for the film and it was originally released as pay-per-view on Showtime. An irony about the Lolita archetype that emerged from the book—a precociously sexy girl who "wants it" from an older man—is that Nabokov's Lolita is clearly an innocent girl corrupted

by a pedophile who chooses to cast her as his object of sexual desire. She never offers herself to him; he takes her virginity like a thief. As the Guerrilla Girls suggest, how come we don't have a Humbert Humbert archetype in the vernacular?[9] The Lolita archetype has an instant snap of association, whether you have read the book or not, but that archetype has become inverted from its original intent as an erotic figment of a pederast's imagination.

Richard Roeper, a middle-aged writer for *Esquire*, in May 2004 discussed the issue of men's attraction to the Teenage Starlet in "The Jailbait Dilemma: Does Ogling Tweeners Make Us Dirty Old Men?" For a film critic called upon to review crossover films with "tweeners" as stars, the sexualization becomes hard to ignore:

> What these films have in common is a photogenic teenage girl in the lead. Sometimes she is a cute and adorable cheerleader type who loves her parents and has a Pepto-Bismol pink bedroom with 100 stuffed animals on the bed; sometimes she's a *dangerous temptress* from a broken home who can barely keep her jeans above the top of her butt crack. Either way, she's cute. Really cute. Check that. Not just cute. Flat-out sexy.[10] (italics mine)

For some male viewers, a Lipstick Lolita is the fantasy "other woman" as underage, unattainable Aphrodite. This midlife crisis view of the teenage girl played out as a dark comic syndrome in the hugely popular *American Beauty* (2000, Sam Mendes). The older male gaze names Lolita in different contexts as a daughter/potential victim to be protected and ogled as "jail bait" tartlet. Is the potential pedophile redeemed in the end if, as in *American Beauty*, he fantasizes endlessly (and graphically) about the teenage seductress, yet in the final moment refrains from consummation? The notion of the teenage girl as "dangerous temptress" brings us full circle to the discussion of male desire from the previous chapter. Are grown men, like teenage boys, allowed and expected to be uncontrollable sexual "dawgs" played by the media to pursue Lolita, who is ultimately to blame for being so "flat-out sexy"? The manufactured publicity drives of teenage girl entertainers coming of age under the public eye provides a nostalgic, titillating glimpse into the "does she or doesn't she" loss of virginity moment mythologized *ad infinitum* by American fiction, television, and advertising. For an aging baby boomer culture, longing for that ephemeral moment becomes palpable.

In May 1992, "The Long Island Lolita" story hit the pavement with the early morning papers. Amy Fisher, a 17-year-old senior and part-time prostitute who allegedly turned tricks for her 38-year-old married lover, Joey Buttafucco, shot his wife in a jealous rage. When Amy's demands for Buttafucco's divorce went unheeded, she took matters into her own hands in an attempt to eliminate the competition. Though Mary Jo Buttafucco survived the attack, she suffered permanent facial paralysis because of the gun wound. In September 1992, Amy Fisher was convicted of attempted murder and sentenced to seven years in prison. Joey Buttafucco, on

the other hand, was convicted of statutory rape and served four months in jail, despite his role as Amy's pimp while she was a minor.[11] This sordid story gave rise to three made-for-TV movies, including ABC's *The Amy Fisher Story* (1993), starring Drew Barrymore. After Fisher's sentencing, the reunited Buttafuccos hit the tabloid circuit, appearing on *Donahue* and *The Howard Stern Show*. The triumphant older woman had saved her marriage against the threat of Amy Fisher, the Long Island Lolita, while Joey Buttafucco maintained his innocence as a married man all the way to the bank. As the Guerrilla Girls ask, "Why wasn't Buttafucco the Hempstead Humbert" in the headlines?[12]

In the case of Hollywood's Best Picture winner *American Beauty*, Lester Burnham (Kevin Spacey) serves as a father figure—a depressed, burnt-out, pot-smoking one—to Angela (Mena Suvari), for whom he develops a fantasy-based obsession. Although the relationship stops short of statutory rape, with Lester controlling himself when the girl makes her offer to him, the entire package of the film's success hinged on this exploration of Daddy desire for an underage girl. In addition to *American Beauty*, Hollywood's *Almost Famous* (2000, Cameron Crowe) depicts teenage girl involvement with older men. In this film, a cast of teenage girls have lost their virginity long ago traveling with rock bands. Crowe, who got his start as a teenage writer for *Rolling Stone* in the 1970s, wrote and directed *Almost Famous* based on this early experience. The story features a bevy of teenage girl groupies who follow the fictitious band Stillwater. These "barely legal" girls, otherwise known as "Band-Aids," include Polexia Aphrodisia (Anna Paquin), Sapphire (Fairuza Balk), and Penny Lane (Kate Hudson), who follow the band from venue to venue, providing postconcert sex and partying. Apparently, the characters are based on the experiences of a real person named Pennie Lane who traveled with several bands from 1970 to 1973 (when she was aged 17 to 20) along with other groupies called the Flying Garter Girls, until she took off for college.[13]

A more highbrow version of the loss of virginity tale occurs in Bernardo Bertolucci's *Stealing Beauty* of 1996, which introduced Liv Tyler to a bigger audience. Also marketed as a loss-of-virginity tale, Tyler's 19-year-old Lucy spends a summer at a villa in Italy. Though the romance culminates in a relationship with an Italian boy of her own age, promotional posters featured Tyler in tête-à-tête intimacy with several much older male actors, including Jeremy Irons, who appeared the following year as Humbert Humbert in the *Lolita* remake. Lucy's loss of virginity provides the focal point of the storyline, with all characters, male and female, commenting on it to such a degree that the exasperated Lucy almost books a flight back to New York. *Who will be her boyfriend this summer? Can you imagine her mother being a Virgin at 19?* Surrounded by many good-looking Italian and English gents who would gladly render the service of deflowering her, Lucy defers ultimately to a young, romantic, and equally inexperienced Italian boy. As

her launch into the public eye, this film paved the way for Tyler's star eminence as the Elf Arwen in Peter Jackson's *Lord of the Rings* trilogy (2001–2003), certainly a classy act, but a role that relies on her willingness to give up her fairy power to live with a mortal man (even if Viggo Mortensen *is* a god). However, on the way to this level of success, Tyler had to endure Bertolucci's camera lens itching to get into her pants. Arty, intellectual, cultural discourse surrounds her as does a gorgeous Italian villa and artful cinematography with a clever screenplay written by novelist Susan Minot, but the camera is still trained on penetrating her.

CELEBRITNEYHOOD

An in-your-face style of teenage titillation emerged at the end of the 1990s. Dressed in a schoolgirl uniform on the album cover like a soft-core fantasy, Britney Spears was packaged from the start to play to obvious Lolita codes. Her single, from the album of the same name, "Baby One More Time," played with smudgy semantics on linguistic and visual levels, underscored by a video in which Britney and a cluster of dancers shake their hips down the hallways in modified Catholic schoolgirl uniforms. The "not that innocent" Schoolgirl is a character frequently appearing in pornography videos.[14] When the album was issued, my then 12-year-old daughter, part of the tween demographic to whom the Lipstick Lolitas are marketed, maintained Britney's lyric "Hit me Baby one more time" meant "Kiss me Baby one more time." "Hit me" in Black Jack of course means "lay another card on me." But the Britney team winked the entire time. Hit me? Kiss me? It didn't really matter which she meant. The subtext of her availability to wild imaginings was clear. Her next hit in 2000, "Oops … I Did It Again," proved more than obvious. Britney Spears's rapid album cover transformation from schoolgirl in 1999 to her low-cut skintight look in 2001 marked her obvious deflowering in the public eye. After the mega platinum album by Alanis Morrisette in 1997 featuring the rage anthem "I See Right Through You, I Can Walk Right Through You," male audiences were apparently ripe for a young chick who liked to "play around" with innocence. A schoolgirl who became fodder for fantasy, Britney filled the airwaves with her sugary songs, knocking Alanis off the charts. This manufactured girl act seemed like a definitive backswing of the pendulum after the authentic energy of Riot Grrrl bands from Olympia, Washington, embodied by Bikini Kill and Sleater Kinney, along with the Girl Power of all-women musicians banding together to pack stadiums at the Lilith Fair from 1997 to 1999 (see Chapter Six).

According to Sheila Whiteley, author of *Too Much, Too Soon*, Britney Spears's managers "orchestrated a sophisticated guessing game about her level of sexual

awareness, alternating apple pie wholesomeness with the brazen acts of sexual prov-
ocation which led to a global obsession with the question of Britney's virginity."15
On her 2001 album *Britney*, Britney Spears released the number two song "I'm Not
a Girl, Not Yet a Woman," continuing to play with blurred semantics, an ambigu-
ous space that allowed the sexual imagination to insert itself. This song was used to
promote her film *Crossroads*, again a play on the concept of the in-between. Other
savory song titles from 2001 included "I'm a Slave 4 U."

Britney Spears and her contemporary Christina Aguilera both appeared as
tweens for the final two seasons of the New Mickey Mouse Club (1989–1994, The
Disney Channel). Aguilera's career, which got its jumpstart after the show through a
genuine Diva outing with the lead song "Reflection" for *Mulan* (1998), was likewise
marketed in a sophisticated campaign of jailbait titillation. Both appeared as "barely
legal" sex symbols on provocative covers for *Rolling Stone* and other popular pub-
lications in the late 1990s and early 2000s. While Britney's manufactured talent
was always questionable, Christina Aguilera possessed true vocal ability from a
very early age.

Rolling Stone, which began as a countercultural newsprint publication in the
1960s known for its liberal journalism by the likes of Hunter S. Thompson, with
1970s rock star covers by David LaChapelle and Annie Leibovitz, had changed
a great deal by the late 1990s. Competing with more explicit publications like
Maxim, *Rolling Stone* published a series of controversial Lipstick Lolita covers
that included an April 1999 photograph of then 17-year-old Britney Spears lying
on a bed talking on the telephone in a push-up bra holding a stuffed toy, with the
line "Inside the Heart, Mind and Bedroom of a Teen Dream." The corded tele-
phone and retro style of the shoot recalled 1950s squeaky clean teen stars (except
they always kept their shirts buttoned). That same year, Christina Ricci (age 19),
independent film vixen of Vincent Gallo's *Buffalo 66* (1998) and *The Opposite of
Sex* (1998, Don Roos), appeared on a *Rolling Stone* cover in a pink baby doll-style
bikini outfit with the text "Nice & Naughty." In May 2000, Britney materialized
again in tight red leather pants and red, white, and blue halter-top with the head-
line "Britney Wants You." Britney again appeared in an army fatigue-style bikini
in September 2001 ("Don't Treat Me Like a Little Girl"), with full frontal cleavage
in a bra in December 2001 ("Britney Takes Charge"), and topless in coy side view
in her underpants, her chest pressed up against a wall.16

Soon after receiving industry honors as "Best New Artist" at the Grammy
Awards, 19-year-old Christina Aguilera was the July 2000 cover girl, gazing dar-
ingly at the viewer in a belly-revealing "Super Girl" shirt, licking her lips sug-
gestively. She wore jeans shorts unbuttoned to reveal a red bikini bottom, and
the accompanying tagline "Guess What Christina Wants." In November 2002

during her Dirty Grrl phase, Christina appeared fully naked on the cover straddling an electric guitar, with an illustrated map of her most intimate piercing included on the inner pages.[17] These kinds of headlines were designed to draw the viewer in, to manipulate purchase of the magazine through a fantasy promise that these barely legal girls would satisfy the reader sexually.

BRITNEY'S LITTLE SISTERS: THE NEXT WAVE OF LOLITAS

From 2002 to 2004, Mary-Kate and Ashley Countdown Clocks appeared on Internet blogs, anticipating their 18th birthday. As Michelle Chiara documented on *Alternet*,

> "For the adult crowd, where sexuality and irony are powerful currencies, the twin appeal runs the risk of morphing into a kind of twisted twin fascination. Like the Olsen Twin Foot Fantasy listserv, for example. Or like the two Florida morning DJs named Lex and Terry who have an online "Jailbait Countdown Clock" to the Olsen twins' 18th birthday, complete with T-shirts for sale that read "Olsen Twins. Open Season is June 13, 2004."[18]

As the twin stars of "Full House," Mary-Kate and Ashley have been in the public eye since toddlerhood and are the wealthiest child stars in history. The Olsen Twins' *New York Minute* (2004) served as a "We're Grown Up Now" feature-length advertisement, complete with the girls walking around in towels fresh from the shower, prancing in their underwear. While their contemporaries Scarlett Johansson and Lindsay Lohan, also child actors, have more serious aspirations as young adult actresses and performers, they have nevertheless allowed their "sexiness" to be part of their packaging as they came of age. The question remains whether this embrace of young sexuality is "empowering" or exploitative.[19] Given the age of the young women involved, and the fact that their DualStar company provides more salaries than their own, it's difficult to rule out the latter.

As an 11-year-old, Lindsay Lohan held her own playing twins raised on opposite sides of the Atlantic, impressively maintaining her English and American accents in the Disney remake of *The Parent Trap*, directed by Nancy Meyers, released in 1998. While many of Lohan's films along the lines of *Confessions of a Teenage Drama Queen* (2004, Sara Sugarman) and *Herbie: Fully Loaded* (2005, Angela Robinson) have been no more than traditional Disney fluff, her performances alongside Natasha Richardson (*The Parent Trap*) and Jamie Lee Curtis (*Freaky Friday*) elevated those millennial remakes to cross-audience success. Her 2004 role in *Mean Girls* marked the pinnacle of her coming-out party with box office bonanza in the public eye alongside *Saturday Night Live*'s Tina Fey. While

simultaneously performing a tabloid role as Paris Hilton's wild Party Girlfriend, in 2006 Lohan appeared in the ensemble cast of Robert Altman's final film *A Prairie Home Companion* opposite legends Lily Tomlin and Meryl Streep, who embraced her maternally on the May 2006 cover of *W* Magazine.[20] Schizophrenic Princess or Genuine Talent? Lohan's legend remains in flux.

Similar to Lohan, Scarlett Johansson's role as Grace in Robert Redford's 1998 film *The Horse Whisperer* put her on the Hollywood "talent to watch" map as a 14-year-old. Yet, despite their high-profile acting careers already underway as young teenagers, Johansson and Lohan celebrated their 18th birthdays under the collective eye with sophisticated marketing campaigns and career-placing strategies emphasizing their nubile endowment and sexual allure. Lohan's August 2004 cover for *Rolling Stone*, complete with a "Hot, Ready and Legal!" headline, ran with a feature article that begins, "Lindsay Lohan has been eighteen for just under a week when she tells me her breasts are real."[21] Johansson, after a snarky performance in 2001 (age 17) in *Ghost World*, and in 2003 (age 19) in highly successful art house crossover films *Girl with a Pearl Earring* and *Lost in Translation*, dished up a sultry cleavage cover for her February 2005 feature in *Esquire* with the opening line "Right about now, Scarlett Johansson is supposed to be surveying the history of dildoes with me."[22] Even the promotional poster for the decidedly arty *Girl with a Pearl Earring* features 40-something Colin Firth (as Vermeer) nuzzled up to teen-aged Johansson's ear with the accompanying text "Beauty inspires obsession."[23] In February 2006, Johansson appeared nude on the cover of *Vanity Fair* along with Keira Knightley and a fully clothed Tom Ford.[24] Though the photos were tastefully arty, the question remains: can young celebrities who opt for maximum "coverage" by uncovering their bodies become everlasting Venuses who are taken seriously as actresses, or will they become throwaways like Venus razors?

Taking their postmodern cue from Madonna, now a cultural Icon of female power who has morphed and borrowed from the lexicon of celluloid iconography as no other performer before her, some Lipstick Lolitas have explored visual allusions to famous Sex Goddess photos of the 1950s and 1960s, conflating their images with a previous generation of fully adult 20- or 30-something sex symbols. Lindsay Lohan's Brigitte Bardot evocation appeared on the cover of *Entertainment Weekly* in 2004, her arms and legs crossed to hide her nakedness, underscored the headline "Lindsay Lohan Opens Up On Fame, Family and Those Nasty Rumors."[25] Her Marilyn Monroe evocation in a 1950s bathing suit graced *Vanity Fair* in January 2006;[26] her nod to Elizabeth Taylor's Academy Award-winning call girl in 1960's *Butterfield 8* appeared on *Interview* magazine in June 2006.[27]

By referring to Monroe or Bardot, this new breed of Sex Goddesses exists in an iconic space without reference to real women. There is no "real"; it is the realm of fantasy, a hall of mirrors in which the hypertext of Baudrillard's simulacra reigns:

"The real is produced from miniaturized units, from matrices, memory banks and command models—and with these it can be reproduced an infinite number of times."[28]

Media literacy reminds us that the Icons of our time are all an illusion, layers and layers of illusion, copies of copies from histories of cultural reference. Though we may talk about celebrity travels, career moves and paparazzi run-ins, they are all part of a narrative of the hyperreal. These Girl Starlets engage in complex performances of the feminine that reference female personifications of previous decades via a public relations strategy system aimed at instant recognition drawn from suggestive nostalgia as empathy in the viewer. This false memory seed manufactures intimacy, which is one part of the artistry involved in constructing any kind of Heroine. It can serve as the pleasure link to engagement in a fantasy. Madonna's take on the Marilyn image removed the tragedy and the sorrow, fully embodying her sexual allure as a power reference, rather than an abused sex symbol. Her postmodern tropes involved creative uses of copies, quotations of the Female. Madonna's originality lies within her referencing system, her reinvention strategies, and the sheer force of her performative personality, more than her actual talent as a singer. Repeating Madonna's strategies in the promotional campaigns of young starlets is a post-postmodern cocktail that's effective for a form of instant recognition but may not spell "original" enough to transcend decades of career viability as Madonna has managed to do.

As Icons, Lindsay Lohan or Scarlett Johansson cannot be physically possessed by older or younger fans. Once elevated to Sex Goddess/Aphrodite status, they can descend if broken by bad fortune or a series of unsuccessful career moves, but even then they can never return to the life of the normal, common girl. Once they have crossed over to fame, the Klieg lights that lit their red carpet will cast a shadow. Whether they come to regret being the sacrificial lambs of celebrity as Marilyn Monroe apparently did, or revel in the material wealth of megastardom, or become enduring Icons like Amelia Earhart is not known.

THE COLLECTIVE GAZE

What happens to the careers of girls entering the visual arena as professional actresses deflowered by the collective gaze? All viewers have the capacity to adopt a voyeuristic gaze, a defining gaze, a naming gaze, an eroticized, objectifying gaze. Laura Mulvey coined the term "The Male Gaze" in her seminal 1971 essay "Visual Pleasure and Narrative Cinema":

In their traditional exhibitionist role women are simultaneously looked at and displayed, with their appearance coded for strong visual and erotic impact so that they can be said to connote *to-be-looked-at-ness*. Women displayed as sexual object is the *leitmotif* of erotic spectacle: from pin-ups to striptease, from as the Ziegfeld to Busby Berkeley, she holds the look, and plays to and signifies male desire. Mainstream film neatly combines spectacle and narrative.[29]

Lipstick Lolitas fall under a collective disrobing as we possess them with our eyes on the covers of fashion and tabloid magazines, on billboards, in pop-up ads, and on bus stops. The undressing of this gaze is symbolic, a ritual of visual culture, the wandering imaginative gaze. This suggested visual entry provides a virtual fantasy of physical connection. This culture of the erotic gaze derives pleasure in looking at an object of beauty. However, as bell hooks notes, "Desire has the power to do just that, to make us forget who we are. It both disrupts and deconstructs. It dismembers and disembodies."[30]

What happens to those who adopt the male gaze and buy into the promise of access to the soft-core allure of the Teenage Sex Goddess? What price does the male viewer pay when it's just a magazine image? Why does the 18th birthday legalize the gaze of older men onto much younger women? Whether the girl is 16 or 18, the sexual intent of the gaze is still questionable. What fundamental shift occurs at age 18 to exonerate the older man's gaze?

The male gaze dupes itself into a myth of sexual availability based, like pornography, on illusion. Are viewer and performer in complete collusion? It marks another opportunity for self-pleasuring through scopophilia—Freud's terms for sexual pleasure derived from the act of looking.[31] Cast under the scrutiny of an adult male gaze, Teenage Girls have become the Aphrodites of the culture, a role once reserved for 20- or 30-something Icons akin to Marilyn Monroe or Brigitte Bardot. While titillation may run high in the busty image of 18-year-old Lindsay Lohan on the cover of *Rolling Stone* magazine, striking fear in the parents of teenage daughters, it is a gaze of relative impotence on a collective level.

Our consumerist gaze is responsible as much as the packaging that brought us to view The Virgin. We do not avert our gaze. We stare shamelessly, criticizing, reviling, or aroused by her. The Virgin of youthful light thus becomes our shadow. Just as Humbert Humbert convinces himself that Lolita seduced him, so we deflect the seduction via jailbait on to the Britneys and their handlers. They are to blame for the lowbrow depravity. Yet we are all Peeping Toms into this orchestrated sideshow-become-spotlight, where teenage celebrities are sold. A photograph is a possession. You buy *Rolling Stone* magazine, you own the cover. So in whatever form, this ownership extends to a piece of Lindsay Lohan. She becomes a public commodity, along with her "virginity," packaged to all who consume her image as

"Ready and Available." "New" and "Free," key American marketing terms often seen as stickers on beauty and personal hygiene products, usually appear with exclamation points.[32] This conflation of terms finds its nexus in the image of the Teenage Virgin offered for "free" on the cover of a magazine. With the commoditization of the coming-of-age narrative as a visual product, a seemingly endless annual supply of teenage girls comes of age under the lamplight. Whether they will gain celebrity status or come to be known to us on a first-name basis is uncertain, but their freshness and newness as unnamed Nymphets of the collective sexual imagination provides as an endlessly renewable, and often disposable, visual resource. In fact, you don't even have to buy the magazine to participate in the seduction; a glance at the newsstand provides a seductive flash. The sex jolt in the public space of routine—train stations, street corners, grocery lines—helps to sell the New Venus Icon into recognizability. They brand themselves with a celebrity identity by making their image, their allure, widely available. With her come-on gaze, she makes a virtual promise of intimacy, of entry. Available to all who choose to look, this false promise is a projection once removed.

Who is being manipulated? The young performer, wanting to "make it big" by breaking out of her tween fan base into an adult one? Or the consumer, by taking the cheap soft-core bait? Is everyone in on the "wink, wink" manipulation and complicit in the exchange? If women read *GQ* or *Esquire*, does that mean they adopt the presumed male gaze of the reader? Is gazing in fact a male activity? Was it ever? Every human has eyes; every human gazes for pleasure. Is the discussion of the Male Gaze, as proposed by Mulvey, still relevant? Don't women take pleasure in looking just as men do? The pleasure of looking has to do with an aesthetic appreciation and a sense of the sublime attained in perusing beauty in a painting, a photograph, a film, not just sexual ecstasy. Unless trained exclusively in the jealous gaze of female critique, women have the ability to gaze admiringly on the beauty of other women of all ages, races. This is not necessarily a lesbian gaze or a bisexualized gaze. If girls have access to the freedom to appreciate fully other girls' beauty on public display, a shift occurs socially and closeted jealousy no longer rules the discourse as a habit of female-on-female criticism.

Perusing Maiden bodies/faces of popular culture, we are peering, peeking, curious, watching the movie of their celebrity lives unfold, projecting our own scripts, narratives, and assumptions onto a body, a set of actions. Looking has been confused with knowing. The unzipped gaze gives us a false intimacy about these Icons. We think we know them; their eyes return our gaze from within the still frame of the magazine. But we do not really know them at all. Gazing at Female Icons takes many forms beyond the salacious in girls and women, which can include detailed critique (look how skinny, look how fat, what a Slut, …) as well as admiration (she's

hot, she's cool, she's wearing great clothes, she's powerful, she's a Role Model). Are we looking at ourselves and our daughters in the mirror of celebrity culture or are we peering in on a fantasy?

The Maiden as Lolita is a public object of desire; she belongs to us all. We watch, fascinated, puerile, amoral. She should be in school, shouldn't she? Yet somehow she escaped the "normal" fate. She's able to play hooky and not get caught, clubbing at night, speeding in expensive sports cars. The rules of "normal life" no longer apply. Why is she playing hooky, why is she available to the collective gaze like this? Why is the cult of celebrity so powerful as to inspire these young women to cut their bloodline to childhood to ride a rocket to a premature adult lifestyle of excess as a rite of passage? Why is she available as a Young Celebrity to be held under our objectifying gaze?

As we gaze on the Maiden, we attempt to possess her, as we wish to possess fleeting youth. She is the trendsetter, yet not fully cognizant of her power, just coming into awareness of it. Not a deer frozen in the headlights, a victim of our scrutiny, she has dressed up (or been dressed up) and says, "Yes, my spotlight, my moment. Look at me." Seeing early videos of Christina Aguilera on *The Mickey Mouse Club*,[33] one witnesses her nascent cult of personality. The craving for attention extends far beyond childhood, where she held the microphone karaoke-style in her living room at seven years old, belting out songs like a preternatural Diva.

While women's bodies continue to provide an erotic spectacle for advertising and reality television, male bodies are increasingly contributing to this showcase as well. Mulvey discusses the flip side of the pleasure in looking, that of the exhibitionist, a phenomenon increasingly mainstreamed through Reality TV. This is what celebrity culture, even the fleeting "fifteen minutes of fame" variety, centers on: the pleasure, at least initially, in being looked at, while we as viewers engage in the pleasure of looking, in many cases hoping to one day be on display as well. "The cinema offers a number of possible pleasures. One is scopophilia (pleasure in looking). There are circumstances in which looking itself is a source of pleasure, just as, in the reverse formation, there is pleasure in being looked at."[34]

As these young stars gaze out from the two-dimensional space of their magazine covers, engaging in virtual eye contact with thousands of consumers, one wonders whether these Sex Goddesses of the 2000s have more power and agency than the character from Nabokov's novel. What is the difference between Venus the Goddess of Beauty honored for her supreme gifts and Lolita the Nymphet tricked into a premature sex life by a false father figure? Is theirs a defiant gaze or a demure gaze, a knowing gaze or an innocent gaze, a gaze of acquisition or loss? Are they in control of their own destinies and careers, making informed decisions

about their images and public identities? Or are they pawns in a system of sexual Icon masterminding of pre-legal Girl Starlets, encouraged to "sell all" before the age of 18, despite their talent, their potential, their future goals as performers?

THE CRITICAL SPECTATOR

One of the activities both teenage girls and boys are trained to perform is observing, judging, and commenting on the way girls look. Endless commentary could be termed visual harassment—She's hot, she isn't; she's fat, skinny, anorexic—the list is endless. For girls, this cultural spectator sport scrutiny goes inward as a constant inner self-critique that affects their freedom to move, act, and speak without inner self-censoring. John Berger in *Ways of Seeing* relates the history of this gender viewership divide back to the Nude in oil painting:

> In the art form of the European nude the painters and the spectators were usually men and the persons treated as objects usually women. This unequal relationship is so embedded in our culture that it still structures the consciousness of many women. They do to themselves what men do to them. They survey, like men, their own femininity.[35]

Teen fashion magazines provide environments where girls often hone their girl-on-girl critical skills, as well as their own self-criticism. This rudimentary form of critical "reading" of advertising and fashion spreads involves an often vicious critique of the model's looks, hair, clothing, mannerisms, weight, and facial features. This carefully sharpened cruelty gaze applies to other girls as they size one another up on meeting for the first time, as well as to themselves. This "criticism gaze" differs from the "critical gaze" of media literacy, which involves a decoding of the Icons and storylines underlying the image as text. In addition, when a girl looks through the lens and gets hooked by the act of framing the world, this self-scrutiny shifts—as long as she's not focused only on self-portraits!

As fed by tabloid culture, celebrity lives remain under scrutiny for flaws. The masses look for the Achilles heel, intent on humanizing these Gods and Goddesses of glamour, to bring them closer to us as viewers, to shorten the distance between our fantasy of being celebrities ourselves and the seemingly unreachable lives of these mega-rich unreal Icons of pop culture. Bringing them down to earth also reduces the humility of being a wannabe, the role to which celebrity obsession relegates us, drawing attention from our own passion and dreams, perceptions, fictions, and projects to the trivial pursuits of the glamour posses, the ultimate celebrity "in-crowd," even more unattainable than the alpha cliques at school.

The criticism gaze offers a false sense of superiority, just like gossip, for the negative knife can be turned in on oneself or turned against a girl as backstabbing

by others at any time. The criticism discourse creates a no-girl's land inhabited by paranoia and dis-ease, a lack of trust and a core insecurity fed by an industry that does not reinforce codes of loyalty among females.

The challenge for this and every current crop of teenage celebrities is longevity. Cashing in big time on youth is one thing; riding the wave into adulthood with an intact career is another. Many of these stars quickly cross to a Sex Idol status linked to their cash-driven otherworldliness, a loss of innocence built on liquid gold. Cleavage in the gaze, their loss of virginity for the collective eye cannot be regained. Are these Maiden Icons virgins sacrificed at the altar of celebrity, the pagan bacchanal of unzipped virginity lost in a public ritual of representation? Is this part of a self-fulfilling prophecy when a self is turned over to the collective eye? Do we impose this kind of sacrifice on our Icons, to be glamorized and admired, then endlessly scrutinized and criticized? As Camille Paglia has expressed, "Deification has its costs. The modern mega celebrity, bearing the burden of collective symbolism, projection, and fantasy, is a ritual victim, cannibalized by our own pity and fear."[36]

As Sex Goddesses, these young women offer up their privacy, their humanity, to serve as sacred prostitutes of the tabloids. Although some claim complete awareness of the exchange, and an affirmation of their own sexual agency, are they fully aware as they sign contracts and agree to the scripts of identity formulated by this packaging?

In 1996, *The New York Times Magazine* published Jennifer Egan's "James Is a Girl," a profile of a would-be supermodel with photographs by Nan Goldin. The article's tagline read "In the Fashion World of the 1990s, teenage models simulate an adulthood they've yet to experience for women who crave a youthful beauty they'll never achieve. Sweet 16 it's not."[37] Soon-to-be Supermodel James King, then age 16, had dropped out of high school to enter the fashion industry at age 14. Once the drug of celebrityhood enters the bloodstream, the chance of return to Normalville, USA, is unlikely. By 1999, James was a 19-year-old Super Model in rehab, trying to kick a heroine addiction apparently begun when she first started modeling. Hers is a classic high-to-low tale of superstardom at the expense of an education.

In the history of celebrity culture, stars introduced to the business as children on the legendary scale of Judy Garland and Elizabeth Taylor, had spectacularly difficult adult lives. Does being a Pop Icon consign a star to a life of strife and emotional impossibility: divorces, rehab, car wrecks, and custody battles? There are a few rare cases, such as Jodie Foster, who seem to have survived the perils of celebrityhood to fashion coherent functioning adult lives and successful enduring careers outside of the tabloid spotlight. However, even Foster, long respected as a "serious" actress and director, launched her adult career by starring as a teenage prostitute who befriends the cab driver Travis Bickel (Robert De Niro) in Martin

Scorsese's *Taxi Driver* (1976), for which she received a Best Supporting Actress Oscar nomination. Foster, the former Coppertone baby, exuded a street wisdom as the 15-year-old prostitute Iris, no doubt attributable to her years as a television and commercial actress. Although Foster never actually undressed for the role, the complexity of the acclaim she received as an underaged performer playing a street-walker cannot be denied. Bottom line, girls are often initially rewarded for selling their virginity to the pop imagination. While Foster appears to have been savvy in her choices and in her ability to remain box office successful into her early 40s, these pieces of her career history provided some of her fame steppingstones. Allowing adult audiences to penetrate into the intimate virginity of a young female performer is often part of this crossover into iconic status. Combined with certain talent, careful orchestration of this "first time" proves key to a performer's longevity. Lolita is conquered, yes, but then she plays alongside the adults, often winning awards and making a lot of money, a trade-off some young female performers have made.

Many young women "introduced" to major celebrityhood like debutantes to their starlit coming-out party at age 15 or 16 have been working models and commercial actresses since childhood. To say that they have a choice in the matter of spotlight obscures the fact that the world of illusion and glamour has defined their consciousness and imprinted a worldview involving artifice and fame as obvious ends. No before-and-after life exists for them, just a continuum of choices made for them by their manager parents, who often become dependent on the proceeds of their child's innocence sold to the lights.

In *Too Much Too Young*, Sheila Whitely investigates how age and gender have shaped the careers and images of pop music stars, examining the role of youth and youthfulness in pop music through studies of male and female performers from the 1950s to 1990s.[38] That the collective eye has possessed these pre-legal girls and named them Starlets is a foregone conclusion of the celluloid industry of illusion. However, childhood and adolescence have been the price. Despite the well-documented permanence of the celebrity imprint on these girls' lives, complete with unhappy early marriages, drug problems, and public betrayals, it's surprising how many young women choose each year to give up a life of school, friends, summer camp, and internships to pursue fame. The allure of stardom, as the mythic ticket out of poverty or perceived suburban "normalcy" still manifests as the number one career choice for thousands of teenage girls.

There is a difference between trying on identities as a public performance and being exploited by identities imposed by money-grubbing managers, sometimes the child star's own parents. When these stars are packaged in the image systems hungry for fame's fortune and the attention spotlight, the sale of their virginity to the public imagination can come at the short-term price of a true career. Producing a coming-of-age/loss-of-virginity act for the masses requires subtlety or the Whore

brand comes down hard and unforgiving. It takes a classic intelligence to elude a minimized status as Sex Kitten. It takes savvy to master the image as it appears under the public eye. Young, first-generation celebrities cannot call upon their parents' experience about finessed behaviors under scrutiny.

In "Teenseltown," Lynn Hirschberg's term for the recent Hollywood obsession with teenage storylines, many actual teenagers launch into adulthood under the collective eye, but often 20-something actors assume the screen role of "the teenager," remaining coy about their age in this context.[39] When popular teenage shows extend into multiple seasons, producers prefer to present the stars as teenagers for as long as possible. Graduating from high school sounds the death knoll for a high school sitcom. Therefore, the teenagers depicted in these shows are often older in real life than the characters they portray, which blurs the so-called legality of the sex scenes in which they may appear. A 20-something actor can "legally" engage in sex acts technically illegal for the teenage character they portray. In this way, these narrative sequences blur the lines between legal, acceptable teenage behaviors and a complete break with rules of youth and adulthood. In an era of teenagers living as adults, it is no longer clear what "of legal age" means. Do these rules, such as they exist, hold weight any longer?

Tabloid culture elevates its Icons to stardom in equal measure with a drive to pull them back to earth for their fallacies, mistakes, and human tragedies. Paparazzi scatter, speeding to photograph celebrities drunk, fighting with their boyfriends, kissing in public, as if to prove that they are human. Look—they have bad hair days, they go to the gym in sweats—they are just girls, not Goddesses. Yet, we all know better. These are not normal girls. These girls-to-women have passed from the grasp of the common eye to their sacrificial status as Icons. These Girl/woman Sex Symbols are no longer human; they are Supra Human, so even their flaws become magnified as betrayals to their initial elevation.

Selling a loss-of-virginity script to the tabloids for millions comes at a risk, as an ephemeral moment, a transition from childhood to adulthood that these celebrities can never recover and that often spells a lifetime of childlike antics acted out in the public eye. Witness Britney Spears in her 20s scrambling for legitimate attention and respect after giving it all away to the gossip rags, with mid-2000s antics that include lifting her skirt to reveal her naked self and shaving her head, with well-publicized forays in drug rehab, all recorded during her early years as the mother of two young children. A Model Citizen? A Role Model for tweens and teens?

As an adult, Britney Spears has morphed into a classic camp reference, which is perhaps what she was at her inception, a confection, a quotation of the Feminine. As Susan Sontag noted, "Camp art is often decorative art, emphasizing texture, sensuous surface and style at the expense of content."[40] Madonna too could be

classified as camp, but she brings along a levelheaded irony and sophistication that eludes Britney as her watered-down offspring. Madonna masters her own tropes, much more so than Britney, who was packaged by a team of corporate producers. Madonna always packaged herself. As quoted in *Manifesta*,

> Madonna is in control of her sexual power, rather than a victim of it; she wields it the way she could a gun or a paintbrush or some other power tool that is usually the province of men. And she is enjoying it, which is her luxury and her strength.[41]

As Madonna has demonstrated since the mid-1980s, owning one's sexuality can be a powerful (and bankable) choice for a performer, especially a female one. However, Madonna's "boy toy" career identity took form in her mid-20s when she was more than "legal," making all of her own business moves. Although many of these young performers evoke Madonna as a role model, Madonna finished high school and a few years at the University of Michigan before she hit New York to become a Diva Icon. Whether Britney Spears will survive as an adult performer beyond her own Celebritneyhood as a cultural quotation remains to be seen. Even the value of this role is up for grabs. With Ashlee Simpson unsuccessfully vying for her coming-of-age and loss-of-virginity packaging in 2006, complete with bleached hair, plastic surgery (nose job), and anorexia well documented in the tabloids, the Uber Virgin may be past her prime.

Since Lipstick Lolitas packaged by Disney and other corporate media companies have established a pattern of extending the marketability and name recognition of child celebrities by selling them as Sex Objects in adolescence, it's worth examining the sugary Starlets and Princesses geared to tween consumers and consider other alternatives to the seemingly innocent, perky Girl Stars who may grow up to become "not that innocent." The good news is there are other role models and Icons out there for tweens; it's all about finding, framing, and naming them. In a cross-cultural rebound for the Lolita Icon, Japanese teenage girls of the late 1990s created the Gothic Lolita or GothLoli style, which combines elements of *Alice in Wonderland*, Edwardian skirts and bonnets, a look doll cute, elegant, and fun for girls (and some boy band members), rather than aimed at attracting a Humbert gaze. The look, gaining cult influence in the United States, defines certain *manga* and *animé* characters, and in some instances combines elements of punk aesthetic.[42] The 2004 film *Kamikaze Girls* (Tetsuya Nakashima) features Momoko, a Japanese teenage girl from Kobe who wishes she could time-travel to France in the Roccoco

era and dresses in layers of frill to prove it, and her unlikely androgynous friend Ichigo, who belongs to an all-girl *yanki* motorcycle clique in Tokyo. This spin of meaning on an English-language Icon of questionable value to girls becomes chic palatable to a new generation through an unexpected East/West culture filter, all the way to Hello Kitty tweens.

Reigning Tweens AND Alternative Tweendoms

Teenage girls are so admired by pre-teens that the preadolescent phase for girls ages 8 to 12 gained its own related term in the 1980s: Tween. As marketing shorthand for "between girlhood and teenage-hood," "tween" has effectively replaced "pre-teen" and "teenybopper." The 8- to 12-year-olds now have a hip, cutesy designation, no longer included in the generic 5 to 12 girlhood demographic. "Tween," a mere digit away from "teen," provides a linguistic metaphor for the accelerated shortcut to adolescence, both biologically and psychologically. The virtual blink of the "tween" phase is a brief station on the way to an adolescence, where another form of accelerated adulthood expectations takes over. The presence of so many teenage celebrities has also extended the age of celebrity worship backward toward tweens and younger children. Tween culture has served to speed up childhood with programming and product lines geared to consumerist notions of girlhood, often by marketing child starlets who by age 18 end up as post-Lolitas on the cover of *Rolling Stone*. Parents sometimes miss the connection between the way these squeaky-clean stars of childhood (Britney, Lindsay, Hillary, Christina) are first marketed to young girls as idols then to older men as Sex Goddesses. If these performers become their early imprint role models, what happens to real girls' understanding of coming-of-age rituals when their Icons transform from cute to sexy overnight? As Sharon Lamb and Lyn Mikel Brown note in their 2006 book *Packaging Girlhood: Rescuing Our Daughters from Marketers' Schemes*,

> We can see the results of all of this effort in the ways products are marketed to preteens, ingenious strategies that combine innocence and edge: childlike stories with teenage stars

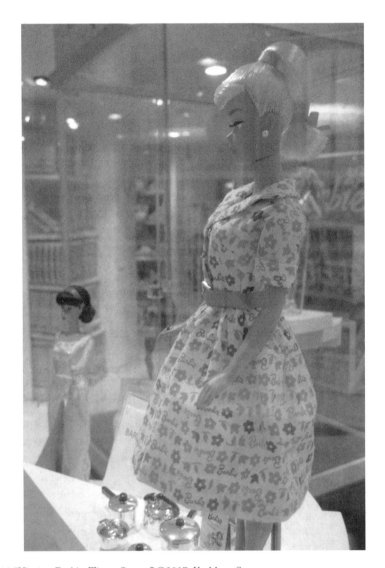

4.1 "Vintage Barbie, Times Square" ©2007, Kathleen Sweeney.

and romantic plotlines (for example, all those princess movies of the past few years), slogans like "cute angel" on Victoria's Secret-like undergarments, and dolls in bikinis mixing pretty drinks and lounging in hot tubs.[1]

Tweens are now treated as first-stage buyers in the teenage club. The tween group in particular worships a certain kind of sugary teenage idol, which has included Britney Spears, Hilary Duff, and the Olsen Twins. Cross-marketing has branded these celebrities from early childhood, who grow up in the public eye just ahead of the kids who admire them. Tabloid scrutiny of these mini-celebrities from childhood to Lolita-ized early adulthood has fostered a false kinship with these fantasy figures who have sacrificed normal lives to stardom. Their paparazzi run-ins, eating disorders, and materialistic lifestyle choices pose many questions for the emerging value systems of their enamored fans. Since children navigate thousands of media messages per day, tween media literacy has become increasingly important as advertisers reach out to them, selling celebrity identities disguised as products, including clothing lines sold at K-Mart (Mary-Kate and Ashley) and Target (Hillary Duff). Clearly these tweendoms are not that innocent.

With many tween-to-teenage celebrities living out their jet-set adolescences under the tabloid eye, the pressure on real girls to articulate a life lived large (while still being skinny) requires navigation. Mirroring celebrity behaviors, often manu-factured stories geared to hype the stars and draw media attention at any cost, can have a negative impact on real girls, as evidenced by photography projects such as Lauren Greenfield's *Girl Culture*.[2]

Many American toddlers and tweens admire the Teenage Girl first as Barbie and the Disney Princesses, then graduate to the Olsen Twins or Hillary Duff, or the next version of the Tween Machine. The preadolescent female hovers between girlhood and womanhood, her parents, her friends, and multiplatform digital enter-tainment. The Girl Icon represents the celebrity friend who possesses secrets for purchase through a magazine cover, a movie, a television show, a CD, an iTune, a clothing line, a fragrance. Tweens are "guided" into their teenage years by a particular breed of celebrities representing brands for "tweenage" consumption of music, books, fashion, videogames, bedding, gadgets, and toys in addition to TV programs. As discussed earlier, the Disney Corporation has been a particularly strong proponent of tween audience building, with cross-marketing campaigns packaging their "tween to teen" pop music stars Christina Aguilera and Britney Spears. Their raunchy late 1990s launches were followed by the tamer celebrity-building of Disney Channel denizens Raven Symoné (*That's So Raven*, *The Cheetah Girls*) and Hilary Duff (*Lizzie McGuire*). With commercials exclusively for their own products, which include ads for their own sitcoms and specials, the Disney Channel's formula has created an enclosed viewing universe for branding Disney celebrities and Icons, a veritable "Tween Machine" and an unexpected cash cow.[3] In addition, Disney Girl

Stars have ample exposure in tween/teen magazines *Teen People, Cosmo Girl*, and others, which combine with television shows, billboard ads and clothing line campaigns to promote young Starlets to household name status.

Peggy Orenstein has written about Disney's recent Princess line of products geared to girls as young as two or three years old.[4] While the Princess Icon clearly pre-dates fairy tales, the codification and marketing strategy draws from the Disney canon to provide a bedroom and boudoir world of pink and sparkles for little girls. Not to mention a lot of plastic. From my own experience raising daughters where trucks and blocks were offered in equal abundance to puppets, books, and dolls, girls are drawn to the Princess Identity in the dress-up bin. But making a unique Fairy Princess costume out of tutus, scrap fabric capes, aprons, and Mardi Gras necklaces is very different from buying the Snow White line of products from the Disney Store. A key component missing from the pre-packaged version, known as creative imagination, means that the Disney movies, rather than the original fairy tales, *The Paper Bag Princess*,[5] or some girl-generated hybrid, provide the codified reference points for the play script.

THE THIN TWINS AND TWEEN ANOREXIA

Outside of the Disney enterprise, the Olsen Twins capitalized on their *Full House* (1987–1995) toddler-to-tween celebrityhood to form their own multimillion-dollar franchise, DualStar, which features a straight-to-DVD "Mary-Kate and Ashley" series, music albums, clothing, and make-up lines. While under the radar for more highbrow parents, these twins have acted in a cutesy line of videos and 100 paperback book titles about their adventures in celebrityland, along with record albums that have sold in the 300,000 to 500,000 range due to their substantial tween following. Mattel Corporation has even produced a pair of Mary-Kate and Ashley dolls, second to Barbie in national sales.[6]

Despite their waifish, skin-and-bones look, these Princesses of Consumption have become Spokesgirls for the American Dairy Association. In the same issue of *US Weekly* that devotes a story to Mary-Kate Olsen's anorexia, the back cover features the twins with milk mustaches in a "Got Milk?" advertisement, with the following copy directly sowing celebrity dream seeds in their fans:

> All grown up. We're not little girls anymore. But, that doesn't mean we've stopped drinking our milk. We know about 15% of your height is added during your teen years and the calcium in milk can help. Who knows, you might be the next big thing.[7]

Despite more than a decade of discourse about eating disorders, tabloids and fashion magazines are still filled with tales of celebrity skinniness and sudden weight

loss. More young girls are talking about their weight than ever before, a subject which used to be of great concern only to teenagers as they began reading fashion magazines. A scene in the 2006 indie hit *Little Miss Sunshine*[8] reveals this phenomenon, demonstrating how striving parents often plant the seeds of distress in their own daughters, reinforcing the messages of beauty culture. The film also serves as a comedic exposé of the freakish nature of beauty pageants. Olive (Abigail Breslin), an eight-year-old optimistic light source for an otherwise struggling, dysfunctional family, prepares to order waffles "à la modie" in a diner on her way to the Little Miss Sunshine pageant in California. Her father, a failed promoter of a nine-step motivational program, jumps in to "teach" her that models do not eat ice cream, because "winners aren't fat." The crestfallen look on Olive's face encapsulates the early imprint of "fat deprecation" culture so prominent in the white American world of so-called winning. Yet Olive makes her comeback when at the pageant's registration desk she asks Miss Florida if *she* ever eats ice cream. "Of course," she smiles, "Chocolate is my favorite."

Often, an anorexic celebrity's attempt to take up less space by weighing less actually leads her to more "coverage" in the tabloids. The girls may begin to disappear in the flesh, but *voila*! They reappear on magazine covers! In their attempt to exist less, the spotlight finds them, and they live large in pseudo-feature stories discussing their "tragic" weight loss. In this way, they are rewarded for starving themselves and enacting a public "disappearing act." Being Diet Houdini Girls gives them more attention, oddly enhancing their "star power." Teenage celebrities appear to be particularly prone to eating disorders, and the paparazzi are willing to comply with documentation.

Mary-Kate Olsen's anorexia was well documented in 2004–2006 as well as Lindsay Lohan's weight drop response to her massive stardom and paparazzi run-ins. Press about Mary-Kate's anorexia coincided with promotion for the twins' first feature film, 2004's *New York Minute*.[9] While obvious signs of attention-getting illness of the celebrity business, regular girls pick up on these strategies as a means of getting attention. Celebrity eating disorders make an imprint on teenage girls and, increasingly, tweens, whose tomboy bodies are just beginning to encounter womanhood. For these girls, photographers don't show up to document their desire for attention. Parents have to watch for and reprogram behavioral "shareware" from the culture at large. Once set in place as addictive patterns in the neural networks, they are difficult to recalibrate. The key is to give healthy girls the attention they need for substantial accomplishments via academic, leadership, athletic, and artistic pursuits before they are seduced into producing a visible ribcage.

While some strides have been made in awareness of eating disorders, anorexia continues to be an illness disorder to "watch for" in teenage girls, particularly when bathing suit season arrives.[10] This mostly white, middle/upper-class issue links to our deepest attitudes about the female body. African-American and Latina

girls, comparatively free of eating disorders, have role models with the prestige of Jennifer Lopez, Beyoncé, and Queen Latifah, all of whom are known for their voluptuousness, and their star turns in the 1990s and 2000s have had an influence on changing notions of the Beautiful.

FAT OR PHAT?

Though frequently mentioned in health and diet discourse, fat remains the most repressed substance in our bodies.[11] Mainstream American culture strives to be "fat free," just as it strives to be "germ free." Despite fat's important role in the nervous system, in milk production, pregnancy, and female "curviness," it serves as a vilified substance in millennial girl culture. Obesity is a curse worthy of social exile, yet more and more Americans suffer from being overweight. While awareness of eating disorders in teenage girls and women has grown, these addictions continue to be challenges to female populations, especially preadolescent and adolescent ones.

Attitudes about Fat play across our social screens, and girls as well as boys learn the good and bad polarity. Skinny is good. Fat is bad. For females, whose bodies are made up of 14 to 20% of fat compared with 12 to 18% for males, this equation begins to plague them from an earlier and earlier age, in part due to the targeting of tweens as consumers. What does this mean for young girls navigating issues of fat and thin? Some of their role models in the 1990s and 2000s, including the Olsen Twins, enter adulthood without any evidence of fat in their bodies. They are not normal girls and never have been, yet normal girls continue to look to them as role models.

Within American culture there are subsets of attitudes about fat. While Fat Phobia obsesses middle-class white girls, African-American girls and women within their own communities and in mainstream culture are simply allowed to take up more physical space. The term "phat" emerged in African-American slang as a designation of cool, hip, rich, entertaining, intelligent, attractive, something to be admired. In use since the 1960s, the word came to designate a certain kind of hip-hop cool in the early 1990s. Originally a moniker for a beautiful woman, as a homonym to the word "fat," its positive association to female curviness suggests a definitive difference between black and white cultures' notions of beauty. In this piece of slang language history, the *prima matera* of women's bodies, the lowly, often hated substance known as fat becomes elevated to the status of cool. Taking the "ph" of Greek is a sly form of wordplay found in the alliterations of the best rap music. Rap culture poetics have provided

taboo-breaking language, a new form of music and racial power, which, like jazz, has seeped into white middle-class culture and become the cross-cultural teenage dance music of the 1990s and 2000s.

In 2000, Kimora Lee Simmons, who began as a model for designer Karl Lagerfeld at the House of Chanel when she a 13-year-old, launched a line of micro T-shirts emblazoned with the words "Baby Phat" which were worn by supermodels Tyra Banks and Claudia Schiffer.[12] Witnessing famous models embracing even a riff on Fat as Phat seemed breakthrough. While the term "phat" has become a bit passé since the early 1990s, this piece of etymological history in the context of racial differences in body image is worth exploring. Baby Phat remains a mainstream brand offering, a pop imprint that may have some impact on countering negative messages about fat for all women and girls.

In the American Association of University Women's seminal self-esteem study, "Shortchanging Girls, Shortchanging America," African-American girls responded to the question "I like myself the way I am" in far greater numbers across adolescence than white and Latino girls.[13] Could this have something to do with cultural attitudes toward fat and body image? Where white culture abhors fat, people of color have often embraced fat as "phat."

Yet an extremely powerful faction of the fashion and beauty industry continues to vilify Fat, oblivious to the fact that the nervous systems of human bodies could not exist without the presence of fat cells, known as lipids, which provide insulation and assist in conveying messages across transmitter cells. This means that all nervous system messages, and sensory awareness messages, including visual, tactile, and emotional messages transmit across micro layers of fat. When the brain stores new information, the myelination process—essentially the wrapping of transmitter cells in spirallic layers of lipids—becomes a crucial component of neural learning.[14] The body acquires new skills, through the layering of fat tissue in the brain. Just as preadolescent girls or tweens begin to become aware of their bodies through consumer fashion marketing and the dieting woes of their celebrity Icons, the "fat is bad" message looms large. Pre-pubescent girls (and boys) often "plump up" before their imminent growth spurts. For all girls, the role of fat in the body is crucial to the development of breasts, eventual milk production, and the very integration of the neurological messages necessary to carry out this significant physical transformation. Chubbiness, so derided in white mainstream culture, is the natural prelude to growth in female bodies. A thickening at the waist prepares the body for the adolescent growth spurt. Yet when girls' bodies begin to show preparatory signs, parents often become concerned and sometimes put them on a diet. The "F" word rears its head with such gems as "Well you don't want to get fat, do you?" "Aren't you getting a little chubby?" and the showstopper illustrated

in *Little Miss Sunshine*, "Do you really need that bowl of ice cream?" Denying girls' comfort in their natural chubby phase can plant seeds in late girlhood that carry over to lifelong struggles with weight and body image, reinforced by plenty of social and pop cultural "advice."

The role of fat in female development could be woven into Sex Education classes so that boys as well as girls have some clue to its role in adolescent biology. In my experiences with girl crises around the issue of weight, boys often first tease girls about "being fat." Ultimately, they tease them for looking like girls and not being boys, for having female bodies, by nature designed with a higher percentage of fat. While we imbibe common national media-based image systems and programming, our education systems vary greatly as to the tools for mediating popular culture and attitudes about girls and their changing bodies. And this includes messages about natural, normal girl bodies.

If the message held by girls is that "fat is bad," then at some level the deepest part of their nervous system may be recording an abhorrence of the very material that contributes to all intelligent transmission in the body and the brain. This inner sound loop may be held by the fat cells themselves, creating a form of static for the relay of other informational learning throughout the entire body/brain matrix. What are the implications for the entire physical, emotional, and sensory awareness in a girl or woman's body when their transmitter cells have been encoded with a negative message about a key element of their neurological functioning? What would happen to our bodies if we constantly said, "I hate muscle," "I hate blood," or "I hate bone?"

In addition to the role of lipids in the transmission of neurological codes, fat is a substance for storage of energy and information. Despite fat's important role, the nervous system, awash in a message of "fat hatred" wraps itself around every other message in the body. The storage of these messages in the nervous system may be part of a female fat obsession and self-hatred, a feedback loop resonating in the deepest nerve cells, which, when patterned into the transmitter nerve cells, repeats ad infinitum unless consciously reprogrammed or vigilantly filtered out.

All nerve cells are myelinated by physo-lipid (fatty) cells as insulation for transmitter cells to translate information from the brain to the body and back again.[15] Teaching girls to abhor Fat may disrupt the easy flow of information into their nervous systems and possibly interfere with academic and emotional growth. When the nervous system, which runs through the entire body, encodes a message that fat is an unwelcome, foreign matter to be rejected, it could disrupt an aspect of neuro-learning. Culturally, if we deny the true function of Fat as an important part of the female and male body at the micro-level, this could be a cause of persistent message misfire. Fat-free diets, while possibly effective in the reduction of body

mass, represent a risk to the proper function of learning in the brain and throughout the entire nervous system.

Making peace with the role of fat in the female (and male) body improves girls' self image and may be linked to curing eating disorders. Understanding this connection to the nervous system helps to underscore the persistent "nerve disorder" aspect in cases of anorexia nervosa or bulimia, which often persist despite long-term psychotherapies and support groups, and, in some extreme cases, hospitalization with intravenous feeding tubes. Lauren Greenfield's debut documentary *Thin* (2006)[16] follows the excruciating experiences of four patients at a Florida clinic for eating disorders, one of them a 15-year-old girl. Despite extensive therapies, which run the gamut from group and private sessions with counselors to constant monitoring and weighing, all four of Greenfield's subjects continue their struggle without substantial breakthroughs.

Shifts in multicultural representation and the presence of such stars as Queen Latifah fully embodying the power and radiance of non-skinniness in films designed for crossover audience appeal may ultimately have an impact on mainstream valuation of the abundant body. That many inner-city black girls remain educationally disenfranchised compared with suburban white girls means that their access to the wide-open spaces of opportunity is narrower and harder to navigate. Comparatively, white girls may have more doors open to them, but many believe they must be thin to pass through them.

The introduction of tight-fitting and revealing fashions for tweens marks an end to a blissful stage of innocence. Girls in tight pants and tight sheath-like blouses—no matter what their body size—press (literally) into an awareness of their physicality as the culture reflects back the young nubile female form via media. That awareness of their physical form internalizes and externalizes as the proverbial glance in the mirror. In some ways, the trend begins with Ariel of *The Little Mermaid*, one of the most popular girls' Halloween costumes for pre-tweens throughout the 1990s, rivaled in the 2000s by the Disney Princess series.[17] Performing Mermaid by revealing a belly button is innocent enough. But when attire for young girls moves beyond dress-up and becomes a part of street wear, it shifts toward a level of body consciousness which had once been blissfully absent from girlhood. If it begins to be vilified through over-awareness, the healthy passage into adolescence is disrupted.

With the influence of 1990s Hip-Hop Culture extending into white suburbs, fashion-wise boys took their cue from hip-hop culture, wearing jeans that drooped below their boxer shorts. Boys in baggy pants, free from constant awareness of their bodies, are in a sense allowed to escape manhood or adulthood by wearing clothes that perpetuate their boy-ness, as if they had raided their father's or big brothers' closets, still too immature to wear a "grown-up" identity.

THE 8-YEAR-OLD WOMAN

Further discussion of sped-up girlhood has taken the form of biological research. A study originally published in the medical journal *Pediatrics* and later reported by Lisa Belkin in her *New York Times Magazine* article "The Making of the 8-Year Old Woman" brought awareness of a strange conundrum of human evolution: Girls, apparently, now enter puberty at younger and younger ages. Published on December 24, 2000, Belkin's article raised many questions and concerns about the puzzling shift toward earlier menarche in America. As she notes, "Puberty research, like so much scientific research, is a mirror into our fears."[18] The arrival of this tidbit on Christmas Eve came as a new fear package for parents of girls. As reported, in some areas of the country girls were exhibiting secondary sexual characteristics at age 8 or earlier. With menarche occurring in America at a younger age, the "tweening" of our culture still needs re-examination. The majority of American girls now menstruate an average of six months earlier than their mothers, closer to age 12 than the previous generation's 13 or 14. This is several years from the "8-year-old Woman" of the alarming headline, who is still a rarity. Yet this news etches into the collective brain as the norm in the buzz created by the reporting. "Did you hear some girls are getting their periods at age 8?" became Parent Night banter after this article appeared. A closer read shows that girls who mature that early are often victims of severe sexual abuse and/or are extremely obese. This clarification makes the statistic no less disturbing but modifies the shock value of the supposed "trend" toward overall young girl menarche. Age 12 is very different from age 8. Yet the six-month drift, if it continues with each generation, could mean a shift into the young tween age range within 75 or 100 years. Some research indicates that our relationship to oversexualized visual culture has combined with airborne and consumed hormonelike substances from pesticides and plastics, obesity, and a high divorce rate to shift the age of menarche by 6-12 months.[19] While none of these theories is conclusive, the trend is disturbing given the increased longevity of humans in the West. Women want to be Girls and Men want to be Boys, but tweens want to be cool teenagers, and the original hip teenager of all continues to be plastic.

BARBIE, THE ORIGINAL POP TEEN

Despite 30 years of feminist critique and dialogue, Barbie continues to fly off the shelves at Toys 'R Us as a classic toy offering at Christmas. She is the beloved Girlie Starlet, the Malibu Single Girl, and the hated Bimbo with the body of a Drag Queen. For young girls, Barbie is the ideal teenager with the sparkly, dreamy

clothes, the tiny Cinderella shoes, and the impossibly sexy body. As M.G. Lord points out in *Forever Barbie*, her comprehensive study of the Barbie phenomenon, "For every mother who embraces Barbie as a traditional toy and eagerly introduces her daughter to the doll, there is another mother who tries to banish Barbie from the house."[20]

While many progressive parents have tried to eliminate Barbie from girl-play due to concerns about her impact on body image, her sales continue to soar. Rejected by Second Wave Feminists in the 1970s, reclaimed by the art world in the 1980s, multiculturalized in the 1990s, Barbie continues to evolve. One of few toys from the late 1950s to endure as a modern Pop Icon, Barbie has become the ultimate middle-aged plastic job. Still a teenager after 45 years, Barbie never ages. The earliest Barbies are now collectors' items. As Lord points out, "[P]lastic in the vernacular is aligned with money … it's slang for the credit card."[21] Therefore, Barbie is made of money. She is money culture. She is American materialism in toy form.

Forever Barbie documents Barbie hagiography at its best. Lord follows the history of Barbie from her origins as a knock-off of a German prostitute doll named Lilli, through her various incarnations, exploring her impact on American and global toy culture and gender-role play as the Single Girl à la Helen Gurley Brown in the 1960s, through multiculturalism of the 1990s. As Lord says, "Barbie may be the most potent icon of American popular culture in the late 20th century."[22] Go figure. Literally. She even quotes Madonna on the influence of Barbies on her own play and dress-up games: "I definitely lived out my fantasies with them."[23]

Compared with the mythology of Disney heroines, the issue of Barbie's parentage is moot, though, according to Lord, her place of birth was Hawthorne, California, just like Marilyn Monroe. Who cares about the lack of a mother; she has a convertible and a beach house instead! Barbie has the "dream life" in girl fantasy: a teenage career gal living on her own with exotic jobs (model, astronaut, scuba instructor) and a wardrobe for every occasion. In addition to having no parents when first introduced in 1959, Barbie worked solo as a teenage fashion model without a boyfriend. Ken appeared on the scene in 1961 after consumer pressure called for one.[24] She's just like the millennial celebrities Lindsay Lohan and the Olsen Twins—except she doesn't pretend to be "real." She's the ultimate in plastic from the get-go.

In the 1960s, the average age of Barbie ownership was seven; today age three.[25] In the 1960s, most girls owned one Barbie and perhaps a Midge or Skipper, but by the 1980s and 1990s girls owned an average of eight Barbies and one Ken … an entire harem! Giving Barbies to toddlers aligns with gifting the Disney classics: it sets in place the iconic idolization of teenagers by young girls. Barbie is, after all, a cultural Icon complete with her own Career Girl mythology. As a model for a

certain manufactured form of surgically derived female beauty, the fact that Barbie was originally a simulacrum of a "real girl" provides an ironic postmodern twist to her waist. Barbie's ridiculous anatomy lacks the 17 to 22% body fat necessary for menstruation, but who ever said Barbie wanted to grow up?

As a further extension of her "plasticity," flexibility, and bendability, everyone has an opinion about Barbie. Barbie's plasticity means that she has always been about choices, even if changing outfits drive a majority of them. By 1989, Barbie had held the following jobs: physician (as well as nurse), astronaut, veterinarian, fashion designer, executive, Olympic athlete, aviator (as well as a stewardess in the 1960s). She has always represented the freedom to physically project into unlimited scenarios. Flying, swimming, walking, jumping, driving—she truly is an action figure. Because she cannot stand on her own two feet, she demands a physical connection to a child's hand to animate, which, as Lord suggests, is a very tactile relationship. [26]

These choices extend to a "do I or don't I?" in parents' toy decisions for their daughters. But the ubiquity of Barbies often overrides the parental prerogative, as many relatives and friends see Barbie, like Disney goods, as part of childhood "classics," necessary for the "collection," and often give them as Christmas or birthday gifts. For progressive parents in the 1990s and 2000s, who may well try to steer their daughters toward "classier" toys such as Breyer horses and the American Girl Doll series, complete with their own period restoration costumes, furniture, accessories, and educational books, Barbies sneak in across the highbrow border zone. Thanks to grandparents, aunts and uncles, and friends who know what the girls "really want," most households eventually surrender to a village of multicultural Barbie immigrants living naked in and around the bathtub, posed randomly in twist and turn variations, always smiling after a dive.

Barbie's original knock-offs of movie star clothing and her first career as a "teenage model" make her the poster girl for playing at jet-set celebrityhood. Not only did feminism fail to banish Barbie, but this doll has inspired artists and writers to a degree not anticipated even by Mattel Corporation. From Andy Warhol to Cindy Sherman, Laurie Simmons, and Vanessa Beechcroft, Barbie has had staying power as a postmodern Icon of pop teenage girl mythology:

> Human icons—Elvis, Garbo, Madonna—can only be possessed through film or audiotape; there either was or is an "original" somewhere that forever eludes ownership. But Barbie herself was meant to be owned—not just by a few but by everybody. Issued in editions of billions, she is the ultimate piece of mass art.[27]

We all have very clear notion about Barbie and her "look." Career wardrobes aside, "She's such a Barbie" is synonymous with being a Blonde Bimbo. She is a child's first imprint of Bimbo-hood, followed by certain pre-1990s Disney

Heroines. Certain millennial films evoked versions of the Blonde Barbie type in madcap comedies that were big hits with teenage girls. In *Legally Blonde* (2001, Robert Luketic) a Barbie-like Sorority Girl played by Reese Witherspoon becomes a Harvard lawyer against all odds and gets the guy too! In *Clueless* (1995) Alicia Silverstone's Cher, a well-groomed Beverly Hills Barbie type—a Do-Gooder seen by most as a highly eligible "Bimbo Babe" and type-A Social Maven who also lands the sweet boyfriend in the end.

As a nickname for Barbara, the root of Barbie's name means foreign, exotic, or, literally, Barbarian. Parents possess ambivalence about Barbie, yet something mysterious and sexy about her continues to draw in girls, who love the allure and the forbiddenness, especially in households where the aspirations for girls run high. Barbie as Bimbo can serve as a form of rebellion against upwardly mobile mothers. The teenage fashion model trashiness of Barbie holds appeal for kids as a way of rejecting more "educational" toys. Psychologists have acknowledged that Barbie and Ken dolls prove effective for working out family dramas and sexual issues in therapy sessions, including cross-gendered play. Alan Berliner's 1997 film *Ma Vie en Rose* (My Life in Pink) features a seven-year-old boy who, enamored of his Barbie-like Pam doll, engages in a highly evolved fantasy world of dresses and lipstick, much to the distress of his parents.

Barbies are highly personalized objects once they walk out of their packaging into the doll harem. The very plastic nature of their bendability makes them objects of personal design. Straight pin earrings are shoved into Barbie's earlobes; ballpoint pen eye shadow applied; tribal outfits fashioned from fabric scraps; the hair snipped, restyled, or buzz cut. Whatever the jet-set aspirations of the manufacturers might be, Barbie often becomes a liberated Punk Princess. As Debbie Stoller, editor of *BUST* magazine relates,

> Barbie didn't teach us so much about sexism as she did about sex. With her torpedo boobs and long legs, she lent herself to hours of sophisticated, perverse play, in which Barbie did stripteases for the other dolls, slept around with both Ken and Midge, stole other dolls' boyfriends, got into catfights, had her hair cut short or simply cut off, and had pins stuck into her head for "earrings."[28]

Since kids like nothing better than to dress Ken in girls' clothes, he may well be the original Drag Queen doll. GI Joe is too bulky to fit into Barbie clothes, and in my childhood scenarios it was GI Joe who nabbed the dates with Barbie, not Ken. High heels make fabulous sports cars. Men's Oxfords provide excellent Cadillacs. I still remember sliding these date-mobiles across the wall-to-wall carpeting at six or seven years old, with two dolls fit snugly inside. Looking back, I realize *I* exerted power over Barbie. Difficult as it might be to admit, by the time I was eight or nine, my friends and I undressed her, colored on her, put her in tree branches, dressed her

up, drowned her in the bathtub, and acted out our sadistic play and sexual fantasies just as much as we "played house." We even took off Barbie's head and laughed. It wasn't quite gentle role play. By then, I knew Barbie was a Ditz. I thought her bendability was ridiculous, comical. Her knee joints bent backward while doing a split; her torso twisted 180 degrees while "walking." She was not human to me, she was not normal, and she was not a stand-in for me. She was a character in my play called "Barbie and Ken have sex in the shoe box." Playing Barbie is very much like directing a free-flowing screenplay. Unlike viewing a movie, a form of passive fantasy involvement, playing with dolls, even a Bimbo Babe, is three-dimensionally proactive. And since the ridiculously small clothes are impossible to put on her and the shoes always get lost, Barbie ends up either naked, wearing a bathing suit, or wrapped in clothes of a girl's own invention.

While parental and scholarly concerns linking Barbie and girls' negative self-esteem have created an often-thwarted attempt to eliminate Barbie from the Girl Scene, Barbie is apparently here to stay. The jury is out on whether girls project themselves onto the doll. Many girls direct Barbie as a character outside themselves, like an actor in a film script. Rather than merging identities with this doll, many girls do not see themselves as Barbie—she remains, for them, always a toy to direct and design into scripted scenes as an actress, with GI Joe and Ken as actors.

Sadie Benning, whose Pixelvision films of the early 1990s featured Barbies and toys in the low-tech animated universe of her bedroom, used video to document a creative dialogue about growing up, creativity and coming out as a lesbian. This innovative output garnered her a MacArthur Genius Award at age 20. Her films, which became favorites of the New York-based Women Make Movies distribution catalogue, continue to play in Women's Studies, Girl Culture, and Queer Studies courses across the country.[29] Seattle's *Reel Grrls* filmmaking program for teenage girls, discussed further in Chapter Ten, has been providing annual training programs for teenage girls in media literacy, filmography, editing, and animation since 2001. Unprompted by the instructors, each year so far an animated take on Barbie has been produced.[30] Where would American plastic arts be without Barbies?

BEYOND SNOW WHITE: DISNEY'S MAIDENS

Just as Barbie has remained an American Girl Icon since the late 1950s, so Disney's Princesses Maidens continue to flicker across home video screens. After producing his first full-length animated feature, *Snow White and the Seven Dwarfs*, in 1937, Walt Disney made the teenage girl subject a staple of his industry. With the opening of Disneyland in 1955, the now-familiar Disney animated characters cemented their role as hallmarks of American culture. A visit to Disneyland in

Anaheim, California, and later Disneyworld, which opened in Orlando, Florida, in 1969, became the American dream family vacation, just as the films became emblematic of American family entertainment. As a populist, Disney's success resided in his ability to produce animated tales for the entire family. These films, which have inspired much scholarly commentary about his alterations to classic tales, include extensive feminist analysis of the emphasis on an evil stepmother/witch who thwarts the beautiful, motherless young heroine who dreams of rescue by the Prince.[31] These themes play out in *Cinderella* (1950), *Alice in Wonderland* (1951), *Sleeping Beauty* (1959), and *The Little Mermaid* (1989), and to a lesser extent in *Beauty and the Beast* (1991).

A common component of Disney films is the absence of the mother, often replaced by a wicked stepmother. (See Chapter Eight for further discussion of the Daughter Icon.) True for Disney's male protagonists as well as female ones, it is part of the landscape of fairy tales and of the hero's journey, articulated by Joseph Campbell in his seminal work *The Hero with a Thousand Faces* (1949). [32] In fairy tales, protagonists are often orphans without parents of either sex; in Disney's classic canon, beloved fathers are almost always present, but not mothers. In *Snow White* and *Cinderella*, the father remarries an evil stepmother, and in the *Little Mermaid*, Ariel must contend with the evil sea creature Ursula, who steals her voice.

What does it mean for young children to view these scripts dozens of times in early childhood? How does this script of the evil woman who replaces the absent mother of these teenage girl heroines link to the challenges to female bonding in American adolescence, dictating themes of female-to-female jealousy, menace, and obstacle making? What is the effect of these storylines on actual social behaviors? What behaviors are subconsciously being modeled? Girls will often rebel by telling you, "You're exaggerating, I know it's only a movie." But in the absence of such critique, do the stories penetrate unmediated? So long as media literacy combines with viewing, naming the Icons, examining the stereotypes, especially of works deemed "classics" of American childhood viewing, the impact of the narratives, particularly in terms of imprinting gender and racial stereotypes, can be tempered.

In response no doubt to critiques about the white-bread nature of Disney heroines, the corporation released *Aladdin*, with his feisty Middle Eastern side-kick Princess Jasmine, in 1992; *Pocahontas* the Native American ambassador who consults her wise grandmother tree in 1995; and *Mulan*, a Chinese cross-dressing Warrior Girl brave enough to take on Shun Ya, a stand-in for Atilla the Hun, in 1998. Though all of these cartoon heroines remain pinch-waisted and motherless, these three spoke to a new generation of parents and girls interested in more powerful multicultural heroines. Even Belle, who stands up to the he-man Gaston in

Beauty and the Beast (1991), marks a far cry from the heroines of the 1930s, 1940s, and 1950s. From the 1990s forward, the evil stepmother disappears. In Disney's multicultural features, the evil influences are male: Jafar in *Aladdin*, Shun Ya in *Mulan*, and the soldiers and warriors in *Pocahontas*. Of all the Disney Maidens, Pocahontas is the only one who does not marry the prince and live happily ever after. Despite the historical schoolroom storyline that Pocahontas married John Smith and moved to England with him, the Disney script has them part ways to serve their people separately at the end.[33]

Unlike Mattel, who introduced a Black Barbie named "Christie" in 1965, Disney has yet to featured an African-American or Latina heroine. In the 1960s, Mattel developed a cooperative relationship with the all-black-owned toy company Shinanda, which produced a series of African-American dolls and toys from 1968 to the early 1980s. This combined with Mattel's introduction of "designated friends" for Barbie, including Christie. According to studies conducted in 1945 and again in 1985 using dolls to explore black children's self-esteem, 65% preferred white dolls and 76% said black dolls "looked bad to them."[34] This contrasts the American Association of University Women's 1991 study on self-esteem in girls in which African-American teenagers responded affirmatively to the question "I like myself as I am" more consistently in adolescence than white or Hispanic girls.[35] One would have guessed that with the success of 1990s characters such as Arabic Princess Jasmine, Native American Pocahontas, and Chinese Mulan, an African or Latin storyline would soon follow. *The Lion King* (1994), set in Africa, may have been Disney's answer to this demographic; however, animal stand-ins for cultural representation don't fit the bill. The Broadway musical version, however, has brought talented African-American children to the stage in the roles of Simba and Nala, choreographed in exquisite Kinté cloth costumes designed by Julie Taymor.

CULTURAL REWIND

Toddlers watch Disney films repeatedly, often choosing one movie as their favorite. Relived participation in storylines used to be the unique domain of first oral tales and later storytelling and books. This tradition has been joined by a third form in Western culture—the repeated viewings of favorite visual stories, which remain with us as metaphors and cultural referents just as books and art works and symbols do. Movies provide the collective common language of reference, visual shorthand for information about gender roles, racial codes, and economic strata which young children learn at an early age.

Just as toddlers receive Barbies, Disney and Pixar movies arrive as gifts. Reviewing reinforces the impact of the storylines and accompanying mythologies

as well as the underlying flaws in the narratives. As children tire of the repetition of the stories, they become more critical of them, hence more potentially media literate. Toddlers and preschoolers derive comfort from repeated viewings of their favorite movies, just as they derive comfort from their favorite books. Of course "repeated viewing" varies according to parental interpretation. Once-a-week screenings of favorite movies vastly differs from daily viewings. Despite claims made by the producers of the video series Baby Einstein (now owned by Disney), babies and toddlers learn best by moving, grasping, and interacting with others, not parked in front of the television, which is detrimental to their neurological and emotional development. Joseph Chilton Pearce, in *Childhood's End*, maintains that "television floods the infant-child brain with images at the very time his or her brain is supposed to learn to make images from within." [36]

Disney films by reputation have attained the self-appointed status of "classics" for the American home video library. The Disney Corporation cleverly markets these movies for sale as limited editions released from Walt's vault to stimulate sales and to elevate their individual status as "collectibles," particularly suitable for gift giving. Depending on the year, only certain classics are available for purchase, increasing their demand. Disney features are an expected component of children's lexicon in America (and, increasingly, globally). If you don't know who Ariel is, kindergarten girls will look at you quizzically. Millennial teenagers know the Disney Classic films so well as to claim subliminal references in particular still frames. This is VCR and DVD replay power at its best, analyzing films to the minutiae of still frames. Teenage students as well as my daughters have informed me that the Disney cartoons of the early 1990s on VHS versions have subliminal messages embedded in them, and several blogs have dedicated on-going debates to these references. [37] Regardless of the veracity of these accounts, this kind of awareness emerges from a level of repeated viewership that casts doubt on the sanctity of the Disney canon. The ability to freeze frame, fast forward, and rewind gives viewers a certain power over the narratives they have known since early childhood and in this way utterly demystifies them—with their obvious gender stereotypes and corny falsetto love songs. And this power over the technology initiates media literacy for children, which often leads to a frame-by-frame shot analysis, an awareness of scene continuity and product placement. When the frame is frozen, visual details rise to surface awareness.

ALTERNATIVE TWEENDOMS

While Barbie has reigned for decades as Prima Teen Career Girl along with the Disney Princesses, alternative myths are emerging. In *Ever After: A Cinderella*

Story, Andy Tennant's 1998 film starring Drew Barrymore, the Cinderella myth revamps a more self-actualized, scrappy Teenage Heroine who fights back against victimhood at the hands of her mean stepmother and stepsister. An alternative to Disney's waifish Cinderella, in this make-over, the Orphan Princess stands up for the downtrodden, befriends Leonardo da Vinci, and finds unconditional love without having to fit into a ridiculously small glass slipper. While the story still revolves around marrying the Prince, this version taps into Girl Power feistiness and ends with true love based on mutual respect.

Since the release of John Lasseter's *Toy Story* in 1995, Pixar Studios has joined Disney as a creative team of animated feature kings, expanding Disney's themes from the Grimms' and Anderson's fairy tales to original storytelling. The role of Pixar in moving beyond the "Prince marries the Princess" form of storytelling spells good news for girls. As viewers evolve into teenagers, Disney/Pixar references now become sources of nostalgia as well as critical reference points, including titles like *The Incredibles* (2004), featuring an entire family of Superheroes and Superheroines, similar to the *Spy Kids* series (2001–2003).

Likewise, Terrence Malick's *The New World* (2006) takes an alternative look at the Pocahontas legend, previously revamped by Disney, with a lush bird-filled otherworld of the Naturals, the film's European name for Native Americans. Captain John Smith (Colin Farrell) goes native, falling not just for Pocahontas but the entire woodland culture of her tribe. Teenage newcomer Q'Orianka Kilcher plays the startlingly deer-like, fiercely clear-eyed favorite daughter of the chief. Malick's film creates an atmosphere of possibility in which Pocahontas and Smith become barely consummate lovers in an idealized Edenic landscape. In defiance of her father, Pocahontas gives the settlers seeds and teaches them how to survive their first winter in the new world. For this loyalty to the Englishman and his people, she is disowned by her tribe and sent to live with the settlers. But Smith, on orders from the Queen, sails away to further explorations.

Pocahontas adapts to Western culture in the settlement, donning long dresses and leather shoes, all in the hope that John Smith will one day return. Rather than exuding imperialist attitudes, the settlers show respect, calling her "Princess," and she, lit royally, holds her hands up to the square of sunlight in her Jamestown house. Since John Smith does not return, she eventually accepts the attentions of tobacco farmer John Rolphe (Christian Bale) and agrees to marry him. The couple is invited to appear before the Queen of England in a shift of landscape so ordered and architectural after the lush, undisturbed, and exquisitely wild terrain of a primordial coastal Virginia that the viewer perceives England for the first time, along with Pocahontas. Though the performance by Q'Orianka Kilcher evokes a much older girl, she was only 14 at the time of the filming, marking a big age difference

between her and Farrell. A great deal of work apparently went into the construction of a "gentle love," with Malick purportedly reshooting many scenes to fit within child pornography laws, removing the more explicit content. The lack of explicit sexual content works in the narrative's favor for a more nuanced and unusual film, with a PG-13 rating appropriate for older tweens.[38]

As an alternative to Disney's nod to multiculturalism, Malick's Pocahontas speaks another language of Native American culture neither hackneyed or stereotypical, yet glosses over the violent imperialism at the root of this historic encounter between the English and the Coastal Native American tribes. For millennial viewers educated in the wrongs done to Native Americans in this country, this New World vision of Native American-European relations, in which sensitive love interests Bale and Farrell treat the Native Teenage Princess with tender reverence rather than violence, seduces the viewer with its highly utopian lushness.

SELKIES MORPH THE LITTLE MERMAID

John Sayles' *The Secret of Roan Inish* (1994) puts an entirely new spin on orphanhood, providing a rich alternative to the Disney's mincing Mermaid Icon. Based on the book *The Secret of Ron Mor Skerry* by Rosalie K. Fry, Sayles' version weaves a visual folk tale about the power of one young girl to reunite her family through sheer belief in the incredible. When 10-year-old Fiona Conneelly (Jeni Courtney) loses her mother to an unnamed illness, the entire clan decides to leave their isle homestead on Roan Inish to seek better fortune on the mainland. Unattended as everyone moves furniture and goods from the shore onto moored boats, baby Jamie's cradle succumbs to the waves, lost at sea in a sudden squawl so fierce his father is pressed back, unable to retrieve him.

Fiona is sent to live in Donegal with her grandparents, fisherfolk who long to return to Roan Inish. On a trip to town, Fiona meets her cousin Tadhg Conneelly (John Lynch), who explains the selkie family legend. Generations ago, Liam Conneelly (Gerald Rooney) took the sealskin of Nuala (Susan Lynch), a beautiful creature half-woman, half-seal. Without her sealskin, she remains in human form, falling in love with Liam but essentially captive to him. The couple have many children, all of whom sleep newborn in an unusual cradle built of shipwreck wood and inlaid with seashells. When Nuala finds her sealskin in the attic and returns to her free existence in the sea, the Conneellys are forbidden from hunting the seals. On the day of the clan's departure from Roan Inish, infant Jamie (Cillian Byrne) drifts away in the legendary cradle. Family lore hints that Jamie is being raised by their long-lost seal cousins, and Fiona fiercely insists she has seen Jamie

in his cradle near Roan Inish. At first only one cousin, Eamon (Richard Sheridan), believes her and agrees to secretly restore the abandoned cottages on the isle to encourage Jamie's return.

The magical realism of the film, along with lyrical cinematography, makes this a definite alternative to Disney girl fare. Oddly, despite the lack of violence, sexual innuendo, or crude sarcasm common in many current children's offerings, the film received a PG rating for its release in the United States due to the appearance of four-year-old Jamie "without a stitch" in and out of his cradle.

MIYAZAKI'S ANIMÉ GIRLS

Globalization has been responsible for a great deal of American iconography finding its way into other cultures. But the influences work both ways. The popularity of yoga, the teachings of Gandhi, and Bollywood have influenced teenage fashions with silk sari-like blouses and henna tattoo parties. Japanese animé has had a profound influence on American popular culture, with the tween cute factor in "Hello Kitty" merchandise, *Pokémon*, *PowerPuff Girls*, and *Sailor Moon* cartoons. In the realm of feature-length animation, Miyazaki's Shinto-esque mythologies, the majority of which depict pre-adolescent and adolescent girl protagonists, have brought a level of wide-eyed painterly originality to the medium. His subtle characterizations stray from the Disney propensity for black and white, young and old, good and evil scenarios to present a world of complexity where heroines experience profound magical transformation. The oversimplified narrative of "good triumphing over evil" is less important in the world of Miyazaki, where magical occurrences provide visual and narrative interest in a fantasy scape of possibility. His heroines' transformations involve episodes of flying as well as encounters with witches, spirits, and demons, but the most profound outcomes of these stories involve the heroine's spiritual growth and maturation, often brought about by a surrender to selfless service. These stories have to do with redemption in which even the initially evil characters are given the opportunity to change.

Because the characters are often regular girls as opposed to Princesses, viewers can identify with their quotidian task making (cleaning rooms, cooking, running errands, sewing, walking the streets of town) even in the context of the fantastic world he creates. As Margaret Talbot points out in an article in *The New Yorker*, "Miyazaki's protagonists are usually girls, and though there are likable and loyal, they tend to be ordinary children which makes them extraordinary in the world of children's films."[39]

While several of his films, including *Princess Mononoke* (2001) and *Howl's Moving Castle* (2004) (see Chapter Seven), contain some scenes of graphic violence

worthy of their PG-13 rating, *My Neighbor Totoro* (1994, English version; 1988, Japanese version) and *Kiki's Delivery Service* (1998, English version; 1989, *Majo no Takkyubin,* Japanese version) are very much G-rated, while *Spirited Away* is appropriate for older tweens. *My Neighbor Totoro* features 4-year-old Mei and 10-year-old Satsuki, two sisters who have recently moved to the countryside with their professor father so they can be closer to their mother, recovering from an illness at a nearby hospital. In scenes of girly silliness, the sisters play together, running around the house and environs engaging in imaginative play, scenes oddly absent from American animation.

They discover that their old Japanese house is inhabited by "soot sprites," who lead Mei to the nest of a giant forest spirit named Totoro. When the girls worry most about the health of their mother, Totoro, their new protector and playmate, sends them a giant Catbus with a huge Cheshire grin, which transports them magically to the hospital. Without being cloying, the film points to the value of a connection to nature, fantasy, and creativity as antidotes to life's anxieties. It also provides scenes of big sister protectiveness, generosity, and extreme closeness between a mother and her daughters whenever they visit her in the hospital. In *My Neighbor Totoro,* Miyazaki captures an often forgotten element of childhood, that the magical of the everyday does seem real.

Kiki's Delivery Service features the voice of Kirsten Dunst in the title role of the 13-year-old witch-in-training who leaves home with her talking cat Gigi on a full moon to seek her fortune and practice her magical skills by offering her services in a randomly chosen town located from her broom flight over the countryside. Though released in the United States after the highly successful comedy series *Sabrina, the Teenage Witch* (1996–2004, ABC-TV) starring Melissa Joan Hart, Miyazaki's Japanese version was a clear precursor to the American fervor for girls and magic. Yet here is an instance of intercultural cross-pollination. Miyazaki was no doubt familiar with the original *Sabrina, the Teenage Witch* of the 1960s, a character included in the *Archie* comic book series, and *Sabrina and the Groovie Goolies* ran as an animated series from 1971 to 1974. Due to the enormous Japanese interest in comic books, known as manga, American comic books have had a high level of readership in Japan, and cartoons have always been popular. Cross-cultural importing of cartoons and films between Japan and the United States has been active since the *Godzilla* movies of the 1950s.

In *Kiki's Delivery Service,* Kiki is the daughter of a witch/scientist mother who appears in her laboratory with test tubes and beakers, preparing her potions, at the beginning of the film. Her professorial father is a bit clumsy but very much the doting parent. Despite initial protests, both parents support her decision to take off at such an early age, especially when the ancient grandmother reminds them that Kiki's mother once took the same brave step. Kiki's Gigi, a small feline, rides with

her on her broom during her Maiden voyage from home and accompanies her on flying delivery jaunts.

Though Kiki agrees to borrow her mother's seasoned flying broom instead of using her own newly constructed one, her airborne skills are initially maladroit. She manages to navigate a successful if bumpy landing in the fictitious town of Carikia, in an unnamed region close to the sea which evokes the Mediterranean. Miyazaki's worlds blend elements of Europe and Japan, in timeframes at once modern and historical. This displacement of time and space out of history or true geography provides a semi-familiar landscape, yet one fictitious enough for the magical to emerge.

As a witch-in-training, Kiki offers her services to a pregnant baker named Osano, an obvious mother figure, who agrees to take on the girl, giving her a room and food in exchange for assistance with the business. As with most of Miyazaki's heroines, magical power links as much to helping and assisting as to the thrill of lift-off. Yet Kiki notices at times the difference between her life and that of other young teenagers in the area, symbolized by the black witch dress she wears every day. In classic *Grimms' Fairy Tale* style, the heroine undergoes a sense of personal deprivation before locating a reward greater than material riches. Her generosity and kindness toward her clients directly contrast the attitudes of the more arrogant bourgeois girls she encounters. After helping an elderly lady prepare a herring and pumpkin pie for her granddaughter's birthday party, Kiki flies off into a rainstorm to deliver the gift. The granddaughter, who answers the door in a fancy party dress, complains about the wet basket, then groans that it's one of her grandmother's "stupid pies." Kiki, taken aback by the girl's lack of concern and selfishness, takes ill and spends several days in bed, fed and cared for by Osano.

Soon after this encounter, Kiki meets up with her friend Tombo, who takes her for a ride on his own "flying machine," a bicycle retrofitted with a propeller, in another interwoven dialogue between magic and human invention in Miyazaki's films. The bicycle lifts off the ground at one point, sending the pair soaring through the air, which he attributes to her magical powers. At the beach after a tricky landing, Tombo's friends arrive in an open-top car to investigate a dirigible that has landed nearby. One of these friends is the wealthy granddaughter Kiki met in the storm. The girls comment on Kiki's strange clothes and ask whether she's a witch. Kiki turns away, making it clear to Tombo that she has no interest in them.

Despite her outward bravura in this encounter, at this point Kiki loses her ability to fly. The underlying loss of confidence in her encounter with Tombo's friends is the root of her impaired power. Kiki takes a break from her delivery service to regain her strength, with the full support of Osano. She visits an artist friend in a cabin in the woods whose painting of a girl on a flying horse has been modeled on Kiki. Seeing the artwork restores Kiki's faith in her abilities. That

Miyazaki includes a scene with a direct nod to the healing power of visual art no doubt allies with his belief in the visual medium of film to restore faith and power in viewers.

Spirited Away, which won an Academy Award in 2002, features 10-year-old Chihiro, a girl caught up in a fantastic spirit world in an effort to save her parents, who unwittingly stumble upon an abandoned theme park and greedily eat food left by demons, which transforms them into pigs. The film deals with Chihiro's Alice in Wonderland-like attempt to find her identity in a world where the rules of the real no longer apply. Like Alice, Chihiro engages at times in magical eating, but more as a means to keep from disappearing and to regain strength than for purposes of changing size. The powerful and greedy witch Yu-baba, who transforms into a crow woman and flies across the sky, steals Chihiro's name to keep her in service at a bathhouse where spirits replenish themselves. Under the new name Sen, Chihiro transforms from a whiny, scared only child into a brave, kind girl who ultimately risks her own safety to save her friend Haku, a river spirit trapped in a human body. Through a series of final tests, she manages to save her parents as well. As Susan Napier points out in her book *Animé*, "[W]hether the viewer believes in a natural or a supernatural explanation, the characters' ability to connect with the other, be it the unconscious or the supernatural, is clearly coded as a sign of inner strength and mental health."[40]

Animals and sprites, like all non-human creatures in Miyazaki's animated worlds, are not overly anthropomorphized as in Disney features. In fact, in *My Neighbor Totoro,* the title character never speaks and the girls must interpret his meanings by guessing, just as one must guess the motivations of a dog or a cat in the real world. In *Spirited Away*, Chihiro saves the bathhouse from destruction through her ability to commune with and interpret the vague utterings of the masked No-Face, and despite her inexperience deals bravely with the mute, but grotesque Stink Spirit, shunned by everyone else.

One part Alice, one part Pippi Longstocking, one part Everygirl, Miyazaki's pre-adolescent girl characters have taken increasing hold in the United States since the mid-1990s. Not relegated to the tween-only audience of cuteness extreme like *Powerpuff Girls* or *Sailor Moon* cartoons, Miyazaki's characters provide cross over potential as artworks of genuine interest to viewers of all ages. His hand-drawn animations have become unique in a world of digitally composed imagery, as even Disney has now shut down its cell animation studios in complete favor of computerized animation. As alternatives to Hillary Duff obsessions, Miyazaki's pre-adolescent heroines provide an entry into a world of magical possibility that involves spiritual growth and the development of a moral core. These rites-of-passage storylines move beyond the consumerist narcissism of the majority of American animated features toward awareness of the environment and the role

of the individual in helping serve a cause greater than the self. In rare interviews, Miyazaki has stated his interest in keeping children engaged with their own imaginations as much as possible and his concern about the effects of computer games on children's emotional life:

> No matter how we may think of ourselves as conscientious, it is true that images such as animé stimulate only the visual and auditory sensations of children, and deprive them of the world they go out to find, touch and taste.[41]

THE SPINES OF BOOKS GIVE GIRLS BACKBONES

As much as American girls are consumers of popular media, they are also consumers of books, which continue to provide alternative tweendoms. Beyond their role as sources of textual literacy and factual information, they obviously expand visual imaginations beyond screen watch. Despite "the end of print" predictions of the mid-1990s when the Internet became a part of middle-class America, pleasure books have not fallen by the wayside like encyclopedias and dictionaries.[42] And girl readers contribute enormously to youth book sales. Female narratives in print are no longer marginalized; women account for a huge market share of book purchasing for themselves and their daughters, and the plethora of Girl Pirates, Witches, Cross-dressing Knights, Princesses, Queens, Horsewomen, Inventors, and Pilots is an outgrowth of Women's Studies since the 1970s.

From an expansive list of recent girls literary offerings, a host of alternative Brave New Girls have emerged in print for pre-tweens and tweens. Classics such as the *Nancy Drew* series, *National Velvet*, *Little House on the Prairie*, and *Harriet the Spy* are no longer the only girls on the shelf. Since the late 1980s the availability of titles depicting strong, brave, inventive girls has grown in even greater proportion to the representational growth of powerful girls in visual media. Clearly, American girls are reading. The American Girl Doll series publishes books about each of their historic multicultural dolls; the *Girls to the Rescue* series includes an array of stories about brave, generous, feisty, intelligent girls drawn from sources around the world. Scholastic Books' *The Royal Diaries* series features fictionalized diaries by young women from multicultural world history, including Cleopatra, Russia's last Czarina, Anastasia, and Nzingha, Warrior Queen of Angola, Africa. Scholastic's *Dear America* diary series provides fictionalized diaries by diverse girls speaking from significant points in American history whose names include Mayflower passenger Patience Whipple, Plantation slave girl Clotee, and Sioux Girl Nannie Little Rose. *The Song of the Lioness* series by Tamara Pierce tells the story of a cross-dressing girl named Alanna who poses as a boy knight in the Middle Ages.[43]

The Sisterhood of the Traveling Pants (2001–2007) a book series popular with 10- to 12-year-old girls, written by Ann Brashares, proposes a quartet of bonded and loyal friends who share a pair of pants.[44] The story of loyal girl friendship echoes the *Betsy-Tacy* series by Maud Hart Lovelace, published in the 1940s and 1950s. The first four books of this latter series recount the girlhood escapades of three imaginative friends and are still in print: *Betsy-Tacy* (1940), *Betsy-Tacy and Tib* (1941), *Betsy and Tacy Go Over the Big Hill* (1942), *Betsy and Tacy Go Downtown* (1943). Not nearly as well known as the Laura Ingalls Wilder's *Little House on the Prairie* series, the *Betsy-Tacy* books provide a window into a girl world for younger readers that is refreshing for its lack of female strife.

Designed for the tween reader, *The Sisterhood of the Traveling Pants* posits that women of different builds could miraculously wear the same pair of pants, transcending issues of weight and body type through loyal friendship bonds. A feature film based on the first book of the series directed by Ken Kwapis from a script by Delia Ephron appeared in theatres in 2005. The film starred Blake Lively as Bridget, Amber Tamblyn of *Joan of Arcadia* (CBS, 2003–2005) as Tibby, Alexis Biedel of *Gilmore Girls* (WB/CW, 2000–2006) as Lena, and America Ferrera of *Real Women Have Curves* (2002) and *Ugly Betty* (2006–, ABC-TV) as Carmen. In the first book and in the film, the four characters take turns wearing the pants during the summer of their 15th year, recounting the events that take place while the pants are in their possession. For each girl the pants provide a certain Sisterhood Power that helps them through a given challenge in their lives. While far-fetched, at least size-wise, this core idea provides a structure for girl bonding in an era of Mean Girl social predators dominating headlines and bestseller lists. Girls need models of community in book and film form to learn how to create networks for their future livelihoods. Too many "girls will be girls" depictions of eye rolling, boyfriend competition, and snootiness prevail in the tween offerings of mainstream America. *The Sisterhood of the Traveling Pants* is a welcome option to the Tween Houdini Girls and Pink Princesses of coy marketing campaigns.

Mean Girls IN Ophelia Land

With the echo boom offspring of Baby Boomers coming of age in the 1990s and early 2000s, the conscious parenting style of the Boomers and now Gen X has created an adolescent-rearing publishing phenomenon. A plethora of teenage girl books now inhabit the marketplace, many of which take a socio-psychological perspective in researching girl behaviors as they relate to loss of self-esteem, eating disorders, and girl-on-girl bullying. While the early 1990s phase of this social wave focused on girls as Victims of American culture and media, along the lines of Mary Pipher's 1994 *Reviving Ophelia: Saving the Selves of Adolescent Girls*, the second wave toward the end of the decade and early 2000s described a previously underground, now possibly innate, proclivity of girls to be Mean, as in Rosalind Wiseman's 2002 *Queen Bees & Wannabes: Helping Your Daughter Survive Cliques, Gossip, Boyfriends and Other Realities of Adolescence*. Both books stirred up debate at the national level, inspiring many popular nonfiction titles, movies, documentaries, girls' clubs, and initiatives which helped to further aspects of the millennial Girl Power movement.

That the 1990s begins with the Victim Girl and ends with the Mean Girl in pop psychology demonstrates the contradictory nature of Girl Power in mainstream culture. In this way, the Victim Girl/Mean Girl polarity becomes a new kind of Virgin/Whore paradigm which has subdivided female culture for eons. The reduction to an either/or in the culture at large leaves girls with a rather limited set of choices: Are you a Good Girl (and maybe a Victim) or are you a Bad Girl (and maybe Mean). This chapter begins with an exploration of Ophelia Country, the climate of endangerment, and the force with which adult rescue efforts have contributed to creating the Decade of the Girl, with variations on Victim Girl, Bad Girl, and Mean Girl Icons.

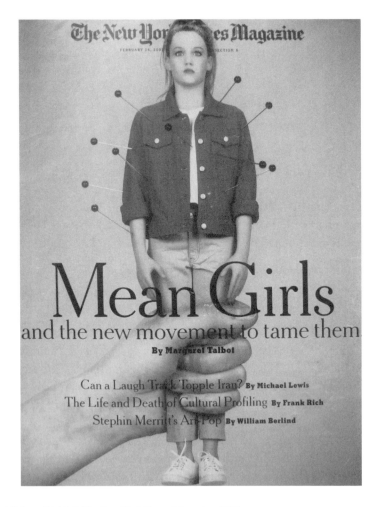

5.1 "Mean Girls" ©*The New York Times Magazine*, 2002.

REVIVING OPHELIA

A collective "teenage girl" alert in America began with the 1994 publication of *Reviving Ophelia*, psychologist Mary Pipher's best-selling "clarion call" to raise awareness of issues of girls' self-esteem. Pipher's conclusion that "America is a girl-destroying place"[1] corroborated the American Association of University Women's 1991 study *Shortchanging Girls, Shortchanging America*, based on research statistics about girls and self-esteem derived from a nationwide study assessing "self-esteem, educational experiences, interest in math and science and career aspirations of girls and boys, ages 9–15."[2] Pipher's work was heavily influenced by Harvard scholar Carol Gilligan and her most popular work, *In a Different Voice: Psychological Theory and Women's Development* (1982). Some 20 years after the birth of Second-Wave Feminism, its forerunners were asking, "Have we failed?"

The AAUW study

> found that as girls reach adolescence, they experience a significantly greater drop in self-esteem than boys experience. The poll also confirms a growing body of research that indicates girls are systematically, if unintentionally, discouraged from a wide range of academic pursuits—particularly in math and science.[3]

The after-effects of this study, which quantified what had been denied in supposed gender-equal classrooms, galvanized a national forum for providing enrichment in science, math, and technology for girls, especially in early adolescence, when seeds of career choices formulate. The years of focus, ages 9 to 15, do not include the final years of high school, which is often when girls reformulate their identities and "find their voice" as they prepare for college. No comparative study (from the 1950s, for example) exists for self-esteem findings, though earlier works particularly Margaret Mead's *Coming of Age in Samoa* (1928) point to Western enculturation, sexual repression, and competitiveness as a source of unhappiness in girls.[4] One echo effect of the AAUW study led to focus on girls who lose their self-esteem, rather than examining the strategies and social structures at play for girls whose self-esteem does not drop appreciably in adolescence. Nearly two decades later, this study, along with *Reviving Ophelia*, still referenced broadly as the *raison d'être* for many current girls' empowerment organizations, has been an important aspect of funding strategies for girls programming, a very good shift indeed. Yet, it is worth examining the strategies of this study. Did the AAUW ask the right questions? Does the question "I like myself the way I am?" take into account that adolescent girl culture polices girls from unqualified broadcasting of their strengths? The respondents may have perceived this question as code for bragging.

The six Self-Esteem Index statements included in the study which have served as the litmus test for girls' core self-belief are "I like the way I look," "I like

most things about myself," "I'm happy the way I am," "I like myself the way I am," "Sometimes I don't like myself the way I am," "I wish I were someone else."[5] One consideration underlying a less than affirmative response to these questions is the fact that girls are already constantly striving to improve themselves. Ironically, the self-esteem movement which has grown out of the study has further fostered a need to "fix girls." White boys who responded overwhelmingly to this question in the affirmative mirror a status quo of privilege. Yes, they like themselves and the system of privilege in which they live; yes, they like themselves just as they are. Girls are not so content. While turning the need for change onto superficial issues of looks is not the answer, responding "No, I'm not satisfied with myself" could be indicative of a discerning active mind and potential source of resistance to the status quo. Not liking yourself exactly as you can indicate an openness to change, improvement, and self-betterment. And it's a way of acknowledging that everything is not okay with the culture of gender and economic and racial assignation. Why so broadly interpreted as a negative sign of low self-esteem in girls rather than an ability to penetrate the gray areas of existence? Saying no to some of these questions clearly indicates that girls weren't satisfied with their lives. But did it mean that they were all in danger, or ripe for change? What is self-esteem anyway? And how is it measurable across a set of multiple-choice questions?

That boys in the study were so overwhelmingly "okay with themselves as they are" should be of deeper concern to parents and psychologists than girls' complex attempts to articulate their fluctuating identities. As bilingual or multilingual inhabitants of American culture, girls are more adaptable than European American boys, who are required to know only one language, that of the white male perspective. Hence the importance of multicultural and cross-gendered aspects of education. Reading Toni Morrison's *The Bluest Eye* in high school may be a white middle-class boy's only exposure to alternative perspectives. Seeing the world through a fictional girl's eyes, African-American eyes, Asian eyes, or Native American eyes is not required of a white boy in a classic educational setting. Girls and people of color must know multiple languages and perspectives, particularly the dominant white male perspective, if they seek to survive economically and socially in American culture. They also navigate the languages of their many-layered subcultures. This lack of multilingualism can actually put boys at a disadvantage. In fact, in 2006 and 2007, 60 percent of all incoming college freshmen were freshwomen.[6] While boys may be socialized to "like themselves they way they are," the self-reflective, self-improvement orientation of girls can be termed a positive under another level of scrutiny. Do we want girls to take on bragging rights of self-perceived "greatness" as boys tend to do? Or should there be some focus on examining the tendency of boys to overestimate their abilities?

The quest for girls' self-esteem brought about by *Reviving Ophelia* and the AAUW has had an enormous impact. The concept of self-esteem now serves as a measure of personal power in girls and an indicator of success in adulthood. *Reviving Ophelia*'s thesis is based on the notion that American girls are "imperiled" by a "girl-poisoning culture."[7] Designed as "a clarion call" to parents and educators, it promoted the idea that girls need to be rescued, something "needs" to be done. The book spawned a new generation of best-selling critique and social interest in girls and, simultaneously, a great deal of failure panic among post-feminist parents, psychologists, educators, and social workers, many of whom continue to believe girls are endangered.

Pipher's book has inspired a great deal of scholarship, documentaries, conferences, websites, girls' empowerment projects, as well as dinner party and playground conversations. Many parents fearful for their daughters woefully witness this now heavily documented issue of girl's self-esteem loss at adolescence taking place in their own bathrooms, bedrooms, and hallway mirrors. "I'm fat" and "I'm ugly" signal a body image obsession contrasting the girl who climbed trees and invented backyard games, much to their consternation. Educators witness previously confident girls dealing with math anxiety and a loss of voice in classrooms. The past 15 years of discourse on girlhood consistently references *Reviving Ophelia*, which clearly helped to reignite the women's movement on a mass scale by making it a girl's movement. As Jennifer Baumgardner and Amy Richards noted in their book on Third-Wave feminism, *Manifesta: Young Women, Feminism, and the Future*, "Similar to the early women's movement, the emphasis on girls has been profoundly successful, especially in terms of launching a feminist idea into the mainstream."[8]

Proclaimed a supposed post-feminist era, the 1990s became the Decade of the Girl. With Girl Power, the agendas of saving, protecting, and educating girls became less threatening and more fundable than saving women from the so-called failure of the Second Wave to pass the Equal Rights Amendment. By shifting the national agenda to the issues of girls' self-esteem, the very means of educating girls and boys became a national topic of discussion, with the ground-breaking Take Our Daughters to Work Day inspiring another question: "What about the Boys?"

WHY REVIVE OPHELIA?

Shakespeare's Ophelia inadvertently became the Icon for the 1990s girls' self-esteem movement, which includes many regional chapters of the Ophelia Project, an organization dedicated to creating safe social environments for girls.[9] Why did Mary Pipher choose Ophelia, who commits suicide by drowning, as her titular

Icon, and why do we need to revive her more than, say, Rosalind of *As You Like It*, Miranda of *The Tempest* or the young lover Juliet? Pre-Raphaelite painter John Everett Millais portrayed "Ophelia" (1852) as a languid figure floating in a marsh, face tilted upward in rhapsody, glassy eyes still strangely open, her palms uplifted to the heavens. Perhaps such romantic visions of Ophelia inspired Pipher, certainly not the text from Shakespeare, who presented her as a pawn to father Polonius, brother Laertes, and would-be lover Hamlet. Ophelia is not nearly as sharp-tongue witty as Shakespeare's cross-dressing Rosalind of *As You Like It* or as passionate as Juliet, the doomed lover of *Romeo and Juliet*. Juliet, her name featured prominently in the play's title, is a heroine willing to risk all she has for the lightning-bolt love of her young life. By comparison, Ophelia, a weak-minded waif, drifts into madness, unable to find steady footing. As a psychologist whose specialty involved working with anorexic and suicidal girls, Mary Pipher would be drawn to a character rendered "mad" by the events of the day—a Victim so overcome by confusion and grief she eventually kills herself.

Ophelia's shining moment of strength comes in retort to brother Laertes when he warns her to be wary of Hamlet or lose "her treasured maidenhead." Ophelia responds to the gendered double standard which still affects teenage girls as one key to their identity dilemma:

> I shall the effect of this good lesson keep,
> As watchman to my heart. But, good my brother,
> Do not, as some ungracious pastors do,
> Show me the steep and thorny way to heaven;
> Whiles, like a puff'd and reckless libertine,
> Himself the primrose path of dalliance treads,
> And recks not his own rede.[10]

In subsequent scenes, Ophelia wavers, confused by Hamlet's advances, his cryptic messages, and ultimate rejection, and eventually drowns herself off stage.

Two filmic versions of *Hamlet* appeared in the 1990s and 2000s. The Pre-Raphaelite aesthetic of the first, less well-known version directed by Kenneth Branagh (1996) extends to Kate Winslet's teenaged portrayal of Ophelia. Michael Almereyda's hipster adaptation of *Hamlet* (2000) set in corporate New York City featured Julia Stiles as the teenaged Ophelia, whose pre-suicide bouquet of flowers soliloquy takes the postmodern form of Polaroid photographs. Ophelia as budding photographer in one scene, greets Hamlet (Ethan Hawke), a video artist using cameras throughout the film, from the red-lit interior of her darkroom. As tragedy follows tragedy, Ophelia drowns in a New York City fountain, surrounded by her floral photographs.

In a complex psychology of rescue, the name Ophelia awakens the hero or heroine in the adult reader, evoking a tragic victim we are compelled to lift out of the watery and emotional realm of her undoing. Is Ophelia an Icon of teenage girlhood worthy of reviving? The fear factor filtered through adults can make girls more uncertain about becoming young women, rather than stronger. Parents have certainly turned to the immediacy of book purchase on Amazon.com to allay their fears for their "Ophelias." Is the answer to parenting fears Amazon.com, the Consumer Warrior, or is it another, internal Amazon in need of cultivation, complete with an adequate Super Heroine tool belt comprised of media literacy, sports/body literacy, creative self-expression, and a developed moral core? While the statistical information of studies conducted by the AAUW has been useful in codifying and naming the issue of self-esteem and gender, the numbers can also be misleading. Having spent a great deal of time over the past decade talking with educators and parents about the "Girl Crisis," I have observed how these numbers have often served to undermine parents' trust in their own abilities to weather adolescence successfully without turning to the "experts," which, bottom line, is a consumer choice as well as a self-educational choice.

Peggy Orenstein's 1994 *SchoolGirls: Young Women, Self-Esteem, and the Confidence Gap* takes an incognito journalism approach to the AAUW study by visiting middle schools and observing girls' self-esteem issues with regard to class and race. In 1999, Sara Shandler, a then-recent graduate of Yale, published *Ophelia Speaks: Adolescent Girls Write About Their Search for Self*, a response to *Reviving Ophelia*. In a sense, Shandler allowed the Victims named in Mary Pipher's book to speak for themselves. The recent *Odd Girl Out* and *Queen Bees & Wannabes* continue in the tradition of *Reviving Ophelia* by promoting a "something must be done!" fervor that whipped up the most recent debate about girls' inherent meanness. Whatever flaws these books might possess, they have all brought attention and funding to girls.

MISSING GIRLS

Early 1990s scholarship guided by *Reviving Ophelia* marked the beginning of a new wave of feminist discourse focused on girls but was also influenced by mainstream media's overemphasis on girls as potential victims of sexual assault and abduction. As Camille Paglia noted in 1994,

> The child-abuse obsession of the past decade, which plastered pictures of missing tots on milk cartons and now induces unknowns and celebrities to make public confessions of miraculously restored memories of ancient molestation, is predicated on a black-and-white paradigm of adult defilement of childhood innocence.[11]

With its focus on Missing Girls, this Culture of Victimhood took the form of highly publicized, gruesome stories about the abduction of white middle-class girls. In October 1993, Polly Klaas, a 12-year-old girl living with her divorced mother in Petaluma, California, was abducted from her bedroom by convicted burglar and sex offender Richard Allen Davis during a sleepover with two friends while her mother slept down the hall. The story received national attention, including a $200,000 reward posted by the actress Winona Ryder, who grew up in Petaluma. A subsequent dedication to Polly Klaas appeared in the credits of Gillian Armstrong's *Little Women*, released in 1994, starring Susan Sarandon, Ryder, and child performers Kirsten Dunst and Claire Danes.

The report of this abduction led to an all-out police alert involving many units and volunteers until Polly's body was eventually found on December 4. To add to the horror of the incident, it was later revealed that the police had encountered Davis the night of the abduction while he may have had Polly in the trunk of his car. Not only did the police fail to do a background check on him, but they actually helped him secure a chain to pull his Pinto out of a ditch. Eventually Davis was picked up on drunk driving charges; arrested, he confessed to the murder of Polly Klaas, for which he was given the death penalty.[12]

In honor of his daughter Marc Klaas established the Polly Klaas Foundation, which maintains a website with information about ways to keep children safe, a hot-line for missing child emergencies, and important statistics, including data about family abductions, which account for 78 percent of the missing child reports printed on milk cartons. Facts such as these are important for balancing Stranger Abduction fears, yet statistics do not the quell the "what if"s for parents.[13]

The Klaas case coincided with pictures of Missing Children appearing on milk cartons as well as on flyers in grocery stores, gas stations, and truck stops across the nation. The fear of losing one's children, especially daughters, was firmly planted in the minds of American parents. With the lightning speed of modern media, reports on par with the Polly Klaas incident become instant global news items. The ubiquity of television screens in public spaces combined with news and magazine coverage meant that the story played for many weeks in many different contexts, a constant reminder in everyday lives. The effect of these multiple screenings beyond the six o'clock or eleven o'clock news heightened the impact of the story, as if this macabre occurrence had morphed into an actual social phenomenon, with depraved predators on every corner. Due to the far-reaching coverage of this story, many absorbed this as the new "norm," even though a stranger abduction from a private home in the middle of the night is a statistical rarity. The "what if" looms intensely enough for parents to keep doors and windows locked for good. It happened to a sweet, well-loved girl like Polly Klaas and the entire nation had witnessed it.

Even more bizarre was the unresolved 1996 murder of JonBenet Ramsay, a six-year-old girl from Boulder, Colorado, whose haunting pageant photos continued to appear in *People* magazine into the 2000s. While the Boulder police force and many news outlets pointed to the possibility of abuse by the parents, the contamination of the crime scene at the outset made evidence difficult to collect. The Ramsays maintained their innocence, and since no concrete evidence linking them to the murders was found, they were never charged. They asserted that the perpetrator of the murder of their only child was an unknown intruder. The family relocated to Georgia, and in 2006 the mother, Patsy Ramsay, died of ovarian cancer, the case still unresolved.[14]

Pictures of JonBenet Ramsay dolled up for a pageant, complete with teased hair and lipstick, caused a mixture of alarm and sideshow curiosity. Was she leading the life of a normal little girl? Her image has since haunted the American imagination, contributing to concern for the welfare of all girls. When a potential suspect, John Mark Karr, surfaced in Thailand in August 2006, JonBenet's pageant girl face was again plastered on the covers of every tabloid in America. Karr, extradited back to the United States, had been in Thailand seeking a job teaching young children when he was arrested. All the major news outlets in print, on television, and on the Internet covered the story, rehashing the tragedy yet again. Despite the continued lack of resolution about the suspect—who may or may not have confessed to the murder, who may or may not have been a deranged publicity seeker—again the American public relived the grisly details of the murder, along with the physical forensics of the sexual assault. In the end, Karr's DNA did not match the sample found at the original crime scene.[15]

These highly publicized murders of white middle-class girls always involve photographs taken during their lifetimes, their smiling faces in eerie contrast to the brutality of their deaths. Images of childhood brought to a premature end cause a haunting mixture of fascination, fear, and revulsion in the viewer. The details project mental movies of the crimes, which often fill gaps in truth, creating public narratives of plausibility. The emphasis on sexual abuse, whether verifiable or speculative, demonstrates tabloid and mainstream news readiness to highlight this aspect of the crimes.

Yet, the grisliness of the details of these crime reports involving the abuse of girls contrasts with coverage of stories of abused boys. When the Catholic priest scandals rocked the news in the late 1990s, many of the visceral details of the abuse were avoided or glossed over, as if the sanctity of the victims and the priests had to be honored. Is this because so much of the abuse involved boys, because many of the stories were decades old, or because the subject of priests abusing altar boys proved too much for the public conscience to bear? With tabloid criminals and

victims, no such honor code exists, and so matter-of-fact reporting about forensic data such as blood, semen, hair follicles, and signs of struggle are analyzed in great detail. Girls' bodies, once dead, belong to a public probing camera eye that allows us all to participate in a second violation.

As a culture we are primed to focus on girls as potential Victims of sexual and physical assault, however, underscored by the revelations of abuses by Catholic priests who swore their altar boys to secrecy, boys can be victims of sexual abuse as well. To focus solely on Victim Girls ignores the point that boys need to be protected from predators too. Yet, under the guise of insulation from potential abuse or abduction, parents have historically curtailed girls' freedoms, not those of boys. Collectively, we fear for girls more than we fear for boys. Some of these fears are fed by mass media, which amplifies reportage of abused and missing girls on every media outlet. According to scholar Susan J. Douglas, statistically no more children are abused than before, but we know far more than we used to. These macabre stories combine with celebrity sightings to sell newspapers and bring viewers to their televisions for hours.

> This lucrative news frame for the 1980s—the endangered, vulnerable child—was sensationalized, magnified, and exaggerated until few mothers felt comfortable letting their kids play on the front lawn without a leash. Wildly exaggerated figures—that as many as two million kids disappeared each year and that five thousand were abducted and killed—circulated in the media. Revised figures in 1988 suggested that, in fact, somewhere between two and three hundred kids nationally were abducted by strangers for any length of time, and of those, somewhere between 43 and 147 died as a result. A small number of tragic cases became a blanket of terror thrown over us all.[16]

The effect on parents of the media's amplification of the primal fear of losing one's child leads to tightened security. Despite the statistical randomness of most incidents, the terror strand inspires a kind of disaster-preparedness—this could happen to any child, my child—that often results in curtailed freedoms, and imposed xenophobia, especially for girls. As there is little one can do while passively watching the often-bungled police efforts to capture the criminals or solve the mystery of the murder, the imploded need on the part of parents to do something about this stranger danger lurking outside is to limit the free rein of their children, even as teenagers. *Bolt the doors, batten down the hatches, and pray.*

Technology has played a role in assuaging some parental fears and has in some cases improved the daily communication between teenagers and their parents. Cell phones, in addition to their GPS tracking ability, allow for immediate connectivity once a destination has been attained. Computer technology has improved the tracking of sex offenders, but it does not alleviate concerns for the well-being of children once Megan's Law[17] alerts them to the presence of a sex offender in their neighborhood, or Amber Alerts[18] initiate immediate broadcasts when a child

disappears. The breaking down of taboos around the topic of sex, however, means that most parents are willing to discuss self-defense techniques and issues of appropriate touch with their children, even as toddlers. As evidenced by the bogeyman role played by the sex offender in the highly acclaimed 2006 film *Little Children*,[19] this villain has become more potent in the public imagination.

With the rapid expansion of Internet use, especially by teenagers, new fears emerged around Cyber Stalkers, strangers posing in chat rooms to lure the innocent into meetings in real time and space. A cover article of *The New York Times Magazine* from January 2005 features a menacing "stranger" lurking outside a bedroom door, his hand poised to do harm. While this image tapped into current fears about Internet dangers, the article actually profiled a man who began cyber stalking his 12-year-old stepdaughter under the initial guise of monitoring her behavior in chat rooms. He became addicted to his cyber identity and initiated prolonged sexualized dialogues with her.[20] While the "lurking stranger" remains a parent's worst nightmare, especially for daughters, most sexual abuse is perpetrated by someone known to the child, usually a family member or close friend.[21] Being on the alert for the bogeyman means we fail to look closer to home.

The fear embedded in the language of "saving girls" from the "girl-destroying places" of American consumer culture often leads to knee-jerk consumerism and overprotective practices that hinder the visibility of girls' actual strengths and hard-wired media savvy. They are, after all, digital natives with a sophisticated knowledge of "how the system works." More than being saved, they need to be heard, given access to the tools of media making, and encouraged to take risks beyond the Culture of Fear. What does this mean for girls growing up in a culture of overly documented cases of Girl Victims? While it may seem that there are more cases of brutality than ever before, our awareness of these cases has been heightened in the information age. How does fear, as transmitted by parents, hobble girls in their willingness to take risks or, conversely, cause them to rebel against restrictiveness by turning the anxieties against their own bodies? Does the culture of victimhood breed more Girl Victims, or does it make us better equipped to protect girls?

Susie Salmon, the adolescent narrator of Alice Sebold's bestselling novel *The Lovely Bones* (2002), is a 14-year-old victim of rape and murder by a disturbed neighbor who goes undetected and eventually moves away. Susie looks down from Heaven as her family struggles to survive the brutal loss. The victim fills in the details of a crime unresolved by her parents or the police. The dark subject matter of *The Lovely Bones* awakened a deep grief in readers, yet this did not affect its popularity; it became a hugely successful first novel for its author, herself a rape survivor. That *The Lovely Bones* appeared almost ten years after the disappearance of Polly Klaas marked a poetic closure for a decade of "what if"s and conjectures around a silenced voice. In many ways, Sebold gives all Missing Girls a chance to speak.

Part of me wished swift vengeance, wanted my father to turn into the man he could never have been—a man violent in rage. That's what you see in movies, that's what happens in the books people read. An everyman takes a gun or a knife and stalks the murderer of his family; he does a Bronson on them and everyone cheers.

What it was like:

Every day he got up. Before sleep wore off, he was to be as he used to be. Then, as his consciousness woke, it was as if poison seeped in. At first he couldn't even get up. He lay there under a heavy weight. But then only movement could save him, and he moved and he moved and he moved, no movement being enough to make up for it. The guilt on him, the hand of God pressing down on him, saying,

You were not there when your daughter needed you.[22]

In this way, Susie Salmon spoke to every adult in America who had been unable to save Polly Klaas, JonBenet Ramsay, and any number of girls who were abused, hurt, or ended up missing. With adults collectively poisoned by news replays and numb to a kind of powerlessness, Sebold accurately characterized the American parental response to this seemingly shared tragedy of missing children. Remaining in motion often involves consumption. Buying books, attending workshops, providing children with martial arts training, bicycle helmets, car seats, and knee pads, and arming them with GPS chip cell phones seem like proactive answers and a way to keep the doors locked and a tight watch on our children—anything to avoid being rendered immobile in the face of random crimes against children. Yet it is only once we confront the true nature of abuse that we can stop these knee-jerk consumerist reactions to the economy of fear.

MOURNING GIRLS

On April 20, 1999, Eric Harris and Dylan Klebold carried out a shooting rampage in their Littleton, Colorado, high school, leaving 12 students and a teacher dead and wounding 24 others.[23] In succeeding months, several copycat shootings took place across the country. The Columbine shootings brought the issue of cliques and bullying to the surface, as Harris and Klebold were later revealed to have been victims of intense social hazing and outcasting. This incident also sparked a debate about boys' use of violent video games, as the massacre eerily played out like an emotionless killing game. Girls in these contexts, sometimes victims of the shootings, were also depicted in the popular press in tears, mourning for their classmates. The 1990s brought us myriad images of high school girls as survivors grieving massacre victims as well as those murdered in drive-by gang shootings. Like war

widows, these young women weeping, often in trios, their heads bowed, carrying roses, and comforting each other in tight circles are an important part of mainstream reportage around gun violence. The tears of girls become grief made public.[24] Despite the obvious horror of these events, by 2002 the big youth-oriented stories in the press were not overwhelmingly about stopping boys' use of guns but about girls as masterminding social bullies or Mean Girls. While real people of all ages continue to die in random killing sprees at schools as a result of inner-city gang violence and a liberal gun policy in the United States, where semi-automatic weapons can be and are purchased by almost anyone, books addressing these issues do not fly off the shelves, though books about girls' self-improvement at the social and psychological level do.

Rosalind Wiseman's *Queen Bees & Wannabes* devotes a chapter to boy peer pressure and definitions of masculinity, not indicated anywhere on the front-cover marketing of the book.[25] Among the best-known recent writings about boys' issues are Jackson Katz's article "More Than a Few Good Men" and Michael Gurian's books *The Wonder of Boys* and *A Fine Young Man*.[26] Despite their accurate analysis of important issues relating to boys-to-men development, none of these works has achieved the household name recognition of *Reviving Ophelia* or *Queen Bees & Wannabes*. What does this say about our culture of readership and self-help? Are the parents of girls the driving force behind the self-help parenting section of the publishing world?

In the AAUW's seminal study boys more often responded positively to the claim "I like myself as I am."[27] Did the findings of the AAUW about boys' self-esteem cause a public lull in actively examining what might be termed male complacency? The prevailing Boys Will Be Boys attitudes in our culture have let Boys off the hook and created a lag in boys' evolution. Girl radar is carefully honed and multileveled. Boys seem less concerned about working on themselves and their parents seem less concerned about this as well, which in the long term impedes their fullest potential as human beings.

While Michael Moore devoted his Academy Award-winning documentary *Bowling for Columbine* (2002) to the culture of violence and the American "right to bear arms," a multibillion-dollar business overseen by the National Rifle Association, Gus Van Sant's 2003 feature film *Elephant*, a poetic take on a fictional school shooting similar to Columbine, had a modest release domestically, despite critical acclaim. *Mean Girls* (2004) was a box-office smash. Like the elephant in the room that everyone refuses to acknowledge, the issue of boys' violence in a culture of gun freedom remains underexplored. On an initial budget of 3 million dollars, the foreign gross of *Elephant* was more than 8 million, but the domestic gross was just over 1 million.[28] Foreign audiences find it easier to to address the issue of American boys and gun

violence than Americans. Clearly boys are not okay as they are, yet the majority of us turn our attention to girls' need for self-improvement.

Girls are not always Victims, just as boys are not always the Aggressors. But there have been no girl-instigated massacres. Girls are not prone to pick up guns; their anger remains subterranean, directed at their own bodies or at other girls. While "relational violence" is an important issue to explore, given the imprint it makes on a girl's articulation of power in group culture, relational violence rarely leads to physical violence on the scale of a school shooting.

That girls need to grow and evolve has been a tenet of social change for decades. Parental scrutiny of girls in the post-feminist era has been so pronounced they have gone to "the experts" in droves to enhance their skills in creating the next breed of Supergirls, leading to best-sellers, box-office hits, and self-esteem buzzwords in the vernacular. Is the need for girls to change within akin to the external pressure to change and improve their appearance? Is there a prevailing undercurrent message that boys are simply okay the way they are, whereas girls are expected in this era to improve themselves beyond gender to such a degree that they can never be good enough? Girls continue to be perceived as the gender in need of "correction"—better math scores, more science, better self-esteem, etc. While certain boys may outperform girls with the highest SAT scores, they also perform at the lowest end of the spectrum, whereas more girls consistently perform in the college-acceptance range of scores, if not at the "perfect" or "genius" level.[29]

Culturally, we seem to forget that one half of girls' issues stems from the privileged position of boys. Girls are now encouraged to do sports, learn to do math, learn science, and pursue careers, yet boys are not encouraged to express empathy, to speak in the classic language of the feminine without fear of being labeled "sissies" (though *Spiderman 3*'s 2007 depiction of Spiderman, Sandman, and New Goblin/Harry Osborn crying in the final scenes provides an interesting development in blockbuster Hero genre cinema). Boys would benefit from their own bilingual education, so they can seek out emotional assistance when necessary. We do not rescue boys so much as egg them on from the sidelines. Why do we rescue girls? Do they actually need to be rescued? Or does "saving them" contribute to weakening their status culturally? How do we strengthen girls, rather that "save" them?

Rachel Simmons's best-selling 2002 book *Odd Girl Out: The Hidden Culture of Aggression in Girls* looks at Girl Victims of another kind: mostly white middle-class girls who suffer psychologically in adolescence due to emotional bullying by other white middle-class girls. The book describes a complex web of hidden problems in girls' social networks, with a focus on the socially driven nature of girls and their intense need for group inclusion, which will often cause them to lose their own moral core to belong to the in-crowd.

Girls experience isolation as especially terrifying. Since girls earn social capital by their relationships with others, isolation cuts to the core of their identities. For most girls there is little more painful than to stand alone at recess of lunch.[30]

The stories of girls and their difficult situations recounted in the book read like mini movie scripts. Interestingly, despite its nonfiction category, *Odd Girl Out* was produced in 2005 as a fictionalized Lifetime Original movie starring Alexa Vega of *Spy Kids* fame. Lifetime's public relations spin included such descriptions as the following: "Surrounded by cliques, gossip and popularity contests, a teenage girl must navigate the harrowing hallways of middle school."[31]

Simmons cites her own victimhood as a girl when her best friend turned on her and cut her off from the clique as a defining moment, a wound that never went away:

On the one hand, I could remember few details. On the other, the anguish of being abandoned by all of my friends at Abby's hand felt raw and real. It was something that never receded gently with the rest of my childhood memories.[32]

Yet Simmons went on to a successful academic career and a Fulbright scholarship to Oxford, where she began writing her book. The initial "scar" of victimhood, while a definitive imprint, did not damage her drive, intellect, or disrupt the inner community of support from her family (including her grandmother, who encouraged her throughout the writing of the book). Her victimhood at the hands of another girl served as a thesis but clearly did not impede her permanently.

While an important articulation of a previously ignored problem, *Odd Girl Out* focuses more on naming the results of girl bullying as an almost inevitable condition of Girlhood, and an either/or equation that sets girls in one extreme role or another. Victimhood, while a powerful passive-aggressive position, is far less potent than proactive confrontation. For girls to paint themselves as Victims instead of doers—painters, writers, filmmakers, lawyers, school politicians, creating and building instead of flinching and reacting—does them a tremendous disservice, hobbling them before they even have a chance to live and take risks. This type of victimhood can seem like a power, but its passive reactive stance sets it apart from visible, proactive power. Socially, no one is a pure Victim. No matter how righteous we are about outcomes, the end of a friendship, love relationship, or community bond is a loss to be mourned. However, if girls wear their loss as a series of badges of their identity, they miss the chance to grow beyond, rebuild, reinvent, basing the new version of themselves on owning responsibility for their own moral compass. Girls who pursue the cool crowd do so at their own risk, as conformity and participatory gossip come at a price. Whispering is a dangerous and thrilling shadow

zone, but girls participate at great risk to their own integrity. Why do Victims allow themselves to be in thrall to a cruel Alpha Girl? Is it a sadism/masochism dance that is an unfortunate part of human social organization?

The continued rehashing of victimhood can be damaging, as much verbiage goes into maintaining the narratives of emotional trauma kept alive by the retelling. Since Victimhood as a righteous identity has its own kind of arresting, attention-getting power, it takes will power to change the channel of instant replay to a blank screen of possibility. The blank screen is scary—it's blank, after all. The past is known—even painful pasts have vivid color schemes and details to reconnect. Self-reinvention after a fall from the cool clique requires a level of courage that goes beyond a prom makeover.

Despite the emphasis on girls as Abduction Victims, occasionally a story comes through about girls who survive such ordeals as random kidnapping by not giving up. In August 2002, *People* magazine featured a piece on Jacqueline Marris, 17, and Tamara Brooks, 16, who worked as a team to attack their kidnapper. The cover's headline read, "Surviving a kidnapping: How We Fought Back."[33] Since most Warrior Girls occur in the digital effects sphere of "Supernatural Girls" (see Chapter Seven), and strong females, as we will see below, are often cast as Bitches or Connivers, girls need to hear stories of Real Girls who transcend the Victim code to protect themselves from danger. While this rare story of kidnap survival provides an example of pluck and strength in teenage girls, more stories of girls who stand up to emotional bullies would be beneficial as well.

A NEW BREED OF BAD GIRLS

In addition to a plethora of Girl Victim stories, the 1990s and 2000s gave rise to the other side of the dichotomy: the Bad Girl and the Mean Girl. A new wave of reportage about Female Killers and Juvenile Delinquents emerged, showing aspects of the Bad Girl Icon that far exceeded making out with leather-jacket boys like James Dean. These included not only fictitious wayward girls in the *noir* tradition of Veda in *Mildred Pierce* (1945, Michael Curtiz) and the jealous conniving schoolgirl Sandy in *The Prime of Miss Jean Brodie* (1969, Ronald Neame), but Bad Girls committing grisly acts recorded in crime blotter detail. The public eye found the dark side of Girlhood, where girls in trouble reside. Major news outlets proclaimed "an epidemic" of Prom Mom Killers, Teen Mom Welfare Problems, and Bad Girl Connivers.

Saccharine traditions about girls being "sugar and spice and everything nice" turned toward a nefarious mythology about "an emerging and growing breed" of inherently mean and dangerous girls, diametrically opposed to Victim Girls. On

closer statistical view, many of these stories proved to be anomalies of hype that helped to sell papers and draw in viewers. These blips on the girl radar tainted the truth of girl normalcy, with unusual headline-worthy cases adding fuel to the narrative about a new breed of bad girls entering the mainstream. In 2006, an article in *Newsweek* proclaimed that violence by girls was up 125 percent, insinuating that perhaps the Women's Movement had gone too far.[34] Ah, backlash, how it spins.

In addition to the Long Island Lolita coverage of early 1990s, a *New York Times Magazine* cover story in 2000 by Margaret Talbot, "The Maximum Security Adolescent," featured the shocking, pimply face of a 17-year-old Girl Criminal tried in Florida as an adult, with the cover headline "What's to Become of the Juvenile Delinquent?"[35] The image shocked. Girls? In jail? Even though the article featured several boys and only one girl, the image of Jessica Robinson, the Bad Girl, tried and jailed at age 14 for robbing her grandparents, was indelible. The core concern of Talbot's article involved the change in certain state laws requiring minors to be tried as adults in criminal cases, leading to incarceration alongside adult career criminals. While juvenile hall is hardly the place to prepare for the SATs, the article points out that social services such as counseling and monitoring to complete the GED are provided for youth offenders in the juvenile correction system but not in adult prison. Talbot profiles Jessica Robinson's experiences in the Jefferson Correctional Institution near Tallahassee, where she first ends up to begin a nine-year sentence for attempted robbery of her grandparents with two teenage friends. In jail, Susanne Manning, a middle-aged woman serving a 25-year term for embezzlement, becomes a "mother" figure who vows to protect Jessica, clearly a questionable role model. Later at Dade County Correctional Institution near Miami, her surrogate Mommy becomes a murderer named "Blackie." Girls and boys being tried as adults provides further evidence of the flimsy line that now exists between childhood and adulthood in many sectors of American culture, even at the legal level.

ANOTHER BAD GIRL: THE TEEN MOM

In November 1996, Amy Grossberg, a teenager from a wealthy New Jersey suburb, reportedly gave birth to a baby boy in a motel room then threw him in a dumpster. While Grossberg gave birth to the baby in the presence of her boyfriend, Brian Peterson, and together they disposed of him, Grossberg, considered more irresponsible received a longer sentence of two-and-a-half years for second-degree murder to Peterson's two years for manslaughter.[36] Seven months later the "Prom Mom Killer," Melissa Drexler, gave birth to her baby in the girls' bathroom,

disposed of him, and then returned to the Prom festivities. She was sentenced to 15 years, but served only 3.[37] According to Susan J. Douglas and Meredith W. Michaels,

> In spite of the fact that there are far fewer infanticides by teenagers now than there were before the legalization of abortion in 1973, *Newsweek*, in a story entitled "Cradles to Coffins," devoted several pages to what appeared to be an epidemic of Melissas and "her kind."[38]

Though only two known cases of these anomalous acts existed in 1996, headlines and subsequent reporting by respected journalists Dan Rather and others, would have viewers believe these crimes posed a new trend. What such reporting fails to acknowledge is that the dismantling of public school sex education programs and access to birth control and abortion information have an impact on teenage pregnancies, as does the contradictory pop cultural incentive to be sexy promoted by the Lipstick Lolita syndrome combined with "just say no" abstinence education in schools.

In the discourse of public policy, one of the most vilified Icons of teenage girlhood of the 1990s was the Teenage Mom. Teen Moms as baby killers only added to the villainy. Teenage Mothers, particularly African-American inner-city girls, in many ways served as pawns to dismantle aspects of the welfare system. Though few teenage mothers made up the actual welfare rolls, they were treated by the media as part of an unstoppable "epidemic." As Susan J. Douglas and Meredith Michaels also point out,

> Even though only 1.2 percent of welfare mothers were under eighteen when they received benefits, and teens accounted for about 5 percent of welfare caseloads, the unwed teen, preferably one whose mother and grandmother had also been unwed teen mothers on welfare for life, was to conservative politicians and the networks what Princess Diana was to *People* magazine: a constant attention grabber.[39]

Despite the fact that Christianity is founded on the miraculous birth of Jesus to a Teenage Mother named Mary, the Teen Mom has been vilified most vociferously by the Christian Right who might otherwise call for Christian compassion toward young, pregnant, unmarried mothers. Yet Conservative Christian mores regarding sex education keep girls from getting the information they need to avoid their less-than-immaculate conceptions.

The Teen Mom syndrome inspired several important mid-1990s documentaries funded by PBS's Independent Television Service (ITVS), including *Baby Love* (1996, Carol Cassidy) and *Girls Like Us* (1997, Jane C. Wagner and Tina DeFeliciantonio). Both were shown extensively on PBS in the mid-1990s and continue to be shown in Women's Studies courses in colleges and universities.[40] *Girls Like Us*, which won the Grand Jury Prize for documentary at Sundance in

1998, follows four working-class Philadelphia girls from ages 14 to 18 as they explore topics of college, sex, and identity. By the end of the film, two of the girls are pregnant, underscoring the lack of sex education available to girls, especially in homes where parents may be too financially challenged or too busy grappling with English as a second language to attend to their daughters' educations growing up in millennial America.

The study guide for Carol Cassidy's 1997 documentary *Baby Love* reveals that adult men (aged 21 and older) father more than 50 percent of the babies born to teen mothers age 15 to 17.[41] Even though statistics demonstrate that the majority of these adult men abandon their teenage partners to a life of poverty as single mothers within a year, it's the girls who are vilified for lack of responsibility. These facts dispel the myth that most babies born out of wedlock are those produced by teenage girl/boy relationships, with both "too young" to handle the responsibility. Since many teenage mothers do emerge from families without fathers themselves, the promise of the sugar daddy/big brother savior may be a component of their attraction to a presumed ticket out of poverty, which never materializes. Acknowledging the role a significant number of adult men play in impregnating teenage girls puts a different spin on the mythology about teen pregnancy.

Many of the Teen Moms interviewed for *Baby Love* shared a common ignorance about biology and economics. Their desire to keep their babies is fueled partly by religious beliefs but also by denial, which often causes them to go beyond time limits for legal abortion. Their stories reveal a heartbreaking search for love that had been otherwise absent from their lives. When they are abandoned by their boyfriends, that search for love transfers to the baby, which is a risky endeavor at best given the enormous needs of an infant in the first two years of life. Since the mid-1990s, teenage pregnancies have actually decreased, due in large part to educational initiatives to teach girls about the risks of young motherhood.[42] But the Teen Mom Icon continues to surface as a cautionary Bad Girl in popular culture.

Several early 1990s independent films delved into the subject of the Teen Mom, which coincided with tremendous mainstream press attention. Owing to girls' overall invisibility as subjects up to that time, the sheer existence of so many pregnant teenage girls and Teen Moms in the indie film scene of the early 1990s is notable. Was it a coincidence or a force of the marketplace? The "hook" involved depicting a protagonist we'd never seen on screen. These films include Alison Anders' *Gas Food Lodging* (1991), *Mi Vida Loca* (1994); Leslie Harris' *Just Another Girl on the I.R.T.* (1992); Jim McKay's *Girls' Town* (1996); and Lisa Krueger's *Manny & Lo* (1996). Many of these early to mid-1990s efforts did not have the teenage girl viewer in mind; geared, like the art house films from Europe, toward a discerning adult audience. The first wave of 1990s coming-of-age films directed by Anders, Harris, and Kreuger led to a "social interest" style of filmmaking one step removed from social

documentary, which will be discussed further in Chapter Nine, "The Girl Gaze." With Teen Moms ubiquitous in mainstream news reportage at the start of the 1990s in the selling of the welfare reform, the "importance" of the topic no doubt had an impact on green-lighting their funding efforts. A second wave of indie Teen Moms appeared in the 2000s, including in Francine McDougall's *Sugar & Spice* (2001), a spoof in which the head cheerleader robs a bank to fund her pregnancy, and Brian Dannelly's 2004 comedy farce *Saved!*, which deals with some of the dark hypocrisies underlying Christian attitudes toward adolescent sexuality. *Maria Full of Grace* (2004) and *Quinceañera* (2006), discussed briefly in Chapter Two, deal with teen pregnancy from a Latina perspective. Hillary Brougher's *Stephanie Daley* (2006) features Amber Tamblyn in the title role as a high school student accused of concealing her pregnancy and murdering her unborn fetus during a ski trip. In *Saved!* Jena Malone plays the appropriately named Mary, a devout teenage girl attending a Baptist School. After experiencing a vision of Christ while swimming in an outdoor pool, Mary decides that the only way to "save" her struggling gay friend Dean (Chad Faust) is to offer her virginity to him. Despite her efforts, Dean lands in a correction program for homosexuals, and Mary ends up not only pregnant but socially ostracized. Mary believes her deep faith will provide for her, when hard facts and birth control would have served her better.

MEAN GIRLS AT THE MOVIES

In an era of blurred boundaries between fact and fiction, the recent appearance of Hollywood Bad Girls begins with 1989's *Heathers* (Michael Lehman), a film about the power of cliques to elicit murderous behavior. Marketed as a black comedy, Winona Ryder plays 16-year-old Veronica Sawyer, a bright but misguided girl who cynically realizes that hanging out with the ruling Heathers elite is a necessary task in high school. "They're just like my job's being popular and they're people I work with."[43] Egged on by her newfound, equally cynical, boyfriend, Jason Dean (Christian Slater), Veronica finds a darker power in helping her "friends" to off themselves. J.D. is the Rebel with a Cause: kill the annoying Heathers and fake their suicide notes. Veronica falls under his dark spell and conspires to kill the Alpha Heather. *Heathers'* popularity ushered in a 1990s Bad Girl trend which included *Heavenly Creatures* (1994), *Jawbreaker* (1999), *Cruel Intentions* (1999), and 2004's *Mean Girls*. This new crop of Bad Girls didn't need a Jason Dean as motivator; they generated their own schemes.

Before his *Lord of the Rings* fame, Peter Jackson directed *Heavenly Creatures*, a film about the intense 1950s friendship between two New Zealand girls who

commit a brutal murder. Drawn from the real-life diary of Pauline Parker, the script by Fran Walsh is based on the notorious Parker-Hulme murder case. The film marked the debut of 19-year-old Kate Winslet as the wealthy Juliet Hulme and Melanie Lynskey, then 16, as her working-class friend, Pauline Parker. Their fantasy world, which involved intricate special effects sequences of the girls' invented kingdom of Borovnia, eliminates the social gulf between them, leading to such an obsessive friendship that both sets of parents decide to sever it. In response, the two misguided girls decide the only way to become true sisters is to murder Pauline's mother.

The year 1999 gave viewers two manipulative, dark-haired Queen Bees, Courtney (Rose McGowan) in *Jawbreaker* and Catherine (Sarah Michelle Gellar, playing against her blonde *Buffy the Vampire Slayer* savior role) in *Cruel Intentions*. In both R-rated scenarios, a clear fantasy emerges of conniving, sex-crazed teenagers (all played by 20-something actors), with a couple of heartless girls at the helm. As *The New York Times* critic Janet Maslin remarked in her review of *Jawbreaker*, "Once again, the babes are hot-looking predators obsessed with cruelty, popularity and materialism, crushing all nerds and innocents in their way."[44]

These movies played into an odd simultaneity of adult nightmares about their daughters' secret lives and soft-core fantasies about their precocious level of sexual activity. The girls in these films drive sports cars and wear designer clothes, while absentee upper-middle-class and upper-class Daddies and Mommies pay the bills. Both films banked on adult and teenage audience crossover to deliver at the box office. In *Cruel Intentions*, based on the 18th-century epistolary French novel *Les Liaisons Dangereuses*, the scenario shifts from the original moral corruption of French elites to New York Society teenagers still in prep school. In both movies, the Queens of Mean are punished by their peers, but not before laying out the game plan for wielding power in high school as visual "how-to" manuals for aspiring Queen Bees everywhere. By the end of these movies the Queen Bees are subjected to group ridicule and scapegoating with a ferocity that mirrors their own scheming at the beginning. In *Jawbreaker*, Courtney masterminds the "accidental" murder of a clique member then masks it as suicide, holding the rest of the girl tribe in her audacious thrall until she is outed and the school population jeers and turns against her at the prom. *Cruel Intentions'* Kathryn Merteuil maintains a Straight-A Uber Girl persona of innocence until the very end. Finally, when the diary of her martyred stepbrother, Sebastian Valmont (Ryan Phillippe), is reproduced for all to read, the entire community shuns her. Though the plan to corrupt two school Virgins is in fact co-masterminded with Valmont, who agrees to deflower Annette Hargrove (Reese Witherspoon) in exchange for a long-desired incestuous night with Kathryn, the Bad Girl takes the heat in the end.

MEAN GIRLS

Just as Teen Mom and Bad Girl Icons crossed over into the millennium, so did the Mean Alpha Girl, a flip side of Rachel Simmons' Victim Girl. An entire genealogy of girls-in-crisis books led to Rosalind Wiseman's 2002 book *Queen Bees & Wannabes*, which in turn spawned 2004's hit film *Mean Girls*, adapted and written by *Saturday Night Live* head writer, Tina Fey. *Queen Bees & Wannabes*, an important milestone in naming the power of girl cliques in teenage social hierarchies and their impact on self-esteem, came out a few months before Simmons' *Odd Girl Out*.

Wiseman writes from the field like an anthropologist reporting on a primitive species. Tina Fey's screenplay for *Mean Girls* includes a scene of teenagers jumping around like animals to jungle sounds in the mall which parodies this Darwinian perspective. It's not surprising that *Queen Bees & Wannabes* adapted so quickly to the screen, as Wiseman's descriptions of girl behavior in her high schools of inquiry often resemble the storylines of Bad Girl films such as *Jawbreaker* and *Cruel Intentions*. Which came first: the evil chick or the egg? It's the perennial media literacy question. While films and media are mentioned in *Queen Bees & Wannabes*, Wiseman's core premise is that girls are inherently mean; we just weren't sufficiently aware of this before, and they need guidance to be tempered and reformed.[45] Part of the rise to power of the Queen Bee paradigm involves teen flick and sitcom reincarnations of this beastly entity who has been termed a given in the adolescent landscape. Is she always fact or is she sometimes fiction? Is her behavior innate or learned from media scripts? The jury is still out.

As background for her screenplay for *Mean Girls*, Tina Fey began with an article by Margaret Talbot published in *The New York Times Magazine* in February 2002, "Girls Just Want to Be Mean,"[46] a profile of counselor Rosalind Wiseman and her Empower Program, which served as shock value pre-publicity for her book. The cover, which featured a girl voodoo doll stuck with pins, evoking witchcraft and evil long associated with dark female power, caught the eye of Fey, who decided to write a screenplay based on the premise.[47] *Mean Girls* proved a huge box-office hit, bringing in adults as well as teenagers, due to in part to Tina Fey's writing credit and the starring presence of soon-to-be tabloid favorite Lindsay Lohan.

In this *Heathers*-meets-*Clueless* scenario set in a high school in Illinois, Lohan plays Cady Heron, a new student enrolling in a mainstream American high school after years of homeschooling on safari in Africa with her anthropologist parents. On a dare from two arty friends, Cady goes undercover to infiltrate the Alpha Girls at school, known as the Plastics. Once inside the clique, Cady finds herself seduced by their power and vies for supremacy with the main Mean Girl, Regina (which means, of course, "Queen" in Latin), played by Rachel McAdams, leaving

her original friends behind. She eventually recovers to excel as a Mathlete after pretending to hate geometry to impress a guy.

Beyond the screen, Wiseman's Empower Program provides a psychotherapeutic, group therapy approach to the problems of girl cliques, a mock scene of which appears in the film. That this concept so easily adapted to the screen indicates how much her book drives on delineations of Girl Types, as if school has become a big social soap opera with costumes and roles. The success of Wiseman's programs indicates how strong cliques have become in certain conformity-driven upwardly mobile school environments, but the emphasis on the Mean Girls themselves speaks to the lowest behavior patterns in girls and casts them as movie stars of the school universe, with far too much attention paid to the negative "fact" of their rulership. Nowhere in Wiseman's book or in *Odd Girl Out* are parents or girls encouraged to counteract the existence of Queen Bees as the dominant paradigm or given clues about how to erase their importance by developing different scripts of social conduct. Both books cast the Mean Girl or Queen Bee as an innate predator who must be noticed and dealt with accordingly. Yet the Queen Bee cannot exist without henchgirls and her audience of cowering peons. She is hated and revered simultaneously.

The Diva princessdoms of Mean Girls observe the rules of pop media, where all attention pours into individual celebrities or rock stars. Attention becomes a kind of currency that delineates It-Girls from Wannabes. All the attention accorded the Bitch in Mean Girls hysteria celebritizes her behavior as a path to social ruler-ship. It-Girls in schools require that eyes be on them. In a culture that values celeb-rities, the school social system becomes a miniature star stage for those players who make it to the top of the food chain. For teenagers who have not yet formulated an identity strong enough to cut through the superficiality of the power codes, these landscapes are active kingdoms and queendoms, which can be oppressive. But the title and writing style of *Queen Bees & Wannabes* assumes that there is only one real-ity: that of hegemonic codified cliques. It does not depict an alternative possibility for girls to become individualists and thus challenge the power of the dominant group by choosing friends and activities that demonstrate a different core value system, one based on creative, athletic, or community service. Queen Bees cannot in fact be "popular" if no one watches their daily movie.

Alternative subgroups gain power if they ignore the so-called popular groups, creating their own styles and forms of self-expression. Theatre arts, video, and dance classes offer alternative identities beyond the "weirdness" designation of the rulership of sports and academic structures, out of which new elites can form. With arts programs being consistently cut from public education, these niche areas become more difficult to locate on campus for those who not only are different from their peers but might want to cultivate another persona beyond the mandatory

conformity veneer. Is it any wonder, then, without access to creative forms of rebellion against the status quo, that Mean Girls gain in power? Schools need to support girls who challenge dominant cliques. And teachers aware of Queen Bees need to check their own tendencies to encourage their power by ignoring their social behaviors. In many cases, teenagers themselves are bored with the Queen Bee/Jock/Token Weirdo or Stoner scripts, which is why Supernatural Girls working for the greater good are so alluring and why the Canadian-produced television series *DeGrassi: The Next Generation*, which deals with problems beyond clique domination, where real kids confront drugs, mental illness, love, abortion, teenage bands, enduring friendship, gay love, and committed relationships, has become so popular.[48]

In the final analysis, who is most fascinated with Mean Girls and Victims? Adults, not teenage girls, bought Wiseman's and Simmons' books chronicling the cruelties of girls and the victim fall-out, making them best-sellers. Wiseman wrote her book from the perspective of a hip, 30-something workshop leader who related well to teenage girls, but she had not yet raised a teenage daughter. Despite this lack of direct experience, many middle-class American mothers were quick to trust a woman on the "inside track" of "Girl World," as if they were being let into the cool crowd themselves.

> This book will let you in. It'll show you how to help your daughter deal with the nasty things girls do to one another and minimize the negative effects of what's often an invisible war behind girls' friendships.[49]

Since American parents on the fast career track don't have the time to look in on MySpace or IM or overhear snippets of cell phone conversations, they will often buy a book or attend a parenting workshop for a game plan. By the time their children reach adolescence, many parents are in full dual-job mode, leaving the girls and boys to mind the store, the remote, the Internet—in short to become adults on their own. Who steps in? Cliques, peers, television, fashion magazines, celebrities, and well-paid experts.

ESCAPING GOSSIP WORLD

Part of the discourse around the supposed "mysterious meanness" in millennial teenage girls denies that the behaviors might be learned at home. Many of the backstabbing tropes described in *Odd Girl Out* and *Queen Bees & Wannabes* find echoes in adult sectors, where women operate along subterranean power lines to gain social and career access. The books may be talking about girls, but the perpetrators of the mean tropes are also sometimes women. Cliques still rule in the

adult world, often along the most superficial materialistic criteria such as the size of your car, house, or wallet. Being shocked at finding teenage girls manipulating each other on this scale seems dishonest at best. Until grown women begin to acknowledge the ways in which they perpetuate subterranean power grabs in the grown-up Girl World, the social machinations of girls in middle and high school will continue.

One aspect of this reexamination involves acknowledging our addiction to gossip, which provides a contagious means for girls and women to infect one another with poisonous perceptions that compromise a sense of community due to an overall lack of trust. Building trusting relationships is a skill. In the no-girl's land of gossip and clique violence, there are no blueprints for strong bonds and no adult mentorship to guide them. Wiseman uses the concept of survival as a game plan for dealing by blending in but doesn't examine the moral codes at work or deeply challenge them. Mothers who indulge in mindless gossip must come to own it as far from idle and that they teach their daughters by example. Wiseman holds girls to a standard of self-examination regarding gossip, but not adults:

> Let's face it. We all gossip: on the phone, at parties, meals and family reunions. I think the best thing about family get-togethers is the gossiping we do when everyone goes home. Girls are no different. In fact, why do you think adults are so good at it? Because we've been sharpening our skills since our teens and it's almost impossible to stop. So do I tell my friend to stop when she calls me at work with some juicy gossip? Of course not. But there's a difference. While gossip still has the ability to ruin your day, its impact on your adult life is usually superficial and fleeting. Hopefully, you shut your mouth when you know you'll hurt someone. But it's very different when you're a teen. Along with teasing, gossip is one of the fundamental weapons that girls use to humiliate each other and reinforce their won social status.[50]

Libel is a crime against individuals that sets a dark-glass view on their reputation. Adolescents within their social systems do not have access to libel laws, yet destroying someone's social currency is nothing less than a teenage crime. The problem with gossip is the vicious cycle of it: if girls engage in it, eventually they too will be the subjects. Growing up in an adolescent environment of betrayal makes for a landscape of insecurity where female-to-female trust becomes a huge challenge at best, sometimes causing girls to look to boys for reassurance.

A lot of female-on-female gossip aims to bring another woman down a notch, digging into her armor, her power, impacting the possibility of trust in other women and girls. Through the practice of their own form of impeccable speech, adults can teach girls to avoid it, as a means of cultivating less poisoned social environments. As an artist-in-residence I always establish a rule of respect that is "diss-free": there are no stupid ideas, only those in progress. Mutual appreciation for all contributions to a video or photographic collaboration means no room exists for

drama or gossip. Everyone is too busy pursuing their projects. Gossip rules when minds are just not engaged and inspired by their research, their writing, their films.

Granted, a difference lies between process talk—conversations aimed at understanding the often mysterious behavior of other girls—and the wanton, dagger gossip aimed at taking other girls down. Parents often fail to see a problem unless their daughters become outcasts. Parents nore easily to intervene when their daughters become Victims than to admit to them being bullies. They rarely perceive their own daughters as perpetrators of emotional violence or physical aggression. The Bad Girls are other people's kids, those who were brought up "incorrectly." It's the adult blind eye, the "My daughter would never do that" mythos that sometimes hinders solutions. Encouraging girls to be truly powerful means embracing a less narrow vision of girlhood and womanhood. We are all victims or the bullies at one time or another; we are all passive and aggressive; we embody both impulses, as well as an entire spectrum of more subtle responses. Yet in social situations, girls are often branded as "either/or" rather than as complex beings with a vast array of human choices and responses. This narrow, black-and-white, perspective on female behavior limits the spectrum of female responses and identities, which is why it's important to not get caught in this divisive paradigm. This blindness serves to perpetuate the demonization of women who are powerful and aggressive in public life (think Hillary Clinton, Martha Stewart, Leona Helmsley). They are the feminazis, bitches, Medusas, Gorgons of our culture, as well as the Queens.

THE BEST FRIEND MYTH

The fallacy of the Best Friend myth aligns with the "one and only" romance promoted by fashion and lifestyle magazines that has young women seeking one Boyfriend and one Best Friend. Some of our mythologies about Best Friends derive from movies, which overemphasize the role of the Best Friend as the sidekick, the "one who is always there." Yet the sidekick or best friend is storytelling shorthand in a visual medium that has difficulty making sense of multiple characters. Queen Bee power often predicates on playing girls off against one another for their time slot as "the one and only" Best Friend. So, while they may all be part of a clique, they are not a trusting community of a girls network looking out for each other's best interests. If girls wait for their moment in the co-star seat, the Best Friend role, how long until they decide to elbow out the Diva and take the main spotlight for themselves? This belief in the narrow range of the spotlight as part of social scarcity enhances distrust and compromises group support for girls. Alternating time in the spotlight reflects an entirely different skill set. The circle-

of-friends community model of a Girls Network brings strength and support for constructing larger goals beyond being Prom Queen or her Best Friend.

CATFIGHT CULTURE AND BACKSTAB MYTHS

We've all seen the tabloid headlines: "Does Hilary Duff Hate Lindsay Lohan?"; "Christina Disses Britney!" "The Boy is Mine," a 1998 song, featured a duet between by the Grammy Award-winning performer Brandy (star of the late 1990s UPN series *Moesha*) and an up-and-coming singer named Monica. The song chronicles a competition between two teenage girls for the same boy; it remained on the Top Billboard Hot 100 singles chart for 13 weeks and became one of the most popular songs of 1998.[51] Catfight stories give young girls messages which may influence Mean Girl clique behavior, with Queen Bees operating as trend-setting Prima Donnas, craving and demanding a spotlight based on revenge against a nemesis.

Classic Hollywood backstab scenes from Bette Davis and Joan Crawford dictate that "women are just like that." All of these visual riffs fully operate as shortcuts to character and storyline establishment in films, television sitcom tropes, and advertising narratives. What we learn from classic Hollywood to 1990s teen movies is that two good-looking women cannot occupy cinematic space without engaging in some kind of verbal sniping. The examples abound to the degree that it becomes difficult to discern "innate" behaviors from learned behaviors. With so many examples of females jabbing each other, it's a challenge for girls to believe in sharing the beauty slot or the power slot. Myths such as "Girls are more jealous than boys" or "Women will always backstab each other" contribute to difficulties in establishing cooperative environments of mutual power for girls. Mean Girl Icons perpetuate the impossibility of female teamwork, as they establish a pattern of belief in an Alpha Girl as a fixture of existence. In children's fare, it's an older woman, the Wicked Witch or Wicked Step Mother, bent on thwarting the Teenage Heroine's happiness. Engrained re-runs teach that women and girls will oppose our best efforts with a cunning that knocks the heroine from her position only to regain it at the opposition's often ridiculed expense.

Rivalry for "the Prince" plays out again and again. In dating game/sex game scenarios two women often compete for the same man. From *Bridget Jones's Diary* to *Legally Blonde*, the zany blonde wins out over the dark-haired intellectual threat who proves excessively unkind to the heroine. Viewed repeatedly by teenage girls, first in theatres and then in at-home viewing on DVD, this culture of scarcity versus a culture of abundance reinforces myths that there are so few "good men" to go around that girls must fight to keep them. This segues into fears about not being

good enough, and continues to reinforce a myth in boys and men that there are scads of women fighting over them. For middle and upper school girls, the notion of boys-as-prize relates to the continued persistence of a Cinderella myth about "rich white guy marriage" which, while out of whack with statistical realities, still holds sway with the middle class. Having a boyfriend becomes a kind of Prom Queen currency wielded by girls in the ruling elite. As Rachel Wiseman suggests, "When Girl World is set up to riddle your daughter with insecurity, she'll seek the validation from a boy and can become desperate to please him."[52]

The catfight at its core is about rivalry for the same man/boy, historically a female's only route to wealth and power. With women and girls socialized to be "nice," to look nice, to act nice, catfights signal aggression that has finally reached a boiling point, a last result. With boys, aggression is also physically spontaneous, with a tradition of the classically arranged "duel" set after school for the boys to "duke it out." The catfight is seen as "nasty," "down and dirty," and "mean." For some male spectators, this behavior is titillating, arousing, and/or comical/ridiculous, absent of duel-like nobility. Guys are expected to be more direct, more confrontational. Girls, when aggressive, are often labeled too "masculine."

Despite mud-slinging fights which crop up occasionally, films and television usually reinforce female gender codes of indirect communication, manipulation, and backstabbing. In her book *Where the Girls Are: Growing Up Female with the Mass Media,* Susan J. Douglas provides an excellent perspective on how politically pernicious the catfight mentality can be and how it influenced the defeat of the Equal Rights Amendment in the early 1970s by pitting a conservative, Phyllis Shlafly, against feminists such as Gloria Steinem.[53]

Anger and aggression, within the female range of emotional response as much as for males, are forced into the subterranean, just like sexual desire. Girls are rewarded in school for being "good." Boys get plenty of attention for taking up space—cutting up, cracking jokes, and disrupting the class, accepted as part of the "boys will be boys" culture. The subterranean tactics most often employed in wreaking vengeance or exacting social control are accepted "girl behaviors." Their convert existence means that educators and parents can abdicate responsibility. Overt aggression requires immediate adult intervention, while subtle emotional aggression does not. Yet this is exactly where girls need the most guidance, which requires a level of intuitive honesty on the part of educators and parents, as well as bravery. As with all aspects of girl culture, their shadow belongs to adults as well, sometimes too harrowing to look at.

The whole notion of operating "behind someone's back" belongs to the realm of girls, a vague and dangerous zone. The promotional poster for *Mean Girls* included the line "Watch Your Back." Just as our anatomy limits our ability to see 180 degrees behind us, we cannot *see* this terrain of talk. In horror movies, demons

can turn their heads 180 degrees, a gaze that has a terrifying hold on the viewer, like Regan in *The Exorcist* (1973, William Friedkin). The ability to perceive this unseen region of social space denotes a terrific power indeed, essentially the power of intuition. Knowing enough truth on a beyond-the-bones level means girls can move away to self-protect if necessary. We sense it, we intuit it, our hairs twitch, but we are not accustomed to articulate the messages fully. We don't want to believe it, and tell ourselves we are "imagining it." As Rachel Simmons points out, "One of the chief symptoms of girls' loss of self esteem is the sense of being crazy, of not being able to trust one's own interpretation of people's actions or events."[54]

When girls confront one another they often deny it, further complicating the messages sent in by intuition. Brothers and fathers will tell you you're imagining it or else "Don't worry, it just means those girls are jealous ..."

As a public service, these two books have brought a shadow terrain to the surface of public discourse. That *Queen Bees & Wannabes* and *Odd Girl Out* have brought awareness to the culture of backstabbing operating in the collective closet is a good thing, but analysis of these mythologies versus their supposed biological determinism needs to continue if girls are to evolve beyond these behaviors. Examining further the role of media, family, and social encoding in maintaining these pernicious behaviors can provide clues to how girls live their social lives in mainstream America with authentic spontaneity or by acting out unconsciously absorbed behavior scripts from pop culture. Without media literacy, there is no way to make a distinction between the dictates of constant replay and originality.

When a Posse Princess bullies other girls outside the purview of parents and teachers, she enforces a level of conformity which aims to eliminate a diversity of voices. While risky to speak out in these homogeneous environments, all girls and women must find their own voice as part of the process of individuation. Most of the girl bullying behaviors described by Rachel Simmons and Rosalind Wiseman take place in predominantly white middle- and upper-middle-class schools, where conformity is already assumed. The perpetuation of Bad Girl/Backstabber Myths weakens potential bonds between girls, and repeated viewing of scenes in films where girls betray other girls helps to reinforce the supposed "inevitability" of these behaviors, leading viewers of both sexes to believe they are "innate" to girls.

With so many outlets of media consumption scanning back over television shows and films from other eras, this particular set of mythologies continues to recur in current and retro forms. The image of a girl or woman threatening the female protagonist with an underhanded plan to destroy her through gossip or political elbowing replays again and again. In some ways, I see this perpetual replay as the "*Psycho* phenomenon." In the well-known shower sequence of Alfred Hitchcock's 1960 film, Norman Bates (Anthony Perkins), dressed as an old woman,

stabs Marion Crane (Janet Leigh) multiple times and kills her. In an often-analyzed scene in film studies classes, a scream-like violin score accompanies the fast-cut slashing sequence. Bates masquerades as a woman killing another woman, but he's really a man stabbing her, not a woman at all. By extension, the catfight and backstab scenarios which replay in our culture are patriarchal attempts to undermine female bonds, all the while disguised as "innate" female-on-female violence.

MOVING BEYOND THE MYTHS

Despite the existence of real viable communities of women around the world, Hollywood consistently depicts vicious catfights and subterranean manipulations, often against the backdrop of extreme LA-esque or Park Avenue, New York, privilege. The majority of girls featured in Wiseman's and Simmons' books emerge from middle-class or wealthy suburbs and exclusive urban prep schools. Meanwhile, around the globe, girls and women work together to harvest food and care for children against backdrops of extreme poverty and duress. This kind of cooperation lies at the core of human survival. When necessity calls, women and girls can definitely work together, and in fact have done so for millennia. Beyond survival needs, women working together have produced profound political movements, including the Women's Movement.

As networked communities, girls become extremely empowered. Yet, as evidenced by the controversy that surrounded the now-classic movie *Thelma and Louise* (1994, Ridley Scott), female bonding is seen as dangerous to male power, especially when they defend themselves against male aggression.[55] Welcome images of young female cooperation have occasionally served as the basis of such films as *A League of Their Own* (1992, Penny Marshall) or *Bend It Like Beckham* (2002, Gurinder Chadha). In both films, pivotal characters grapple with rivalry on the field (baseball in the first; soccer in the second) but eventually reconcile. These kinds of representation help to balance out the overemphasis on female betrayal in mainstream fare, though based on traditionally male team sports frameworks. We need far more images of girls and women cooperating with one another, working as teams in other contexts, as in *The Sisterhood of the Traveling Pants*. And perhaps it's time for a pop psychology book that looks at the ways girls create successfully cooperative communities and long-term bonds of friendship.

Trust serves as the foundation of self-esteem and personal realization, actualization. Without community trust, girls cannot flourish. Discourse about the "inherent" tendencies of girls to stab each other in the back as competitive predator/prey does them a disservice and ignores the role media often plays in increasing girls' social vulnerability. Insecure girls, more reliable consumers, will seek validation

from name-branding themselves and their bodies. This scrambling of codes in subterranean communication goes hand in glove with the challenges already faced by girls in navigating their identity in a culture that hands them so many mixed messages. When the mixed messages extend into their close social networks and they can no longer be certain of their place in that universe, a breakdown in self-trust can lead to depression, withdrawal, and self-abuse, hampering girls' ability to lead and create as mavericks.

Despite the existence of the term "Girl Power" in the vernacular since the early 1990s, girls still navigate what Power means. As Lyn Mikel Brown remarks in her book *Raising Their Voices*, a study of adolescent girls' strategies for expressing anger and power in working-class versus middle-class school settings,

> Girls' vetriloquation of the dominant culture's denigration of femininity and female relation-ships serves to disconnect them from other girls. It works ultimately to divide them from themselves through self-hate and deprecation, thus threatening to secure their subordinate status within the prevailing social order.[56]

Mean Girl reportage forces us to look at ways to harness the anger girls direct at each other into voices of political action and voices of change beyond a pernicious and limiting status quo. Girls have few outlets to express their anger, which relates back to the discussion of desire and passion in Chapter Two. The accepted boxes of containment for their bodies and their personalities allow very little room for spill-over. Girls are constantly navigating what it means to be powerful, often along very narrow avenues of behavior. They must appear beautiful, fashionable, intelligent (but not too smart), socially popular, and desirable to guys—all without seeming "stuck up" or "conceited." In a consumerist culture of acquisition, it is difficult to locate definitions of power that extend beyond "collecting" friends, boyfriends, and popularity. In the Girl Power generation, girls learn they can be anything they want to be. And yet they must above all else not give into ego, desire, or self-aggrandize-ment. They must not be "show-offs," though expected ultimately to compete with males encouraged to be show-offs. In this way, girls remain in their place, forced to bury talents underground, or, if visible, modest about them. Adolescent boys wax vocal with bragging rights language as part of exploring themselves. Girls are trained to tell secrets and learn codes of self-effacement to elicit the attention they desire. "I'm so fat." "No you're not! You're sooo skinny!"

Wiseman's emphasis on the importance of "image" for girls to succeed under-scores her book's main flaw: that surviving adolescence involves a conformist strat-egy for dealing with the Queen Bees, not designing a unique identity. She describes the types of personas typically singled out by the Queen Bees and advises how to keep from being ostracized. In Wiseman's view, based on interviews with girls, the list of Dangerous Reputations for girls to avoid (in addition, of course, to "The

Slut"), include "Quiet, Morose Girl/Loner," who writes poetry and wears black; "Big Girl/Tomboy;" "Jock," who excels at sports; "Social Climber;" "Teacher's Pet;" "Lesbian/Butch/Dike;" as well as, "In-Your-Face Angry Girl: She's not afraid to dress differently and be 'bitchy.' She is dramatic, interested in zines (magazines authored by teens and printed and/or posted on the Internet). She has no patience for popularity and the people in the popular cliques. She can be cause-oriented and talk about her issues constantly. She comes across as cynical and not easily impressed."[57]

From my perspective, many of these "types" become the true trendsetters, creatives and activists who put another spin on teenage existence. I have often encountered these girls as mediamakers and writers, yet Wiseman counsels her readers to be careful about acquiring one of these Girl Identity labels. As mentioned earlier, the Queen Bee presence is determined as a non-negotiable given, a policing force of conformity in an environment lacking avenues for uniqueness. From my observations, Girl bullying may link to the lack of creative outlets in schools for girls to step outside of the boxes ascribed to them, to be encouraged to express themselves with reckless abandon at times through dance, filmmaking, music, stand-up comedy, even "weirdness."

Wiseman includes the "Actual Happy Person" in this section on reputations: "Not every girl is miserable. There are actually genuinely happy girls. People look up to them. The cliques cut them a lot of slack. I don't come across them very often, but they do exist."[58]

If you're on the lookout for Mean Girls, perhaps these Happy Girls cannot be seen. We need to locate more of these girls and decode their elusive secrets of personal success. The successful girls who make it to college and beyond without eating disorders, or other self-destructive behaviors, who manage to find ways to engage in healthy competition without compromising their moral core haven't been analyzed enough in adolescent self-help psychology books. Those girls exist, but very few documentaries or narratives focus on their positive outcomes.

Rosalind Wiseman and Rachel Simmons's work in getting underhanded networks out into the open is important as is their insistence that educators take the time to treat these issues seriously. Girl on girl emotional violence can take its toll on a girl's confidence, especially in middle school, leading to social careers of self-censorship. However, it is important to remember that girls are not innately deviant or cruel, but that the gender codes of our culture, reinforced by endless examples in the media and in our childrearing practices, limit their access to healthy languages of passion, anger and aggression. The language of friendships and relationships is crucial to female development and yet in schools, fluency in emotional language is often truncated in favor of a more scientific, expository

voice. It's no wonder the emotions become extracurricular and/or underground, like secret diaries.

Some of the complex backstabbing scenarios described in *Odd Girls Out* and *Queen Bees and Wannabes* read like cinema. If Queen Bees had a means to channel that level intrigue into writing, directing and producing a play or film, they would have a complex piece of creative force on their hands. But destructive collaborations need to be guided toward primary, proactive, forms of self-expression. These girls clearly have leadership skills that could be implemented to direct plays, spearhead political activism, lead relief efforts (like Cher in *Clueless*) instead of plugging their brain power into the inverse of creativity…underhanded manipulation. Alpha Girls clearly possess the leadership abilities to direct large networks of people and operate at the helm; they just have to get out of their narrow subterranean hallways and closets, where such power gets twisted.

We have reached a point in our civilization where clarity of vision, purpose and leadership are crucial to our survival. Since this requires all of the best and brightest, we have to allow girls to "be all that" without compromise or apology. Girls' intelligence and creative social skills can be redirected, as Wiseman points out in *Queen Bees*, but the redirecting of her rehabilitative educational programs, hinges largely on group talk therapy, not creative programming for girls to channel inner rage and deep passion into canvasses and inventions. The absence of the arts as a significant presence in public education and their role as a "sideline" to more important academics at many prep schools, individuality reinforces conformity. Creativity goes underground, channeled into social operatives that could otherwise be applied to zines, filmmaking, mural painting, and so forth.

Mean Girls and Victim Girls exist in a bipolarized vision of girlhood and womanhood that ignores an entire rainbow of possible outcomes, relationships and experiences. Despite the black-and-white polarity that exists in print, Real Girls exist in broad spectral light, not the either/or of a bipolarized reality. Clearly they need more currents of expression to avoid the flip switch of these extremes.

Emily White's *Fast Girls: Teenage Tribes and the Myth of the Slut*, Rosalind Wiseman's *Queen Bees & Wannabes*, and Rachel Simmons's *Odd Girl Out* (all published in 2002) demonstrate that like it or not, girls are not always Victims; they are sometimes cruel instigators. This view runs counter to a noble feminist notion of women as Victims in patriarchal history.[59] The appearance of these books provides a balancing out of the victim theory, providing a powerful view of girls. But it cannot stop as "proof" of a biological determinism that posits girls as DNA-wired to be cruel to one another. Looking under the layers of behaviors we must seek clues to a misdirected and misguided power underlying psychological violence and encourage girls to find their own authentic voice, which may be the road to the Happy Girl.

Reviving Ophelia's subtitle, *Saving the Selves of Adolescent Girls*, cast adults as saviors. Through the parenting self-help industry adults seek safety helmets and harnesses in the form of books and workshops to protect their daughters from the emotional crashes that are a part of growing up. When girls learn to perceive themselves as needing "saviors," they do not learn to trust their own navigational skills or take full responsibility for their actions in their passage from childhood to adulthood. Suggesting that girls inherently alternate between the extremes of Mean Girl and Victim leaves them with a kind of insanity plea. If parents and educators buy into the fear hype about teenage girls being in danger of emotional wounding or of being unconscious sadists themselves, they cannot begin to trust their own moral compass. While books such as *Queen Bees & Wannabes* and *Odd Girls Out* provide a service in naming issues, they ride on waves of hype to the best-seller list, fomenting anxiety and a lack of personal agency along the way.

True empowerment must move beyond critique of Media Power and Social Power to involve proactive, creative steps to activating girls' own sense of agency and an ability to do for themselves. Programs such as Outward Bound's outdoor adventuring for teenagers are one example,[60] along with the media-making initiatives outlined in Chapter Ten. This kind of empowerment process provides a series of creative steps rooted in locating self-trust and a belief in the value of individuality in the context of group collaboration over blind conformity. American success lies with the mythology of the "self-made man" and "the rugged individualist,"a gendered male storyline. But women in American history have embodied this as well: Edith Wharton, Annie Oakley, Willa Cather, and Amelia Earhart are just a few examples. All creative artists, intellectuals, and inventors spend time in a Room of One's Own to manifest their unique offering to the world. Overemphasis on fitting in socially hinders girls' access to the benefits of "alone time" as an antidote to the power of the group mind, the clique mind. Fitting in cannot be the primary operative of adolescent development. Given the techno sped-up overscheduled lives that children currently lead, they are rarely afforded "chill time" daydreaming in their rooms, writing, drawing, breathing in. Not only are loners vilified as "losers" and "loneliness" something girls learn to avoid, but the fear of the predator bogeyman justifies the scheduling of constant group activities. Yet the great novelists, screenwriters, poets, lyricists, researchers, pioneers, inventors, and innovators produce most of their best work alone. Defining girls in terms of social success limits their access to alone time, essentially genius time.

With media hype nudging us along, we tend to focus more on the girls who are missing than the girls who are home, girls who are Victims rather than the ones who are resilient in positive ways beyond Mean Girl abuses of power. Our obsession with Girl Victims may be a greater danger than stranger abduction, and our

willingness to pin the blame on Bad Girls may be more pernicious than any actual backstabbing they do. The discussion of relational and psychological bullying also comes from a position of fiscal privilege—white middle-class girls—which obscures a healthy discussion of those truly victimized and bullied by gun violence, poverty, war, natural disasters, toxic waste, and a lack of education. As I have observed, when schools take on bigger issues and initiate community efforts around tsunami relief, AIDS walks, global warming, and other social causes, the larger perspective helps to lift students out of the little queendoms of playgrounds and hallways. Self-esteem is a luxury concept accorded white middle-class American girls who, when cast as "endangered" or "in danger," adopt a fearful attitude toward taking responsibility for their own lives and decisions. An overemphasis on psychological victimhood and bullying shrouds girls not only from a sense of agency but from a larger perspective as global citizens.

With so much Victim pathology, adults return to this image of the forensic Victim from news reportage, burned on our collective memories. But, as Sebold's dead heroine notes so wisely in *The Lovely Bones*, "the living deserved attention too."[61] We need to see the Real Girls before us, not the pathologized ghosts of unhealthy society. These anomalies must remain marginalized, despite our over-saturated visual trauma resulting from of a sometimes-perverse Pandora's curiosity. We must keep healthy, living girls front and center, amplifing attention to them that will assist with the departure from Ophelia land and its dangerous liaisons. Being ostracized from a petty regime of narcissists can actually provide a path of nonconformity beyond fashion police materialism. The trick is not to adopt the Victim identity as a new career. Girls who have been ditched by the conformist elite in middle or high school can choose to cave in to a lifetime of woundedness and revenge or accept difference and cultivate it as uniqueness, forging a social pathway to other maverick originals. That many girls manage to maintain their personal integrity and individuality in the face of navigating these multiple roadblocks is cause for celebration, funding, and support. We need to hear from the girls who succeed against the odds—the young Amelias, Willas, and Margaret Meads of American iconography—more than we need to revive Ophelia or erect another throne to the Queen Bee.

Out OF THE Gender Box: Title IX Amazons, Brainiacs AND Geek Girls

GIRLS SCREAM, WE ALL SCREAM

Beyond issues of conformity in the bipolar discussion of Victims and Mean Girls in pop psychology, many Girl Icons and Identities continue to break out of the Female Gender Boxes of expectation and preconceived packaging. Alongside and despite the presence of Lipstick Lolitas and other contradictory Icons of girl consumption, many new Girl Characters, Athletes, and Performers in popular culture have been projecting their voices, bodies, personalities, and talents across time and space in the digital continuum, transcending limiting categories of Girlhood.

While gossip operates in the realm of whispers, girls' outward vocalizations have proven powerful enough to stimulate the music industry and deliver box office clout. The screams of teenage girls, which fueled Beatlemania in the 1960s, gave soundtrack jolts to 1990s and 2000s box-office smashes including Wes Craven's *Scream* series (1996–2000), *I Know What You Did Last Summer* (1997), the *Scary Movie* spoofs (2000–2003), and *The Ring* (2001). The teenage girl voice—screaming, yelling, singing, and emoting—offers a cultural wake-up call, a thrill sign of excitement, a response to a rollercoaster ride. Girl screams sell tickets and cause the lines to snake through the theme park. While screaming may seem like the girliest of activities, it's actually a sonic release of female power.

6.1 © 1999 Newsweek.

The Screaming Victim on screen who fulfills a preconceived gendered expectation about rescue differs from the screams of girls at concerts or movies, which provide collective release indicative of tremendous raw female power. While girls often serve as symbols of public mourning, they also provide the vocal engine of ecstasy. Teenage girl voices create a wall of sound for trend setting and excitement, a signal to watch and pay attention. In this way, they possess a spectacular capacity for unbridled freedom. The Beatles found this out. If the girls are screaming, the crowds will come. The screams of girls boost sales.

In *Where the Girls Are: Growing Up Female with the Mass Media*, Susan J. Douglas describes the exuberant screams of adolescent female Beatles fans in the early 1960s as a sound wave that burst through boundaries, sowing seeds for the Women's Movement:

> Girls wantonly jettisoned social conventions about female decorum by screaming, jumping up and down, even fainting in public … They crawled under, climbed over, and simply burst through police barricades, demonstrating that arbitrary boundaries and the laws of old men, meant nothing to them.[1]

Following the British invasion, powerful young American female performers Aretha Franklin, Janis Joplin, Joni Mitchell, and Grace Slick launched their revolutionary voices into microphones to the applause and screams of the crowds. Aretha's 1968 Grammy-Award-winning cover of Otis Redding's "Respect" has become an anthem for Girl Power scenes in mainstream movies well into the 2000s. Rebellion and ear-shattering performances characterized female vocalists of the 1960s, 1970s, and 1980s, with songs that continue to provide soundtracks to the iPod generation: Nico of the the Velvet Underground, Patti Smith, Chrissie Hynde of the Pretenders, and Joan Jett, as well as less well-known legendary punk rebels such as the Slits, Siouxsie and the Banshees, Wendy O. of the Plasmatics, and Nina Hagen. The B-52s' Kate Pierson and Cindy Wilson brought new wave, beehive hairdos, and retro fashion into FM radio culture along with Debbie Harry of Blondie and Tina Weymouth of Talking Heads and the Tom Tom Club. Tori Amos, Björk, and Kate Bush, all prodigies who entered the music arena as teenagers, but didn't sell their virginity to the business and flame out, still make albums in their 30s and 40s. Since their debuts, they have written their own songs and managed key aspects of their own public identities and careers. Post vinyl, these recordings are all available to the millennial DJs via iTunes without need

of massive record shelves. As Lipstick Lolitas reference Madonna and Marilyn, another clan of female vocalists reference the originals mentioned above.

RIOT GRRRL: ANOTHER KIND OF GIRL

Like Punk Girls of the 1970s and early 1980s, the 1990s gave rise to a noisy rebellion known as Riot Grrrl. As Lyn Mikel Brown remarked,

> Not unlike girl gangs, the angry girl movement thrives on contradiction and the re-appropriation of conventionally feminine images and language historically used against women and girls.[2]

The much-appropriated term "grrrl" first etched in zines of the early 1990s Riot Grrrl band movement. A word growl that pushes the edge, "grrrl" denotes alternative power linked to technology, sexuality, body piercing, and anarchy. With short skirts and shaved heads, baby doll dresses, and "Slut" T-shirts, the Riot Grrrl movement tapped into the nexus of the girly, the alternative, and righteous rage. These bands coincided with a DIY (do-it-yourself) zine culture and activist websites where bands advertised shows, produced cut-and-paste manifestos, and documented events. Riot Grrrl bands included Bikini Kill, Sleater-Kinney, Bratmobile, Babes in Toyland, and Hole. Bikini Kill's Kathleen Hannah and her microphone scream vocals emblemize an era in which rebellious, anti-label girl voices lent a raw energy core to the nascent Grunge movement. Both music strands originated in the Olympia and Seattle, Washington, with better-known bands Nirvana and Pearl Jam and a certain Courtney Love of the band Hole blasting out of the anti-commercial stance of Riot Grrrl toward mega-money and, in the case of Love and Kurt Cobain, legendary status. The punk-inspired, openly feminist group energetic behind Riot Grrrls signaled a shift in the music world away from singleton celebrity of 1980s performers Madonna and Janet Jackson to all-girl bands of wake-up sound.

Despite their anti-pop stance, the Riot Grrrl revolution had an energetic impact on mid-1990s music that coincided with several other alternative approaches. In some ways kindred to the DIY concept, Ani DiFranco founded her own label, Righteous Babe records, as an 18-year-old performer in 1989, and she continues to perform her alternative folk-rock hybrid without compromising her artistic freedom and openly progressive politics to corporate marketing strategies.[3] Salt-N-Pepa, who began as a trio of teenage girl rappers in the late 1980s, had by 1993 produced "Shoop," a saucy, dance-worthy, unapologetic proclamation of girl-to-guy desire from their album *Very Necessary*. The album also included "None of Your

Business," which in 1995 won a Grammy for Best Rap Performance, making them the first female rappers to do so.[4]

In 1995, 19-year-old Alanis Morissette released her collection of rage and passion ballads on *Jagged Little Pill*. Filled with songs of biting irony and vocal potency not often delivered in the pop music industry, the album drew upon her precocious years as a Canadian teenage recording star. Issued on Madonna's Maverick label, the album went unexpectedly platinum, winning four Grammy awards. Morissette, who penned or co-authored all of the songs on the album, tapped the force of a Medusa who spoke for all women ever jilted or disappointed. "I see right through-ou you-ou, I walk right through-ou you-ou …"[5] Against the backdrop of the more underground Riot Grrrl movement, Alanis' intelligent girl pop tunes overtook the airwaves. This voice unleashed a response to relationship travails and betrayals, addressed to "Mr. Duplicity"[6] and "Mr. Man."[7] Having been part of the business since age 14, Alanis had evolved beyond entertainment industry virginity by the time *Jagged Little Pill* released. Despite an early rite of passage that might have broken a less substantial intellect, she wrote about her experiences with a primal scream of retribution accompanied by witty, textured lyrics. Alanis sang like a grown woman at 19 because she'd been around the block and back again, emitting an articulate electrified response to love and life in the music industry. Alanis Morissette's angry girl sound, with its unique syncopated alliterations, has been imitated by early 2000s teen stars Avril Lavigne and Michelle Branch. Her song "Hands Clean," from her subsequent 2002 self-produced album *Under Rug Swept*, recounts her affair as a teenage performer with an older married man who swore her to secrecy, a chronicle of the challenges faced by underage musicians navigating the adult-led entertainment industry.[8] While Alanis used her life experiences as metaphors for her songs, when she appeared as the "Angry White Female" on the cover of *Rolling Stone* in November 1995 in a white linen buttondown and black leather pants, she didn't need to unzip.

In 1996, 19-year-old Fiona Apple's album *Tidal* appeared, also to unexpected multi-platinum success. Like Morissette, Apple arrived in the public eye as a teenage virtuoso who not only performed her own lyrics but played the piano as well. Her sultry cabaret voice also suggested a maturity that inspired a double-check on her age. Despite controversy about Apple's scantily-clad heroin chic performance in the video for her single "Criminal," her January 1998 cover photo on *Rolling Stone* featured her floating in a swimming pool surrounded by a halo of hair under the headline "Getting in Deep with Fiona Apple."[9] Despite the obvious innuendo, there's nothing provocative about her pose. Clearly her undeniable musical talent has been the primary selling point and has proven long-lasting, with multiple risk-taking albums to her credit, including the 2006 *Extraordinary Machine*.

Missy Elliott, a rapper and producer, fostered collaborative hits and albums for male and female performers throughout the 1990s and 2000s as one of the most successful women in the hip-hop industry who has won major awards for music and music video production for her own work and that of many other performers, including the late 1990s teenage group Destiny's Child and the mid-2000s Brit rapper Lady Sovereign.[10] While already in her 20s in the 1990s, her fostering of young talent in the music industry has been undeniable. Known for her fabulous dance beats and innovative videos, Missy Elliott is a curvy woman who has no trouble taking up space, even under a fish-eye lens, as a performer, writer, producer, and collaborator. TLC, an R&B group formed in 1991, made up of Tionne "T-Boz" Watkins, the late Lisa "Left Eye" Lopes, and Rhozanda "Chili" Thomas, drew attention for their use of condoms as fashion accessories and for promoting safe sex through their 1994 hit "Waterfalls," which dealt with issues of drug dealing and AIDS. They produced two major Girl Power hits on their 1999 album *FanMail*, "No Scrubs," addressing deadbeat guys, and "Unpretty," which takes on the beauty industry, directly speaking to issues of looks, race and self-image.[11]

These examples demonstrate that despite the often maddening presence of breathy Lipstick Lolita vocals on the airwaves by the end of the 1990s and early 2000s, young women in the industry in fact provide many alternatives regardless of the porno fare offered by some of the major labels. Hit songs such as "Unpretty" provided mini-anthems for multicultural teenage girls to counteract the mindless influence of other kinds of music media, combining listening and vocalization for the fans after the hooting and screaming release of a live performance. TLC's videos, in which they appear as sci-fi water sprites, space genies, and robotic dancers provided an innovative techno-special effects layer to their songs. Throughout the video for their 1999 song "Unpretty," the TLC trio float mid-air like guru goddesses on silk cushions, interspersed with two mini-narratives about a woman seeking breast enhancement, including visceral visuals of breast implant removal surgery, and a teenage girl obsessed with her appearance who eventually rebels against her own cut-out wall of images.[12]

The Lilith Fair, a consortium of more than 100 multicultural female recording artists, joined forces in cities across the country from 1997 to 1999. Named for the mythic Lilith, Adam's first wife who fled the Garden of Eden to freely roam the earth, the Lilith Fair was formed by Canadian singer-songwriter Sarah McLachlan in response to concert promoters' refusal to feature two female artists back to back.[13] With sell-out shows in most cities grossing over $28 million, the Lilith Fair proved them wrong. At first criticized for not featuring enough diversity, the roster expanded to include rap and R&B performers Queen Latifah, Missy Elliot, and teenage singers Mya and Monica. The Lilith Fair also raised more than $2 million for non-profit

organizations including the Breast Cancer Fund, Planned Parenthood, and women's shelters in sponsoring cities. For her efforts, McLachlan received an Elizabeth Cady Stanton Visionary Award for advancing the careers of women in music.[14]

Alicia Keys' debut album *Songs in A Minor*, drawn from songs she wrote as a teenager, released in 2001 to win no less than five Grammy Awards, selling 10 million copies worldwide.[15] Like Morissette and Apple, Keys composed and arranged her own music—in her case, after years of classical training. A stunning beauty in her own right, Keys chose to focus on talent as allure rather than selling out with short-lived titillation packaging. Even though she signed with a record label and released one song for the *Men in Black* soundtrack in 1997, Keys spent most of her teenage years studying, practicing, and composing rather than coming out fully in the public eye. That Alicia Keys rose from modest circumstances, as did Christina Aguilera, means that class is not the only determining factor in choosing a Lolita identity versus a jazz smoke persona of musical artistry. Unlike the Lipstick Lolitas, she has also used her celebrity bred from teen-hood to promote awareness of social causes, such as the AIDS crisis in Africa.[16]

THE HORROR GENRE AND THE GIRL VOICE

Girl voices at many frequencies influenced the songstreams of radio and MTV, while in another form, screaming continued off the hook in horror movies and thrillers at the multiplex. Beatlemania couldn't have existed without the screams of girls, and the same holds for horror movies both on screen and in the theatres. While the horror genre often belittles the female screamer as a helpless or stupid Victim, without her screams the movie doesn't begin to shock the audience or inspire them to scream along with her. In the horror movie theatre, you have permission to scream. It's interactive, an allowable response in an environment where, after the previews have ended, the management urges you not to talk during the film. Screaming provides an acceptable way of breaking the taboo with a group boundary crossing that's a thrill.

In the hero genre, the female love interest screams for help and rescue from Superman or Spider Man. Classically, the scream alerts the aggressor/demon/enemy as well as the savior/superhero. Thriller/action films also depend on girls/women screaming to increase storyline adrenaline. The scream alerts the inner super hero/savior of the omniscient viewer, female as well as male. This viewer of horror genres "knows" what will happen before the girl screams. The audience is in on it; they know she has crossed the line; the viewer is smarter than the naive girl who opens the door, answers the phone, makes the fatal mistake.

Horror operates in the realm of the forbidden, the shadow, and the horrific, and screaming responds to the shock of its appearance as a release, a form of vocal ecstasy. As Camille Paglia points out in *Sexual Personae*, "Horror films are most popular among adolescents whose screams are Dionysian signals of sexual awakening."[17] Girls screaming in horror films is orgasmic, an interplay of yes and no, the response to the opening of the door, the opening of Pandora's box. Screams provide the interactive boost to the already heightened sound tracks of horror films. Live as well as cinematic teenage girl screams increase decibel abundance whenever a demon strikes. In this way, the horror genre is as audience participatory as comedy. From screaming to hiding one's eyes, to gripping the arm of a friend, horror causes physical reactions in individual viewers and collective reactions in the audience at large. Horror involves active spectatorship like arena sports, with girls in on the unbridled exultation. In school environments girls must be relatively contained, yet in the horror movie theatre, like a live music performance, girls can be noisy, with reactions spilling over raucously, screaming for the sheer buzz of it. Horror moviegoers, long assumed to be teenage males, are increasingly female, which has to do in part with the changing characterizations of women on screen:

> Since the heyday of the slasher films of the late 1970s and early 1980s, women's roles have evolved from hysterical, half-nude teenage victims to more complex and satisfying characters—the family protectors, feisty self defender or sometimes the killers themselves.[18]

As domestic box-office receipts of the 1990s and 2000s reveal, horror films spell big business, as do the spoofs of horror movies.

Scream (1996)	$103,027,000
Scream 2 (1997)	$101,363,000
Scream 3 (2000)	$89,138,000
I Know What You Did Last Summer (1997)	$72,219,000
Blair Witch Project (1999)	$140,530,000
Scary Movie (2000)	$42,750,000
Scary Movie 2 (2001)	$71,277,000
Scary Movie 3 (2003)	$110,000,000
Scary Movie 4 (2006)	$90,704,000
The Ring (2002)	$128,580,000
The Ring Two (2005)	$75,889,000[19]

Since the 1970s, horror films have equated monstrous, evil, mostly preadolescent girls with terrible power. The inherent terror of these apparitions lies partly with their mutant defiance of the "good little girl" and the "purity/innocence of

youth" standards of our national ethos. Boys can be bad, but girls are expected to be good. When they are not, when they are evil, the result can be more frightening than evil adults. The most enduring examples include *The Exorcist* (1973, William Friedkin), in which pre-pubescent Regan levitates and spins her head, shouting obscenities in a masculine Devil's voice and performing obscene acts with a cross. Brian DePalma's *Carrie* (1976), discussed earlier, relies on menstrual taboos, which have in recent years begun to erode, yet this film still has locker room legend status with teenagers. Haunting girls of the 2000s include *Silent Hill* (2006, Christophe Gans), which featured a creepy billboard image of an intensely blue-eyed girl with her mouth erased, the opposite of a scream.

As the petite teenage blonde with her diminutive, preppy name, Buffy kicks back against type as the ultra-strong Vampire Slayer, a formidable warrior in defiance of the horror genre's typical screaming victim. While the character will be discussed more fully in Chapter Seven, it is worth including a reference here to the Emmy Award-winning "Hush" episode from Season Four (2000, WB), which carries the metaphor of the teenage girl voice a step further. In this episode, Buffy's voice and the voices of the entire town of Sunnydale are taken away by an evil force released by a gruesome pair of razor-carrying "Gentlemen" who cruelly cut out the hearts of their voiceless victims. Part way through this episode, Buffy realizes that the only way to defeat the Gentlemen is with a human scream, preferably the demon-slayer's. In the end, she restores the lid to a magic box filled with mute-rendering poison. With the airborne spell contained, Buffy unleashes a renewed resounding scream so powerful it causes the villains' heads to explode.

In Gore Verbinski's *The Ring* (2002), based on Hideo Nakata's Japanese cult film *Ringu* (1998), a postmodern twist situates a girl demon inside a deadly videotape. (Appropriately, these films were brought to my attention during an edit session with a very Goth-studded girl for a youth media project at DIA: Beacon.) In the film's logic, whoever watches the tape's surreal, dislocated visual sequence will experience a live *déjà vu* of the series of eerie experimental images before meeting their gruesome death. In *The Ring*, a seemingly innocuous object—a videocassette—becomes the source of visual poison in a seven-day death sentence. Even in its almost retro analogue form, the tape takes the potentially evil power of the media to an entirely new level.

Rachel Keller (Naomi Watts), a *Seattle Post-Intelligencer* journalist, finds the video after the sudden death of her 16-year-old niece Katie (Amber Tamblyn). Death shock has left a disturbingly permanent Edvard Munch-like scream mask on Katie's face. The film's disorienting mixture of past and present technologies elicits a troubling time-space disconnection in the viewer. Amid dusty paper archives Rachel pursues the mystery, without a high-tech Google computer search. When her young son Aidan (David Dorfman) accidentally views the tape, the chase to

find an antidote before the seven-day death countdown begins. The strange video visuals lead back to a disturbed girl-child named Samara Morgan (Daveigh Chase), whose penetrating gaze is the death source to the video's spectators. When she emerges from the television screen on the seventh day, her silent, deadly stare elicits screams of horror in her victims, while she remains one of the vengeful, voiceless dead, peering out from her seaweed hair. Ultimately, Keller discovers the antidote to the curse lies in duplication, as she and her son avoid an encounter with Video Demon Girl by generating a next-generation dub. *The Ring* taps into general paranoia about the unknown power of electronic media via homespun visuals ostensibly produced by a disturbed and deranged preadolescent girl.

THE NON-LINEAR SCREAM

In the late 1990s and early 2000s, a string of non-linear films such as *Being John Malkovich* (1999, Spike Jonze/Charlie Kaufman) and *Memento* (2000, Christopher Nolan) emerged with underground popularity to imprint on the mainstream. Tom Tykwer's 1998 unconventional narrative *Run Lola Run* (German title: *Lola Rennt*) is part of this trend. In the film, 18-year-old Lola (Franka Potente) possesses an athletic body which drives the motion of the film, with three separate outcomes like a video game. In a gender twist, Lola's sprint through the city provides the rescue solution for her boyfriend Manni (Moritz Bleibtrau), but her ability to vocalize provides the power she needs in the final narrative strand. Manni's fate rests on her ability to deliver 100,000 Deutschmarks in time to placate the drug punks threatening his life. The speed of her limbs powering through time and space sustains the visual metaphor for this story. She does not take a train, a cab, or a bus. She runs, tapping her physical strength as proof of her devotion. The film explores the effects of fate on the events in one's life, demonstrating how the slightest shift in action can influence a life-or-death outcome.

Unlike linear filmmaking, in which the story arc leads to a single conclusion, *Run Lola Run*'s three endings provide a commentary on random possibility. In one fate storyline, Lola cannot raise the funds and so Manni dies; in the second, she obtains the money from her banker father but is shot by a random bullet; in the third version she enters a casino, betting her last sum of money on the roulette table. When the roulette ball lands on a number different from her desired bet, she amps her prodigious voice to banshee volume, causing the ball to lift from the random slot into the one she bet on, gleaning the cash needed to save Manni's life. In this final outcome the desired result hinges on the power of Lola's own voice, a scream so piercing it literally shatters glass and stops time. The three endings provide satisfaction to multiple

viewers, multiple meanings, and multiple genres: romantic satisfaction ending; film noir ending; action thriller ending. Bottom line, Lola, with her shock of punk red hair, is an androgynous athlete, a muscular woman of action, bent on rescue. A flawed teenaged heroine, she succeeds in the end, running, screaming, doing whatever it takes to save the guy she loves. And run she does, against time, against fate, against the inevitable, but in the end her scream saves them both.

WARRIOR GIRLS

With the release of the films *Terminator 2: Judgement Day* (1991, James Cameron) and *La Femme Nikita* (1990, Luc Besson), a new breed of Warrior Woman arrived at the multiplex. While "chicks and guns" are now a mainstay of certain action genres, this phenomenon brokethrough in the early 1990s. Even more controversial, Ridley Scott's 1991 release of *Thelma and Louise*, a girl-bonding road movie which helped put action-based female narratives on the map. *Thelma and Louise* has become a modern classic about grown "girls" gone off the map which teenage girls discover at a certain point in their rental history. The impact of this girl buddy movie about women who fought back against rape and went a little too outlaw awakens the possibility of female retribution in the collective psyche. The turquoise 1966 Thunderbird convertible driven by Louise, which eventually flies out over a canyon, is shot against the spectacular mythic American West backdrop of Utah's Arches National Park and Canyonlands. *Thelma and Louise* draws as much upon the pioneer spirit of American women featured in the novels of Willa Cather as it evokes Robert Redford and Paul Newman in *Butch Cassidy and the Sundance Kid* (1969, George Roy Hill). A ragtop Cowgirl tale as well as a Feminist fable, *Thelma and Louise*, based on an original script by Callie Khouri, had a definitive impact on mainstream America about changing gender roles. A 1991 *Time* magazine cover featured Susan Sarandon and Geena Davis with the headline "Thelma and Louise Strike a Nerve."[20] The movie also gave women permission to "scream real loud" in the theatre when a porno-brained truck driver, certain he's on the verge of roadside "girlie favors," witnesses the explosion of his oil tanker.

As author Sherrie Inness notes in the introduction to her collection of essays *Action Chicks: New Images of Tough Women in Popular Culture*, "Strong women characters have always existed in American mythology. What has changed are the sheer numbers."[21] Up until the 1990s, women holding their own without need for male rescue were rare, but images of turbo-charged teenage girls were even more unusual. Beginning with independent features showing at Sundance in the mid-1990s, depictions of strong girls began to kick up at the box office.

Jim McKay's independent narrative *Girl's Town* (1996) features a multicultural group of inner-city girlfriends on the verge of high school graduation: Angela (Bruklin Harris), Patti (Lili Taylor), Emma (Anna Grace), and Nikki (Aunjanue Ellis). With Patti a teenage mother struggling to graduate, and Angela at war with her overbearing mother, Emma and Nikki are college bound. The focus of the story is on Nikki, an high-achieving African-American girl who, despite an early acceptance to a prestigious college, commits suicide, leaving her grieving friends to ponder the cause. Reading her diary, they discover that Nikki had been date-raped by a journalist she met during a summer internship, causing Emma to reveal that she too had been date-raped by a popular football player. Trangressing codes of "girl behavior," the three survivors spray paint the word "Rapist" on the hood of the jock's car, then proceed to scratch the entire chassis. As a stand-in for the rapist's body, the car becomes a public spectacle of ridicule. Fueled by their taboo-crossing act of revenge, the girls then track down the journalist who violated their deceased friend and beat him up on a city sidewalk. By depicting girls "acting like boys" in seeking physical payback, McKay shows that girls can get even just like guys, but he also questions the efficacy of these acts. Unlike the spectacular ending in *Thelma and Louise*, McKay's indie lens trails off at the end of *Girl's Town*, leaving an impression of vague drift to the future of these Tough Girls.

Girlfight, Karyn Kusama's 2000 indie feature, launched teenage Michelle Rodriguez's career from unknown Tough Girl to Action Chick sensation, starring alongside big muscle boys like Vin Diesel while generating a Hollywood Bad Girl reputation in the tabloids. Before *Girlfight*, women had never been seen in the boxing ring on the big screen, let alone teenage girls from the projects. Unlike the scenes of teenage martial arts warrior Jen Yu, played by Ziyi Zhang in Ang Lee's *Crouching Tiger, Hidden Dragon* (2000), Michelle Rodriguez's fighting scenes were not digitally enhanced. Kusama used slow-motion strobe techniques to dramatize Rodriguez's timing in the ring, but the real workouts and the gleaming, sweating skin all contributed to the success of her gritty *verité* style.

Diana Guzman (Rodriguez) starts out as a volatile Latina with a killer gaze that can practically X-ray the high school lockers. The opening series of dis-solves shot in a populated high school hallway leads us deeper into Guzman's eyes, establishing her as intensity incarnate. Her anger is palpable; this is not a girl who kowtows to anyone on the social ladder or whispers backstabs in the Girls Room. She confronts the Alpha Girls head on and is headed for expulsion. As the story unfolds, Diana (read: The Warrior) turns this intensity away from hallway dust-ups into a disciplined skill that allows her to self-actualize in a new kind of Cinderella story. Guzman hones her craft to defeat her own male peers in the ring and stands up to her unloving and emotionally abusive father, whom she accuses of causing

her mother's suicide. In a rite-of-passage scene classically reserved for boys challenging abusive fathers, Diana pins her father to the ground, avenging her mother (and by extension other women and girls) who aren't/weren't strong enough to defend themselves. Diana the Warrior Girl moves far beyond Mean Girls to a transcendent arena that even involves letting go of the Tough Girl persona to become emotionally intimate with Adrian (Santiago Douglas), a fellow male boxer and even remains loyal to her best friend in the process. The success of *Girlfight*, now a staple of many teenage girls' DVD collections, rests in the visual power gleaned from watching girls who fight back with the gloves on and win. Through the course of realizing her dream, she becomes more and more luminous.

This film, like *Love & Basketball* (2000, Gina Prince-Bythewood), explores the complications encountered when a teenage boyfriend practices the same sport as the girl. In *Love & Basketball*, which actually shows a guy using a condom the first time the protagonists have sex (a shockingly rare visual in my research), Quincy McCall (Omar Epps) breaks off the relationship with college freshman B-baller Monica (Sanaa Lathan) when her dedication to team discipline interferes with the caregiver role he desires from her. In *Girlfight*, Adrian (Santiago Douglas) must navigate definitions of his own masculinity when called upon to fight his girlfriend in the ring. Both Diana and Monica are called upon to be as strong and skilled as male athletes without losing touch with their own ability to empathize with their boyfriends.

TITLE IX AMAZONS AND TENNIS GODDESSES

With girl roles expanding in popular culture, notions of girls' power and strength has been linked repeatedly to athleticism. Title IX of the Education Amendment of 1972 is the Women's Movement in action.[22] This Amendment stipulated that girls be granted equal public funding for sports programming, which over the past 30 years has brought unprecedented numbers of girls to the fields and courts. The millennial generation of Post-Title IX girl athletes has witnessed the rise of the Women's National Basketball Association (WNBA), the 1999 World Cup-winning United States National Team (WNT), and the arrival of teenage tennis stars Venus and Serena Williams in the mid-1990s, changing the face of international tennis.

The Coming of Age of Title IX has meant that more girls participate in sports across the country, exposing them to healthy workouts and teamwork. This "body literacy" afforded by team sports has given girls access to networking skill sets often available only to boys. Until the 1970s, outside of exclusive girls' prep schools, which historically included competitive team sports for girls, most girls in public high

schools experienced teams as Cheerleaders. While we often hear about women's Mean Girl inability to play fair, hundreds of thousands of girls are learning team skills and successfully taking them beyond college into the work world. And, despite reports of obesity and anorexia, undeniably real problems, again, hundreds of thousands of girls incorporate body literacy into their lives through this early exposure to sports. While individual celebrity dominates tennis and golf, team sports depend upon the cooperation of the entire group to succeed. The fact that young professional women are evening the score in careers of medicine, law, and business indicates that they have learned to be "team players" in ways that extend beyond the sports arena. The popularity of the girl team films *A League of Their Own* and *Bend It Like Beckham* reflects these trends as well.

When Serena and Venus Williams took to the court in the mid-1990s as teenagers, their presence at the net transformed the celebrity make-up of the female game for ever. With their Goddess appellates, they have become tennis legends, traversing racial lines to bring increased multicultural interest in the game. One year apart, they both turned professional at the age of 14. Venus, at six feet two inches tall, towered over most mortal players. (Serena is five feet ten inches tall.) Serena won her first Grand Slam in 1999 at age 17. Rising from the ghetto of Compton, California, to become champions in a sport that so gleaming white even the original dress code was white, these Amazons, with their sculpted arms and legs and their larger-than-life fashion sense, became Icons of possibility in a sport dominated by white girls. In the process, they ditched tennis whites for good. While Arthur Ashe famously finessed men's tennis in the 1960s and 1970s as the first African-American male to win a Grand Slam, Venus and Serena broke racial and gender barriers with their repeated victories. Never in the history of professional tennis had two sisters, let alone teenage African-American ones, found themselves in a singles match during a major Grand Slam competition. When they competed against each other in the 2001 U.S. Open, Venus won. In 2002 this well-publicized repeat showdown led to a victory for Serena. By 2003, both in their 20s, Venus and Serena had competed in six such prestigious Grand Slam events as sisters on the court, with Serena winning the majority of the titles.[23] The notion that sisters could compete on the court and still be supportive of one another as siblings, publicly cheering each other's success from the sidelines, proved monumental in a culture that looks for bipolarization, jealousy, and backstabbing in women on and off the courts. Their athletic prowess combined with their sisterly bond has made them formidable as young tennis stars.

In addition to their muscular presence on the court, they are also known for their vocalizations when delivering the ball to the other side of the court, prompting discussions about the physics of vocal sound added to the game, the politesse of

"grunting," and the shout on contact as game strategy.[24] Clearly, these Goddesses aren't afraid to use their immortal voices to enhance their game.

USING THEIR HEADS: BRAINIACS AND GEEK GIRLS

While girl characters and public personalities have been emerging and multiply-ing as Warriors, Amazon Athletes, and Rock Stars, many have been using their intelligence as an identifying trait as well. In teenage media of the 1930s to 1980s, Popular Girls were often less bright than their male counterparts and the Smart Girls were frequently cast as incidental characters in need of a makeover. Being mega-smart and a main character didn't used to gel in popular culture. In the big-screen tradition, good-looking girls who wore glasses eventually took them off for their final transformation as romantic heroines. The lifting off of the spectacles symbolized a willingness to see less clearly to "get the man," and even play dumb if necessary. Brains and beauty have often been mutually exclusive on the big screen, except in the case of legendary firecrackers Bette Davis, Katharine Hepburn or Lauren Bacall. Yet for all of their sharp wit, they were often paired with much older men (Spencer Tracy for Hepburn and Humphrey Bogart for Bacall), who presumably could "handle" them. A lot of this has changed in the era of Power Girls.

Both TV's *Buffy the Vampire Slayer* and the *Harry Potter* media complex of books and movies feature Brainiacs in pivotal roles. Buffy's friend Willow Rosenberg uses research and technology skills to help her in the fight against demons, a role cred-ited for inspiring girls interviewed by scholar Mary Celeste Kearney to become "cybergurls."[25] Willow cracks the web, hacks into sites, and otherwise demystifies and decodes the language of computers for the benefit of everyone, becoming one of the first Geek Girl Heroines. Likewise, Hermione's unusual intelligence and magical know-how serve the greater good in friendship to the orphan wizard Harry Potter, who repeatedly credits her with providing essential clues and information drawn from her assiduous studies. Both the Scooby Gang in *Buffy the Vampire Slayer* and the characters in *Harry Potter* make the library and the mystical world of dusty books seem completely cool, as well as validating the notion of investing prodigious amounts of free time to research ways to trump evil. In addition, Joss Whedon's short-lived sci-fi series *Firefly* (2002–2003, Fox-TV) and its spin-off feature *Serenity* (2005) include River Tam (Summer Glau), a waif-like teenage girl with a brain so evolved, the military try to harness it as a secret killing weapon. The image of the Girl Brainiac who is not the town loser wearing "nerd alert" clothes is a relatively new phenomenon in sci-fi fantasy as well as in comedy or drama. As

Willow announces tentatively in the first season of Buffy, "It's the computer age. Nerds are in. They're still in, right?"[26]

MTV's animated series about a too-cool-for-school Brainiac, *Daria* (1997–2001), features the ultimate intellectual outsider who, along with her artsy friend Jane Lane, comments dryly on the conformist world of high school and affluent suburbia into which she's born. That Daria originally appeared as an incidental character in contrast to the sniveling dimwits on MTV's *Beavis and Butthead* (1993–1997) was itself a revelation. Compared with her younger airhead sister Quinn, whose quest for popularity supersedes the desire to read, Daria looms as an intellectual cast in a world of cartoon parodies. Her linguistic edge serves as special effects in an otherwise simplistic animation format. Daria and Jane are the only characters who speak with alto deadpan; everyone else, parents included, speaks in the colloquial tone reserved for mocking imitations of idiots.

In many ways, *Ghost World* (2001, Terry Zwigoff), an alternative-style film released by United Artists, picks up where *Daria* left off. Based on the comic book by Daniel Clowes, it features Thora Birch as the cynical Enid, a smart-aleck outsider with a penchant for vintage clothes. A recent high school senior who discovers she is one credit shy of officially graduating and must attend summer school, Enid joins forces in an apartment rental search with her childhood friend and co-outsider Rebecca (Scarlett Johansson). At first as a lark response to a personals ad, they begin an odd liaison with Seymour (Steve Buscemi), a 40-ish collector of vinyl records. Like Daria, Enid is far too cool to consider herself a misfit, yet her sarcasm and anti-mainstream addiction impede holding down a job, even at a movie theatre. Meanwhile Rebecca responsibly works the counter at a café. As they wander through this year of limbo, certain they possess the last snarky word on pop culture, big business, and everyone in their graduating class, it becomes clear that the friendship must take a fork in the road. Enid is a budding artist who refuses to mature, while Rebecca begins to pair up with Josh (Brad Renfro) and starts a bank account, tired of dissing the entire world. At the end, her choices narrowing in suburban America, Enid takes the bus to nowhere, anywhere, and "out of here."

In ground laid by *Daria*, HBO's *The Sopranos* (1999–2007) and *Six Feet Under* (2001–2005) delivered Meadow Soprano and Claire Fisher, two worldly-wise cynics with levels of experience Gidget never imagined. *The Sopranos* interweaves the lifelines of Tony Soprano (James Gandolfini), a successful New Jersey don, and his extended family living in the affluent New Jersey suburbs. Tony's daughter Meadow Soprano (Jamie-Lynn DiScala), a verbal wit who began the series as a 16-year-old, fulfills the upwardly mobile dreams of her parents by acing the SATs her junior year, followed by an acceptance to Columbia University. Though she can see through her father's deceptions and cover-ups designed to "protect the family" from knowledge of his criminal activities, Meadow is an Italian American girl conflicted

by her intelligent assessment of the dubious family enterprise and her loyalty to the clan. In a mafia tradition in which women are depicted as crying, being slapped, or making pasta, the arrival of a teenage firecracker like Meadow Soprano brings a fresh female character to the Mob scene.

In *Six Feet Under* (2001–2005) Claire Fisher (Lauren Ambrose), the youngest of a mortician's clan, drives a green hearse to school and is known as a universal freak. In the tradition of *The Addams Family* (1964–1966, ABC-TV) and *The Munsters* (1964–1966, CBS-TV), Claire struggles with her family's reputation against her own aspirations, yet the series provides far more doses of reality interwoven with vivid nightmares and very little absurd comedy. Since her self-absorbed older brothers Nate (Peter Krause) and David (Michael C. Hall) are actively experimenting with their lives after the death of the family patriarch, Claire knows she lives under their radar and in typical latchkey fashion must fend for herself. Her mother explores her second life as a widow, dating a series of men whose attempts at playing surrogate daddy cause Claire to eye-roll. Yet like all the Fishers, Claire falls into a natural counselor/caretaker role and takes on a sequence of difficult boyfriends. The first, a druggie named Gabe (Eric Balfour), turns her on to mescaline the day she learns of her father's death, then runs into trouble with the law and addictively seeks out Claire for rescue long after they have broken up. Her next boyfriend, Billy Chenowith (Jeremy Sisto), a much older, brilliant but bipolar photographer introduces her to a medium that eventually provides her entry into art school. How's that for senior year of high school? Eventually, her Aunt Sarah (Patricia Clarkson) recognizes her artistic talent and encourages her to apply to the prestigious LAC-Arts, to which she is accepted. With an educational fund set aside by her deceased father, and no claims to the family business, Claire heads off to college, where driving the hearse becomes code for offbeat cool.

While all these cool Smart Girls emerged in the late 1990s and early 2000s, the Brainiac found some vilification as well. MTV films joined with Paramount Pictures in 1999 to produce *Election* under the direction of Alexander Payne. Tracy Flick (Reese Witherspoon) is an "overachiever" on a mission to become class president. One of her teachers, Mr. McAllister (Matthew Broderick), makes it *his* personal mission to challenge her by promoting a candidate of his choosing, Paul Metzler (Chris Klein), the captain of the football team, whose injury has sidelined him for the season. Broderick achieved fame as the self-made schemer in the 1980s teen hit *Ferris Bueller's Day Off* (1986, John Hughes), in which he endlessly thwarts his penis-envious sister Jeannie (Jennifer Grey), who never manages to finesse her own rebellion as he does. *Election* is in some ways a sequel to that teen flick, as the story of a frustrated adult, a Ferris Bueller who never quite grew up yearning for days when he could skip school, swipe his friend's

Dad's sports car, attract the attention of the pretty girl, and elude retribution from school authorities. The original ads for *Election* were bizarre. A miniature Broderick broods inside Reese Witherspoon's smiling mouth. (In DVD re-release, the cover art changed significantly to feature Witherspoon and Broderick side by side, with Witherspoon holding her "Pick Flick" campaign button.)

Like *American Beauty*, also with an R-rating, *Election* dialogued with "hot teenage girl" terrain designed for an older audience, even if the results led to comedy. The subtext reveals that Tracy has been having an affair with McAllister's friend, Dave Novotny (Mark Harelik), another teacher, fired for the underage transgression. McAllister determines to revenge his friend's demise. Along the way, McAllister must navigate his own attraction to the blonde go-getter, who appears to him in bizarre nighttime hallucinations while having sex with his wife. As comedy, *Election* veers into the absurd, yet again the notion of significantly older adult males seeking relationships with high school girls becomes a "no big deal" norm. In the end, Tracy Flick wins the election and goes on to a college career at Georgetown, but somehow the Brainiac conflates with The Slut and the accompanying myth that Smart Girls can't make it without sleeping around. That she's a Brainiac Republican Slut somehow justifies McAllister's personal project of vengeance. So while the Brainiac has undergone a great deal of transformation from the undesirable Nerd Girl to the nemesis of the adult male in midlife crisis in *Election*, there are many more images of Smart Girls bending gender typecasts.

Akeelah and the Bee (2006) takes on gender and cultural stereotypes about African-American girls and scholastic success. Borrowing a seed from the 2002 documentary *Spellbound* by Jeffrey Blitz, which profiled multicultural preadolescent and adolescent spelling champions competing in the 1999 National Spelling Bee in Washington DC,[27] this narrative explores the social risks for a girl in an environment where academic achievement can be perceived as "acting white," a phenomenon discussed at length in *SchoolGirls* by Peggy Orenstein.[28] Akeelah Anderson, played with subtlety by newcomer Kiki Palmer, is a bright, if underachieving, 11-year-old girl whose father died several years earlier in an act of random violence. Her overworked single mother, Tanya Anderson (Angela Bassett), a hospital night-shift nurse, strictly disciplines her daughter but can provide only minimal attention. Akeelah overcomes peer pressure and fear of ridicule to enter her school's Spelling Bee, countering her mother's concerns about sidelining her major subjects into extracurricular failure. Not only does Akeelah win her classroom Bee, she continues to excel in competition, making it all the way to the National Spelling Bee Championships held in Washington DC, with her entire community, even the gang boys, rooting for her. Laurence Fishburne plays Dr. Larabee, a university professor on leave who serves as her father-figure mentor, a role often reserved in mainstream media for African-American coaches to young (often white) male athletes.

At a crucial moment in the story, Aretha Franklin's song "Respect," an anthem for empowerment often co-opted in soundtracks about white women's success, finds a reclaiming moment underscoring Akeelah's triumph under pressure. Setting aside reservations about the Brainiac label, she not only wins the Bee but also proves herself a moral person who doesn't need to humiliate the challenger to succeed.

Images of complexity and depth in depicting African-American girls have begun to find their way to the big screen. With Starbucks as a co-sponsor of the film, the correlation of a bright black girl with words such as "pulchritude" and "prestidigitation" merged with cappuccino consciousness, expanding Icons for Americans unaccustomed to this kind of female representation. In the complex, subtle 2007 Indie film *Half Nelson* Shareeka Epps plays wise 13-year-old Drey, who becomes a confidante to her teacher (Ryan Gosling) after she catches him smoking crack after school. The documentary style of the film recalls Frederick Wiseman's 1968 film *High School*, with a believable honesty in the role-switching friendship that emerges between a student and her addicted teacher who has yet to grow up himself.

GENDER BENDERS: HYBRID IDENTITIES

Many New Girl Icons embody the merging the sexes; they are equally male and female, part of their electric allure. Biologically "female" in form with classically "masculine" attributes of physical strength, fighting skills, and athletic prowess, these turbo-charged girls are in many ways transgendered and often transracial, as in "beyond gender" and "beyond race," liberated from the box of stereotypes. Some of these gender-blended New Girl Icons include Girl Warriors, Transgender Girls, Title IX Amazons, and Geek Girl Brainiacs. The breaking down of gender role taboos in mainstream media has brought about opportunities for representation that in turn green-lights possibilities for individuals in the culture at large. Yet this plethora of choices can also breed nostalgia for an era when the clearly delineated categories of "male" and "female" provided a comfort zone of easy expectations.

Donna Haraway's groundbreaking book *Simians, Cyborgs, and Women: The Reinvention of Nature* brought together a collection of essays on the subject of female gender in postmodern pre-millennial society that continues to influence discourse on gender, science, and technology. Haraway's premise is that in the cyborg era in which we live, gender is a social construct defined more by our connection to technology than biology. In this way we all exist, on some level, as transgendered cyborgs.[29]

While social and biological components contribute to the construction of identity for teenage girls, the presence of transgendered narratives in the mainstream

indicates a fluidity in gender assignation previously found only in science fiction, gay, and queer discourse. The margins, the exceptions, the unusual have in many ways become the focus of a culture interested in all kinds of closets. Ultra fems and ultra machos have become camp quotations, while new males and females have been appearing on screens and in print, playing against "type" for audience interest, curiosity, and extended dialogues about the meanings of gender categories.

In 1993 the Barbie Liberation Organization, or BLO, an underground activist group, purchased 300 Teen Talk Barbies and Talking Duke GI Joes, switched their voice boxes, then returned the toys to stores to be bought a second time by unknowing consumers as holiday gifts, providing unexpected comedy under the Christmas tree. The altered dolls, which showed up at random stores across the United States, surprised kids who found their Barbies yelled "Vengeance is mine!" and "Deadmen tell no lies" in deep falsetto while their GI Joes pondered in breathy tones, "Let's plan our dream wedding!" and "Will we ever have enough clothes?"[30] As M.G. Lord expressed,

> Barbie is a space-age fertility archetype, [GI] Joe a space-age warrior. They are idealized opposites, templates of "femininity" and "masculinity" imposed on sexless effigies—which underscores the irrelevance of actual genitalia to perceptions of gender. What nature can only approximate, plastic makes perfect.[31]

The goal of the Barbie Liberation Organization, which apparently had operatives across the country, was to "reveal and correct the problem of gender-based stereotyping in children's toys." This stunt provided a new twist to social activism, utilizing a humorous surprise to drive home a point about encoded gender stereotypes in toys. While the BLO did not cause Barbies or GI Joes to be pulled from shelves, Mattel, under pressure from many groups, including the American Association of University Women, did eliminate the "Math class is tough" script from Barbie's one-liners.[32]

As part of the stunt, the group circulated flyers with complete DIY instructions for switching the voice boxes in your very own home, which still circulate on line. The flyers feature Barbie and GI Joe with a shared voice bubble: "We were forced to say things we didn't want to. Luckily, we checked ourselves into special hospital and had the damage reversed. You can help us! Liberate us!" While the current location of the group is unknown, their ideas continue to blog.[33]

BOYS DON'T CRY

While multicultural images of heterosexual girls using their voices, bodies, and intelligence to break out of gender boxes continue to evolve throughout the millennial

media era, the concept of Transgendered Girls has made an imprint as well. Hillary Swank won an Academy Award for her performance as Brandon Teena in Kimberly Peirce's transgender narrative *Boys Don't Cry* (1999), based on a true story about a teenage girl-gone-boy in the Midwest. Brandon Teena, born Teena Brandon, was a teenage girl who not only identified herself as a male but managed to successfully pass as a beer-drinking, bumper-surfing guy. Early on in the film, the elaborate process involved in the creation of this persona reveals the depth of Brandon's willingness to sacrifice personal comfort for another identity by binding her chest and wearing a sock to simulate male genitalia. A local girl, Lana Tisdel (Chloe Sevigny), is drawn to Brandon Teena's gentleness and his articulate dreams of life beyond the trailer parks of Nebraska. Lana's attraction transcends gender; even after she discovers that Brandon is a girl, she remains loyally smitten. In the end, Brandon Teena suffers brutal punishment for tricking the local machos in the land of tractor pulls and dirt bikes and for stealing one of "their" young women.

The subtlety of Swank's performance, down to the body language, hand gestures, and convincing male falsetto, combines with Brandon's "true story" audacity to pursue this masquerade in a violent culture of sexism. While the focus of the film is on transgender identity, in many ways it transcends this issue to humanize a potentially freakish story into one which deals with the horrible power of conformity. Cross-dressing on the stage, a Shakespearean trope that plays for laughs in the high-jinx comedies *Twelfth Night* and *As You Like It*, is still practiced in traditional Japanese kabuki theatre. Drag Queens are accepted in certain flamboyant contexts, even though outside of the urban progressive landscape, on dark street corners, gay bashing always looms nearby. So long as the Drag Queens are performing and overtly out there, they are acceptable in a theatrical sense. Drag Kings—women who dress as men—are less well known to the culture at large and more a phenomenon of gay bars and underground gay culture. Brandon Teena's offense was not so much that she dressed like a boy but that she passed as a man to a group of dangerously Midwest machos, encroaching on their turf as a seducer of a teenage girl. For this she was severely punished.

In 2004, Jeffrey Eugenides published his Pulitzer Prize-winning novel *Middlesex* about Calliope Stephanides, who begins life as an upper-middle-class girl from a Chicago suburb but in adolescence discovers she may be more boy than girl. By the end of the book, Callie has become Cal, a runaway drifter who hitchhikes to San Francisco seeking acceptance for her physically hybridized identity. Her Greek parents, finally aware of her unusual turn at adolescence, are unable to accept her decision not to submit to a permanent "girling" through surgery. Eugenides' first acclaimed novel, *The Virgin Suicides* (1999), explored a family of repressed Catholic girls, providing the inspiration for Sofia Coppola's 1999 debut feature. That the *Middlesex* adolescent storyline would find its way out of the

margins and into the mainstream to win the Pulitzer Prize denotes unprecedented collective rule bending in iconography. In an earlier generation, *Middlesex* would have been banned. The presence of transsexual stories in *The New York Times Magazine* indicates just how profound the shift from the margins to the center has been. Clearly, American definitions of gender, including adolescent ones, have changed.

WILL AND JANE'S GIRLS—REVIVING O'HISTORY

As Reality TV brought American culture to spectacular lows of self-absorption and questionable topics for celebrityhood, 1990s and 2000s media makers also thumbed through the classics with great fervor in search of rite-of-passage tales with female historical characters breaking gender stereotypes to dramatic effect. Film adaptations of works by Shakespeare, Jane Austen, the Brontë Sisters, E. M. Foster, and others brought about many mainstream revisions of classics starring young heroines. In this way "high art" contrasted with "the low" in a perpetual search for the story with a draw. Some of these offerings from Europe met with limited art house release, but many others received wide distribution, often with the backing of the newly formed classics divisions of the big studios competing with the indie-gone-megabucks distribution company Miramax, which later merged with Disney Corporation. Even the Teen Queen Marie Antoinette took a revisionist turn as a party girl scapegoated for her love of sweets, gambling, and shoes in Sofia Coppola's 2006 visual festival *Marie Antoinette*.

Many historic figures dusted off and refreshed to iconic status in the 1990s, included the Teenage Warrior Joan of Arc, who reappeared twice in 1999, proving that the French Warrior Girl has enduring magnetism. A made-for-television movie, *Joan of Arc* directed by Christian Duguay in a Canadian-American co-production between CBS Television and the Canadian Broadcasting Corporation (CBC), featured LeeLee Sobeiski as the girl in shining armor. *The Messenger: The Story of Joan of Arc*, directed by Luc Besson, cast Milla Jovovich as the young martyr-to-be. This violent version includes an early highly misogynist scene of a young woman being raped—hardly Girl Power territory. Yet both productions included high-end acting talents such as Olympia Dukakis, Shirley MacLaine, and Peter O'Toole (*Joan of Arc*), Dustin Hoffman, Faye Dunaway, and John Malkovich (*The Messenger*).

Jumping a couple of centuries to the Renaissance, a historical foray by director Shekhar Kapur covered the early years of Queen Elizabeth I's reign, including her teenage transition from private citizen to public Icon in *Elizabeth: The Virgin Queen*

(1998). As the crimson-haired monarch in training, Cate Blanchette delivered a nuanced portrayal traversing several decades of the Queen's rule, a role which established her as an actress of the highest order, with a Golden Globe Award for Best Actress and an Academy Award nomination. *Elizabeth* features a scene in which the teenaged Queen tearfully practices standing up to her statesman in the veiled privacy of her bedroom in a series of jump cuts exploring the emergence of her power as tempered, focused passion and a deep will to survive. Even as a young ruler, Elizabeth never lost her claim to the throne despite many attempts to unseat her, and went on to become one of the most formidable monarchs of history, an Icon in crimson contrast to Disney's Pink Princess culture.

In 1997, French Director Agnes Merlet brought the extraordinary life of Renaissance painter Artemisia Gentileschi (1593–1653) to the screen in *Artemisia*, which had a successful art house release in the United States. The film, based on the early life of the first woman admitted to the prestigious Academia del Disigno (Academy of Drawing),[34] explores her desire to experience life beyond the confines of traditional girlhood. Recognized by her father Orazio Gentileschi, a well-known artist of the School of Caravaggio, as more talented than his sons, Artemisia arrived at age 15 to study under the master Tassi. While under his instruction, Tassi raped her, then proved unwilling to take her in marriage in accordance with the laws of the era. While lower-class women had little recourse if assaulted, given the emphasis on virginity and the bride price in early 17th-century Italy, Orazio Gentileschi pressed for the trial to preserve his family's reputation. Tassi's rogue behavior resulted in a spectacular seven-month public trial, which included Artemisia's torture to ascertain the truth; in the end, despite overwhelming evidence of additional crimes, he spent only a year in jail.

Undeterred, Artemisia continued to hone her skills, married another painter, and achieved an international reputation as a court painter, creating works for members of the European royalty. While many of her epic paintings of Bible scenes such as *Judith and Holofernes* or *Susanna and the Elders* hark back to themes of female betrayal and retribution, her mastery of the medium moves beyond wounded revenge to an artistic legacy that far exceeded Tassi's place in Art History. Like *Elizabeth*, *Artemisia* showcases a radiant dynamic spirit, a larger-than-life teenage heroine forced by her circumstances into a premature womanhood who ultimately locates indomitable strength that transcends any trace of victimhood.

Peter Weber's 1997 adaptation of the popular book *Girl with a Pearl Earring* by Tracy Chevalier features Scarlett Johansson as the fictitious subject of Johannes Vermeer's famous painting. The film's highly detailed period-accurate sets and costumes set the stage for an exploration of the relationship between a servant girl, Griet (Johansson), and her employer, the already well-known painter Johannes

Vermeer, played by Colin Firth. With the poetic license afforded historical fiction, Griet becomes not only a model for his paintings but also his studio assistant. There she learns how to view perspective through a *camera obscura*, grind minerals into pigments for his oil paints, and arrange the artist's tools. The film's success drew upon the enormous popularity of the book, one of many historical fiction works published by women in the 1990s and 2000s, which have served to fill in the imaginative blanks left by a history written mostly by literate men. Chevalier's novel transcends the dearth of historical documentation about the lives of young women in the late Dutch Renaissance to create a tale full of so many rich, down-to-earth, and plausible factual threads that Griet comes to life as a real person, fulfilling the female artist's fantasy about not being just an object of the painter's gaze but an active collaborator in the creation of a masterpiece.

Kenneth Branagh's hugely successful adaptation of *Henry V* (1989) ushered in an era of filmic adaptations of Shakespeare that helped launch more sophisticated ingénues in the 1990s and 2000s. In addition to the two versions of the teenaged Ophelia portrayed by Kate Winslet in Branagh's *Hamlet* (1996) and Julia Stiles in Michael Almyreda's 2000 version discussed in Chapter Five, Baz Luhrman directed an MTV-inspired remake of *Romeo and Juliet* in 1996 starring Claire Danes as Juliet. Luhrman's *Romeo and Juliet*, with its updated youth-centric interpretation of the Bard driven by a dynamic contemporary soundtrack, launched the career of teenaged Claire Danes in her role as a bright-eyed, intelligent Juliet. She first appears in angel wings at a baroque masked ball hosted by her father, where she lays eyes on Romeo, played by Leonardo DiCaprio. In a fully clothed balcony sequence that ends in a swimming pool of scintillating lights, the two "starstruck" lovers exchange their breathless vows. Their pool scene, which takes place under the radar of the Capulet mansion's surveillance cameras, proves alluring and erotic without drifting to exploitation riptides. Setting the play in a modern-day South American city similar to Los Angeles, Luhrman raises the plausibility factor in his modernization, rendering the forbidden love scene wholly convincing due to the emphasis on the added Catholic censure on sexuality. In fact, Juliet and Romeo's final death scene takes place on a ritually inspired bed as altar surrounded by votive candles depicting The Virgin Mary, sacred angels, and myriad saints.

In this second installation of Luhrman's "Red Curtain Trilogy," the infusion of the classic story with hip-hop gangsta subtexts and an alternative music video style of editing drew in the desired young audience and led to the Shakespeare remake fad, which included 1999's *Ten Things I Hate About You*, a loose high school adaptation of *The Taming of Shrew*. Directed by Gil Junger, the film posits Julia Stiles as the "feminist" Kat Stratford eventually won over by Pat Verona (Heath Ledger). While about as true to the text as Amy Heckerling's 1996 *Clueless* was to

Jane Austen's *Emma, Ten Things I Hate About You* proved almost as popular, like *Cliffs Notes* for the movie-going hoards, not just the straight-A set.

Though Jane Austen's Emma is in her early 20s in the original text, Heckerling rewrote this "inspired by" screenplay for a "hymenally challenged" 16-year-old named Cher Horowitz, played to Valley Girl perfection by Alicia Silverstone. Replete with Valspeak—"Whatever …," "That is so five years ago," "Going postal"—this Alpha Chick classic provides the perfect antidote to the Mean Girl Icons of the 2000s. In *Clueless*, the would-be Alpha girls have their encoded social rules about dating and clique-ing, but backstabbing never reigns. Instead, Cher and her friends adopt roles as social do-gooders and matchmakers for their friends and teachers.

With modern adaptations of Shakespeare and Austen proving gold at the box office, other directors explored classic ingénue tales such as Charlotte Brontë's *Jane Eyre*. Franco Zeffirelli, a theatre and opera director known for his filmic adaptations of the classics, especially his 1968 adaptation of *Romeo and Juliet* starring unknown teenagers in a then-scandalous nude scene with underage actors (Olivia Hussey as Juliet was 16; Leonard Whiting as Romeo was 17), tried his hand at Brontë in 1996. Yet this interpretation of *Jane Eyre* wasn't nearly as popular as the narratives influenced by Jane Austen and Shakespeare.

In keeping with the public interest in classic adaptations in the 1990s, Ang Lee brought Austen's *Sense and Sensibility* to the screen in 1995 with an Academy Award-winning screenplay adaptation by Emma Thompson, who starred as the sensible older sister, Elinor Dashwood. Kate Winslet played the younger sister, Marianne Dashwood, a lively, if impetuous, teenage girl who falls for a man already secretly engaged. Winslet's nuanced performances in this film and Kenneth Branagh's four-hour Victorian-era version of *Hamlet* the previous year, at age 19, set her up as a serious actress who went on to star in *Titanic* (1997, James Cameron).

The 2005 remake of Austen's *Pride & Prejudice* (Joe Wright) depicted *Bend It Like Beckham's* Keira Knightley as the feisty Elizabeth Bennett, an outspoken girl who refuses to take the most eligible match offered in the absence of ardent love. In addition to Knightley, the *Pride & Prejudice* cast includes her three young sisters, all engaged in a dance party of eligibility: Jane (Rosamund Pike), Kitty (Carey Mulligan), and Lydia (Jena Malone). Only Mary (Talulah Riley), the less socially endowed Bennett who attempts to impress the crowd with her limited musical abilities, finds herself on the periphery. Breaking with the oppressive female corsets of decorum from the early 1800s, Knightley, nominated for an Academy Award, fulfills the spirited expectations for a character tracked by thousands of Austen-philes, even holding her own in scenes with Dame Judy Dench as Lady Catherine

de Bourgh. Much screen time is devoted to the fierce loyalty between Elizabeth and her sister Jane including under-the-covers girlish conversations and the cross-table looks of prodigious allies in the matchmaking game. After her debut in *Bend It Like Beckham*, Knightley appeared as another pseudo-historical Elizabeth, Elizabeth Swann, in the *Pirates of the Caribbean: The Curse of the Black Pearl* (2003, Gore Verbinski), in which she also played a feisty teenage girl who holds her own on screen alongside pirates, British sea captains, and skeleton demons (though these do bring out the girl screams). By the time the sequel, *Pirates of the Caribbean: Dead Man's Chest*, was released in 2005, Elizabeth Swann had left behind her corset and cross-dressed in pirate garb as well.

With New Girl Icons gender bending and changing the rules even across the historical narrative, it is clear that the deck of visual cards includes many strong examples of girls taking off the corsets, putting on the gloves, and kicking up more than dust by stepping into many different kinds of shoes.

Supernatural Girls[1]:
Witches, Warriors, AND Animé

Whether possessing a capacity for magic or the ability to do battle with the undead, there is no question that contemporary teenage heroines have power with a capital P.[2]

In the digital effects era of the past ten years, Supernatural Girls have emerged as a new species of Female Icon. Bursting out of the "girl" category box, they transcend gender expectations, defend themselves, and vanquish demons. When first introduced, they are often 15 to 19 years old. Just like the young starlets who portray them, these characters evolve into young women before our eyes through television syndication and in blockbuster sequels. Part of the fascination with Power Girl Icons lies in the way they discover their special powers at adolescence. Heroine Icons of millennial teenage girlhood embody many American ideals of individualism: responsibility for the greater good, boundless energy and resources, and a can-do attitude. With these girls, anything is possible. These are qualities to value in popular Icons, be they cartoons or special effects-driven Super Girls. These are adrenaline-driven role models.

What's not to love about supernatural powers? For girls experiencing a loss of control over their bodies, ever-changing social circumstances at school and at home, the allure of magic powers resonates. Whether watching media featuring wand-waving, ninja-kicking, shape-shifting Supernatural Girls or actually looking to "spells" as protection from the evil empire of girl cliques at school, girl magic has come out of the broom closet. Despite attempts by the Far Right to squelch programming

7.1 ©2002 Warner Brothers Entertainment.

dedicated to witchcraft and vanquishing demons,[3] the spell casting continues, in live-action dramas, comedies, and animated features and programs featuring teenage girls with intergalactic gifts and talents. Advances in special effects have combined with a mainstream readiness for "chicks with power" to alter the visual landscape. But just as new Internet technologies, DVDs, and iPods have been so seamlessly integrated into American daily life as to obliterate their novelty, a look back at media history as recent as the late 1980s reminds us that Power Girls are a relatively new phenomenon. Before the 1990s, girl viewers had to content themselves with filmic dreaming via male superheroes. Now they have their own pantheon.

A new breed of tough, gun-toting, fast-talking heroines appeared on the screen beginning with Carrie Fisher's Princess Leia in *Star Wars* (1977, George Lucas) and Sigourney Weaver's Ellen Ripley in *Alien* (1979, Ridley Scott). In the same way that racial diversity first occurred in television history in the 1960s with Lieutenant Uhura (Nichelle Nichols) on *Star Trek* (1966–1969, Gene Roddenberry), the futuristic landscape of science-fiction fantasy opened up possibilities for female characterizations of power in the 1970s and continues in the 1990s and 2000s. *Star Trek: Voyager* (1995–2001, Rick Berman) featured the Federation's first female at the helm, Captain Kathryn Janeway (Kate Mulgrew).

In the late 1980s and early 1990s many more of these adult female characters who possessed what could be termed "male power in drag" received spectacular press, especially Nikita (Anne Parillaud) in *La Femme Nikita* (1990), Sarah Connor (Linda Hamilton) in *Terminator 2: Judgment Day* (1991), and, of course, Louise Sawyer (Susan Sarandon) and Thelma Dickinson (Geena Davis) in *Thelma and Louise* (1991). With the arrival of Trinity in *The Matrix*, female bodies as slo-mo weapons of martial arts technique and skyscraper hopscotch became lightning bolts of possibility. While the creation of these characters expanded expressions of female power in mainstream media, they depend on Tough Girl machismo. Their power has to do with wielding phallic tools of power—sub-machine guns, pistols, and fast cars. The power is a strap-on appendage of physical strength and deadly force via technology.

Since the mid-1990s, popular culture has expanded its collection of Female Icons to include television shows about teenage girls endowed with the special powers of *Buffy the Vampire Slayer* (1997–2003) and feature films with the remarkable characters Jen Yu of *Crouching Tiger, Hidden Dragon* (2000), Hermione Granger of the *Harry Potter* series (2001, 2002, 2004, 2005, 2007), Rogue of *X-Men* (2000, 2003, 2006), and Violet of *The Incredibles* (2004). Add to these Hayao Miyazaki's animated features *Howl's Moving Castle* (2004), *Spirited Away* (2001/2002), *Princess Mononoke* (1997/1999), and *Kiki's Delivery Service* (1989/1998)[4] and the conflation of girls and the supernatural in the popular imagination expands even further. For a post-feminist discourse seeking balance in gendered images of power, the past

decade has witnessed a dynamic shift in representation, and much of it involves adolescent girls.

The recent proliferation of Supernatural Girls makes it easy to forget that teenage girl characters of the 1950s, 1960s, 1970s, and 1980s media barely had narratives dedicated to them, let alone the ability to karate-kick evil-doers as center-stage denizens. Despite the presence of certain enduring teenage girl characters exploring the power of magical red shoes like Dorothy of *The Wizard of Oz*, teenage girls have historically provided the screaming prelude to a rescue by Super Guys. While classic heroes Spiderman and Superman continue to swoop in for the girl on the big screen, Supernatural Girls provide an alternative to that Cinderella myth. In their worlds, Prince Charming isn't coming, and they know it. These girls save not only themselves but sometimes the entire universe. And they have the power and resources to do it. Special effects finally caught up with the human imagination, yet the collective mind-set had to be ready for Power Girls. We've come a long way from Kansas, Dorothy.

Girl characters developed in the 1990s no longer had to dress like men to embody power. Young women in all their blossoming girliness could now defend themselves and rescue those in danger as well. In many ways equally male and female, these Supernatural Icons are the embodiment of a "beyond gender" merging of the sexes.[5] Biologically "female" in curviness of form, these characters combine classically "masculine" attributes of physical strength, fighting skills, and the urge to rescue and protect. With these characters liberated from boy-girl expectations of behavior, snappy dialogue often plays against those stereotypes for humor. These Teenage Icons have it all: magical and physical powers, good looks, close friends, and resources. They are classic androgynes, approaching the status of Maiden Goddesses.

In Disney's animated classics *Snow White and the Seven Dwarfs* (1937), *Cinderella* (1950), *Sleeping Beauty* (1959), and *The Little Mermaid* (1989), the wan protagonists receive supernatural assistance from "magical helpers," often small creatures—dwarfs, mice, a crab, a fish, and a seagull. Power arrives in the form of rescue and resides ultimately in their "purity and goodness" (read: passivity) and eventual pairing with "the Prince." Females with active power in these narratives are always older and evil—the Queen/Witch, Lady Tremaine, Maleficent, Ursula.

The actively powerful post-1990s generation of adolescent animated and special effects Heroines are often responsible not just for capably protecting themselves but also for saving others. Interestingly, this new crop of girl characters includes Disney's *Kim Possible*, shown daily on the Disney channel since 2002. *Kim Possible* features a teenage Super Girl kung-fu expert, top cheerleader, and ace student. Talk about K(impossible) … but the Disney Corporation has been riding the girls-of-power animation bandwagon since producing *Mulan* (1998). *Kim Possible* follows Cartoon

Network's highly successful airing in 1998–2000 of the 1995 Japanese series *Sailor Moon*, the first animated series to feature an entire cast of Teenage Superheroines.[6] *Sailor Moon* drew heavily from mythology, featuring characters capable of transforming into Heroines named for the planets in their fight against the evil minions of Negaverse. The series demolished network assumptions that girls were interested only in Barbies and Pretty Ponies. As Joyce Millman remarked,

> Once you get past those Sailor Scout costumes "Sailor Moon" actually holds together like an amazingly female-centric fantasy that teaches little girls the power of sisterhood … when they transform, their bodies get more adult-looking (they all sprout legs like Tina Turner's), they cease bickering and work together to right wrongs and triumph over evil. These little women are *empowered*.[7]

Powerpuff Girls, which debuted on the Cartoon Network in 1998 and continues in syndication, features a trio of cutesy characters named Blossom, Buttercup, and Bubbles, endowed with super strength, flight ability, super speed, and X-ray vision to assist them in their fight against evil villains, including the crab-clawed "Him," a Satanic creature who remains unnamed, like Voldemort in *Harry Potter*. Since its debut, *Powerpuff Girls* has been responsible for increased ratings on Cartoon Network, inspiring Nickelodeon to create the animated Girl Power series *My Life as a Teenage Robot* (2003–2006) set in a New Jersey suburb in the year 2072 and featuring XJ-9, a super-charged teenage girl robot otherwise known as Jenny.[8]

Clearly, girls in power sell. No longer content with characters in the passenger seat, female viewers are increasingly being acknowledged as a market force intent on a turn behind the wheel.

BUFFY THE VAMPIRE SLAYER—FIGHTING DEMONS IN THE DARK

> In every generation there is a chosen one, a slayer.[9]

Five years after the lukewarm reception of 1992's feature *Buffy the Vampire Slayer*, writer Joss Whedon revived the concept as a 1997 television series for the nascent WB Network. With its blonde, would-be cheerleader protagonist, *Buffy the Vampire Slayer* provided millennial Girl Power at maximum Ninja speed. Originally marketed to teenagers, *Buffy the Vampire Slayer* became an audience-crossing critical and cult hit that has inspired prodigious scholarly commentary, with global conferences dedicated to analysis of its unique language (Buffyverse) as well as its impact on pop iconography, its symbolism, and its moral complexity.[10] The show ran for five seasons on the WB Network before transferring to UPN for its final two seasons. Sarah Michelle Gellar stars as the "Chosen One," a young woman on a mission to rid the world of demons and vampires. Still in syndication in the

United States and on BBC Television, *Buffy the Vampire Slayer* combines post-punk Goth sensibility with the pre-Apocalyptic, Y2K fervor of the late 1990s. The show is set in Sunnydale, California, a "center of mystical convergence," where the "Hellmouth" hosts vampires, demons, and other evil creatures in after-hours abundance.

Buffy's high school bedroom is ultra-frilly, girly, suburban, "normal." Yet her vanity drawers contain essential demon tools: wooden stakes, holy water, and communion wafers, not make-up or jewelry. Clad in leather pants and animal prints, Buffy is a good girl disguised as a bad girl. A silver cross around her neck keeps the "Big Bad" at bay.

Buffy, if not book learned, has "psychic street smarts." Her nightly patrol in local graveyards to fight and "stake" vampires keeps her multitasking at top speed, offing six or more in a session. With little time for homework, Buffy is constantly in danger of being expelled. The school administrators treat her as a troublemaker, unaware that she works the late shift for the greater good. Parodying the Uber achievers of suburbia, she laments, "I have at least three lives to contend with and none of them mesh."[11] In a pinch she turns to Willow (Alyson Hannigan), a new Geek Girl Icon, who not only hacks the city's information systems for needed clues to the demonology puzzles presented to them but tutors Buffy before finals. Unlike the classic brainy girls of Hollywood, Willow has her share of dating intrigue, first with Oz (Seth Green), a coolly brilliant musician who's secretly a werewolf, and then with Tara (Amber Benson), an earthy Wiccan lesbian.

Buffy's other best friend, Xander (Nicholas Brendon), is the endearingly loyal but insecure guy constantly trying to prove to Buffy that he's "the man." His courage serves him well in many instances of assisted vampire "dusting," but he turns to Buffy for rescue from industrial-strength demons. In many ways Xander represents a masculinity confused by the cross-gendering of a character like Buffy ... what's a guy to do when a girl can rescue *him*?

The most alluring male characters on the show are reformed vampires: Angel (David Boreanz), a vampire "cursed" with a soul helps Buffy conquer evil entities, which warranted his own spin-off show, *Angel* (1999–2004, The WB Network), and later in the series called for the arrival of Spike (James Marsters), a bleached blond Sid Vicious-inspired Brit wit. But reformed vampires, like reformed addicts, continue to possess a link to the dark side which makes them dangerously attractive to Buffy, whose powers as the Slayer make her no match for a regular teenage boy.

While *Buffy the Vampire Slayer* may have made Girl Power strides in breaking against the blonde cheerleader type for its heroine, her mother Joyce Summers is another story. Buffy's unwitting mother appears foolish and vulnerable, and in several episodes must be saved by her daughter. In this way, Buffy, "on her own",

must count on her friends for support. Joyce Summers is a caring, nurturing mother figure, but oblivious to the gravity of her daughter's late-night encounters with the sewer tunnel underworld of demons. In the first season, Buffy literally descends like Persephone (in a black leather jacket and long white dress gifted by her mother) to fulfill her destiny as The One to confront the Nosferatu-like Master, a mega-vampire who bites her to liberate himself into the world above. This Hades figure gains strength from her blood, but Buffy also amps her power through this encounter, along with the mouth-to-mouth resuscitation by her young friend Xander. Afterward, she proves capable of vanquishing the Demon Father to end the season with a smash of glass that provides the spike to his demise.

Despite the perennial absence of her divorced biological father, Buffy's "Watcher," the school librarian Giles (Anthony Stewart Head), functions as a flawed father figure. As partial repentance for a misguided occult past, Giles trains Buffy in slaying techniques, though he himself does not possess her level of power. Instead, he researches techniques for vanquishing the more potent and unusual demons from his ancient leather-bound library. The term "watcher" implies a theme of voyeurism. As media-gazing consumers, we are all watchers, viewers. Like Peeping Toms we frame Buffy through windows, down dark alleys, across the schoolyard. The vampire's gaze is legendary. Like us, the vampires and demons often lurk outside, watching. Watching is a relatively passive activity compared with Buffy's proactive, get-out-and-slay approach. Giles, like Xander, is relatively impotent compared with the Blonde Slayer Babe, whose supernatural strength, martial arts skills, and ability to scale fences in a single bound are all part of her "Chosen One" package. Xander and Willow research; Giles interprets; Buffy slays. As androgyne, Buffy is all-action physical prowess combined with honed instincts; with her sixth sense for demon proximity, she remains one impulse ahead of everyone. Intellectually, she is unthreatening to males (though she miraculously pulls a 1300 on her SATs). Physically and in terms of sheer bravery and warrior instinct, she is awe-inspiring.

One possible reading of *Buffy the Vampire Slayer*, that it addresses the unconscious or night-world phenomenon of vampiric entities preying upon young people in close proximity to Hollywood, grants a fable of self-actualization (the hero's journey) in the face of overwhelming evil forces. (In fact, Joss Whedon's spin-off show, *Angel*, is set in Los Angeles.) Sunnydale, located near Hollywood, indicates proximity to the LA value systems of consumption and the commodification of beauty and youth, which feeds on young people's vitality. Vampires recoil from the daylight, which sizzles and singes them and can cause them to erupt in flame. But vampires are also drawn to light, as they are drawn to Maidens, Virgins, and virgin blood, young Victims and their white porcelain necks. Buffy is the blonde, the light ray in the realms of darkness who boots back against the Victim expectation of her physical and personality type.

One of the key rules of vampirology repeated in *Buffy the Vampire Slayer:* only those vampires explicitly invited into a home can cross the threshold. Vampires can trick humans into entry by pretending to be a friend of the family, a trope of certain episodes of the series, but otherwise a forcefield of protection keeps them outdoors in the darkness. This basic lesson becomes a metaphor for self-protection. As entities preying on young minds, they suck their vitality. Disguised, they enter as seeming friends, only to bite your neck unawares.

The idea that the vampire must be invited into the house is an interesting one. On a metaphoric level for teenage girls, this means that one must become conscious of the collusion. You can become the victim of a vampire within the safe space of your "home" only if you invite them in, similar to Eleanor Roosevelt's famous adage "No one can make you feel inferior without your consent."[12] No one can psychically drain you, make you a "victim," unless on some level you allow them to. This sadism/masochism thread in the primal vampire mythology provides its sexual subtext. Battling demons becomes a metaphor for the teenage experience, with Buffy perhaps a response to *Reviving Ophelia: Saving the Selves of Adolescent Girls.* She doesn't cave in and allow herself to be sucked on by a culture of vampires; she fights back and "dusts" them with "Mr. Pointy" (her wooden stake) for the good of all. Buffy is not a victim to vampire attacks, whether covert, from behind or head on. She defends herself against all forms of demonology, which makes her an important Girl Icon, though given the demons, the dusting, and the sex, she's definitely not for tweens.

SABRINA, THE TEENAGE WITCH

Sabrina: It can take years to develop a craft. Look at my aunts Hilda and Zelda.

Josh: Which craft were they involved in? Which craft were they involved in?

Sabrina: Witchcraft? Who said anything about witchcraft?[13]

Sabrina, the Teenage Witch (1996–2003, Nell Scovell) began as ABC-TV's retro nod to the hugely popular, wacky series from the 1960s *Bewitched* (1964–1972) starring Elizabeth Montgomery as the nose-twitching witch Samantha making a go of mortal existence as a housewife. As with *I Dream of Jeannie* (1965–1970, NBC), starring Barbara Eden as the zany Jeannie discovered by her astronaut "master" Captain Nelson (Larry Hagman), these series depicted powerful women who attempt to suppress their magic to serve as successful suburban helpmates to the bumbling men in their lives. Posing as a "normal" teenage girl, Sabrina Spellman (Melissa Joan Hart) must hide her powers as well. As in the retro series conceit, the nutty comedy outcomes hinge on the young witch's inability to put

a consistent lid on her power. One of the more interesting aspects of the show is the young witch's interaction with her middle-aged witch aunts, Zelda Spellman (Beth Broderick) and Hilda Spellman (Caroline Rhea), who act as her Wiccan advisors and guardians. Compared with Samantha's evil, sarcastic mother Endora, whose appearance always met with a dose of dread in *Bewitched*, these aunts come off as stylish, witty, loving, and favorable characters.

Always designed as a comedy that referenced its retro predecessors, as well as the early cartoon from the *Archie* comic book in the series, *Sabrina, the Teenage Witch* doesn't possess the Iconic legs (or kicks) of *Buffy the Vampire Slayer*. Yet its arrival in the same year as *Buffy* (1997) is significant, as it coincided with *Harry Potter and the Sorceror's Stone's* appearance in print, marking a pop cultural turning point for mass interest in magic and sorcery. Clearly magic in the air brought forward a comedy-lite version of the Teenage Witch as well as a darker backdrop for the Super Savior Girl Buffy. The previous year a feature film, *The Craft* (1996, Andrew Fleming) starred Neve Campbell and Fairuza Balk as teenage witches at a Catholic school in Los Angeles. Soon after, the WB produced *Charmed* (1998–2006) with Rose McGowan as one of three sisters with special powers. For decades witches had been seen on occasional *Bewitched* reruns or else on Halloween. By the end of the 1990s, they were practically the Girl Next Door.

HERMIONE GRANGER—BRAINIAC WITCH

An' they haven't invented a spell our Hermione can' do.[14]

Some critics denounce Hermione Granger's role as secondary to that of Harry Potter in the enormously popular series.[15] As the brains of the operation, however, Hermione works collaboratively with Harry to solve the mysteries of the day in their fight against the evil Voldemort. Compared with Hollywood's teen hegemony-in-the-hallways genre, few examples of a nonhostile or nonsexualized friendship such as theirs exist in the lexicon of the school coming-of-age narrative. *Harry Potter* provides a consistent storyline of cross-gendered teamwork that is not trivialized as flirtation. Harry not only encourages Hermione's role in the acquisition of power; he depends on her and deeply respects her intellectual gifts and refined magical skills.

Unique in the popular imagination, Hermione Granger exists concurrently in bestseller print and blockbuster movie form. As quoted in *Wired*, J. K. Rowling "is the reigning master of what you might call MMFWs—massively multi-reader fictional worlds—inspiring a generation of screen-fed kids to devour old-fashioned books on paper."[16] After reading about Hermione, a massive global audience has been watching her grow up on screen, played by now-mega-celebrity

Emma Watson, an A-level student in real life, not just an onscreen Brainiac Witch but a Brainiac Celebrity. Like the other characters in the *Harry Potter* series, Hermione arrives at Hogwarts School at age 11 to begin her training. As a brain-enhancing evolution in advanced magic, her rite of passage into adolescence is far from Lolita-esque. And she's just as capable with her wand as Buffy with her demon-slaying wooden stake.

Unlike Harry (Daniel Radcliffe), whose lineage is magical, Muggle-born Hermione is a prodigy of mortal parentage. Because of her intelligence and maturity, Hogwarts' senior wizards grant Hermione privileged access to knowledge of time travel devices, spells, and lore revealed not even to Harry. Without Hermione, it is doubtful this generation of viewers would have catapulted the series to such levels of success. Girl viewers no longer accept male privilege as a given in the realms of power. They want in on the secrets, and Hermione delivers them.

Hermione's character functions as an indispensable Brainiac Best Friend to Harry just as Willow is to Buffy.[17] Both characters, hardworking dogged researchers with elevated intellectual abilities, prove themselves brave and powerful in their own right alongside the "chosen ones." With secret strategy meetings often conducted in the library at Hogwarts and Sunnydale High, the core of knowledge must be pursued with hours of focused research before the fingersnap moment of resolution. That books—often ancient, dusty ones—combine with bookishness as key storyline components in the Internet era marks a positive thread back to the necessity of reading to uncover mysteries and locate power. The Christian Right's ban on *Harry Potter* is, of course, linked to the ancient prohibition on witchcraft-as-heresy in the Christian tradition, but Harry and Hermione's high level of literacy combined with defiance of authority is a big part of the fear. If children become highly literate, they cannot be brainwashed into the fundamentalist mind-set and become soldiers for Christ.[18]

That Hermione's character exists first on the page and then on screen also links back to the simultaneity of, and equalized importance of, word and image in millennial media.

ROGUE OF *X-MEN*

The first boy I ever kissed went into a coma for three weeks.[19]

In an early scene in *X-Men* (2000, Bryan Singer), 17-year-old Rogue (Anna Paquin) discovers she has a very unusual power—when she touches someone, she takes on their life force. If she holds on too long, she can kill them. This power, like that of all mutants in the films based on the Marvel comic book series *X-Men*, reveals itself at adolescence. Horrified by the strange power of her nefarious touch,

Rogue dons gloves and long sleeves and runs away from her Mississippi home. On the road she meets fellow mutant and future protector, Wolverine/Logan (Hugh Jackman), who has retractable metal prongs embedded in his knuckles and can self-heal from any wound. He saves Rogue's life on two occasions by blending his power with hers. Similar to Buffy's attraction to Angel, the implication is that only one of the mature X-Men can handle her and relate to her.

Rogue, eventually transported to Xavier's Academy for Gifted Children run by Professor Charles Xavier (Patrick Stewart), meets other mutant teens including Bobby/Iceman (Shawn Ashmore). The villain Magneto (Ian McKellen) kidnaps Rogue, seeing her power as a secret weapon to turn against humanity. He tries to harness Rogue's power to a centrifugal force machine designed as a conduit to transform all humans into mutants, an evil deed staged dramatically on the Statue of Liberty in New York. As a symbol of immigrant freedom and acceptance of all (even mutants), Lady Liberty becomes the set piece for the X-Men's reversal of Magneto's plan. At first magnetically trapped inside the Iron Maiden Liberty, Wolverine frees himself to free the others, bring Rogue's wild power back to earth, and save humanity from a dubious mutant fate. Rogue now has a signature shock of white to mark her rite-of-passage near-death experience in a nod to *The Bride of Frankenstein*.

Rogue's power is dangerous, mysterious, and volatile but dependent upon a connection to others. She's highly conflicted about her "rogue force" identity. Like many teenagers, she has power she cannot control. Rogue of the *X-Men* comics, however, is far more potent than the scripted character of the Hollywood films, who delivers several chilling "rescue me" screams typical of the classic horror and action genre. Yet Rogue joins a cast of female mentors with impressive attributes– Storm (Halle Berry), a weather shifter; Dr. Jean Grey (Famke Janssen), a telepath; and to a certain extent the evil chameleon Mystique (Rebecca Romijn-Stamos)—who provide pivotal power plays in all three *X-Men* movies.

JEN YU—MARTIAL ARTS WARRIOR GIRL

It must be exciting to be a fighter, to be totally free.[20]

With *Crouching Tiger, Hidden Dragon* (2000), Director Ang Lee introduced a unique teenage girl heroine to the martial arts epic tradition. Jen Yu, played by 19-year-old actress Zhang Ziyi, proves capable of outmaneuvering adult martial artists Yu Shu Lien (Michelle Yeoh) and Li Mu Bai (Chow Yun Fat), in sequences choreographed by action director Yuen Wo-Ping, of *The Matrix*. Initially, Jen appears as a privileged, aristocratic teenager rebelling against the gendered prison

of an arranged marriage. As the narrative unfolds, Jen becomes the star of the film, stealing Li Mu Bai's 400-year-old Green Destiny sword and marauding across the desert with her free-spirited sparring partner and lover, Lo (Chang Chen).

In a film replete with mythological symbols, a flashback sequence reveals how Jen Yu's ivory comb—an ancient symbol of the feminine—was stolen by Lo when her family processional was overtaken in the desert. In the absence of this comb, a stand-in for her female power, Jen seeks a replacement in the form of the Green Destiny sword. The sword, set aside at the beginning of the film by a troubled Mu Bai, suggests a masculinity in limbo, which allows for the entry of a Maiden female power beyond expectations. Because Jen Yu assumes the sword through thievery, however, she is ultimately deemed unworthy of ownership, despite her mastery of the weapon.

After years of training in womanly decorum, Jen Yu balks at all rules of traditional culture. She refuses an offer by Mu Bai to master the Wutan wisdom ways under his tutelage, choosing instead to run wild. Scenes include Jen Yu leap-flying over tile rooftops, vanquishing a host of pompous male warriors in a tea house, running across water, and a final magical battle with Mu Bai in a bamboo forest. Unlike her would-be mentors Shu Lien and Li Mu Bai, Jen Yu has acquired the warrior arts on the sly through a manuscript stolen by her ersatz teacher, the evil Jade Fox. Though she demonstrates remarkable physical skills, Jen Yu misses the moral depth of the warrior code until the end of the film, when it is too late. Her core self-interest and wanton rebelliousness prove her undoing. Aware of her shortcomings following Mu Bai's death, Jen sacrifices herself to the mythic waterfall of Wutan Mountain in a scene of breathtaking cinematic flight.

CARMEN CORTEZ: GADGET SPY GIRL

Never send an adult to do a kid's job."[21]

Carmen Cortez (Alexa Vega) of *Spy Kids* (2001, Robert Rodriguez) does not possess any innate magical powers, though she is fit and spunky and thinks on her feet. Her parents Gregorio (Antonio Banderas) and Ingrid (Carla Gugino) require her and her brother Juni (Daryl Sabara) to work out on the jungle gym every morning before school. But Carmen has a lot of Super Gadgets at her disposal, including a jet pack that allows her to fly. She rescues Juni from villains; she is the family protector, part of the gender spin trend at work in this new generation of Girl Action Heroines. Carmen doesn't need to be rescued. Her Big Sister self-confidence has a full tank of gas.

The coolness factor rules in *Spy Kids*—wearing shades, hip kid fashions, and an endless supply of spyware gizmos supplied by their Uncle Machete (Danny Trejo). The high-tech gadgets and space-age technology of *Spy Kids* enhance the cunning and agility of the main characters, not magically endowed like Buffy or Sabrina. It is a colorful, 3-D graphics kids' world enclosed within itself, where technology combines with their natural smarts to hyper-charge them for any challenge. While digi-tech carries the day, the children are bona fide fluent geeks who don't need to use the manual. Adaptability, quick reflexes, and street smarts are spy qualities that Carmen in particular embodies. All members of the Cortez spy family know how to keep secrets. Sneakiness and conniving behavior become attributes in a spy movie, where survival skills include the ability to escape from villains when necessary. Sibling bickering and banter keeps the characters real, allowing viewers to identify with them, but ultimately Carmen remains allied with her little brother. This is a child's fantasy world come to life – as if it could happen to anyone. The only children more powerful than Carmen and her brother Juni are robots, designed in their image as *doppelgangers* by the evil Minion (Tony Shaloub) and his boss, the misguided Floop (Alan Cumming).

A lot of Carmen and Juni's gadgets begin as innocuous toys or candy—electro-shock bubblegum, for example. Infrared spy glasses, navigational watches, computational translators, wish-fulfilling microwaves, and pod submarines assist them in vanquishing the bad guys in all kinds of terrain—underwater, above water, flying through the air. The *Spy Kids* film series rides on a wonderland of materialism, yet family values also rule. Keeping the nuclear unit together is the basic operative principle, and the children successfully rescue their parents at the end of the first film. "Spy missions are easy. Keeping a family together—now that's a mission worth fighting for,"[22] Carmen's last line in *Spy Kids*, marks a new definition of the millennial family movie and is its primary marketing strategy. The fact that the Cortez family is Latino and bilingual proved not only breakthrough for the American audience but cleverly built in a global market with a South of the Border color scheme to the entire enterprise. The Latin flavor continues with the sequels, *Spy Kids 2: Island of Lost Dreams* (2002) and *Spy Kids 3-D: Game Over* (2003), but the first movie of the series truly belongs to Carmen Cortez.

INCREDIBLE VIOLET

We *act* normal, Mom. I want to *be* normal.[23]

Like the hugely popular gadget-driven *Spy Kids*, the animated feature *The Incredibles* (2004) depicts an entire family of Superheroes whose destiny in the

zero hour hinges on teenage Girl Power. In this narrative, the initial invisibility of Violet Parr (Sarah Vowell) morphs into a power beyond self-protection.

At the start of the film, the Superheroes have been forced underground by the government due to cost overages and bad publicity. Attempting to live a "normal" suburban life while suppressing their true powers, the family confronts the limitations of American conformity. Enter the midlife crisis of Bob Parr/Mr. Incredible (Craig T. Nelson) and the family is finally given an opportunity to utilize their true gifts and return to Super status. What a metaphor for an escape from the middle class!

At the outset, Violet is a certifiable "shrinking violet"—mumbling, shy, and angry. Secretly, she can disappear at will and can produce a spherical force field around herself and anyone else she chooses to protect, enviable skills for a teenage girl. When Violet's dad falls in with psycho bad guy Syndrome (Jason Lee), her mother, Helen Parr/Elastigirl (Holly Hunter) pilots a rescue jet on which Violet and her brother Dash (Spencer Fox) have hidden as stowaways. When her mother realizes they are on board, she orders Violet to emit a force field against oncoming missiles. Unaccustomed to her power, Violet fails in the initial attempt and the plane explodes over the ocean, forcing Elasti-Mom to save them all by transforming her flexi-body into a parachute. After swimming to safety and depositing the kids in a cave, Elastigirl remarks,

doubt is a luxury we can't afford any more, sweetie. You have more power than you realize … When the time comes you'll know what to do. It's in your blood.[24]

Playing on viewer knowledge of self-esteem discourse, the mother/daughter dialogue provides a "Eureka" light bulb. Following this scene, Violet masters her powers to safeguard herself and others. When caught in Syndrome's forcefield, Violet's invisibility quotient allows her to disengage from the electric prison cuffs to free the entire family. Later, her forcefield shields them all from oncoming bullets.

In a remarkably subtle piece of human-like body language (she is a cartoon, after all …) Violet emerges from behind her dark hair once she discovers her powers. No longer a shrinking violet; she becomes an Ultra-Violet, out there and Incredible.

JOAN OF ARCADIA: SUBURBAN VISIONARY

Joan: You are not real.
God: So people keep telling me.[25]

The short-lived CBS drama *Joan of Arcadia* (2003–2005), while not as blatantly supernatural as *Buffy the Vampire Slayer* or as special effects-driven as *Spy Kids* and

The Incredibles, centers on a teenage girl named Joan (Amber Tamblyn) who for some inexplicable reason is being visited on a daily basis by God. God takes the form of the most mundane individuals who cross her path in daily life—a teen-age boy, a chess teacher, a sanitation worker, a postal lady. By following God's instructions—enrolling in Advanced Chemistry, joining the chess club, building a boat—Joan performs small every day miracles. *Joan of Arcadia* disappeared after two seasons on ABC, perhaps because the spiritual core of the show proved a stretch for a network devoted to cop shows, Reality TV, and legal dramas. The show is difficult to categorize. It isn't science fiction, it isn't a sitcom, and despite a father's role as chief of police, it isn't a cop show. As a profile of a family of former Catholics, this show deals with philosophical issues about fate and the spiritual meaning of our postmodern lives. The quality of the writing and the acting (the father is played by Joe Mantegna; the mother by Mary Steenbergen) is unusual for network television.

While the show obviously made a play on the named Joan of Arc and her story as a prophetess with a special line to God, "Arcadia" a plays on the word "arcade." Joan deals with the notion of life as a game, a set of strategies to acquire. Chess is a game, life is a game. Unlike the historical Joan of Arc, the teenage Joan of this show is not called to lead her people into battle, though Joan does discover a book about her namesake and flips the pages in exploration of the historical Icon. This modern-day Joan focusses on her brother's recent paraplegia, the result of a car accident, and its effect on the entire family.

The themes of the show parallel spiritual questions arising in contemporary America. Taboo subjects such as magic and spiritual healing have entered the mainstream. Millennial Americans grapple with a great deal of fear, and the power represented by miracles, magic, and Super Heroines provides a needed salve to social stress. Amplified by the father's role as career cop, fears of murder, child abduction, and random violence provide the back beat to *Joan of Arcadia*'s otherwise happy-family-against-the-odds drama. The parallel to the omnipresence of God is the omnipresence of potential criminals, with the premiere episode shadowed by the backstory of a teenage girl's murder and rape. Part of the lesson here is that fate can shift and turn at any point in time; anyone can be affected, as the characters all lead fragile lives, yet outcomes always improve when Joan heeds God.

Thematically the show deals with the classic dichotomy between reason and intuition. By listening to these voices of God in hallways and on sidewalks in her everyday life, Joan breaks the rules of reason and runs the risk of being perceived as unstable, just like the historic Joan of Arc. Her father represents the super ego law of the land. Having secrets is classic teenage territory; having spiritual secrets is not. Joan is not doing drugs or having sex with her boyfriend; she's having conversations with God. As a role model, then, to girls watching this show, Joan explores the value

of trusting her own intuition, represented by God-of-many-guises, pretty heady stuff for a show on CBS in prime time.

Compared with her brothers, one a math and science whiz and the other a former sports star and all-round popular guy, Joan is rather ordinary, a classic middle child, not much of an achiever. Only her random conversations with God set her apart, and those remain hidden. While verbally feisty, she takes a fallback position as a back-seat artist of good, an almost retrograde Helper Girl role, watching from the sidelines as her good deeds benefit others. This sets her apart from the Daring-Do Girls Buffy the Vampire Slayer and Hermione Granger, whose powers are acknowledged front and center. Positing Joan's wisdom and intuition in the form of an externalized God character, however, suggests that girls should look outside themselves for guidance, rather than within. On the other hand, since no one except the viewer and Joan see the forms of God to whom she speaks, He/She could be a metaphor for her own inner voice of wisdom.

MIYAZAKI'S MUSES

Issues of morality and spiritual transformation lie at the core of *Princess Mononoke* (Japanese/U.S. release 1997/1999) and *Howl's Moving Castle* (2004), two of Hayao Mijazaki's animated features designed for older teenage and adult viewers. Miyazaki creates transformative fantasy realms replete with richly drawn "futuro-retro" characters and beings in which transformation is possible and gender as a category is blurred. This begins with some of his earlier animations, including *Nausicäa of the Valley of the Wind* (1984/2005). His female *shojo* characters are unusual combinations of Japanese "cute" culture (wide-eyed, stylized faces) and a new power, often based on surrendering to a cause greater than self while proving themselves strong and autonomous in a traditional masculine way. As Susan Napier notes in her book *Anime*, "Miyazaki Hayao's young female characters are indubitably shojo in terms of their age and general innocence, but some of them are moving out of their liminal state toward a sense of identity as mature human beings."[26]

These independent female characters pursue their own journey toward self-actualization, "not domesticated by marriage or a happy ending but are instead interested in living separate but presumably fulfilling lives …"[27] This is particularly true of San (Claire Danes, voice), known as Princess Mononoke, a human Wild Child who lives in a forest of Mountain Spirits with a family of wolves. San, who considers the enormous white Wolf Goddess Moro (Gillian Anderson) to be her true mother, rejects her humanity and vows to kill the Lady Eboshi (Minnie Driver), whose mining operations for Irontown are destroying the forest. San, a prodigious and ferocious teenage Warrior Girl, is first seen by another main

character, Ashitaka (Billy Crudup), with a mouth blood-covered from licking her wolf mother's gunshot wound. Quest-driven to heal from a toxic curse placed on him by a dying giant boar enraged by deforestation caused by the humans living in Irontown, Ashitaka has come to the realm of the Forest Spirit Shishagami, a mute, multi-antlered baboon-faced stag possessed with the power to give and take away life. Ashitaka ultimately triggers San's humanity despite her proclaimed hatred for the selfish humans. She takes pity on him, using her abilities to guide him toward reversing his wounds. While San proves an agile leaping warrior, adept with her wolf-tooth blade, only through reconciliation does she come to terms with her true capacity to love another human being.

Sophie (Emily Mortimer, voice), the *shojo* of *Howl's Moving Castle*, a somber young hatmaker, prefers to attach whimsical fruits and flowers to felt rather than join her peers in frivolous evening activities. In the film, based on a 1986 English novel by Diane Wynne Jones, the character of Sophie (for the Greek *Sophia*, or wisdom) finds herself cast from her tame life when the Witch of the Waste (Lauren Bacall) casts a vindictive spell that turns her into a crone. Now an old woman, she heads out to the Waste to try to find an antidote to the curse, which has the added feature of preventing Sophie from telling anyone. Sophie takes a free ride in the mystical anthropomorphic moving castle made of scrap metal belonging to Howl (Christian Bale), an eccentric wizard of many identities, waging a battle against evil sorcerers.

Sophie's character as a site of animation undergoes many visual changes when her character grows and awakens to her own voice and power. At times depicted as an ancient woman voiced by the elderly Jean Simmons, she appears as a silver-haired hybrid with a young face voiced by Emily Mortimer whenever she speaks from the heart, stands up for herself, or expresses her true feelings for Howl. The metaphor of aging as a loss of voice in a young person resonates with previous examples of Girl Icons' vocal abilities being linked to their youthful power. In this case the heart, as symbolized by the castle's talking hearth fire, Calcifer (Billy Crystal), must not be neglected or Howl risks death.

Fantasy represents the realms of "what could be." The yes realm of possibility is an important space for girls to visit. Fantasy allows viewers access to the power of their own creative imaginations to traverse and transcend the mundane world of limitations. Many of Miyazaki's Supernatural Girls have the power to fly or launch themselves through the air and across rooftops. As Napier notes in the case of Miyazaki, "It is not surprising that virtually all his *shojo* characters are strongly associated with flight because it is in image of flying that the possibilities of escape (from the past, from tradition) are most clearly realized."[28]

All innovators operate from this basis in possibility, with non-conformity a requirement for inventing and envisioning new worlds. Like dream sequences, the

power of possibility in filmic depictions can inspire viewers to defend themselves and take risks of heroic stature in their own lives. Fantasy scenarios involve a Heroine's Journey (like Joseph Campbell's "Hero's Journey")[29] that includes a series of tasks, clues to a puzzle of experience they must resolve which renders them wiser and more capable. By contrast, Disney's formulaic approaches to fairy tales closes the circuit on the viewer's imagination. The increasing popularity of Miyazaki's films in America, which are, ironically, now distributed by Disney/Pixar, would indicate an American readiness for more open-ended potential for female characters in animated scenarios not limited by black-and-white polarities.

GIRL POWER INCARNATE

In Supernatural Girl scenarios, girls are expected to be Warriors, to transcend gender expectations, often proving themselves stronger than the male characters. Superpowers mark the adolescent body as a site of possibility and transformation. Here, girls assume an active role; they are not passive under a supposed male gaze, or any gaze. The gaze has become transgendered just as the actor in these gender-bending roles breaks gender stereotypes. Our engagement as viewers with proactive Heroine Girls has a thrill power once aligned exclusively with male superheroes. *Wonder Woman*, the 1970s television show starring Lynda Carter (ABC 1975–1977; CBS 1977–1979), never inspired the level of engagement that *Buffy the Vampire Slayer* has. Part of this involves the evolution of special effects; part of it lies with the sheer athleticism and grit that has been accorded the newest generation of Girl Power incarnations.

Animation and special effects dramas allow the viewer to transcend the limitations of the human body by identifying with the super-endowed protagonist. For female viewers constantly reminded of their bodies' shortcoming via advertising, the fantasy realm of Super Girls liberates them from these constraints. Fantasy is the space of metamorphosis and potential for change. As Susan Napier points out, "The animated space becomes a magical tabula rasa on which to project both dreams and nightmares of what it is to be human, precisely as it transforms the human figure."[30] Since the adolescent body is literally a site of transformation, the appeal of characters who locate powers beyond human capacity becomes easily understood.

Many of the teenage Supernatural Girls produced since the 1990s combine fully embodied magical power with nurturance and social or environmental consciousness. In addition to kicking "undead butt" until the wee hours, Buffy the Vampire Slayer takes care of her mother, her sister, and her friends. She is not just a killing machine. Hermione Granger uses her mental and magical know-how to

perform complex magical tasks but also genuinely cares for her friends Harry and Ron in an almost maternal way. Miyazaki's characters Chihiru, Princess Mononoke, Kiki, and Sophie also display combinations of magical power with nurturing service to individual others as well as bigger causes including protecting the environment. This new breed of teenage Superheroines tap into webs of teamwork, which puts them in contrast to the tradition of the lone superhero personified by Superman, Spiderman, Wonder Woman, and for the most part Batman. Traditional Superheroes work alone, in disguise, and have tortured inner lives. Millennial Super Girls perform their tasks of daring-do in the context of communities, parting ways with the Western concept of lone, rugged individualism. As mentioned above, Harry Potter would be nowhere without Hermione and Ron. Buffy the Vampire Slayer depends on her "Scooby Gang" to problem solve, to feed her clues and information, as well as to provide loyalty, support, and, in the case of Willow, outright magic of her own. Both Carmen of *Spy Kids* and Violet of *The Incredibles* work alongside and in cooperation with their families to undo evil. Rogue of *X-Men*, isolated by virtue of the curse/power of her touch, is drawn into the X-Men community and finds a family of power. Sabrina the Teenage Witch is aided by her wacky witch aunts, who adore her and guide her. And while Joan of Arcadia must keep her connection to God a secret, all of her actions are designed to improve and strengthen her family and community. For Super Girls, the heroine's journey involves a web of bonds in a safe haven, a place to which they return for rewiring and recharge. The blending of gender attributes marks a Girl Icon evolution.

The success of *Buffy the Vampire Slayer* and *Sabrina, the Teenage Witch* links not only to teenage viewers but also to cross-over audiences of grown women and men in their 20s, 30s, and 40s. As the first generation of rock and roll to drive the carpool, Baby Boomer parents share a common pop culture with their children. But single women and men also keyed into the explosive power of these heroines, which contributed to the change in definitions of female "possibility" on the screen. In Hollywood, if it sells, if viewers buy, we will see more and more. With Female Superpowers, particularly teenage ones, that will definitely be the case well into the new millennium. Supernatural Girls are here to stay.

Because the *Harry Potter* films, *X-Men* series, and many of the other films and television syndicated shows mentioned appear as series developed over five or more years, Power Girl Icons are not blips on the visual horizon but repeated images that have embedded themselves into Western cultural vernacular. The arrival of the mail-order company Netflix has been very good news for consumers previously dependent on the taste of buyers for Blockbuster or local video rental stores. We have a culture of re-runs, repackaging, multiple screenings, both at home and in the theaters. With so many mass-cultural examples, Power Girls have broken through to Icon status, changing the parameters of female possibility, especially in

the realms of fantasy. Buffy, Rogue, Hermione, and Violet will continue to penetrate our collective narratives, joined no doubt by new characters and concepts in Girlhood.

While many trends have contributed to mainstream readiness for young female role models of force, power, and beauty, there is no doubt that these breakthrough gender-bending Icons have permanently altered accepted definitions of the category "Girl." Lolitas, Ingenues, Tomboys, and Girls Next Door[31]—the Teenage Girl Icons of previous generations—have some new little sisters to reckon with. Perhaps Supernatural Girls will rescue even them from one-dimensional mediocrity.

GRRLS versus WOMYN: Generation Blending

GRRLS, WOMYN, AND SPELLS

The references to Magic, Girls, and Spells lead back to the library, where Buffy, Willow, and Hermione spend a lot of time. Millennial books echoed the theme of word power with Myla Goldberg's *Bee Season* (2000) about an 11-year-old Jewish Girl Spelling Champ, becoming a feature film in 2005 (Scott McGehee and David Siegel). This was followed by an African-American Word Wizard in *Akeelah and the Bee* in 2006. Meanwhile, Sabrina studied spells along with the cast of *Charmed* on television from the mid-1990s into the mid-2000s. A *Spellbound* documentary (2002, Jeffrey Blitz) brought multicultural Girl Spellers to the microphone along with the Broadway musical the *25th Annual Putnam County Spelling Bee* (2005–). Clearly Spelling Girl Brainiacs and Teenage Witches' spells are part of the turn-of-the-century zeitgeist. But how exactly do you spell Girl, and how do you spell Woman? And how have these words become interwoven as Girl Power webs of meaning?

When Hermione Granger first meets Harry Potter on the Hogwarts' train, she utters "Oculus Reparo,"[1] and with a wand-flick, fixes his broken glasses. Spells and spelling can help us to see how Word Power has informed female representation. A wand, like an extended index finger, points, names, and transforms. Where we see the word "Girl," we often mean young females, but Girl also means Woman, as in the grown-up kind. Like many areas of blurred boundaries since the floodgates of possibility, taboo, gender, and sexuality opened in the 1990s, the delineation between the terms "Girl" and "Woman" is obviously no longer clear in our culture.

8.1 © 1996–2006 Ellie Brown from the series *About My Sisters*, 1996–2006.

In previous generations, it was much easier to separate the boys from the men and the girls from the women.

The core of any social change exists as language first. Slang often originates with teenagers, artists, and radical thinkers. This process involves inventing words and sometimes reclaiming banished language from previous eras. One generation banishes a word as a political act; another reclaims the taboo language of the previous generation as an act of rebellion. Taboos are powerful. But breaking them, as we have witnessed, can be even more powerful. For Second-Wave feminists, one of those banished words was "Girl." In the nineties, Girl returned full force, reclaimed by women and actual girls as a fluid concept linked to power. As Debbie Stoller expresses it,

> In the 70s, when feminism was reborn, the word "girl" was suddenly stricken from the vocabulary. In those years, girls seemed to be suffering from an image problem. Girl was cloying, girl was weak, girl was giggly. Tomboys were in; girlie-girls were out. Feminism, it seemed, was prepared to celebrate everything about womanhood—everything but the girl.[2]

The etymology of "woman," with two letters added on to the word "man," literally means "man with a wo-mb." In the 1970s radical feminist and lesbian groups transmuted "Women" to "Womyn," an act of word re-spelling designed to eliminate the need for "men" altogether. Influenced by the work of feminist scholar Mary Daly[3] and others, this wordplay relates to a rejection of Eve's origin from Adam's rib, a myth similar to Zeus' supposed creation of Athena from his own head. "Womyn" moved toward its own category, with the variants "wimmin," "womban," and the singular "womon." For Radical Feminists this was linguistically symbolic of breaking away from patriarchy embedded in Judeo-Christianity. Yet, the very nature of the permutation meant "men" would be referenced anyway, as the palimpsest of the original word. "Womyn" as a term designates a philosophical and physical space separate from men, and separate from mainstream heterosexist culture. From the space of separation, a great deal of Women's Studies evolved, as well as empowerment in the form of consciousness-raising groups, political activism, and a recovery of many forms of Sisterhood. Multicultural hetero, bi, and gay "womyn" were separatist by design to gain perspective, privacy, community, spirituality, academic depth, and, in some cases, safety from violent men. The annual Michigan Womyn's Music Festival continues in this womons' tradition.[4]

When Cyndi Lauper's anthem "Girls Just Wanna Have Fun" hit the airwaves in 1983, the term "girl" was beginning its resurgence after a season in feminist purgatory. Madonna, Pop Queen in progress, released her "Material Girl" album in 1984, an epithet longer lasting than her "Boy Toy" costume belt tag. While

Madonna herself avoided the term "feminist," preferring "humanist" instead,[5] in the 1980s women began to play with the political power of the term "girl," which eventually transmuted into the 1990s punkish "grrl," with extra r's added for effect when necessary. "Girl" begins as its own category. There's no "man" or "boy" anywhere in sight. By returning to "Girl," 1990s culture achieves a fully separate but equal status in terms of gender words. As we know, Logos rules. Words are the Supremes.

"Girl" leaves the woman-man discussion for word slicers. "Girl" says, "Forget all that. We already are different. We're Girls!" "Girl" connotes fun and linguistic freedom from syntactical codes embedded in "womb-man." "Grrrl," from 1990s underground music culture discussed in Chapter Three, doesn't have anything to do with eliminating men; it's a word in its own category without "man" etymologies to navigate. "Grrrl" accesses primal female power beyond rage to include girly fun in punk fashion. Men aren't the reactive reference point for "Grrrl," which is more about creative proclamation and accessing raw female energy as music, art, zines, and DIY than reaction or separatism. In fact, a lot of grrrls even like boys, a piece of information not manipulated by 1990s mainstream press to the same degree as the Second-Wave message. The efforts of hardcore anti-ERA career crusaders operating in the mode of Phyllis Shlafly, helped equate feminism with lesbianism, unisex bathrooms, and women in the military rather than equal pay for equal work.[6]

Two key words differentiate 1970s feminism from 1990s feministas: lipstick and comedy. Third-wave feministas appreciate the role of fashion in identity construction and self-expression as well as the rebellion inherent in raucous laughter. While the messages of the late 1960s and 1970s were geared toward women being taken seriously after centuries of belittlement, issues not lost on 1990s and 2000s women, the importance of wordplay and the quality of life expressed in a good dress-up game have characterized a new generation of social activists. By 1994, even legendary radical academic Mary Daly produced the comedic feminist dictionary *Webster's First New Intergalactic Wickedary of the English Language*, spinning many gender terms with utter badinage, including Daughter, Sisterhood, Virgin, Amazon, Banshee, Dryad, Fairy, Harpy, Mermaid, Nymph, Pixie, Prude, Sibyl, Sylph, Vixen, Witch, though not Girl.[7]

The category "Girl" expanded in the 1990s, unfurling a new vista of definition for girls and women-as-girls and a plethora of marketing jargon. Of course, mixed messages about "Performing Girl" abound, but deciphering the meanings and possibilities is part of the creative task. "You go girl," the 1990s phrase adopted by women and girls to boost each other's efforts, lingers in the 2000s as a jocular quotation. "Girl Power" not only refers to the movement to help girls counteract the ill effects of the beauty culture but also gives women permission to return to the sense of playfulness they possessed before becoming Super Women in business suits. The girling of American culture has another side, that of allowing women

to "hang with the girls," read "chick lit," and be girlish as well as serious, strong, multitasking women. Underneath the layers of Girl Power meanings lies the re-spelling of the F-word, Feminism, a movement for equality for Girls and Women that returned in a bold new form in the 1990s, carrying knitting needles, wearing girly lipstick and a Bitch t-shirt.

While the word "feminism" may still be the unacknowledged chiaroscuro underneath Grrrl Power portraits, the fact that "Ms." now appears as a check-box category on every official form, providing three choices of nomenclature to every Miss and Mrs. America, is due to the efforts of 1970s spelling whizzes who knew how to roar. At the end of the day, Teenage Girl Icons are not just for girls; they're clearly of great interest to grown women as well. A Teenage Witch is less danger-ous than a full-fledged adult Witch, just as Girl Power is less threatening than the word "Feminism." But Girl Power has emerged with its own neoprene suit, karate-kick, special effects-driven movie as an animated performance of, yes, Feminism in action. While many women have been on a mission to rescue girls since the 1990s, the proliferation of the Teenage Girl Icon has in many ways rescued and revitalized the women's movement with its core impact on the culture at large.

PERFORMING GIRL AS AN ART FORM

In the 1980s artist Laurie Simmons arranged dolls in large-scale C-prints, making visual play of gender role stereotypes, domesticity, and feminism. Cindy Sherman, who rose to superstar status in the 1980s, is now considered one of the great-est artists of the 20th century. In her early *Untitled Film Stills* produced from 1977–1980, her own body becomes a living chameleon mannequin on which she drapes identities. This practice has continued in subsequent bodies of color pho-tography referencing identity, gender, art, and film history. Both tapped into girl-hood dress-up masquerades and interior worlds that broke open many possibilities for postmodern art beyond appropriation and continue to influence recent artis-tic practice, including the late 1990s and early 2000s "installations" of live, high-heeled caryatids by Italian artist Vanessa Beecroft. Her sculptural performance art pieces involved rows of naked models standing immobilized for hours like huge Barbie fetish objects in galleries and museums. Under the gaze and direction of a female artist, this controversial "body" of work becomes allowable as art, as a commentary on eating disorders and the female obsession with fashion and the perfect "doll" body.[8] A similar body of work by a male artist would likely have been perceived as misogynistic, an indicator that in the art world, at least, the Female Nude,[9] a subject treated extensively by male artists for hundreds of years, is being reclaimed by women.

International artists have also been influenced by the Girl masquerade tradition of Cindy Sherman. Japanese artist Miwa Yanagi had her first one-person show in New York in 2007 at the Chelsea Art Museum. Her inter-cultural explorations of girls as techno-cyber ciphers, as "Elevator Girls" and East-meets-West folklore Icons, demonstrate the continued possibilities for the Girl Icon in the art world.[10] Her newest body of black-and-white photographic work, "Fairy Tale," explores famous western Girl Tales drawn from the Brothers Grimm and Hans Christian Anderson. In these eerie photographs of Rapunzel, Snow White, and Sleeping Beauty, young Asian girls wear old woman masks in decaying rooms filled with soil, mirrors and diaphanous draperies evoking the beyond innocence struggle at the core of collective mythology, even those sugary versions in the Disney canon.

Cindy Sherman's signature style of self-portraiture, on the other hand, emerges fully clothed from a retro closet evoking B-movie actresses, starlets, housewives, mistresses, and other "girls" of the 1950s and 1960s, especially in her *Untitled Film Stills*, referenced extensively in international photography collections and in universities, influencing many young photographers and filmmakers. In these early photographs, her characters suggest deeper, inchoate storylines threading through the lives of those who sometimes wear a costume borrowed from movies and magazines just to survive. Often the subject/object of her photographs as well as the director, Sherman renames dress-up as identity art, masquerade with a capital "M." A seemingly endless supply of chameleon identities underscores just how many versions of "performing girl" are available.

Bringing this work to public gallery and museum spaces, Sherman transformed the private narcissism of childhood dress-up games into a performative charade which broke open definitions of "the artist," "the cinematographer," "the genius," and "the gaze." Sherman's explorations of film and art historical identity, voice, subjectivity, and power include not just B-movies but also horror, Great Master paintings, pornography, and, in the early 2000s, the subject of women ageing before the lens. Through the sheer multiplicity of her guises, Sherman demonstrates how notions of gender and identity are constructed beyond biology as an endless set of façades to take on and off at will. As Amalia Jones notes, this practice "reiterates femininity with a twist, opening the formerly sutured gap between its conventional codes and the bodies these codes are designed to fix as 'female.'"[11]

In a nod to Sherman's influence on her own career, Madonna, the consummate reinventive Dress-up Queen of iconography, underwrote the 1997 Cindy Sherman retrospective of *The Complete Untitled Film Stills* at New York's Museum of Modern Art.[12] Unlike Madonna, who never loses her celebrity self in the process of changing her "girlie look," Sherman melts into her characters in such a way that a suggestive déjà vu of semi-recognition takes place. While Madonna has assumed many public

8.2 Miwa Yanagi, *Rapunzel*, 2004. From the series *Fairy Tales*.
Gelatin Silver Print Deutsche Bank Collection © Miwa Yanagi

identity poses throughout her long career, the Madonna persona never disappears; she is always Madonna doing another version of Madonna. Whereas Cindy Sherman is the ultimate noncelebrity shapeshifter, Madonna borrows shamelessly from histories of pop culture to produce the hypertextual multi-layered Uber-Celebrity Girl. The wigs and hair extensions, the torpedo bra, the mink/diamond eyelashes are fabulous, as are the references to Marilyn Monroe and Dita Pardo, but it's all Madonna. It's a case of impersonation versus personification. Cindy Sherman impersonates the Girls of Western culture; Madonna personifies the Girls as quotations of Madonna.

Out of the same 1980s downtown New York art scene that produced the Icon-making Girls Cindy Sherman and Madonna, the Guerrilla Girls collective began a crusade addressing women, power, and exhibition opportunities in the art world. Wheat-pasted flyers and posters began appearing on walls and lampposts in Soho and Tribeca in the mid-1980s attacking the sexist practices of major museums and galleries in New York. Like Barbara Kruger's signature work in graphic design-as-art, the Guerrilla Girls' ad campaigns combine text and image in visual puns that activate their political messages. An early poster superimposes a gorilla head onto Ingres' 1814 nude "La Grande Odalisque" and asks, "Do Women Have to be Naked to Get into the Met Museum?" In dialogue with Linda Nochlin's famous 1973 essay "Why Are There No Great Women Artists,"[13] the Guerrilla Girls did their homework, providing statistics that have impacted the practices of galleries and museums in the new millennium. A comprehensive study of women, the arts, and representation can be found in Whitney Chadwick's *Women, Art, and Society*, which also references activist art by women like the Guerrilla Girls.

As explained on their website,

> We wear gorilla masks to focus on the issues rather than our personalities. Dubbing ourselves the conscience of culture, we declare ourselves feminist counterparts to the mostly male tradition of anonymous do-gooders like Robin Hood, Batman, and the Lone Ranger. Our work has been passed around the world by kindred spirits who we are proud to have as supporters. The mystery surrounding our identities has attracted attention. We could be anyone; we are everywhere.[14]

Favorites of the college lecture circuit, these masked crusaders have published two humorous and valuable resources: *Guerrilla Girls' Bedside Companion to the History of Western Art* in 1998 and *Bitches, Bimbos, and Ballbreakers: The Guerrilla Girls' Illustrated Guide to Female Stereotypes* in 2003. "Guerrilla" is a term for revolutionary or underground warriors à la Che Guevara, a movement to overthrow the dominant regime. Performing as wordplay incarnate, Guerrilla Girls have created a comedic "brand" imprint. Bottom line: You can't ignore a big, hairy aggressive

(but humorous) gorilla that calls itself a Girl. Just as the factual inequities cannot be ignored about men, power, and the art world or the film world (which is the Guerrilla Girls' most recent focal point), gorillas are impossible to miss. This interplay of guerrilla tactics and the comedy of the gorilla mask becomes subversively effective. In movies, the appearance of gorillas and monkeys signifies slapstick comedy.

The gorilla is a comedic stand-in for the stereotype of the ball-busting, bra-burning Feminazi. As "beasts," Guerrilla Girls present some terrible truths about women, men, and power easily digested in comedic form, which permits them verbal and political license not afforded unmasked, nameable feminist scholars. The gorilla mask provides a visual pun that activates political messages as living theatre and also affords members the anonymity to speak out radically without fear of hand slapping, demotion, personal ridicule, or attack by the art critics, curators, or members of the academic art departments in which some of their member operate for their livelihood. Donning gorilla masks allows the collective to appear in many places at once and so multiply their message. Unable to be seen or identified as individuals, Guerrilla Girls do not age. Given the fact that complete gender and racial equity remains a continued challenge, their message has not grown stale. As Girls, their playfulness has given staying power to their political messages, which continue to be effective for new generations of feminists, whether they use the F-word or not.

In 2004, the Whitney Museum hosted a one-woman exhibition for Ana Mendieta, a Cuban-born performance artist, and MoMA Queens produced an extensive exhibition of works on paper by Kiki Smith and a major retrospective of the work of Lee Bontecou. Major exhibitions in the 2000s by the likes of Shirin Neshat, Laurie Simmons, Barbara Kruger, Louise Bourgeois, Carrie May Weems, Kara Walker and many others have taken place in a revision of the term Art Superstar which now includes women artists and artists of color. A walk through New York City's art galleries in the 2000s reveals an art marketplace open to a new generation of young women with MFAs selling work in major one-person exhibitions. Did the Guerrilla Girls have anything to do with this? Girls just wanna say yes.

In the late 1990s and early 2000s the Guerrilla Girls expanded their operations beyond the art world to challenge imbalances behind the scenes in the film industry. With such slogans as "Want to Direct? You're in the Wrong Bathroom" and "The Anatomically Correct Oscar," the snide wit continues. Their 2006 billboard project, co-sponsored by a host of women's film advocacy groups including Women in Film, Movies by Women.com, and Women Make Movies, appeared just a few blocks from the site of the Academy Awards. The ad featured Queen Kong in a pink evening gown struggling with shackles and the headline "Unchain

the Female Directors." An obvious reference to Peter Jackson's huge box office hit, *King Kong*, the billboard refers to key statistics about women behind the scenes in Hollywood. A quote from the web page sums up the campaign: "Hollywood likes to think of itself as cool, edgy and ahead of its time, but it actually lags way behind the rest of society in employing women and people of color in top positions."[15] (See Chapter Nine.)

Guerrilla Girls have always been about shareware. It's part of their success in getting their messages out: it's the sisterhood of the traveling zeitgeist.

BAD GIRLS AND SPICE GIRLS

Like Lily Tomlin's naughty Edith Ann character in the 1960s, *Saturday Night Live*'s comediennes have created many girl characters, including Gilda Radner's wildly imaginative Judy Miller in the 1970s; Molly Shannon's clumsy, armpit-sniffing Catholic schoolgirl Mary Katherine Gallagher in the 1990s; and Amy Poehler's hyperactive Caitlin. Women playing loopy little girls allows for an outrageous bacchanal of verbiage and body language not allowed to "ladies" or "women," especially skinny white ones, who must tone themselves down, who cannot easily rant and rave without censure.

Tapping into the power of comedy and the Girl moniker as art, The New Museum of Contemporary Art hosted *Bad Girls* in 1994, a carnivalesque exhibition of multicultural artists curated by Marcia Tucker that brought humor into the context of "serious" artmaking. A companion show mounted at UCLA's Wight Art Gallery featured a West Coast line-up of women artists flipping the bird at narrow definitions of feminism, the Nude, self-portraiture, domesticity, race, shoes, dolls, and Girlhood with wicked combinations of text and image. As curator of the New York show Marcia Tucker expressed,

> [B]ad girls play with words by transforming them into objects, by rewriting narratives so that they conform to their own visions of the world, or by pointing to the absurd gulf between words and actions ... There is an endless flow of words in this exhibition, spilling and spewing, exhorting, insulting, cajoling, cheering and cursing.[16]

Clearly women artists who call themselves Bad Girls give themselves permission to do more than play bridge or go shopping with "the girls." Exhibitions such as these, with their emphasis on photography and video, assisted with the acceptance of Bad Girls breaking boundaries in the art world and helped transform the media's image of Feminists as humorless school marms or fascistic Feminazis. Being Girls has been a part of this. By 2000, another group of Bad Girls—Cecily Brown,

Lisa Yuskavage, Sue Williams, and Sam Taylor-Wood—were being described by
Deborah Solomon in *The New York Times* as

> the latest cool school in the art world. Defying the rules of sisterhood, they elevate high
> school stereotypes—the slut, the bimbo, the messed-up chick—into the realm of art. Their
> work weds high aesthetic quality with debased ideals, suggesting it is O.K. to chase guys,
> tell dirty jokes, read *Cosmo* instead of Virginia Woolf and wonder why your self-esteem is
> scraping the pavement.[17]

In line with the multiplicity of examples of blurred definitions, in the same era
that Bad Girls appear in tabloids as alcoholic teenage celebrities, they're also hip-
ster female painters selling prodigiously in New York galleries. Obviously, it all
depends who is doing the spelling.

In the mid-1990s the term "Girl Power" had been co-opted by the Spice Girls,
a quintet of British 20-somethings bubble-packaged in five flavors to teenyboppers.
Riding the Girl Power meteor for three years before flaming out in fluff attempts
at solo careers, the Spice Girls' sexy charisma, moderate musical talent, and "Girl
Power" philosophy made them pop music's Next Big Thing. With a madcap humor
that included spanking Prince Charles at a press conference, the Spice Girls walked
away with millions and have become an enduring camp reference from the 1990s.

With a "Spice Girls Conquer the World" cover story on *Rolling Stone* maga-
zine in 1996, these "girls" hit the pop charts with their leather bustiers and spike
heels, all the while saying "We're tame, we're fun, we come in five flavors …"
Scary, Sporty, Posh, Ginger, and Baby Spice combined the aesthetic of the late
1950s and early 1960s Girl Groups the Shirelles and the Ronettes with a high-
ly evolved marketing strategy that eclipsed "The Leader of the Pack." Despite
Scary Spice's multicultural skin tone, penchant for animal prints, and prominent
pierced tongue, these "girls" were anything but scary. Also known by their first
names, Mel B, Mel C, Victoria, Geri, and Emma, their bubble gum lyrics and silly
dished up a confection of girls-night-out rowdiness with a watered-down version
of feminism which included their liberal eyebrow-raising embrace of then Prime
Minister Margaret Thatcher as "the original Spice Girl." Despite Lefty critique
of their suspect politics, their messages helped to mainstream what had been the
underground Riot Grrrl movement, decidedly more radical and rough than most
little girls could fathom.[18] At the height of their success almost every magazine
or newspaper featured one or all of the Spice Girls. Playing a role that spoke to
their tween fans, they sang songs about their mothers and "being friends," in a
girl-to-girl fan universe most often allied with boy crazy fervor à la Beatlemania.
As a camp reference in millennial vernacular, the Spice Girls diluted what "Girl
Power" meant at its core: giving voice and power to the pre-teens who made

them millionaires. But deep into the 2000s they remain name-brand recognizable. Granted this kind of "Girl Power" means something completely different from the "Girl Power" headline of *Newsweek*'s coverage of the American team's victory in the Women's Soccer League World Cup in 2000.[19] While easy to dismiss the Spice Girls as an overly sexualized confection, with record sales in the region of 53 million,[20] they are an undeniable piece of music history as well.[21]

GIRLS BUSTING OUT

BUST: The Magazine for Women with Something to Get Off Their Chests grew out of zine culture in the early 1990s. Originally published on newsprint, it has grown to a full-color magazine found on major magazine racks even in Barnes and Noble's mega-bookstores. *BUST* began with a pun that broke through barriers of feminism by *BUST*ing up laughing, *BUST*ing myths of womanhood and of course the obvious jokes brought on by their retro bra-studded masthead. The editors and many of the original writers of *BUST* used pseudonyms during the early phase of publication, including Celina Hex, Betty Boob, and Ophelia Lips, not unlike Guerrilla Girls disguises. These avatars for the zine age allowed them to rant on, diary-style, about their most audacious ideas toward a feminism that transcended "ism" and embraced voices not allowed in print, particularly around issues of female desire and bad girl behavior. Playing with identity and anonymity allowed them access to another voice of power, which included nail polish, make-up, dress-up, knitting, cross-stitch—girly activities once deemed too lowbrow for Feminists. *BUST* magazine has liberally reclaimed the use of the word "girl" and championed the DIY (Do-It-Yourself) culture of Girl Crafts as viable businesses. The honesty of the writing in *BUST* is refreshing and confessional, very much like a sit-down chat with girlfriends who have "something to get off their chests" while rattling the knitting needles. When *BUST* proved successful beyond their dreams, the editors Debbie Stoller and Marcelle Kamp (aka Celina Hex and Betty Boob) revealed their true identities.

BUST in the early 1990s as a newsprint zine provided an oasis of sexual irreverence and laugh-out-loud wit that spoke to my own need as an artist, feminist, and mother for some girl fun along with razor-sharp wordplay wit. It was (and still is, now in its four-color quarterly incarnation) a naughty girl empowerment rag with a post-punk retro aesthetic that has tapped into a loyal reader base. Originally inspired by the now-defunct *Sassy* magazine for teenage girls, *BUST* incorporates the fun style of girl world into a publication for women. Editor Debbie Stoller saw *Sassy* as an antidote to the "girl poisoning culture" described by Mary Pipher in *Reviving Ophelia*, which "turned the convention of women's and girls' magazines

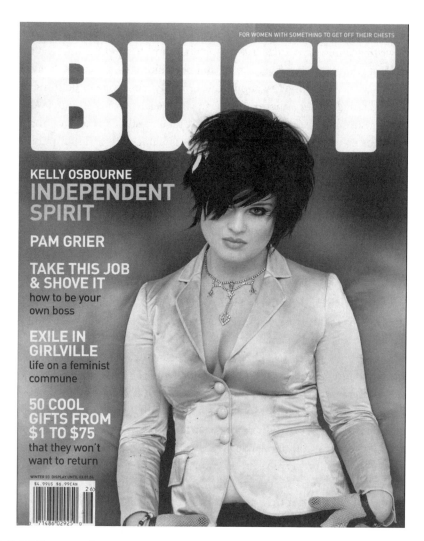

FOR WOMEN WITH SOMETHING TO GET OFF THEIR CHESTS

BUST

KELLY OSBOURNE
INDEPENDENT
SPIRIT

PAM GRIER

**TAKE THIS JOB
& SHOVE IT**
how to be your
own boss

**EXILE IN
GIRLVILLE**
life on a feminist
commune

**50 COOL
GIFTS FROM
$1 TO $75**
that they won't
want to return

WINTER 03 DISPLAY UNTIL 03.01.04
$4.99US $6.99CAN

8.3 ©2005 Bust magazine.

on their heads by focusing on the pleasure, rather than the pain, of growing up girl."[22]

Clearly, *BUST* is a magazine for and by women, with "girl" the operative concept. *BUST* tosses The Slut Myth out the window, and desire is not only an acceptable *BUST* girl pursuit, it's a Good Vibrations-like manual for pursuing one's own sexual desire with or without men in tow. *BUST* is part of a new generation of alternative magazines, including *Bitch*, which have invigorated the next wave of discourse about women, girls, power, desire, and pop culture. Not a whiner's rag, *BUST* provides a manifesto of honesty about the continued challenge of defining what it means to be female in an American culture which exalts us, lashes out at us, backlashes us, crashes in on us, sells to us, sells out on us, and keeps reinventing myths and Icons for us to decode and decipher. This is a not a passive rant publication, a complainer module for Gen X or Millennials. It's can-do, "let's speak up, joke, yell and hey what about having a party," all the while looking back on adolescence, rites of passage, relationships, pop culture, heroines, and make-up. This magazine embraces Cyndi Lauper's anthem lyric and goes a mile or two beyond it.

BUST women, like Riot Grrrls, reclaimed the term "girl" in the early 1990s for a number of reasons. First and foremost, being girls is a lot more fun than being womyn. It is also more inclusive of boys and men, whom *BUST* fully embraces as part of the discourse of change as well as Girl Talk. The publication features interviews with pop cultural "New Males" such as Beck, Rufus Wainwright, Moby, and others. This inclusiveness comes at a time of relative privilege for millennial women, whose advances in equality owe homage to the sometimes forgotten contributions of 1970s feminists. The level of respect, vocabulary, power, and career access accorded millennial women has become a deeper given due to the previous generation of feminists, which publications like *BUST* certainly acknowledge. Unapologetic use of the term "feminist" blended with "girl culture" is one part of that acknowledgement. *BUST* creators, writers, interview subjects, and readers operate from this position of relative privilege, at the same time reclaiming certain aspects of female culture as fun self-adornment and self-expression through make-up, clothes, and personal style; with craft industries as art forms, businesses, and community builders rather than symbols of 1950s patriarchal oppression.

This is not a magazine for tweens or little girls; it's for older teenagers, as well as women aged 20-something to 40-something or older who have embraced their inner "girl." *BUST*'s editors have consciously constructed their version of "back to the Barbies" as a parallel to the 1970s "back to the land" movement, a means to reclaim the terrain of girlhood—fun, play, girlfriends, in-jokes, dress-up, creativity, and imagination—for clues to the power lost in the process of performing womanhood. "Celebrating our girlhoods in this way lets us take pride in our pasts, and can help build the self-esteem not only of girls, but also of women."[23] In the 1990s

BUST championed MTV's Daria, Sabrina, Buffy the Vampire Slayer, Ally McBeal, Bridget Jones, Ani De Franco, and Missy Elliot. *BUST* cover Icons from recent issues include Frances McDormand, Bjork, PJ Harvey, Lilli Taylor, and teenage stars Jena Malone and Kelly Osborne.

 BUST isn't just about knitting and celebrating female achievement and desire; it also confesses the dark side of the female experience: shoplifting (an almost all-female crime), jealousy, man troubles, body image, navigating self-hatred, and other topics. But even in shadow country, the irreverent toughness and the sly wit of *BUST* writers inspire frequent bouts of laugh-out-loud reader response. Some of these pen-sters just happen to be the neighborhood Slut who wasn't ostracized or victimized but is here to report at adulthood that her teenage sex empowered her, vastly different from the reports of those who answered Emily White's ad for stories for *Fast Girls: Teenage Tribes and the Myth of the Slut*, discussed in previous chapters. *BUST*'s articles on sex and desire provide an empowerment platform for women as well as an expanded discourse on the definitions of sexuality, sexiness, and sexual politics.

LAUREN GREENFIELD'S GIRL CULTURE

In full-color large-scale photographs, Lauren Greenfield's *Girl Culture*, a monograph drawn from her traveling exhibition of the same name, the fluidity of the terms "girl" and "woman" takes on disturbing implications. Greenfield is an acclaimed youth culture photographer whose first book of photographic journalism, *Fast Forward: Growing Up in the Shadow of Hollywood* (1999), documented teenagers growing up against the backdrop of the ever-present celebrity business in Los Angeles. *Girl Culture*, a large-scale book of photographic anthropology, includes a brief introductory essay discussing the definitions of "girls," both young and old, in America at the close of the millennium. This four-color visual analysis of American definitions of "Girlhood" includes examples of women trying to look like girls and girls trying to look like women. The exhibition based on the book continues to tour the United States and Europe, providing a troubling full-color view into the dangers of blurring girl culture and woman culture.

 Greenfield makes the point that the term "girl," as in Call Girl and Go-Go Girl, has always been aligned with the sex industry. Any Google search with the key word "girl" will reveal the same disturbing linkages. Greenfield notes that a favorite image of the soft-core porn industry is the adult woman dressed as a schoolgirl in uniform.[24] This powerful collection of photographs takes a hard look at the more pernicious side of our current culture of conflation, where, depending on the context, "girl" means nonadult girls, preadolescent girls, teenage girls,

adult "girls" out on the town, women who use beauty tropes of make-up, exercise, and plastic surgery to look more like "young girls," as well as sex workers and Las Vegas Show Girls. Greenfield's *Girl Culture* illuminates ways women are objectified as "girls" by the sex industries, as well as the way girls grow up too fast in an extended obsession with weight gain and loss. Her photographs, gleaned from visits to weight-loss camps, eating disorder clinics, quinceañera parties, debutante balls, public schools, and malls, are juxtaposed with the adult Girl Land of Las Vegas, Nevada, celebrity culture, porn film sets, Reality TV stars, Girls Gone Wild beach events, and modeling and fitness contests.

While Greenfield's mirror on girlhood is cause for alarm, the photographic eye since Weegee and Diane Arbus often zeroes in on the unusual, the freakish. And while Greenfield's work presents as a "slice of the current normal," her eye roves over landscapes with a particular vision in mind. All cultural anthropologists enter the field with a point of view.[25] For the most part, Greenfield is not looking for happy, well-adjusted girls and women. She rarely photographs girls laughing at a slumber party, enjoying themselves on a soccer field, in close conversation with their mothers, in school plays, or hugging one another. She looks for the five-year-old whose parents tart her up in clothes bought in the same stores in which Britney Spears shops, or the unhappy girl who cuts herself with a razor because she hates her body. Greenfield seeks out the extremes illustrating cultural changes within the norm: the emphasis on thinness, the dress-up Princess persona, the celebrity mirror, and the plastic surgery industry.

When a photograph of girls playfully stuffing their bras[26] is followed by a girl taking off her top at a spring break beach debauch,[27] then a silicone-endowed playmate at the Playboy mansion,[28] a seeming progression of disturbing content emerges that may well be a mixing of genres. Is it appropriate to link these images sequentially or is the intent to shock and disturb? Is there truly a dot-to-dot connection between girls dressing up provocatively in front of their bedroom mirrors and the soft-core porn industry? Can these worlds be kept separate?

Greenfield's photographs of girls and women caught in moments of pain, fakery, and posturing far outweigh the images of girls laughing and enjoying themselves as kids. Given that I have spent the past 18 years in the company of girls at parties, school plays, festivals, sleepovers, funerals, weddings, bat mitzvahs, christenings, dinnertimes, TV Times, movie theaters, and beaches, a great visual collection of plays of intelligence, curiosity, experimentation, drama, humor, and fun comes to mind that is infrequent in Greenfield's lens view. As photographers and filmmakers, we find what we seek. Greenfield was looking for proof of Naomi Wolf's *The Beauty Myth* and of Mary Pipher's assertion that America is "a girl-destroying place," and she found plenty of examples. As an investigation into the troubles of 1990s girlhood, this is an important document, yet calls for a visual balance between

"boob job" culture, lap dancers, debutantes and girls as Real Girls captured in the dignity of their own search for identity, not only juxtaposed with aspects of the soft-core image systems. Greenfield provides edgy, ironic photographs that evoke powerful reactions in the viewer. Yet Greenfield herself writes that *Girl Culture*'s "truth is a subjective one, as true as one's perception of oneself in the mirror."[29] Greenfield's book gives us an important visual document about the shadow side of the blurring that has occurred in the vernacular of "Girl," but it doesn't show the girls who are successfully making strides in their lives. Despite the fact that accomplished, self-assured girls now outstripping boys in four-year college attendance, excel at sports, creating buzzwords of style, making videos, and playing in bands, these kinds of girls remain an infrequent minority in highly public media. More portraits are needed of those not buffeted by pop culture, who stare back at the camera with "I know who I am." Greenfield articulately acknowledges these extremes in her work:

> there are girls and women in my photographs whom readers may view as marginal or whose lives may be perceived as extreme. In effect, the popular culture has caused the ordinary to become inextricably intertwined with what to many seems extraordinary.[30]

Because of this, encouraging girls to self-represent as photographers and film-makers finds even more urgency. We need to see the arc of multicolor possibility that exists within that polarity of extremes. This directly contrasts the approach of filmmaker Zana Briski, who not only documented the lives of her subjects in *Born into Brothels* but empowered them to look through the lens themselves. (See Chapter Ten).

ABOUT MY SISTERS

Ellie Brown, a professor of photography at Temple University, began photographing her younger sisters, Emily and Abby, as a sophomore in college. Her project *About My Sisters, 1996-2006*, documents their transition from girlhood to young adulthood and includes Brown's commentary on her sisters' affluent, suburban culture of the mainstream. As a stepsister 12 years older than they, Ellie had a unique view on their lives:

> I would go to the suburbs with my 4x5 Speed Graphic and try to make photos that felt candid and would represent these girls in an honest, non-exploitative way. Through photographing, I began to see my sisters' images as representative of the greater girl who held a broad definition of being playful, vain, sexual, boisterous, and brave and so many more traits.[31]

The girls' history is unusual. When Ellie's divorced father remarried his current wife Jane, their inability to conceive led them to adopt their daughter Emily.

Nine months later Abby was born. As nonbiological "twins" Abby and Emily grew up in a Liberal Jewish home attending the same grade at the same school with dramatically different outcomes. Capturing their lives on film proved complex and challenging, as they began to resent the intrusion into their lives, even for the sake of art. Perhaps because of this, Brown noted, "The difference is larger than I ever could have comprehended. I feel like some strange older relative instead of a sister."[32] But would the project have changed if Emily and Abby had been given cameras to develop their own portraits of each other? Despite Ellie Brown's evident passion, neither Emily nor Abby showed any interest in photography and they remained reluctant subjects rather than active participants in the project. At times they even rebelled and ran away from her camera. In Abby's case, this related to anger, but in Emily's case, Brown realized it was part of an eating disorder-driven desire to disappear from view. Emily's development of anorexia posed conflicts for Brown about continuing the project, which focused so much on exploring girl identity yet failed to protect her sister from eating issues relating to body image.

Unlike Lauren Greenfield and other better-known documentary photographers who have dealt with the teenage girl subject as an outside observer, Brown had a way into the bedrooms and couches and bathrooms inhabited by her girls due to the privileges of sisterly intimacy. Because her activities as a photographer became an accepted part of her role in the family, no photograph is posed. The viewer enters in, as if sitting at the kitchen table like a member of the family. While Brown contemplates the causes of her sisters' choices, her photographs reveal just how quickly the American mainstream takes over and dress-up can become a serious and dangerous investment in "How do I look?" Despite the sometimes troubling commentary of the artist looking in on these girls' lives, a haunting beauty emerges in her capture of mid-sentence conversations, body language, and various forms of playing Girl.

M/OTHERHOOD AND MATERIAL GIRLS

By the 1990s, Madonna, the original "Material Girl" of the mid-1980s, was an extremely wealthy, savvy businesswoman, a multi-platinum powerhouse at the music box office. In the mid-1990s, as the tabloids tracked Madonna's own forays into motherhood with the birth of her daughter and son, the original Material Girl Madonna launched Alanis Morissette from her newly formed Maverick label all the way to multi-platinum success. By 2000 Madonna appeared in *Teen People* wearing a Britney T-shirt, and a year later in *Elle* explained,

> Britney Spears became my talisman for the week—the week she did Letterman and the show in New York. I became obsessed with wearing [Britney] t-shirts. I slept in them as well. It was like I felt it would bring me good luck. And it did.[33]

As if that suggestive remark wasn't kinky enough, her Britney embrace became literal as her "love affair" with the paedo pop Princess culminated in an onscreen kiss at the MTV music awards in August 2002 to promote their collaborative single, "Me Against the Music." The Britney-Madonna "lip lock" instantly circulated on weblogs and no doubt helped to boost sales of the single. As a music industry "mentor," or mother figure, Madonna's role in this campaign fit with her willingness at every stage of her career to titillate, self-pleasure in the public eye, and continue breaking sexual taboos, even with her industry "daughters."

While Madonna may have served as a dubious "mother" figure to teenage performers in the 1990s and early 2000s, the ways fictitious mothers and teenage daughters were relating to one another onscreen has been changing as well. The significance of the Mother/Daughter paradigm is more than underscored by the relative absence of its treatment in popular culture before the 1990s, an absence extending back to images of Motherhood in Art History defined as a sacred bond between Mother and Son (Jesus and the Virgin Mary). The Mother/Daughter archetype as a unit of exchange and mythic interaction goes back to Demeter and Persephone, yet its importance in celluloid thematics has been often eradicated, backstabbed, or belittled.

In classic Hollywood, a Daughter was often entirely orphaned, like Dorothy in *The Wizard of Oz*, or, in the classic Disney pantheon, a Daddy's Girl linked to an ineffective father who marries an evil stepmother (*Snow White and the Seven Dwarfs, Cinderella*) or doesn't marry at all (*The Little Mermaid, Beauty and the Beast, Mulan*). In the rare divorce scenarios of early Hollywood, Daughters and Mothers incarnate utterly at odds, never in close intimacy. At the self-sacrificing insistence of Barbara Stanwyck's mother character in *Stella Dallas* (1937), the Teenage Daughter rejects her working-class origins to join her father's upwardly mobile lifestyle. In *Mildred Pierce* (1945) Joan Crawford's single-mother business success story crumbles with a pistol-toting Bad Seed Daughter named Veda.

Teenage Daughters of the best-known nuclear family scenarios of television history and their inevitable TV Land re-runs were caught in such corny, limited, and sugary roles you wished them a genie bottle for escape. Good Girls like Princess and Kitten always turn to the patriarch in *Father Knows Best* (1954–1960, CBS-TV), while well-adjusted straight-A Good Girls Marcia (Maureen McCormick) and Jan Brady (Eve Plumb) in *The Brady Bunch* (1969–1974, ABC-TV) nod at their parents' advice. The first single mom of a Teenage Girl may well have appeared in *The Partridge Family* (1970–1974, ABC-TV), but Laurie's (Susan Dey) back-up singing, tambourine-playing Daughter with great hair hardly spoke on screen, let alone rebelled against or bonded with her mother. Joanie Cunningham, the Kid Sister in the boy-saturated *American Graffiti* spin-off

Happy Days (1974–1984), while penis-envy desperate to be in on the scene, is always condescendingly patted on the head, especially by her retro mother-in-a-housedress. This mother role reappeared more recently as satire on *That '70s Show* (1998–2006), where the extreme ditzy-ness of Mrs. Kitty Foreman (Mary Jo Rupp) and her neighbor, Mrs. Midge Pinciotti (Tanya Roberts), plays for laughs. The deadpan personality of Midge's teenaged daughter Donna (Laura Prepon) has more in common with Daria than Marcia Brady, and all of the high school characters in *That '70s Show* treat their parents with the classic eye roll, a definite Marcia taboo.

In *One Day at a Time* (1975–1984, CBS-TV), Teenage Sisters Barbara (Valerie Bertinelli) and Julie (Mackenzie Phillips) growing up with a divorced Mom finally had more screen time to develop their characters, with topics ranging from dating to sex and sibling rivalry, but the jokey dialogue always kept it lightweight. Even the working-class smart-aleck mother played by Roseanne Barr in *Roseanne* (1988–1997) must deal with the even smarter verbal sarcasm of her Teenage Daughters, Darlene (Sara Gilbert) and Becky (Alicia Goranson). Though the verbal sparring is a far cry from Snow White's battle with the Wicked Queen, not until the 1990s did some examples of friendships between teenage daughters and their often-single mothers begin to multiply, even with the daughters often role-reversal smarter and wiser, as in *Gilmore Girls* (2000–2007, WB).

The release of Allison Anders' *Gas Food Lodging* in 1991 began a trend in exploring the complexities of Single Moms parenting Teenage Daughters. While social policy discourse cast poor single black mothers, especially Teen Moms, as villains in the 1990s, white upper-middle-class single moms became the stars of mother-daughter television series and feature films. *Gilmore Girls* (2000–2007), created by Amy Sherman, who began as a producer and writer for *Roseanne*, deals with one-time Teen Mom Lorelei Gilmore (Lauren Graham), now 30-something, who has turned her Bad Girl image around by producing a teenage Good Girl, Rory (Alexis Beidel), and successfully running a New England Bed & Breakfast. Lorelei is a breezy personality compared with her wise, serious teenage daughter, who ends up at Yale. The series, which follows the love lives of both characters, proved successful with teenage girls and their mothers and, in a new pop cultural concept, depicted them as best friends. The title of the show winks at the cross-generational use of the term "girl" as a sign of lighthearted fun and an indicator that both women are good-looking enough to attract the "boys."

Gilmore Girls has a less outrageous but parallel storyline to the hilarious BBC series *Absolutely Fabulous* (1992–2005). Edina "Eddy" Monsoon (Jennifer Saunders), owner of a London PR company, is a partying fashion maven who cavorts with her alcoholic best friend Patsy Stone (Joanna Lumley), an Ivana Trump wannabe. At the start of the series, Edina's teenage daughter Saffron ("Saffy") (Julia Sawahla) looks

on with deadpan disapproval at every antic turn. A serious student, Saffron refuses to follow in her former hippie mother's footsteps and has no interest in partying, sex, or rock 'n roll. Along with Edina's mother, she's the "straight man" for the middle-aged comedians, who see Saffy's uptight, responsible appearance as a sign of personal failure. As Patsy notes, "She's so cold, she must have her period in ice cubes."[34]

In *A Walk on the Moon* (1999), mentioned in Chapter Two, Pearl Kantrowitz (Diane Lane), a former Teen Mom stuck in curlers, plays *mah jong* at a Jewish family camp in the Catskills during the Summer of Love, while her husband, Marty (Liev Schreiber), is backlogged in Manhattan fixing televisions for the July 1969 moon walk. As her 15-year-old daughter Alison (Anna Paquin) falls in love with a fellow camp counselor and wears short shorts, Pearl's eyes wander to a free-spirited traveling salesman, Walker Jerome (Viggo Mortensen). Though married to her teenage sweetheart, Pearl goes through her own renewed adolescence, questioning the early start to her adulthood as a teenage mother. Tension arises when her mother-in-law guesses she's "shtuping the blouse man" and her daughter sees her with "the other man" at Woodstock. While Pearl regrets losing her youth, her daughter helps her transcend the infidelity glitch and return to marriage with a new soundtrack by Jimi Hendrix. A similar scenario takes place in *Gilmore Girls*, which hinges on the mother's continued viability as a love interest. Both storylines focus on the second adolescence experienced by mothers as their daughters become teenagers. With the mothers of teenage daughters still in their 30s, this early mid-life crisis becomes a hey-day for parallel dating scripts.

While lighthearted comedies like these redeem the white single mother, the African-American version has yet to find her way onto the screen as a successful 30-something double-dating with her daughter. African-American Daughters, while certainly newer to the television screen in the 1980s and 1990s, fared no better in limited roles as the sarcastic walk-on-and-off Denise (Lisa Bonet) in *The Cosby Show* (1984–1992, NBC-TV) and the credit card Valley Girl Hilary (Karyn Parsons) in *The Fresh Prince of Bel-Air* (1990–1996). While African-American teenage girls have appeared in central title-bearing roles such as UPN's breakthrough *Moesha* (1996–2001) and Disney's *That's So Raven*, which debuted in 2002, Moesha (Brandy) is raised by a single father after her mother's death, and Raven's (Raven Symoes) mother is happily married. While Moesha's father eventually remarries, the show focusses on Moesha's reactions to this territory-encroaching character, not on their parallel lives. The most believable African-American single mother of a teenage girl in recent years is Tanya Anderson, the overworked nurse who has lost her husband to random violence, portrayed by Angela Bassett in Doug Atchison's 2006 feature *Akeelah and the Bee*.

In a continued nod to the changes in the nuclear family, a surge of teenage soap operas geared to cross-over audiences were developed for television in the 2000s,

acknowledging that the WB's 1990s series *Buffy the Vampire Slayer* and *Dawson's Creek*, originally designed for teenagers, were watched by adults as well. On *The O.C.* (2003–2007, Fox-TV), a Dallas-style soap opera of excess which initiated the teenage career of Mischa Barton, the "Moms" with their botox-ed faces and lipo-suctioned bodies look a lot like the teenage fashionistas they supposedly parent.

In the real world millennial parents do not age in the same way as previous generations. Even without plastic surgery, in the 1990s and 2000s a growing number of middle-aged Americans were looking younger than their parents did due to fitness, health standards, general affluence, and overall longevity, and their Boomer interests in rock and roll and technology overlap with their kids.

The girling impact on the fashion industry means that Super Models and "fresh faces" became even younger in the 1990s, exerting pressure on women to keep themselves "looking teen." In fact, fashions for teenagers and middle-aged women at times took remarkable mirror clauses. The absurdity of the blur between generations found its epitome in the movie *13 Going on 30* (2004, Gary Winick) starring Jennifer Garner. Jenna (Garner) undergoes a transformation on her 13th birthday and wakes up as the 30-year-old Art Director of a top fashion magazine. This fully grown Jenna doesn't know how to insert a tampon and screams when she sees her boyfriend emerging from the bedroom clad in a towel. Jenna finds out that her adolescent wish to be part of the "in crowd" has come true, yet this life seen through the eyes of her more authentic self, the 13-year-old, changes her perspective on what she has gained. Jenna realizes that her true friend is not a girl but a guy and that the backstabbing lifestyle of the fashion world is not for her. This traveling forward in time contrasts the trends in the publishing industry, which have fed grown women's desires to travel back in time to the girl's coming-of-age novel.

OPRAH'S BOOK CLUB GIRLS

Throughout the 1990s and 2000s the national phenomenon of women's reading groups inspired in part by Oprah's Book Club, often catapulted books to bestseller status and eventual film adaptation through persistent cross-generational interest in the teenage girl subject. Oprah's Book Club, formed in 1996, gave a boost to a lackluster publishing industry at a time when the distractions of e-mail and the Internet went mainstream, along with dire predictions about the "end of print culture."[35] Oprah's Book Club Selections served as a huge boost to the careers of several writers of debut novels about Teenage Girl Heroines, including Janet Fitch, Edwidge Dandicat, Kaye Gibbons, and Wally Lamb. There is no denying the impact Oprah has had on literacy and publishing industry sales in America:

Winfrey's actions have inspired so many book-buying frenzies that we are no longer fazed. She has repeatedly proved herself to be the arbiter of literary taste for millions of Americans.[36]

Two recent scholarly books discuss her influence on American reading habits: *Reading Oprah: How Oprah's Book Club Changed the Way America Reads* by Cecilia Kochar Farr (New York: State University of New York Press, 2004) and *Reading with Oprah: The Book Club That Changed America* by Kathleen Rooney (Little Rock: University of Arkansas Press, 2005), establishing her as a literary maven as well as a successful broadcast entrepreneur.

A number of Oprah's book picks feature an adolescent heroine who deals with abuse, neglect, and orphanhood. While the orphan protagonist extends back to fairy tales and is prominent in the classic novels of Jane Austen, the Brontë Sisters, and Charles Dickens, the 1990s trend brought a new generation forward. Oprah's selections included Wally Lamb's teenage girl struggling with her weight and psychological issues in *She's Come Undone* (1996); poor, undereducated white girls with Huck Finn spunk such as Kaye Gibbons' *Ellen Foster* (1997); a Haitian girl searching for her true mother in Edwidge Dandicat's *Breath, Eyes, Memory* (1998); a pregnant 17-year-old abandoned in front of Wal-Mart in *Where the Heart Is* by Billie Letts (1995); and a middle-class teenager who unexpectedly finds herself in foster care in Janet Fitch's *White Oleander* (1999). In this novel, 15-year-old Astrid is forced to fend for herself in a series of foster homes when her eccentric but brilliant poet mother is imprisoned for murdering her boyfriend.

In addition to helping establish the careers of many first-time novelists writing from the teenage girl perspective, Oprah has championed classics featuring girl characters by Carson McCullers and Toni Morrison, as well as coming-of-age narratives by well-known contemporary writers Joyce Carol Oates (*We Were the Mulvaneys*, 1996), Isabel Allende (*Daughter of Fortune*, 2000), and Barbara Kingsolver. Kingsolver's *The Poisonwood Bible* (1999) uses a Faulkner-esque series of first-person monologues to travel the reader to Congo in 1959, where a Baptist missionary family from small-town Georgia is overrun by unstoppable forces of revolutionary change. Of particular focus are two teenage heroines, Leah and Rachel Price, who have given up civilization to minister to the "heathens." In the end both are transformed by a world no longer willing to bend to Christianity and the Western ways of Betty Crocker and Art Linklater.

Oprah's Book Club, loyal to the fiction of Maya Angelou and Toni Morrison, included Morrison's first novel, *The Bluest Eye* (1970). Growing up poor and black in a harsh, dysfunctional family, Pecola Breedlove is an 11-year-old who wishes for blue Shirley Temple eyes so she will be loved like the white children around her. The story underscores issues of race and beauty, which continue to be relevant. Oprah's

selection, given her position of power in the entertainment industry, provides a measuring device for changes that have taken place for African Americans in the United States. Selections for the Book Club have proved an economic boon to each of the authors selected, often bringing classic novels back to the bestseller list.

Oprah's Book Club Selections Featuring Significant Girl Characters

1996
The Book of Ruth (1988) by Jane Hamilton
She's Come Undone (1992) by Wally Lamb
1997
Stones from the River (1994) by Ursula Hegli
The Rapture of Canaan (1995) by Sherri Reynolds
Ellen Foster (1995) by Kaye Gibbons
1998
Here on Earth (1997) by Alice Hoffman
Breath, Eyes, Memory (1994) by Edwidge Danticat
Where the Heart Is (1995) by Billie Letts
1999
White Oleander (1999) by Janet Fitch
Mother of Pearl (1999) by Melinda Hayes
The Poisonwood Bible (1998) by Barbara Kingsolver
2000
Gap Creek (1999) by Robert Morgan
Daughter of Fortune (2000) by Isabel Allende
The Bluest Eye (1970) by Toni Morrison
River, Cross My Heart (1999) by Breena Clarke
Drowning Ruth (2000) by Christina Schwartz
2001
We Were the Mulvaneys (1996) by Joyce Carol Oates
Icy Sparks (1998) by Gwyn Hyman Rubio
Cane River (2001) by Lalita Tademy
2002
Fall on Your Knees (1996) by Ann-Marie MacDonald
The Heart Is a Lonely Hunter (1940) by Carson McCullers[37]

In addition to her Book Club, Oprah chose two girls coming-of-age novels for adaptation as television movies in her *Oprah Winfrey Presents* series: Connie May Fowler's 1997 novel *Before Women Had Wings* and Elizabeth Strout's 2000 *Amy and Isabelle*. Fowler scripted *Before Women Had Wings* for television

with Oprah Winfrey as the wise neighbor Miss Zora and Ellen Barkin as the alcoholic, abusive mother, Gloria Marie Jackson, for which she won an Emmy. Julia Stiles played the teenaged Phoebe Jackson, with Tina Majorino as her sister Bird. Outside of Oprah's list, Sue Monk Kidd's 2002 bestseller *The Secret Life of Bees*, like Fowler's *Before Women Had Wings*, features an abused Southern girl who is spiritually rescued by an African-American woman. Though girls are the focus of these coming-of-age novels, they are written mostly by adult women for adult female readers. With such a prodigious number of examples, the victimized girl overcoming all odds has become one of the core heroines of American literary and cinematic imagination and marks a parallel to the overwhelming interest in non-fiction titles dealing with girls in need of rescue. Yet popular fiction for women often sets these girls finding a unique voice and survival mode into young adult-hood. Oprah's confessional forum on her extremely successful television show has brought a plethora of girl survivor stories into the public eye.

While most of Oprah's Book Club selections are fiction, the memoir itself, like confessional television, found a remarkably successful publishing niche in the 1990s, with many documenting young women overcoming challenging childhoods with spunk and wit, such as Mary Karr's *The Liars' Club* (1995) and Sapphire's *Push* a novel drawn from the author's experiences as an inner city teacher. Like the Book Club selections, these books were successfully marketed to multicultural women across the economic spectrum as evidence of collective interest in tales about adoles-cent girls searching for recognition. Dorothy Allison's *Bastard out of Carolina* (1993), a grueling, semi-autobiographical story set in Greenville, South Carolina, concerns Ruth Anne "Bone" Boatwright, a girl born into extreme poverty. In an attempt to legitimize her "bastard" daughter, Bone's mother Anney unwittingly marries a sexu-ally abusive man. The novel, adapted and directed by Angelica Huston in 1996 with financing from HBO films, met with considerable distribution difficulty due to its explicit content and was offered limited DVD release.[38] Despite this, Jena Malone's portrayal of the gutsy Bone won her great praise, establishing her as an indie favorite throughout her teenage career. In an interview in *BUST*, she describes the experience of taking on such a difficult role at a young age:

> People think that young actresses shouldn't go through these things but I understood what I was going to be doing, and never once did anyone try to manipulate my feelings or manipulate how I was going to emotionally react in a scene.[39]

These rite-of-passage novels and memoirs tapped into millennial adult female interest in the Girl Icon in literature as a stand-in for their own forms of recovery and power. Girl Icons in print along with Girl Icons in visual media have been guiding grown women in their search for clues to their lost girlhood. This trend toward girls' coming-of-age tales as sources for popular women's fiction belies a

collective need to revisit childhood, to locate a survival code in the form of a spunky young heroine. Girl Heroines written for women readers—especially those who prevail despite many trials—relate to the Supernatural Heroines discussed earlier, who have been serving a deep psychological need in the collective mind since the mid-1990s.

Literary fiction's theme of a Single Mom parenting a teenage daughter found its way into several millennial feature films, including the 2003 remake of *Freaky Friday* (Mark Waters), the indie favorite *Tumbleweeds* (1999, Gavin O'Connor), and many others adapted from some of the aforementioned "women's novels," including *Anywhere But Here* (1999, Wayne Wang), based on the popular mid-1980s novel by Mona Simpson, and *White Oleander* (2002, Peter Kosminsky) drawn from Janet Fitch's best-selling book. Catherine Hardwicke's *Thirteen* (2004), based on an original screenplay, also part of the Single Mom/Teenage Daughter trend, will be discussed in detail in the next chapter.

Given how the early imprint of the teenage heroine in Disney animated features is motherless and must navigate the older female as evil incarnate, the emergence of mother/daughter relational explorations on film (often drawn from bestselling novels) marks new representational terrain in popular media. In *Anywhere But Here*, Adele August (Susan Sarandon) decides impetuously to move from Bay City to Beverly Hills, with plans for her daughter Ann (Natalie Portman) to become a movie star. The 17-year-old Ann has other ideas—she wants to move east to attend an Ivy League college and is sullen and resentful of her mother's reckless behavior. The tagline of the film, "The story of a mother who knows best and a daughter who knows better," continues the role-reversal trend found in *Absolutely Fabulous* and *Gilmore Girls*. The mom is a live wire and the daughter must reduce her amperage to survive. But the mother seems to be having the most fun!

Tumbleweeds, based on an original story by Angela Shelton, takes to the road like *Anywhere But Here*, with a free-spirited Southern woman Mary Jo Walker (Janet McTeer) and her 12-year-old daughter Ava (Kimberly Brown) as a duo on the run from failed relationships. Moving from state to state, job to job, school to school, this pair of adaptable survivors rises above any suggestion of victimhood to make the most of newness as inspiration, which eventually lands them in San Diego. Unlike Natalie Portman's cold, glaring personification of the resentful teen in *Anywhere But Here*, McTeer and Brown radiate a quirky warmth that provides breakthrough representations of mother-daughter intimacy, including a humorous first period interlude and a kissing lesson on an apple. The slogan for this film, "They ran away from everything but each other," underscores this contrast in tone. *Anywhere But Here*, distributed by 20th Century Fox, had a much wider distribution than *Tumbleweeds*, an independent production released by Fine Line. While both feature reckless mothers, the ultimate exploration of the mother-daughter bond is the focal

point. Despite Adele's ditzy glamour ideal for her daughter and her fears of college costs, she eventually sees her off at the airport into her teenage girl dream.

White Oleander, the darkest of this triad of motion pictures, presents the mother, Ingrid Magnussen (Michelle Pfeiffer), as a brilliant but evil presence from whom the daughter Astrid (Alison Lohman) must liberate herself psychologically. The film involves a cast of surrogate foster mothers, including Robin Wright Penn and Renee Zellweger, yet Pfeiffer's performance as the riveting icy blonde who murders her lover with poison in a perfect crime gone awry proves frighteningly magnetic. With Astrid constantly on the move, the suitcase becomes an artistic trope for coping with the many difficult stages of her short life. By the end of the film, she creates a series of mixed-media scenes in vintage suitcases representing each of the mothers she has known.

Freaky Friday, the hugely successful 2003 remake of the goofy 1976 original, breaks from nuclear family fare to rewrite the mother as Tess Coleman (Jamie Lee Curtis), a single mother on the verge of remarriage who shares a magic fortune cookie with her 15-year-old teenage daughter Anna (Lindsay Lohan), causing them to switch identities. Disney's slapstick, corny original features embarrass-ing housewife mishaps by Ellen Andrews (Barbara Harris) with a bubbling-over washing machine, a scene water skiing in a black dress, and a pivotal Pat Nixon make-over for her tomboy daughter Annabelle (Jodie Foster). The Curtis/Lohan remake situates the mother in a multitasking career as a psychologist and the daughter as the lead guitarist for a girl band. When Anna becomes Tess, she takes full advantage of the credit cards to provide the mother with a complete make-over—new clothes, hipster haircut, and a pierced ear cuff. In fact, Anna-as-Tess becomes so cool/desirable that Anna's boyfriend (Chad Michael Murray) develops a far-fetched crush on her. Tess-as-Anna comes to realize that being a teenage girl requires skills she hadn't acknowledged before. Beyond being unable to play the electric guitar onstage when living in her daughter's body, she comes to a deeper appreciation of the stresses of school and social cliques that Anna navigates on a daily basis. Anna-as-Tess takes on a full roster of therapy clients, dishing out earthy, honest, "untrained" advice but is glad to relinquish her mother's responsibilities when the fortune cookie spell breaks the next night.

Comparing the two versions, notable is the seeming age difference between Jodie Foster's 15-year-old Annabel and her unsophisticated group of preadoles-cent girlfriends, all "kids" with bad haircuts and baggy tomboy pants who play field hockey and eat ice cream after school. On the other hand, Lindsay Lohan's Anna, the sophisticated lead singer and guitarist for her own ambitious garage band, joins arty hipsters wearing black nail polish and "Chica" T-shirts. The point of both movie versions is that mothers and daughters can understand one another only by spending a day in each other's shoes. Since 1976, those shoes have changed

considerably, and intergenerational interest by girls in adult culture and women in Girl Culture spells significant representational differences. In 1976, the generation gap was palpable, with the shallow approach making fools of them both; in 2003, while hardly highbrow Austen material, the mother and daughter both emerge with audience respect.

Beyond the few classic examples listed above, such as *National Velvet*, the majority of mainstream teenage girl-driven movies from *Snow White and the Seven Dwarfs* and *The Wizard of Oz* to *Taxi Driver* before the 1990s feature motherless daughters fending for themselves. In the Nabokov's novel and the subsequent films, Lolita's mother dies early in the story, leaving her to deal solo with Humbert Humbert. The millennial trend in representing Girl Icons includes increased pairing with supportive mothers rather than just Evil Stepmothers from Hell. This trend in exploration of intergenerational relationships bodes well for a balanced culture of narrative structure in the mother/teenage daughter paradigm. After all, Elastigirl keeps her name (and flexible superpowers) after having three kids and a life incognito as a Super Mom in *The Incredibles*. She and her teenage daughter Violet combine powers with the other Incredibles to help save the world. Since pop culture has yet to find a way to include Wise Girls interacting with teenage granddaughters who aren't only Grandma trees, as in *Pocahontas*, or Royal Queens with material goods, as in *The Princess Diaries* (2001, Garry Marshall), a fuller spectrum of women and girls of all ages awaits us.

If you still think your woman/girl dictionary pages require Hermione's "Oculus Reparo" to understand them fully, it's because the terms are still transitional, with Girls who want to be Grown-up Girls a rampant phenomenon and Women who have rediscovered the power of being Girls. Claiming Girl Power has shifted the focus of the women's movement to Girls. Yet underlying that focus are the rights and power of women as well. The *Reviving Ophelia* efforts of women scholars, artists, and activists have been as much about reviving representations of Girls as about rescuing women and reclaiming feminism through alternative Icon making.

The Girl Gaze:
Indies, Hollywood, AND THE
Celluloid Ceiling

The changes in depictions of mother-daughter relationships on film, as well as revisionist ideas about Single Moms, Teen Moms, and Girl Heroines, have been influenced by the increased role of women behind the scenes in the film and publishing industries, as well as the prodigious output of women's rite-of-passage novels and memoirs entering the millennial idea stream for screenplay adaptation. While the changes in the power structure of Hollywood continue to move at a shockingly slower pace than other male-dominated industries, the impact of women as Executive Producers, Directors, Writers, and Television Series Creators cannot be denied. That said, an initial glance at Martha M. Lauzen's "Celluloid Ceiling Study" is enough to induce math anxiety. This annual San Diego State University study has been reporting on behind-the-scenes statistics for women in the film and television industries since 1998. Lauzen's 2005 study found that women made up only 26 percent of producers, 11 percent of writers, 16 percent of editors, and a mere 3 percent of cinematographers. In 2004, despite Sofia Coppola's historic nomination for Best Director at the Academy Awards, only 5 percent of Directors were women.[1] In an era of discussions about girls, self-esteem, and popular media, the equation seems clear: it all comes down to who is looking through the lens. In any given year, women rarely determine the final framing of female bodies on the big screen, though they are clearly influencing content, editing, and character creation. While women directors have made inroads into the

genres of documentary, coming-of-age dramas, and romantic comedies, men by and large still direct horror and action films. According to Lauzen's study,

> Women comprised 31% of individuals working on romantic dramas, followed by 30% on romantic comedies, 22% on documentaries, 17% on dramas, 16% on comedy/dramas and 16% on sci-fi features, 15% on animated features, 14% on comedies, 9% on action adventure features, and 4% on horror features.[2]

These statistics do not reveal whether women are consigned by gender to certain genres of filmmaking or whether this is entirely a matter of choice, though shifts have occurred with the action genre (eg. Karyn Kusama's 2005 *Aeon Flux*). Increased interest in female action characters with the warrior finesse of Trinity in *The Matrix* films, as well as the Supernatural Girls mentioned in Chapter Seven, will no doubt bring more women directors to treatments of this genre. However, the required big budgets of most action films with special effects enhancements, sets, and explosions may make this genre off limits to most young filmmakers, though the most creative directors can always find ways around the issue of big budgets. Georges Méliès' remarkably magical *Le Voyage Dans La Lune* (1902), Maya Deren's surreal *Meshes of the Afternoon* (1943), Chris Marker's *La Jetée* (1962), and Andrei Tarkovsky's *Stalker* (1979) are ample evidence of memorably innovative approaches to special effects and sci-fi moods. A trip to YouTube weblogs proves audience interest can be drawn off a low-end video camera if the character onscreen is compelling. Budgets aside, some women directors may simply be more motivated by character driven stories. Either way, the driving force behind any director's film remains the singular unwavering passion to manifest a vision onscreen. These women are simply undeterred by "I don't think so …" or "You can't do that …"

Compared with the field of medicine, however, where steady annual increases since the 1970s resulted in a 44% female medical student population in 2002–2003,[3] Lauzen's celluloid coiling statistics clearly show the film world lags behind. Given the power of global media in imprinting and encoding our identities, this gender imbalance is nothing short of a feature-length wake-up call. With Entertainment Media one of our largest global exports, American media making continues to exert a tremendous influence. Should wealthy white males control the cultural production of 85 percent to 90 percent of global media? In the interests of representational equity the answer would have to be a resounding "No."

Despite the obvious Sisyphean task revealed by Lauzen's statistics, first-time women directors have been instrumental in introducing new Girl Icons to the mainstream in recent years, as have screenwriters, producers, and other women behind the scenes. While the numbers may still favor the Big Boys in the business, it's important to note how many of the significant changes and "out of nowhere"

success stories of both independent films and television series shaping new gender constructs have come from the unwavering focus of women filmmakers, producers, and writers. Christine Vachon, the producer of many successful cross-over independent films, notably Kimberly Peirce's *Boys Don't Cry* (1999) (see Chapter Six) is the owner of Killer Films, and has written two excellent behind-the-scenes accounts based on her evolution as a producer in the era of independent film's transition to Hollywood distribution deals. Her dogged efforts with directors Todd Haynes, Mary Harron, John Waters, Todd Solondz, and others have earned her a significant place in the recent history of filmmaking.[4] These books provide a realistic how-to for aspiring filmmakers, with key insights into the process of getting a film made and out into the public eye.

In addition to the role played by Vachon and other independent producers in getting new Girl Icons to the screen, Female Executives of 1990s and 2000s Hollywood have served as cultural shape shifters through newly evolving power to greenlight projects in Hollywood.[5] Following executive breakthroughs in the 1980s by Sherry Lansing, who became the first female President of Production at Paramount Pictures in 1980, and Dawn Steel, who in 1987 took the mantle as first woman to head Columbia Pictures, the recent "girls network" has had an influence on expanding notions of gender in such films as *Spiderman*, where the brooding, thoughtful male provides a new level of depth to the classic action hero, and gender-bending female action Heroines in the Drop-Dead Gorgeous Warrior style of Lara Croft have managed to kick through a few glass ceilings.

Sabrina, the Teenage Witch, produced jointly for ABC-TV by actress Melissa Joan Hart and her longtime agent/mother Paula Hart, represents an interesting piece of behind-the-screens power for the star and her mother to match the magic spells onscreen. Created by Nell Scovell, a writer for *Murphy Brown* (1988–1998, Diane English, Creator), *Sabrina, the Teenage Witch* demonstrates a professional female lineage in television which not only made it possible for this teenage Power Girl character to emerge on one of the "big three" networks but no doubt influenced the favorable depiction of Sabrina's middle-aged aunts. As indicated in the earlier discussion of *Sex and the City*, the increased presence of women behind the scenes has definitely expanded female points of view in terms of subject matter and characterization. The list grows prodigiously. *Buffy the Vampire Slayer* had the backing of several female WB Executive Producers—Gail Berman, considered to be the driving force behind bringing *Buffy* to the television screen, Fran Rubel Kuzui, Marti Noxon, and co-Executive Producer Jane Espenson. Both Espenson and Noxon had additional roles as writers and directors for the series, and for its last two seasons after leaving the WB for UPN, creator Joss Whedon turned the helm over to Noxon.[6] The short-lived CBS drama *Joan of Arcadia*, 2003–2005,

was created by veteran network TV writer/producer Barbara Hall, who worked on *Judging Amy* (1999–2005, CBS-TV) and *Northern Exposure* (1990–1995, NBC-TV). Salma Hayek, a successful actress memorable for her portrayal of Frida Kahlo in *Frida* (2002, Julie Taymor) as well as many other films, is the Executive Producer of the runaway hit series *Ugly Betty* (2006–?, ABC-TV), demonstrating how many actresses are taking roles behind the scenes as well as *on* the scenes.

While numbers remain an important consideration, it is crucial to acknowledge the significant impact of women directors in introducing young female characters who have gone on to achieve iconic status, through gender-bending themes, pop cultural trends, and new ways of considering girls in our culture. With the slow but steady increase in women behind the scenes, the heyday of Arnold Schwarzenegger, Sylvester Stallone, and Steven Segal machismo has waned. Women's presence in studio chairs at the big desks has been linked to the arrival of many girl-themed films, including the highly successful *Freaky Friday* and *The Princess Diaries*,[7] as well as the gender-bending Girl Icons discussed in previous chapters.

Even more powerful than gun-toting females or action chicks is the image of a woman on the set pointing her finger authoritatively or peering into the long arm of the camera lens. Every era of film history has been influenced by the contributions of women, which include Alice Guy-Blanché, Mary Pickford, Dorothy Arzner, Maya Deren, and many others. Yet those recognized as Directing Geniuses and Auteurs in Cinema History—Hitchcock, Huston, Wilder, Truffault, Godard, Scorcese—have been overwhelmingly male. Yet, since the 1980s, more and more female directors have been increasing their influence on pop cultural representations of all kinds. While the tracking of industry numbers is important, it's also imperative to take notice of the cultural shifts that take place when women directors do find the crew and the backing to manifest their visions onscreen.

Gillian Armstrong's 1994 adaptation of *Little Women* featured Susan Sarandon as Marmee in a beyond-smarmy interpretation that included Winona Ryder as Jo, Kirsten Dunst as the young Amy, and then unknown Claire Danes as Meg. While not culturally earth-shattering, this full-fledged portrayal of a supportive, intelligent mother to her four daughters did so well at the box office[8] it began a trend in girl classics on the screen, recognizing the value of pulling in literary girls and their mothers, which continued with the mining of Jane Austen for adaptations. Amy Heckerling's rewriting of Jane Austen's *Emma*, *Clueless* (1995), had an impact on retrofitting classics as pop cultural phenomena that influenced 1990s vernacular, like the widespread use of the campy, dismissive "Whatever ..." That the film continues to find its way onto "Best of the 1990s" lists underscores its

continued influence as a comedic Teenage Girl rite-of-passage story. Likewise, Susan Seidelman's *Desperately Seeking Susan* (1985), produced by Sarah Pillsbury and Midge Sanford, launched the career of Uber-Icon Madonna.

Despite the success of many female directors, certain myths about female failure abound. In the unexpectedly high-grossing independent feature *The Blair Witch Project* (1999, Daniel Myrick and Eduardo Sanchez), made for the garage band amount of $60,000,[9] Heather Donahue, a hysterical, screaming young director of a documentary, loses her crew to an unseen demon in the woods during a location camping trip. On *verité* footage "found" by the producers, Donahue famously "self-interviews" by flashlight in a tears-for-fears victim monologue. "It's my fault because it was my project," she sobs, hardly emerging as the poster girl for young women filmmakers. However, her directorial personality—annoying, hysterical, or otherwise—serves as the driving force of this Indie film, which grossed upward of 140 million dollars. Needless to say, despite this enormously popular depiction of a female documentary director doomed to more than filmic failure, many women directors in Indie Land have clearly managed to direct successful narratives and docs without putting themselves or their crew in mortal danger.

2004 proved a banner year for women directors at the Academy Awards, with nominations for Best Director and Best Original Screenplay, among others. That three of these films—*Lost in Translation*, *Thirteen*, and *Whale Rider*—involved stories about adolescent girls and/or young women is significant. That they were all directed by women—Sofia Coppola, Catherine Hardwicke, and Niki Caro—who went on to make subsequent big-budget films in 2005 and 2006 is also significant. While it will take some time for the statistics to catch up, Sofia Coppola's Oscar nomination for Best Director and the presence of women directors and writers in national box office hits will no doubt influence the career choices of a new generation of young women filmmakers. It is important to note, however, that all three of these films were produced independently, often as co-productions with several small film companies. *Lost in Translation*, produced through American Zoetrope, with the blessing of film royalty in the form of the Coppola family dynasty, was released by Focus Features. *Thirteen*'s production partners included three independent entities, but was ultimately released by Fox Searchlight Pictures. *Whale Rider* garnered production funding from the New Zealand Film Commission and New Zealand Production Fund along with several other independent entities with theatrical distribution through Newmarket Films. In other words, these fresh characterizations of teenage girls were not funded by corporate Hollywood monies except at distribution, after having gained traction at the Sundance, Cannes, Toronto or Berlin film festivals. That some of the most interesting and culturally groundbreaking films manifest outside of Hollywood is notable. Additional studies tracking the contributions of women filmmakers in the independent film industry

will be important, given the influence of these films on the creation of new cultural Icons.

While many women have taken on powerful industry roles as Executive Producers, Directors, Writers, and Creators of network shows, documentaries, and feature films, certain technical areas of Hollywood remain entrenched boys' clubs. The most salient example is cinematography. According to Lauzen's "The Celluloid Ceiling," depending on the year, 0–4 percent of women cinematographers find themselves at the helm on film sets of the top 250 Hollywood features.[10] Even when women direct, this crucial technical issue of the Collective Gaze in mainstream media deserves examination. From a strictly technical point of view, even with independent features directed by women, the gaze is often male. Catherine Hardwicke worked with cinematographer Elliot Davis for *Thirteen* and *The Nativity Story*; Sofia Coppola worked with Lance Acord on both *Lost in Translation* and *Marie Antoinette*; and Niki Caro with Leon Narbey on *Whale Rider*. What does this mean in terms of the way male or female bodies, faces, and spatial relationships are constructed and lit in cinematic space? Whose lens, whose gaze courses across the physical bodies and faces of those on screen? Who sets up the technical shots on the basis of a history of visual significance and symbols of power? And how does this technological statistic about The Gaze define our view of physical bodies in filmed spaces? With eating disorders a continued issue for young women and girls, the ways the lens represents female bodies remains an extremely important consideration. Why do so few women enter this exclusive club, clearly a key adjunct to articulating the director's vision?[11]

One area of technical expertise in which women have excelled historically is editing. In 2007, Thelma Schoonmaker won her third Oscar for Best Achievement in Film Editing for Martin Scorsese's *The Departed*. Her first Oscar was for *Raging Bull* (1981); her second for *The Aviator* (2004). The percentage of women working professionally in this role in Hollywood comes in higher (17% in 2005) than the director slot (7% in 2005), with these contributions significant given the level of industry recognition combined with the way highly visible honors imprint female career goals in the industry. Despite editing's reputation as an "invisible art," editors shape the story and in many cases filmmaking history, often with quiet fanfare. Tina Hirsch, the first woman elected President of the American Cinema Editors (ACE) in 2001, has made it her mission to bring more public awareness to the role of editors in filmmaking.[12] Part of the task of film scholars and historians involves continuing to shed light on the cultural influence of women in the edit suite.

Dede Allen, known for innovative uses of the medium in such auteur films as *Bonnie and Clyde* (1967), *Serpico* (1973, Sidney Lumet), and *Reds* (1981, Warren Beatty), also edited the Brat Pack classic *The Breakfast Club* (1985, John Hughes). Likewise, Verna Fields (1918–1982), who won an Academy Award for her work

on Stephen Spielberg's 1975 summer thriller *Jaws*, also cut George Lucas' 1973 high school nostalgia flick *American Graffiti* (1973, George Lucas). The 1962 Peter O'Toole classic *Lawrence of Arabia*, directed by David Lean, was edited by Anne V. Coates, who provided the splice to such notable films as *The Elephant Man* (1980, David Lynch) and *Erin Brockovich* (2000, Steven Soderbergh). Of key girls' rite-of passage narratives mentioned in previous chapters, several were edited by women, including Karyn Kusama's *Girlfight* (2000) by Plummy Tucker; Kimberly Peirce's *Boys Don't Cry* (1999) by Tracy Granger, who also edited Allison Anders' *Mi Vida Loca* (1994) and *Gas Food Lodging* (1991); and *The Sisterhood of the Traveling Pants* (2005) by Kathryn Himoff.[13] While the "Celluloid Ceiling" statistics may be numbing, the groundbreaking role of women in pivotal films often proves far more culture-shifting than the absence of a Geek Girl army would suggest. As more women take to the helm as Executives, Producers, and Directors, there will no doubt be more women trimming clips as well.

INDIE SCENE AND THE RITE OF PASSAGE NARRATIVE

While Jewish culture's Bat Mitzvah ceremonies along with Latina Quinceañera celebrations have increased as important cultural rites of passage for girls in the new millennium, American adolescent culture at large lacks a formal rite of passage into adulthood. The Teenage First Time spans drug use, falling in love, sexual encounters, road trips, and nose rings. Beyond fashion and body art, movies server as the primary venue for depictions of the First Time. There, in the dark, we acquire our archetypal notions of what it means to become an adult in terms of gender, power, and sexuality. The Cinderella story, a trite manifestation of this transformation, takes form as a "sophistication make-over" in many teenage girl scenarios. Despite the absence of formalized rituals for most of American youth, popular culture on the big screen and on television is now saturated with rite-of-passage narratives. By viewing First-Time movies in a group, American teenagers acquire a collective vocabulary of entry into adulthood, largely visual but very much identified with an iconic Folk Hero or Heroine, a stand-in for the adolescent psyche. As explored in previous chapters, this historically male figure has in recent years acquired a female identity, with many more of these narratives involving teenage girls proving themselves as proficient Warriors, Soccer Aces, Witches, and, in some cases, Sex Symbols.

As discussed in the previous chapter, adult viewers return to the rite-of-passage movie and the rite-of-passage novel as a collective opportunity to start afresh, to reinvent an often less-than-ideal entry into adulthood, to lay aside awkward autobiography for the more evolved, special effects-enhanced version

of a screen protagonist. The viewer accesses the euphoria of the First Time, not just sexually but through all forms of awakened experience. Ritual as viewership becomes an endless youth culture renewal. For teenage viewers, this is their moment, their entry, their embodied euphoria mirrored on the screen. For adults it's revisitation by proxy.

In the 1950s, mostly teenagers were interested in *Beach Blanket Bingo*. 1950s parents listened to entirely different music and watched different kinds of adult dramas. Teen films were not taken seriously by adults. In the 1990s and 2000s, however, the teen subject became as generationally cross-over as music. Baby boomer parents share a culture in common with their teenage offspring, which includes the nostalgic allure of the screen teen. And many of these rite-of-passage stories with girls as protagonists emerged from the edgy independent film scene directed by women. The increase in multicultural Girl Tales has expanded aspects of the film canon, which traditionally mirrored the *Bildungsroman* of classic literature, with a Young White Male as its subject. For a culture bent on a rapacious search for "virgin" storytelling, a rebalancing of gendered Icons has been one of the by-products. Like first novels, first features often tell a coming-of-age story, and women telling these stories from a girl's perspective has marked a major cultural shift.

Years since its inception in the late 1960s, Sundance has become a seedbed for Hollywood distribution companies. By the 2000s, with the unprecedented success of independent distribution companies like Miramax, the category of independent film transformed to the point of a blurred role between Hollywood and independent studios. Before the success of Steven Soderbergh's 1989 *sex, lies, and videotape*, independent cinema rarely crossed over to the mainstream.[14] Art films were shown in limited release to a rarefied audience in film festivals, galleries and museums, and "art house" cinemas. Miramax, Good Machine, and other distribution companies changed that in the 1990s, with some cross-over successes such as *The Blair Witch Project* literally emerging from the woods. The Sundance Film

enwriting and Directing Labs[15] have seeded opportunities

ral and female voices to find expression. In the context of

nany independent perspectives on the teenage girls narrative

rst independent feature, *Gas Food Lodging* (1992), broke sig-

he story of Nora (Brooke Adams), a single mother with two

ning a small-town Texas truck stop. The younger daughter,

an offbeat romantic with a penchant for Mexican border

crossing, fantasizes about a "normal" life with a live-in father. The older daughter, Trudi (Ione Skye), seeks the adult male attention she craves through direct contact, which leads not only to a reputation as the town Slut but to a full-term pregnancy that ends with an adoption in Dallas. This painful turn of events provides her with a

ticket out of "smallville" scrutiny and onto a new life. Trudi and Shade's appearance contributed to the first wave of teenage girl representation in early 1990s independent filmmaking, giving voice to previously ignored complexities of growing up female without a father.

Anders' second feature, *Mi Vida Loca* (1993), draws its characters from the girl gangs of Echo Park in East Los Angeles. Sad Girl (Angel Aviles) and Mousie (Seidy Lopez) take the viewer through a unique glimpse of *chola* culture, as these former best friends compete for Ernesto (Jacob Vargas), the drug dealer and gang leader who fathers their babies. Following Ernesto's murder, the Teen Moms resolve their "she's a bitch" differences to recreate girl community on the other side of premature adulthood. This subtle resolution provides an alternative to oversimplified depictions of female rivalry on screen, underscoring the fact that survival in the barrio often depends upon female community. Unlike Hollywood's pre-multiculturalist approach to *West Side Story* (1961, Robert Wise and Jerome Robbins), in which mostly white actors and actresses play the teenage Puerto Ricans in "brown face," Anders tapped directly into Chicano culture, hiring all Latino acting talent. To make her script as authentic as possible, Anders based much of her dialogue on street interviews from ten years living in neighborhoods populated by Chicanas.[16]

In 1992, Leslie Harris brought an African American spin to the teenage girl tale with *Just Another Girl on the I.R.T.*, honored with a Special Jury Prize at Sundance. Often compared to John Singleton's *Boyz n the Hood* (1991), this film introduces Chantel (Ariyan Johnson), a high-achieving 17-year-old girl living in a Brooklyn housing project. A straight-A student, Chantel plans to graduate early and exit the ghetto for college and a medical career. These plans stall when she meets Tyrone (Kevin Thigpen) and falls in love. Chantel, now pregnant, is faced with the decision to have an abortion and pursue her career or have the baby and set aside her dreams. In conversations with her friends, Chantel reveals their collective ignorance about baby making. Despite her interest in medical school, these scenes demonstrate the persistency of urban myths about pregnancy (can't happen standing up; during your period; or if withdrawal takes place quickly enough, etc.). Harris explores the complex distractions even ambitious girls face on their way to achieving their personal goals. Though made on a slim budget of 130,000 dollars, the film received good reviews, despite reservations about the ending, which involves a clumsy homebirth scene, and the fact that promising, intelligent Heroine Chantel allows the pregnancy to occur. Yet, unlike her contemporary John Singleton, Harris has yet to produce another feature film.[17]

Lisa Krueger wrote and directed the quirky *Manny & Lo* (1996) as an unusual take on teenage pregnancy, tenaciously loyal sisterhood, and the search for absent mothers. Following the death of their mother, 16-year-old Laurel, or "Lo" (Aleksa Palladino), and 11-year-old Amanda, or "Manny" (Scarlett Johansson), escape the

fate of foster care by taking to the road in the family station wagon. On the lam, they move on whenever trouble or the police show up in the rearview mirror. The duo shoplifts for food and break into fully furnished model homes, where they sleep at night, making ample use of the clean towels and toiletries. There, they fantasize about living a "normal life." When Lo discovers she is pregnant, her Tough Girl persona waxes needy until she scams a plan to enlist Manny's help in kidnapping a maternity store saleswoman named Elaine (Mary Kay Place). Brandishing an antique gun, the girls bring Elaine to a rustic vacation cabin to await the baby's arrival. Though Lo refuses to succumb to sentimentality, she heeds Elaine's advice to stop smoking and improve her prenatal eating habits. When the girls are forced by intruders to leave the cabin, the baby is born alongside a stream in a "back-to-nature" plotline twist. There, Lo finally surrenders to her need for help from the mother figure Elaine, who becomes her unwitting midwife. Despite the absurdist tactics of *Manny & Lo*, Krueger tackles the issues of sisterhood and improvised motherhood in the context of low-budget survival, in many ways a metaphor for the task of bringing an independent film to fruition.

First-time directors Alison Anders and Leslie Harris began to explore the young female rite-of-passage narrative in the early 1990s with a modest degree of box office success combined with a critical success soon "trendified" by male directors in Hollywood who realized that these storylines were not only fresh but when told from a Male Gaze perspective, many teenage girls crossed over as sex symbols. Ten to twelve years later, however, rite-of-passage features by Independent directors Sofia Coppola, Niki Caro, and Catherine Hardwicke have moved beyond awards at Sundance to winning Oscars and expanding viewership at the multiplex. The emphasis on the marketability of the teenage girl as subjects has been very good news for a number of female directors who, even in mainstream Hollywood features, are being called upon to direct vehicles for Teen Stars. In addition to Amy Heckerling's role in promoting the teenage girl subject via *Clueless* in 1995, Martha Coolidge directed Hilary Duff in *Material Girls* in 2006, while two women directors were hired by Disney Corporation to direct Lindsay Lohan in *Herbie: Fully Loaded* (2005, Angela Robinson) and *Confessions of a Teenage Drama Queen* (2004, Sara Sugarman), with editing by Anita Brandt-Burgoyne and Wendy Green Bricmont, respectively.

WOMEN DIRECTORS AND THE GAZE

While a certain number of clearly pink and fluffy teenage girl vehicles have emerged from Hollywood with women directors as hired guns in the past decade, many significant changes have taken place in Teenage Girl iconography since the

1990s, in part due to the efforts and storytelling of women directors and women behind the scenes in other capacities. The new generation of girl rite-of-passage narratives directed by male directors, in particular Sam Mendes' *American Beauty* (2000) or Bernardo Bertolucci's *Stealing Beauty* (1996), involves loss of virginity, or in the case of Cameron Crowe's *Almost Famous* (2000), the sexual promiscuity of a teenage girl as the focal point. As discussed in Chapter Two, the young actresses making their debuts in these films were eroticized as part of the packaging of the films. But what happens to stories of girls' lives when a female director takes the helm? Do women behind the lens engage in a different form of looking less objectifying, or do female narratives simply replicate a classic Male Gaze? Some would argue that female directors are less objectifying in their gaze than male directors, while others maintain that the very act of "shooting" is an aggressive act regardless of the director's gender. While Sofia Coppola's *The Virgin Suicides* (1999) deals with Lux Lisbon's (Kirsten Dunst) loss of virginity as a turning point in the film, the difference in treatment revolves around the complex Catholic culture of five vibrant sisters stifled by their parents' restrictions. And while the film deals with the subject of suicide, Coppola's gaze expresses absence with shots of empty rooms and an abandoned turntable rather than graphically violated bodies. Her final scene in 2006's *Marie Antoinette* uses the same trope: we see torn bedclothes and a broken chandelier as telltale results of recent violence.

When discussing Coppola's *Lost in Translation* in my lectures and classes, female students often point out that Sofia Coppola objectified Scarlett Johansson by showing her in her underwear, making her "no better than a male director." Should female directors be censured for exploring intimacy with the lens? The very act of looking can be termed an erotic act. Looking through the film lens produces a sightline of collective viewership that symbolizes the collective eye of desire, regardless of the gender of the director. Female directors seek an intimate connection with their subjects just as males ones do. The question involves identification versus objectification; that is, sympathizing with characters versus dominating them. In the case of the films discussed above, the way teenage girls are represented with a woman at the helm has made a huge and influential difference, often bringing us to a place of intimacy with a female protagonist, and a complex, humanizing result.

In a 2003 article in Salon.com, Eileen Kelly articulates the way The Female Gaze operates from her perspective in daily life as a "visual machinery" not self-deprecatingly comparative or sexualized. As a straight woman living in New York City, Kelly finds herself in active Gaze mode on a daily basis, looking at women from all walks of life as an exploration of physical, visual, aesthetic language. As she describes it so accurately, it provides an activity, an engagement of visual readership and curiosity not always sexualized or backstab-ish:

Women *do* eye women, no surprise there. What has struck me is that looking at other women's bodies is, for me, a habit as ingrained as tucking my hair behind my ears. It's a tune I can't get out of my head. When teenage girls with their cigarettes out mob past me on the sidewalk; when the weary cashier hands me my change folded into the receipt; when a friend shifts her weight as together we push playground swings—I realize I am doing it. It's my machinery buzzing, and I can't turn it off. ...

A woman's body—in everything shy of a burqa, I guess—has a table of contents. At least, to me. Form and fashion play a part: The female body is shapely, and cashmere clings. But women's bodies are not only more sticking-out-ish, more visible, than men's bodies—they are more informative. They speak—and I listen.[18]

Kelly describes a type of gaze that is day-dreamy, a kind of half-conscious, breezy frame-search for colors, shapes, and meaning in the daily lives of passing bodies often found in *Sex and the City* street scenes as Carrie Bradshaw muses about her life in New York. With more women at the helm in recent years, our visual culture has been engaging in different forms of looking as well as different definitions of visual desire, and will continue to do so. With cell phone cameras, digital snapshot cameras, video cameras, and web cams a part of our lives, we all have the ability to See Like a Camera, to frame the world like a camera, originally the purview of the cinematographer. That some of these gazes—curious, admiring, roving—find their way into the visual lexicon of mainstream films as well as the eroticized, objectifying Male Gaze named by Laura Mulvey in the mid-1970s (see Chapter Two) means our cinema is undergoing significant transformation. There are Female Gazes as well as Male Gazes. There are Gay ways of Gazing as well. Advertising has been exploring these varied gazes for most of the 1990s and 2000s, with shirtless muscular Young Males on display alongside teenage Girl Models. Getting beyond the question of the Male or Female Gaze to the power of the Human Gaze allows us to acknowledge our own abilities to focus, zero in, and select. In terms of freedom of speech in an increasingly media-saturated culture, using the camera's selective focus expresses our ultimate "right to choose."

THE HYPE ABOUT THIRTEEN

One of the fallouts from the independent film world is that with paltry marketing budgets, shock value and intrigue are strategies employed to gain attention for a "story never before seen or heard." These *cinema verité* films, accorded a level of social realism, often attract viewers in search of "the truth" to the movie theatre. In the case of marketing illusion, ploys like this blur the invention, by presenting them as "based on true stories." Catherine Hardwicke's approach to

Thirteen (2003) involved sharing writing credit with Nikki Reed, the 16-year-old co-star of the movie, who promoted the film alongside her. Tapping into the increased popularity of body piercing in the 1990s and 2000s and youth fashion as a form of modern primitivism, Hardwicke's *Thirteen* featured the audacious image of two girls sticking out pierced tongues on promotional posters. Similar to the hype for Larry Clark's 1995 *KIDS*, the marketing strategy for *Thirteen* was one of "teenage girls in crisis." Coming from the independent scene of "truth," grit, and reality, this narrative achieved notoriety for supposedly "telling it like it is." The movie tapped into the prepared ground of social angst about "sweet girls" like Tracy Freeland (Evan Rachel Wood in her film debut) being infiltrated by negative forces, and Hardwicke's publicized collaboration with Reed lent social realism to the screenplay. Tracy suddenly drops her Good Student persona to pursue drugs, sex, and petty crime with her loose cannon Bad Girl friend Evie Zamora (Nikki Reed). The tag line "It's happening so fast" played to adult concerns about sped-up childhood that fast-tracked them to the theatres. The film garnered an Oscar nomination for Holly Hunter as Melanie Freeland, Tracy's well-intentioned but utterly self-absorbed Twelve Step Mom who must confront her daughter's Persephone-like descent into the underworld of sex and drugs.

The actresses were 16 when they played their 13-year-old characters on screen. Lowering the age bar for these fictitious girls clearly provided part of the marketing hook. We've seen 18-year-olds, 16-year-olds "doing it"—how about 13-year-olds? While girls do seem to "change overnight," only in cinematic space does a productive young student turn a one-eighty when she meets a fast, influential girlfriend. In other parts of reality, it's a process that involves many factors, but Hardwicke successfully filled the tank of the marketing machine with "girls in crisis" hype all the way to the Academy Awards. Savvy to these business strategies, directors like Hardwicke play the system for the box office numbers that will lead them to a second, third, and fourth feature opportunity. In Hardwicke's case, she was given that chance when her debut delivered the necessary returns and brought her to the Oscars. Hardwicke demonstrated that cleverly playing the numbers game is, for better or worse, part of the operation beyond the vision, beyond the script, beyond getting the film made. Generating opening weekend buzz often determines box office success, yet exploitation of teenage girls as sexual titillation factors must be called a spade whether the director is a woman or a man. Ironically, Hardwicke's following feature, *The Nativity Story*, chose the purest, de-sexualized Teenage Icon of all: the Virgin Mary.

MULTICULTURAL NARRATIVES

As the 1990s bridged into the new millennium, the Teenage Girl continued to emerge as a significant protagonist alongside explorations of taboo subject matter and multicultural, gay, and female-centric storylines. Narratives of the "Other," while initially of exotic interest, have come to the mainstream in a fascinating blurring of insider/outsider filmmaking categories. In a culture seeking new and uncovered terrain, an openness to fresh perspectives in Hollywood came of age in the 1990s. Fueled in part by the Women's Studies and Multicultural Studies initiatives at the university level with challenges to the Western canon of classic influencing filmic narrative structure, women's perspectives began to take vision on the screen in larger numbers than ever before. The rise of the American independent film scene, particularly at Sundance in the early 1990s, opened up narrative possibilities as it coincided with multicultural educational initiatives and demands for equity of representation across the United States. The commercial orientation of the media industry, constantly in search of sell-able narratives, has combined with a changing language of gender and race in popular media. In the case of the two films mentioned below, this acknowledges the growing middle-class niche markets for Indian and Latin cultural offerings. When multicultural women filmmakers break new visual ground by introducing characters never seen before, they are often called upon in interviews to "speak for their gender" or "speak for their race." This continues to be an issue for Latino, African American, Native American, and Asian directors of both genders. While liberated from the standpoint of lifting the mantle of "acting white" or "acting like a man," the burden of such mandates, whether explicit or understated, can either be a creative liability or a source of marketing spin. Some of the early 2000s narratives glibly rode the press potential for their unique culture perspectives.

Two 2000s rite-of-passage narratives by female directors, Patricia Cardoso's *Real Women Have Curves* (2002) and Gurinder Chadha's *Bend It Like Beckham* (2002), explore girls' personal aspirations versus their traditional relationships to their families. These films take a look at the blurring of cultures: Chicanos in East LA in one scenario and East Asian Sikhs in London in the other. Both films explore the comedic aspects of culture blending as well as the more poignant issues of a family's desire for social integrity and family values in a predominately European or American city.

Patricia Cardoso, a native Colombian, received the Dramatic Audience Award at the Sundance Film Festival for her *Real Women Have Curves* in 2002, with a subsequent distribution deal by HBO films. Adapted for the screen from a play by Josefina Lopez, *Real Women Have Curves* marked the debut of America Ferrara as Ana Garcia, an 18-year-old Rubenesque Chicana who struggles with her desire to accept a full scholarship to Columbia University in New York City

against the wishes of her Los Angeles-based working-class family. Breakthrough in its depiction of a curvy Latina grappling with self-acceptance and definitions of beauty who clearly sees the value of her intelligence over her appearance, the story leads Ana to rebel against the critical evaluations of her traditional Mexican mother, Carmen (Lupe Ontiveros). Carmen, a histrionic hypochondriac, guilt trips her youngest daughter into remaining in East LA to assist with the family sewing business and believes that cutting Ana down will preserve the family integrity. That Ferrara has gone on to star in *The Sisterhood of the Traveling Pants* (2005), which explores not only the value of loyal female friendship but a diversity of female body types, and ABC's tele-novella-inspired *Ugly Betty* (2006), a spoof of mainstream beauty culture, underscores the pivotal role *Real Women Have Curves* played in establishing her as a new millennial Icon. Cardoso's film not only introduced a Latina perspective on the rite-of-passage narrative of a first-generation immigrant but also questioned the beauty industry's limited view of womanhood in a series of defiantly celebratory scenes. The introduction of an intelligent, first-generation teenage Latina who doesn't become a Teen Mom is a breakthrough alternative as well.[19]

Tapping into the post-Title IX generation fervor for girls soccer, the success of the Women's Soccer League in the United States, and continued global interest in the game, Gurinder Chadha's *Bend It Like Beckham* (2002) became a cross-over hit with tweens, teens, Soccer Parents, and Girl Power athletes. The film provides a foray into the cultural differences between a middle-class English girl, Juliette "Jules" Paxton (Keira Knightley), and Jesminder "Jess" Bhamra (Parminder Nagra), her East Indian soccer pal; its comedic flavor relies on two retrograde mothers fearing for their daughters' future in the world of girls soccer. A devout Sikh, Mrs. Bhamra (Shaheen Khan) is horrified by this unseemly leg-revealing sport and believes Jess should be preparing for law school and eventual marriage, while Juliette's mother (Juliet Stevenson) fears she is becoming a jockish lesbian. Mrs. Bhamra, in the midst of traditional wedding preparations for her eldest daughter Pinky (Archie Punjabi), protests, "Who'd want a girl who plays football all day but can't make chapattis?" Paula Paxton, obsessed with bust-enhancing bras and girlie pastels, hints, "Sporty Spice was the only one without a fella." That the lesbian thread plays for laughs in a PG-13 movie with broad appeal shows how much taboos have shifted. *Bend It Like Beckham* simultaneously explores Girl Power and girl bonding and its effectiveness hinges on the fact that girls still have to fight for their place on the field.

Mediating identity as a cultural ex-patriot, Gurinder Chadha, who co-wrote in addition to directing the film, provides a breakthrough character in Jess, torn

between her devotion to her family and her dedication to playing soccer like her idol David Beckham. Crossing cultural lines in a secret life on the field, she falls in love with her Irish coach, Joe (Jonathan Rhys Meyers). While the rite of passage emerges as an important aspect of the tale, passion (for sports) trumps a culminating loss-of-virginity scene. Chadha's exuberant editing approach crosscuts scenes of Jess and Jules's triumph on the pitch with Pinky's ecstatic, bejeweled sari wedding celebration at the conclusion of the film, leaving behind any trace of girl victimhood or defeat. *Bend It Like Beckham* is about girls, their choices and not giving up on the big dream, whether that means the dazzlingly beautiful East Indian wedding ritual or a full scholarship to UC Santa Clara to play soccer.

In Niki Caro's *Whale Rider* (2002), based on the novel by Witi Ihimaera, Paikea, a 12-year-old Maori, played by Keisha Castle-Hughes, is the only living descendant of tribal chiefs due to the death of her twin brother and mother in childbirth. Pai desires to learn the ancient ritual wisdom and martial arts of her tribe, but her grandfather, Old Paka, the current tribal leader, has eyes only on male leadership. He gathers all the young boys in the tribe to train them in Maori martial arts and mysticism in hopes of finding a new leader. Despite the boys' obvious ambivalence and lack of maturity, and Pai's comparative aptitude, he adamantly refuses her repeated requests to learn. Banned from the sessions simply because she's a girl, Pai trains in secret and succeeds in invoking the legend of the Whale Rider, thus breaking tribal gender role stereotypes and fulfilling her destiny as the next in line to lead. With a blend of mythic elegance and a dose of reality about the fate of native peoples in New Zealand, Caro illuminates issues of tradition and leadership in a community influenced by Western materialism.

An interesting commonality of these three popular films is that they share what by American standards would be retrograde assumptions about girls' access to education and freedom of choice. Their refreshing, multicultural Heroines navigate access to opportunities already assumed as givens by white American girls: the right to choose one's destiny. Yet so much of American fragmentary, transitory, post-immigration culture has lost its connection to rich family traditions and historical connectedness. The individual's quest, so valued over the needs of or responsibilities to a tribe or community that setting off on the road to college without looking back is an expectation of the American rite-of-passage adventure. The commercial success of these multiethnic films indicates audience interest in narratives about finding meaningful connection to a circle beyond one's self without compromising one's talents or intelligence, and how to circumvent binding traditions which may limit girls without losing one's family of origin.

LOST IN TRANSLATION

Sofia Coppola's original screenplay for *Lost in Translation* depicts a young woman's platonic relationship with an older man against the backdrop of a Tokyo seen by displaced Americans. Following the success of *The Virgin Suicides*, Sofia Coppola set her 2003 narrative in the "nowhere" of an upscale international hotel, where an unusual friendship develops between a precocious Yale graduate named Charlotte (played by Scarlett Johansson, then aged 18) and Bob Harris, a 50-something actor (Bill Murray) hired to shoot a Japanese liquor ad. Charlotte, a newlywed neglected by her fashion photographer husband John (Giovanni Ribisi), finds a soul mate in the disenchanted actor. The linguistic loneliness of their extended stay in the non-culture of an expansive posh hotel set the stage for a chance encounter which proved ultimately more believable than manufactured Lolita stories in the style of *American Beauty*. Coppola definitely played to Lolita expectations, drawing on the "what if" tension of their relationship. That a completely different outcome results provides a fresh approach to a motif now grown predictable. Coppola received an Academy Award for Best Original Screenplay for this film and was also nominated for Best Director, the first American and third woman ever nominated for this award, following Australian Jane Campion (*The Piano*, 1993) and Italian Lina Wertmüller (*Seven Beauties*, 1975). A female director has yet to win the award.

Coppola's third feature, *Marie Antoinette* (2006), drew its Teen Queen storyline from Antonia Fraser's 2001 biography of the Austrian-born Princess married at age 14 to the French heir to the throne, Louis XI, then 16. Long vilified as the "Let them eat cake" monster of aristocratic excess, Marie Antoinette is depicted in both the book and the film as a young woman born to excess and privilege thrust into a leadership role for which she was ill prepared. That she became the scapegoat of the French Revolution is history; that Coppola treats her as a lavishly placed Austrian pawn in the foreign court of Versailles who pursues a Paris Hilton style of decadence in response to her surroundings presents a new twist on a Teenage Icon. Blending the sexy candy palette of 1980s New Romantics music with the real backdrop of Versailles, Coppola effectively positions the Teen Queen as a naïve girl choosing the excess of shoes, powdered wigs, and silken gowns as her easy-path rebellion against a frustrated mandate to produce male heirs with a French royal, Louis XVI, who preferred to ride horses to the hunt. Though Coppola was criticized for an aristocratic surplus of pastries, fabrics, and champagne over historical veracity,[20] she achieved her biopic goal of bringing younger viewers into intimacy with the Austrian Princess who became Queen at nineteen.

Statistical discourse often points out that women directors of the first indie wave in the 1980s were not often given a second or third chance to make a film despite critical acclaim for their first efforts.[21] Ultimately it all comes down to the box office. If the women deliver there, they are given a second chance. By the late 1990s, with legacy filmmakers like Sofia Coppola at the helm, this trend

appeared to be shifting. In Coppola's case, she's on to her third feature film. Karyn Kusama, whose *Girlfight* (2000) launched the career of Michelle Rodriguez, directed Charlize Theron in *Aeon Flux* in 2005, with the backing of MTV Productions and Paramount Pictures. Niki Caro, reeling from the 2004 Best Supporting Actress Oscar-nominated success of her directorial debut *Whale Rider* (2002), took on *North Country* in 2005, a film about women fighting for their union rights as coal miners in Minnesota, funded and distributed by Paramount Pictures. *North Country* garnered Academy Award nominations for Theron and Frances McDormand, as a union leader taken down by a debilitating disease. Following debut acclaim for *Thirteen*, Catherine Hartwicke directed New Line Cinema's big-budget *The Nativity Story* in 2006, which featured Keisha Castle-Hughes, the Academy Award-nominated star of *Whale Rider*, as The Virgin Mary.

If gender balance is to occur at the movies with women directing in equal numbers to men, their efforts must be supported by viewers seeing their films the weekend of their release, then renting them, buying the DVDs, and putting them on their Netflix wishlists. While many people remain gender blind about directors, choosing films based on celebrity rosters, subject matter, or genre, many do invest in tracking the numbers with the specific goal of supporting women directors. The First Weekenders Group, sponsored by the non-profit organization Movies by Women,[22] announces features and documentaries directed by women the first weekend they arrive at the box office. Members sign on to the site to receive e-mail announcements of films directed by women released that week.

As sobering as The Celluloid Ceiling statistics may be, looking beyond Hollywood make-believe filmmaking provides sample evidence of women media makers in other pioneering arenas of image production as well. While Hollywood statistics for Best Director in the fiction filmmaking category are important, we must not forget that since 1975, eight feature-length documentary films with women as single and co-directors have won Academy Awards,[23] and eighteen in the Documentary Short Subjects Category,[24] with even more women nominated. This indicates a driving interest for women filmmakers in tapping the documentary medium as a viable means of storytelling, often with a social cause attached. Given the overwhelming number of issues worthy of attention in an era of global warming, corporate abuses, wars, and human rights violations, this tendency of women directors is not only laudable but also necessary.

Influenced in large part by the overwhelming success of Michael Moore's *Bowling for Columbine* (2002), many mixed-gender documentaries dealing in equal measure with issues of importance to girls have made it into mainstream circulation in recent years, including *Mad Hot Ballroom* (2005, Marilyn Agrelo) and the Academy Award-winning *Born into Brothels* (2004, Zana Briski). *Mad Hot Ballroom* profiles multicultural teachers and students in New York City middle schools

involved in the unlikely art form of ballroom dancing, in an environment where street smarts rule over white-glove etiquette. The unexpected success of the film, which depicts focused inner-city kids competing as dance partner teams, proves a public forum exists for alternative representations of inner-city youth beyond gang banging, teen pregnancy, and violence. The success of this documentary paved the way for Liz Friedlander's 2006 narrative film *Take the Lead* about Pierre Dulaine, an audacious dancer who introduced the concept of ballroom dancing for inner-city students. Based on a script by Dianne Houston, the film features a cast of detention-bound high school students challenged to "take the lead" and dance back beyond the roots of rap.

Born into Brothels, co-directed by Zana Briski and Ross Kauffman, turns a lens on teenage prostitution in Calcutta. The film documents the efforts of a British photographer (Briski) as she reaches out to the children of the red-light district through a photography teaching project. Originally on-site in Calcutta to photograph prostitutes, Briski befriended the children and learned that every day teenage girls born to prostitute mothers join "the line" as a rite of passage into an economy that literally feeds on their virginity. Since virgins fetch the highest prices in this industry, families inculcated into this economic system are loath to give their daughters educations. The difficult lifestyle perpetuates itself, with mothers denying their daughters an exit due to their economic dependence on the continuation of the lineage. In a remarkable departure from objective journalism, Briski moves beyond anthropological storytelling at a distance to engage in teaching children from Calcutta's poorest district to use cameras to tell their own stories. These children produce startlingly wise and poignant images of their environments in an example of media literacy as media production in action. Unlike many documentary makers before her who move in on a controversial subject then return to their Western lives in the midst of their non-fiction filmmaking accolades, Briski has remained in contact with her subjects. Through her non-profit organization Kids with Cameras, she has auctioned the children's photographs to establish education funds for careers beyond the red-light district. In some cases, her students have gone on to pursue their studies, but she has had to face an uphill battle with family systems dependent upon the income derived from selling their daughter's bodies to clients. That this has gone on for generations only exacerbates the issue. Since mothers and grandmothers each took their turn in the line to support entire families, daughters are hard pressed to break from tradition. That this tradition, as caught by Briski's camera, includes the verbal and physical abuse of these children as a means of bending their will to the systems in place shows how difficult it is to break the cycle in psychological terms. The enormous success of the film, along with Briski's dogged efforts to continue to raise money for the children's education, has raised awareness of the issue of child prostitution in India.

She has published a companion book of photographs entitled *Kids with Cameras*, and her non-profit organization maintains the Calcutta project and sponsors new projects for children of poverty in Haiti, Jerusalem, and Cairo. Their mission is to teach "the art of photography to marginalized children in communities around the world," a vision which hinges on of the power of self-representation. "We use photography to capture the imaginations of children, to empower them, building confidence, self-esteem and hope."[25] The success of these documentaries indicates that American media is not just transmitting to the rest of the globe but opening up to multicultural issues and narratives for American audiences as well, and women directors have had an important role in using media to promote social justice.

In addition to strides being made by female directors of narrative and documentary film, groundbreaking video installations by Shirin Neshat, Eve Sussman, Fiona Tan, and Ann Hamilton and others have shown at major museums in the past few years. Likewise experimental applications of new media at technology labs and universities support many pioneering women as innovators in the field. Some of the most influential American photographers and graphic artists of the past twenty years—Annie Leibovitz, Cindy Sherman, Sally Mann, and Barbara Kruger—produce images that have challenged our concepts of female identity, celebrityhood, and adolescence. Many alternative screens of image making exist beyond Hollywood. It depends on how we train ourselves to frame the visual culture around us. The next generation of Girl Filministas are learning how to invent the world with a lens.

Girls Make Movies: Out OF THE Mirror AND Through THE Lens

Despite changes in job options for women, if you ask many pre-adolescent girls about their dream career, many will still tell you: model, actress, singer, celebrity. If you ask boys, they will often say: professional athlete or movie director. Girls need to be retrained about options in the movie business. Some girls understand this, and change is taking place in all forms of media making. Many more teenage girls are beginning to choose The Director as a dream career over The Super Star or The Super Model. Giving talented girls access to advanced media-making skills as early as possible helps to address the gender divide behind the scenes in Hollywood. Many young women decide to become directors once they determine that the real staying power exists behind the camera. But quite often they find themselves pursuing this goal as an anomaly in a field dominated by the guys. Many advertisements and brochures for film schools depict young men behind the camera, with young women holding the microphone as "the talent" on camera. The New York Film Academy has this ethos embedded in its logo, which shows men behind the camera looking at female talent; advertisements for this school regularly feature this gendered configuration. Mixed-gender youth groups like Utah's SpyHop productions post similar images. Because of an entrenched gender bias and the fact that young men still enter film school in higher numbers than women, these promotional images are changing slowly. The landscape of the filmmaking business would look very different if more young women pursued digital editing, lighting and set design, special effects, and directing skills, but

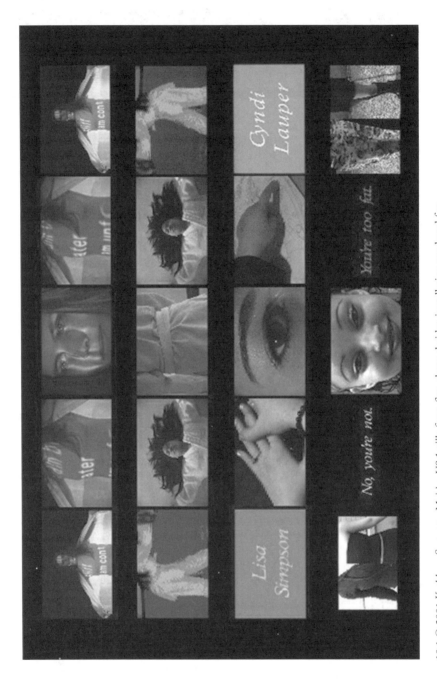

10.1 © 2001 Kathleen Sweeney *Maiden USA* stills from five-channel video installation produced for 2001 NEA residency at Reel Grrls, Seattle, WA.

support is needed to get them there. The power of programs like Reel Grrls and Girls Film School links to the representational photographs on their websites, which show teenage girls actively managing professional cameras and production equipment.[2]

Continued bestselling clarion calls for "Girls in Crisis" along with "The Celluloid Ceiling" statistics provide a clear plan of action. It's time to encourage more girls to make media. In an alternative to fear-based scholarship of "endangered girlhood," a number of programs have emerged in recent years that combine media literacy with technical skills advocacy for teenage girls. Mary Celeste Kearney's book *Girls Make Media* (2006) provides an excellent scholarly overview of the cultural origins of these millennial trends.[3] Arming girls with the creative tools of a media industry that so assiduously targets their self-esteem moves beyond passive critique to digital activism, paving the way for an expanded generation of "filministas" and digital culture leaders. Providing girls with access to technology—video and digital still cameras, tripods, lighting and sound equipment, editing, and web design software—in hands-on workshop settings both addresses the persistent gender imbalances behind the scenes in Hollywood and demystifies codes of fashion and filmmaking illusion. Why shouldn't young women be trained in equal numbers to produce their own Icons that impact the way we view ourselves and other cultures around the globe? In the 1990s, through films and television, the teenage girl began to tell her stories in a public spotlight that previously cast her in shadow, but a majority of these stories were projections of adult fantasies or reminiscences of a coming-of-age told from an adult perspective looking in. What happens when girls possess the tools to tell their own stories in film and video? While much discussion conters on girls and conformity in our culture, girls also carry the prehensile creative imprint to innovate. They clearly have the digits to participate in digital culture. It's more a question of awakening those abilities and providing girls with the tools and skills to create their own moving picture Icons than any gender-based inability to do the math of technical task making. And, as Kearney points out, much of this media making takes place outside schools, often in girls' own bedrooms,[4] but also in a host of after-school, weekend, and vacation media programs designed for girls.

Several national initiatives are taking this challenge head-on. Since the turn of the millennium, women filmmakers, youth advocates, media artists, and self-proclaimed Geek Chicks have decided to move beyond media critique and "what a bummer" hand wringing to proactive girls programming via digital filmmaking. Some of the most successful programs include GirlsFilmSchool at the College of Santa Fe, Girl's Eye View at Eyebeam Atelier in New York City, Divas Direct in San Diego, Seattle's Reel Grrls, and Girls Inc's national pilot video program for teenage girls, Girls Make the Message. These organizations are combining studies

about girls learning styles with "The Celluloid Ceiling" and Director's Guild statistics as part of their strategies in landing major funding for their girls filmmaking programs taught almost exclusively by women. The focus of these programs is to inspire girls to think beyond dream careers as actresses and models to the long-term career zone behind the lens.

In a bold attempt to address the persistence of gender and racial inequities behind the scenes in global media making, these initiatives have established Girl-Friendly environments for mastering filmic arts. The goal of these programs, funded by the National Endowment for the Arts, the MacArthur Foundation, and AOL/Time Warner Foundation, among others, is to teach girls how to maintain the long-term commitment to script, produce, direct, edit, and distribute films, videos, and web media, while demystifying valuable career skills. Through coalition building with Apple Computer, Girls Clubs, YWCAs, media art centers, university film departments, and cable stations, these national girls film programs are gaining substantial recognition, proving them capable of staying power. Reel Grrls and GirlsFilmSchool provide programs that match girls with female mentors currently working in film and high-tech industries. These national technology-based empowerment projects for girls have emerged partly in response to the critical cultural dialogues about the impact of mainstream media on the loss of self-esteem, as well as addressing racial and gender imbalances in the media industries. As Deborah Fort, founder of GirlsFilmSchool of Santa Fe states,

> You cannot grow up gender neutral in your perceptions of the world, just as you can't grow up class, race, etc. neutral. That is why it is so important to have more diversity amongst those who are creating the images by which we define ourselves.[5]

The women behind these projects often have their own gender bias anecdotes from film sets and academic film departments. Some have come to the conclusion that the only way to create a viable "women's film network" in an industry of entrenched nepotism is to inspire teenage girls to explore the power behind the camera as early as middle school. By the time they are ready to enter film departments and professional work environments, they will have acquired enough fluency in the language of the craft to gain credibility. The approach of these pioneering groups is to establish a national girls film network which feeds into and expands the women's film network, with ongoing mentorship cross-pollination. Critiquing, naming, and analyzing popular culture marks only the first step. Making films and videos is the second. Establishing girls networks of distribution is the third. Significant film festivals now have youth media categories and many, such as San Francisco's MadCat Women's Film Festival, highlight work by teenage girls. With the arrival of venues like YouTube, self-distribution on the web has become a viable possibility for alternative media makers.

MEDIA LITERACY: READING AND WRITING MEDIA

Most filmmaking programs are founded on two kinds of media literacy. One involves a decoding process toward understanding the vocabularies of meaning embedded in the media we consume at every level of our visual existence. The other is technical, the acquisition of media-making skills. One involves "reading media" as a text; the other involves "writing media" with images. This takes us back to the definition of "iconography," which means "writing with images." The two skill sets are interdependent components not only of training for careers in media but of true literacy in a highly media-saturated culture such as ours. Ideally, all children need to be exposed to media literacy, Photoshop, and media making to understand the technical underpinnings of image construction, of Icon making in the global media complex. As discussed in Chapter One, with these tools, it's easier to locate the wizard behind the curtain. Moviemaking requires girls to look through the same kinds of lenses used to produce corporate media's images of beauty, power, and celebrity. And it grants them a wizard's power to create illusion.

Given how assiduously advertisers market to youth, with special consumer niches dedicated to teenage girls, it is incumbent upon girls to understand the marketing strategies at work in projecting Icons onto their bedroom walls. The seductive impulses of visual language often operate at levels of lower consciousness difficult to decode. Some girls contend that over-analysis takes the fun out of watching movies and looking at fashion magazines. There is a pleasure principle inherent in "ignorance is bliss," as well as an eye-candy aspect of certain types of iconography, which, just like junk food, we imbibe knowing full well it isn't good for us. But ignorance about the dosage proves more dangerous, as anyone who works with girls and eating disorders knows: the tyranny of images of skinny models and actresses feeds the persistence of eating disorders, which also emerge from unconscious impulses. We certainly cannot forget that media consumption involves a doorway of escape into the pleasure drome far from the mundane that is hardly educational, spiritual, or good for the teeth. Over-analysis can break the spell. Yet there are ways to be media literate and still enjoy the visual ride.

Our brains replay fragments from film and television alongside our own visual memories of our pasts, early childhoods, happy interludes as well as traumas. How much of our visual recall is "real event" based and how much of it is virtual, borrowed from screen-life, which now includes computer screens, television screens, iPod screens, as well as movie theatre screens? A complex of flat screens filled with pop-up ads and images embedded with significance influences the multiplexes of our visual memories. Since this is the case, girls must be active participants in the production of our collective memory banks and in distinguishing primary impulses and ideas from visual implants. Unlike Spam filters, which simply block

information from entering our e-mail boxes, media literacy in a sense "installs" mediating filters which help viewers to name and process the information transmitted throughout our daily lives as media consumers. What are we watching and why? What do we see by chance and how do these images inform our unconscious choices, emotions, actions, and reactions?

We live in an era in which images command as much power as words. We navigate images or Icons encoded with messages about gender, class, and race by the thousands every day. With our world so densely media saturated, most of this navigation occurs unconsciously. As Americans with wallets, we ostensibly make choices about the types of films, videos, books, and websites we consume. Are we forced to go to the McDonald's of culture? On the most primary level of choice, no. However, while we do not choose to see ads in public spaces, the increasingly appearance of video screens in airports, train stations, and on the Internet means we need a tool belt of navigational devices for decoding the impact of these messages, and so do teenage girls.

Parents and educators know that a "see no evil" attempt at insulating girls from mainstream media is a limited enterprise. As mentioned in the Introduction, no American exists in a pop culture vacuum. Whether we actively consume popular media or not, we collectively navigate the Lolitas, Mean Girls, and Amazon Barbies appearing in movie trailers, in channel-surfs, on billboards, and on grocery store magazine racks. Pop culture Icons belong to the zeitgeist; they inform us through visual osmosis. If teenagers know that mixed messages abound and are fluent in the tropes of the stereotyping shorthand of some forms of media, these messages lose their power and can be situated in a cultural context. Manipulating and dialoguing with pop imagery assists in the acquisition of power over image systems that shape and inform our collective identities and values.

With a market economy driven by buying and selling, we will always need to counteract power imbalances in our image systems. This is one role of educators, critics, students, artists, and media literati, who can treat media images and narratives as texts to be read and decoded as symbol systems to be understood. As discussed in the first chapter, media literacy is a skill like any other, but in the absence of a consistent curriculum in American schools, media literacy has fallen to youth advocacy and media activist groups, media art centers, girls clubs, museums, and specially funded guest speaker/artist events in schools. The result is scattershot. Girls are only "lost" if left unsupervised without a language of reference in the realm of Big Brother, particularly when Big Brother has a salacious look in his eye. There is no end to the discussion and the navigation of stereotypes. Barbie didn't go away. Neither did classic Disney. We need to name these Icons of pop folklore in the pleasure land of media consumption and understand their place in the pantheon. Millennial Girls are already savvy media consumers. Contrary to adult fears of girls

being "duped and misled" by media images, many girls are quite articulate in naming stereotypes and predictable storylines. Taking it a step further into acknowledging the power of influence inherent in visual media and learning "the tools of the master" is what girls' media-making programs are all about. When taught the technical skills, girls also learn how faces and bodies are enhanced, thinned out, airbrushed and how camera angles create relationships of power.

The critique aspect of media literacy serves girls only insofar as it doesn't descend into wanton gossip. Looking for flaws in celebrities can sometimes overly sharpen a tendency to search for imperfections in oneself. Dishing on women's PhotoShopped faces is not the goal of media literacy; awareness of the role of technology and fantasy in the creation of images and Icons is. Using cameras as the next step in the media literacy process moves beyond critique to proactive creativity. Focusing solely on media critique can lead girls into a level of awareness that reinforces negative, shallow criticisms. The visionaries behind Reel Grrls and GirlsFilmSchool and other programs mentioned above have read *Reviving Ophelia: Saving the Selves of Adolescent Girls* and decided that armchair analysis does not suffice. Girls already know a Dumb Blonde from a Xena Amazon. Girls have opinions on every celebrity and performer on the planet; bottom line, it's just too gossipy and passive. Empowering girls involves teaching them to own their consumerist choices and not cast themselves as Media Victims. As far as these professionals are concerned, "Girls gotta make movies!"

MEDIA LITERACY AND THE MIRROR

Cameras serve as particularly potent tools for gaining mastery over a jump cut universe of unmediated messages. Framing the world in close-up becomes a step toward self-awareness, a way inward beyond the visual spillover of celebrity culture. One goal of filmmaking programs for girls is to inspire them to peer through the lens rather than peering obsessively at the mirror or at fashion magazines. Mirrors are not to be trusted. Just as fun house mirrors exaggerate, so exaggerations of reflection embedded in so-called regular mirrors, bumps and ripples in the surface make waists or breasts or rear ends seem larger than life. Mirrors are endlessly flawed (ever look at yourself in a plate-glass window?), but girls trained to look at the flat surface of magazines and billboards expect to find the same 2-D imagery in their reflective surfaces. The best mirrors are your good friends. Beyond that, it's more empowering to create a self-portrait in video, film, or PhotoShop than trust a flawed mirror. Creativity becomes a channel for rage that can otherwise be turned against the body. "Let the camera be your mirror" could be used as a girls media-making mantra. Looking and seeing beyond the

mirror means the question "How do I look?" becomes "How do I look at the world?" The goal of girls' media-making initiatives is to get girls out of the mirror and behind the lens, training their eyes away from the self-reflective obsessions of the beauty industries and onto a wider world of power.

Peering, peeking, looking, pointing ... these are classically boy activities (What is a Peeping Tom, after all?). Once girls begin to frame their world through the lens, issues of power, reference, and choice come into focus. If girls take up cameras and learn to look rather than posing to be looked at, seen, and watched, they gain a different perspective on the power of The Gaze (see Chapters Three and Nine). Locating the lens becomes a metaphor for focus, both as a technical discipline and a discipline for personal development. Focus through the lens helps girls articulate a narrative beyond those fed to them in the media cacophony of consumption. Making films empowers girls to tap into their individual creativity as an alternative to the supremacy of "the cool crowd." Looking through the lens connects girls to the powerful universe of image creation. In a fast-cutting image-saturated environment such as ours, providing girls with tools for re-framing and reconfiguring notions of beauty, selfhood, race, and gender poses a challenge to a status quo bent on selling purchase power and social status as the predominant currencies.

To counteract the seductive impact of Lipstick Lolitas who reside alongside Girl Power Icons on par with Buffy the Vampire Slayer, girls must be encouraged to take up the tools of the media and be supported in making their own films, photographs, videos, and websites. The only way to reorient the dream career goals of girls from the model/actress/celebrity track—a schooling in being looked at—is to interest girls in the technologies of looking, peering through the lens, framing the shot. With a camera, girls turn their gaze away from the surface self to the external world, framing expanses of space rather than zooming in on facial blemishes or other imperfections. The gaze of the camera lens is expansive; the mirror gaze limits and distorts.

GIRLS GONE DIGITAL

The digital revolution has proven to be a great gender equalizer. With lightweight high-resolution cameras and laptop editing software now available, the possibilities for broadcast-quality video production on a relatively low budget have expanded exponentially. Tech programs across the country increasingly provide girls with creative outlets to counter the conformity codes of fashion that channel so much of their resources into disposable consumerist quests for social acceptance. As iPod advertising conveys, trim technology is sexy, with girls drawn to James Bond-sized

gadgetry as much as boys. Better to invest in a digital camera than two pairs of designer jeans …

Apple Technology has been crucial in the growth of these programs that use FinalCut Pro software, G4s, G5s, and other Apple platforms. Girls Inc.'s Girls Make the Message program purchased eMacs with iMovie software to make their pilot program as user-friendly as possible. Deborah Fort of GirlsFilmSchool has had a strong relationship with Apple for many years. She notes, "The affordability of the technology opens up possibilities for all previously underrepresented groups. The accessibility opens it up particularly to women, who are generally acculturated to not feel comfortable with technology."[6]

In *Gender Play*, based on playground research, conducted by Barrie Thorne, Professor of Sociology at the University of California, Berkeley, observes that some girls and boys play in single-sex settings, while others are adept at crossing the gender divide, fluently shifting from same-gender play to mixed-gender play. Girls accepted in boys' games are those with a comparable or superior athletic skill level.[7] Applied to technology, girls must have the same level of competency or endure keyboard or camera takeover by boys.

In mixed-gender high school film classes, girls often choose the "talent slot" as narrative actor or on-camera documentary interviewer rather than the riskier leadership role of videographer or director. This unmediated gender role drifting leads to missed career-building opportunities. Just how many Diane Sawyers or Jennifer Lopez slots exist out there? Malory Graham, Executive Director of Seattle's Reel Grrls, taught youth in mixed-gender settings for several years before deciding "that the only way for girls to learn technology was in a safer girl only environment where they were not intimidated by boys and had women filmmakers as role models."[8]

Female-only mentoring opportunities can provide safe spaces for girls to try on identities/roles outside their carefully constructed social personae. The fear of ridicule in high school is a censorship tool demanding conformity. Young women can break through gender role stereotypes only in environments where such permission is granted.

One thing girls have to know from the get-go is that in the land of techies, you have to memorize your model numbers or the guys will not respect you. Teaching girls the tech talk is important. They need to know that they shot their piece on a Canon XL-1 or a Sony TRV-18 and edited on a Mac G5 on FinalCut Pro software. It's a language, and knowing the codes is part of finding the way in professionally. Just as girls can be acculturated to overcome math anxiety (or be dogged by it), so they can be taught to overcome tech anxiety. In my experience in mixed-gender youth media settings, newcomer girls will sometimes surprisingly turn the camera over to the boys or the instructor out of a fear of breaking it. Where this fear

originates is uncertain, but girls in middle and high school can overcome this barrier more easily when the pressure to "play girl" in front of boys is eliminated. Liz Slagus, Director of Education at New York City's Eyebeam Atelier, created the single-sex Girl's Eye View Program not due to girls' inherent inabilities to interface with boys but as a way "to get rid of one more distraction" keeping girls from deep engagement with technology.[9]

In an era of animation and special effects, the number of credit roll slots at the end of a film for technical jobs scrolls far beyond the number of actors. The math speaks for itself. How many talented women wait tables for years in an attempt to make it as an actress/celebrity when a comparable amount of effort backed by tech skills would land them a job as an off-line editor or an assistant producer in their 20s? Filmmaking initiatives like Reel Grrls, GirlsFilmSchool, and Divas Direct are inspiring girls to adopt a life-long career path rooted in these stepping stone skills.

Thelma Schoonmaker won her third editing Oscar (see Chapter Nine), at age 67. Would she have been consistently in the game if she had been an actress? Probably not. Obviously a great deal of work can be done in analyzing and promoting curricula that transcend gender categories for career choices in media making. Girls do not have to be relegated to short-term careers as actresses and models if they want to enter "the industry." But they need to be introduced to the wide variety of options, which include lighting and set design, post-production editing and special effects, screenwriting, directing, and producing. All of these careers require a great deal of training and are not "flash in the pan" stories of instant success. While actresses and models who make it in the industry also do so as a result of fierce determination and hard work, the myth of "being discovered" remains a persistent category of fantasy for girls pursuing a life in front of the camera. With media making, waiting to be discovered isn't necessary. Discovery self-activates with a finger press of the Record button.

REEL GRRLS, SEATTLE, WASHINGTON

The original 2001 Reel Grrls website opened with a startling Flash sequence: "Most ... Girls ... will have watched ... 5,000 hours ... of television ... before entering ... kindergarten."[10]

Where does all of this electronic information get stored and how do children process it? And what does it mean to overcome the identity and gender encoding of those messages received by preschool brains? Reel Grrls' annual program encourages girls to tap the referential riches of their media minds.

As a response no doubt to their extensive toddler programming, every year a Reel Grrls team produces a spoof on Barbies. The Barbie videos are some of

the funniest and most on-target projects to come out of the program, along with pieces on gender identity, sexual orientation, and self-portraiture. Through collaboration with Seattle's 911 Media Arts Center, they have hosted stop animation and Claymation workshops. "If Men Menstruated" (2003) features GI Joes and World Wrestling Foundation dolls discussing the performance-enhancing merits of their "cycle." The breakthrough quality of these animations lies in the outrageous, often deadpan, delivery of decidedly feminist messages, which could otherwise be Miss Manners dogmatic. While feminism is definitely part of the staff's agenda, Executive Director Malory Graham has "learned from our girls that fighting for feminism seems irrelevant to them because they believe that the feminist movement is no longer needed. While from my perspective this can seem naïve, it can also be seen as refreshing."[11] The Reel Girls program, in existence since 2001, spans a four-month period of weekly after-school meetings, culminating in a week-long post-production intensive, which provides one of the most comprehensive programs in the country. Through partnerships with the Metro-Seattle YWCA and their local PBS outpost, KTTW, Reel Grrls has managed to attract a multicultural group of girls to its programs every year. In addition to the digital skill set, graduates of Reel Grrls come away with a significant video exhibition record that has included the Gen-Y Youth Conference at Sundance, Hong Kong Film Festival, San Diego Girls Film Festival, and Women in the Director's Chair. The compilation of these impressive credentials has been due in no small part to the dogged distribution efforts of Malory Graham. Their "get the videos out" approach serves as a programming role model to other girls film programs, as does their innovative website, which includes updates on Reel Grrls graduates and clips from their reels.

The importance of screening work in professional venues cannot be underestimated in completing the circuit of pre-professional training. With posters, flyers, e-mail announcements, and press releases, the public and the press show up. These marketing efforts by Reel Grrls, GirlsFilmSchool, and other programs have resulted in significant journalism coverage. Screenings in school, while useful for peer review, do not elicit the same kind of attention. The relatives show up, but not the general public, and so the impact is much more limited in conveying the importance of distribution. Making media often empowers girls to overcome other kinds of gendered social programming to speak out on social issues as well. Inspired by the success of their videos, some Reel Grrls graduates have become youth advocates. Covering issues such as abusive relationships, eating disorders, self-mutilation, and teen homelessness, Reel Grrls have served on panels at film festivals and youth leadership conferences sponsored by the National Organization for Women (NOW) and other organizations.

In every girls filmmaking program, there are those who take to the editing software with remarkable fluency, who understand the concepts behind the

storyboard and scripting of shot sequences. Despite the blundering public pro-nouncements of former Harvard President Lawrence Summers regarding women in math and science careers,[12] as far as the math tech involved in FinalCut Pro and other software goes, no inherent deficiencies in girls' brains prevent them from accessing the concepts or the technical skills.

Before the 1980s, movies showed exclusively in theatres or on television, and distribution and network programming controlled viewing schedules. This relatively recent personal "control" over programming fluency through personal video collections has extended to recording programs on VCRs and, more recently, TiVo digital recording at any time of the day. In this way, we amass digital video "libraries," where "page-turning" involves control buttons for return to sequences, skipping scenes, or holding a still. Girls and boys are fluent in the technology. Babies barely able to walk know how to push buttons on the DVD player and on the television. This allows for a demystification of the films, at times a ridicul-ing of still frames, which catch movie stars between expressions and gestures, and a capacity to analyze the compositions of shots, special effects techniques, and relational schemes. In many ways, the early experience with the remote sows the seeds of editing skills in children. Well before adolescence, girls as well as boys become "remote fluent," as well as versant in cable and satellite television menus and TiVo savvy. Outside of the movie theatre environment, a collective space of passive viewership, the helm of the remote in home viewership makes editors and directors of the general viewer. With more and more DVDs pack-aged with special behind-the-scenes features, young viewers increasingly learn about the special effects technologies and the creation of the illusion of filmmak-ing. This form of millennial media literacy is producing a generation of gender blind media-savvy viewers and nascent media makers. Both boys and girls are digital natives.

In my eight years of Visiting Artist residencies with teenagers, I have witnessed a progressive evolution of fluency in each class of newbie editors, particularly notable in girls. No doubt this increased skill acquisition loads back linked to the ubiquity of iTunes downloading, MP3 players, social networking sites, and YouTube. Girls, less mystified by the technology, are entering programs with more predetermined familiarity with button pressing of all kinds.

GIRLSFILMSCHOOL, COLLEGE OF SANTA FE, SANTA FE, NEW MEXICO

Deborah Fort decided to create a summer film program for teenage girls when she noticed that the majority of her undergraduate students were male. Spurred on by

studies indicating that girls learn better in single-sex environments, Fort established the GirlsFilmSchool in 2001 to address the gender disparity in film departments and by extension in the industry. Despite some girls' initial reticence at learning filmmaking in a female-only setting, by the end of the program they often realize that the boys' absence allowed them to apply themselves more fully to the technology. "The girls will tell you that it works," Fort says, "I believe them. I've seen it."[13] Fort would like to see the girls-only trend in programming continue though aware that "a lot of men, who are still in the majority in film programs, don't understand why it is important to have a single-sex environment. Fortunately my colleagues and the administrators at College of Santa Fe do understand."[14]

With the film world still so predominantly male, some might justifiably argue for girls learning how to "duke it out" with the "real-world boys." Experience shows, however, that beginner girls are sometimes too willing to share, resulting in boys' segueing into the roles of the camera operator, director, and editor. It's much easier to spar with the techno geeks and masters of ego chess moves when the vocabulary and skills are solid. It takes an ultra-strong persona to proclaim oneself a director, editor, animator, or cameraperson. Beginning to build a reel as an adolescent assists in this process, as does adult guidance with professional-level distribution. Armed with an impressive resume of youth screenings, the college film school pitch can begin, followed by professional internships and production jobs.

Deborah Fort perceives the collaborative tendencies of girls as a professional asset, because ultimately a film set requires teamwork and pooling of resources. "Many are techno-phobic when they arrive but once they get involved in their projects, even the most skittish overcome their fears. The small group mentoring definitely helps. As does the emphasis on community and collaboration."[15]

While GirlsFilmSchool's two-week summer camp format focuses on digital video self-portraiture and animation, they also produce a narrative 16 mm project, complete with sync sound, dolly, Nagra, and lights, in which, Fort explains, "all the girls rotate though all the positions on the set … it is one of the favorite activities because it is like a 'real' film set."[16] Their alliance with the College of Santa Fe affords them access to a variety of film formats, which sets them apart from other programs which use only digital video.

Graduates of GirlsFilmSchool have so far enrolled in film programs at College of Santa Fe, Sarah Lawrence, and NYU. Says Fort, "I write letters of recommendation for 5 or 6 girls a year … The program is too young to see any real long term effects, but we will."[17] At the college level, Fort noticed that

the work of my female students is generally very different from that of my male students. The women tend to be much more interested in social issues … The girls are generally more mature than the guys and you see it in their work. I almost never see drinking, pissing, fighting, guns, fast cars, stupid gags, etc. in work by women students …[18]

Given the trends in Hollywood filmmaking mentioned in the previous chapter, clear echoes originate in film school. GirlsFilmSchool makes a huge effort to diversify their student body, which means their funding efforts include a large scholarship program. Says Fort, "New Mexico has a strong Hispanic and Native American population so we make an effort to get New Mexican girls who represent that demographic."[19]

GIRLS EYE VIEW

Education Director Liz Slagus developed Girls Eye View (GEV) at Eyebeam Atelier as a means of engaging New York City middle school girls from underserved populations in new media. Through a competitive application process, female teaching artists apply to work at Eyebeam to develop individual and group projects investigating media's influence on female identity. Since 2002, projects have included digital photography self-portraits, HTML web-related projects, and multimedia.

Eyebeam's unique location at the heart of New York's contemporary gallery scene in Chelsea allows for field trips to local art institutions to explore cutting-edge applications of video projection, large-scale digital photography, multichannel film and video installations and web media exhibitions. Each girl in the program is given a journal to record impressions of the art seen, respond to presentations by guest speakers, and brainstorm ideas for her final project.

In spring 2004, visiting artist Cat Mazza partnered with girls from the Women's Leadership School in Harlem. As part of her ongoing project on sweatshop and women's labor issues, http://www.MicroRevolt.org, Mazza invited the girls to contribute knitting and crocheting designs to be posted on the website. Through software Mazza developed, stitches translate into pixels, "small stitches to create a movement." Slagus marveled at one girl's design, "an image of Batman taking off his mask, revealing that he was a woman."[20]

DIVAS DIRECT

Following the success of her 2003 San Diego Girl Film Festival, with the slogan "Positive Women—Positive Media," Executive Director Renee Herrell established a summer workshop for young women filmmakers. In 2005 Divas Direct launched as a summer program taught exclusively by professional women filmmakers. As part of Herrell's plan to involve faculty and student interns from academic film programs as far away as Los Angeles, she hired Giovanna Chesler, Professor of

Communications and Film at UC San Diego, as Director of Programs. Herrell hopes to establish Divas Direct as a feeder program for undergraduate programs in Film and Broadcast Communications. One Divas Direct graduate recently entered UCLA's Film Department, and Herrell invited her back to mentor in 2006. Girls from their inaugural program have become volunteers for the summer program, where they "presented their films to the new 'recruits' and talked about their experiences."[21]

One of Renee Herrell's goals is to "build a network of women filmmakers in San Diego." San Diego's cable provider, Cox Communications, donated airtime for the PSAs (public service announcements) produced at Divas Direct, and was one of the sponsors of 2005's third annual San Diego Girls Film Festival, along with Lifetime/Real Women, Listen Up, Frills, and the Oxygen Network. Clearly, Herrell's network has been initiated.

GIRLS MAKE THE MESSAGE

In 2004, the national advocacy organization Girls Incorporated received a major grant from AOL /Time Warner Foundation to produce a Girls Pilot Filmmaking initiative called Girls Make the Message, with the goal of creating a national network of girl media makers. The concept of the project was to create eight pilot video-making sites for girls in Pasadena and Santa Barbara, California; Omaha, Nebraska; Owensboro, Kentucky; Dothan, Alabama; Denver, Colorado; Holyoke, Massachusetts; and New York City and simultaneously publish a reproducible curriculum for girls filmmaking. Pilot sites met criteria for ethnic diversity, urban/rural/suburban representation, and their track record for completing projects.

According to Associate Director of Outreach Deborah Aubert, the objective of the program was to create "a curriculum that would be primarily facilitated by non-filmmaker and non-artist youth development staff"[22] through the 12-session production of 30-second PSAs using eMac and iMovie technology. The goal of the Girls Inc. initiative was a more "process as opposed to product" program. Says Aubert, "It tends to be the format of Girls Inc. to empower local facilitators to run the programs themselves. We encourage them to reach out to professionals in their community, but it's not a requirement of the program."[23]

The lack of professional filmmakers in key roles differentiates the Girls Make the Message program from others in the field, even though their curriculum, distributed to all Girls Inc. affiliates in 2006, is based on many of the same principles as that of Reel Grrls. Unlike some of the other girls film programs, Girls Make the Message also focuses exclusively on the PSA format favored by youth media collectives such as *Listen Up!* The advantage of the PSA is that it provides a

10.2 ©2005 Eliss Maehara, *Untitled.*

framework for producing a 30-second media message. This serves as a manageable segment for completion, and can be compressed for web-viewing in Quicktime or Windows Media formats. The shortcoming of PSAs can be prosaic preachiness, as in "Just Say No" or "Clean Up Litter," but the best PSAs deliver a creative message through low-budget innovation. Some successful examples include Reel Grrls' "Can You Look at a Woman without Judging Her" (2001), which explores the ways girls and women are schooled in aggressive female-on-female critique. In a clever sci-fi style, the video situates a robotic Girl Gaze in the viewer's point of view. Scanning girls at the Mall, the screen read-out informs "Threat Detected" or "No Threat Detected," in a commentary on the aggressive gaze-as-computer-program. This piece provides an effective adjunct to the current discussion around female hegemony. Another successful piece produced at the 2004 Divas Direct program deals with authentic identity. In the video, a people-pleasing chameleon girl yeses her friends, in one instance telling them she is a vegan, in another a meat eater, until they confront her with the contradictions and urge her to be real.[24]

WORDS FROM REAL REEL GIRLS

Lori Damiano has been making films, videos, and animations since age 16. Her work was included in a 1998 San Francisco Cinematheque program I curated called "Real Girls/Reel Girls," at the Yerba Buena Center for the Arts. Included in the program, her Super 8 animation "Strongman," possesses a garage band rawness in its cartoon-style questioning of male fascination with guns. While still in high school, Lori produced this and other Super 8 shorts and animations at the California State Summer School of the Arts (CSSSA), under the guidance of several Bay Area filmmakers, including Greta Snider. Now a guest instructor at CSSSA, she says that her experience in this program "completely changed my life's course."[25]

While CSSSA is staffed by men and women instructors, Damiano reflects back on the experience:

> It made a big difference for me to have women mentors … I remember being especially affected by Greta and her films … there was a strength about her that I hadn't really seen in women I had met before … her influence really opened things up for me. My sense of being limited because of my gender really dissolved for the first time.[26]

After high school Damiano focused on graphic design and animation at CalArts and had her first national broadcast in Fall 2007 of a short animation, "Listening," on Nickelodeon's show for preschoolers, "Yo Gabba Gabba." An avid skateboarder since high school who often designs for skateboard companies, she

also produced, shot, and directed a freeform feature-length documentary about the elusive world of female skateboarders, *Getting Nowhere Faster*, which premiered in Los Angeles in Spring 2005.[27]

Melissa Maehara participated in Reel Grrls' inaugural program at Seattle's 911 Media Arts Center in 2001 because she "dug the idea that we would be creating media whose intention was to serve as a force for social change, especially within my own peer group."[28] Melissa was struck by the all-female composition of the Reel Grrls staff:

> Only after I had a better grasp about how under-represented women were in media related fields did I come to realize how amazing it was to have all my mentors be women actively and passionately working/creating in the field. It's more of a post-hoc: "Awe, rock!"[29]

After her stint at Reel Grrls, Melissa graduated from the University of Washington in Sociology (2003) and spent two years as a "wanderlust hobo" traveling the world while teaching English before moving to New York to obtain a Master's degree in Arts Education. Along the way, she has created an extensive on-line digital library of inspired photojournalism portraits and completed a video art piece inspired by Japanese mass transit.

Tenzin Mingyur Paldron, a Tibetan political refugee living with a Seattle foster family, proved such a FinalCut wizard in Reel Grrls' 2003 program that she went on to study filmmaking at Evergreen College and served as video mentor to rookie Reel Grrls in 2004 and 2005. While the interest in filmmaking sparked during her sophmore year of high school, she acknowledges that "Reel Grrls gave me the ground to stand on and know myself for the first time as a real filmmaker. And I haven't wavered a bit."[30] In addition to producing two documentaries about her extended Tibetan family living in exile in India, Tenzin now edits projects professionally for non-profit clients and has decided that "editors are way cooler than cinematographers. We make the rhythm" Tenzin's assessment of the impact this early filmmaking experience had on her personal development is clear:

> Reel Grrls was certainly the foundation on which I was able to stand to feel secure and ready to begin the rest of my projects. I don't think of myself as a geek, except maybe in that I spend some of my free time browsing the latest equipment in film/video, and I enjoy imagining my perfect film studio. I think the words writer, artist, creator, and producer are more in alignment with who I am and want to be.[31]

One of the projects she edited while at Reel Grrls was a music video entitled *Shadow*, based on a song dealing with rape written and performed by a fellow participant, songwriter Tess Jabrun.[32] *Shadow* won third place at the Northwest Fast Film Festival in 2003, and it screened at Olympia Teen Fest in 2004. Inspired to give back to the next round of girls after her experience finding a voice creating

videos on eating disorders and sexual assault, Tess became a Reel Grrls mentor for the programs in 2005 and 2006.

> Reel Grrls was the first place to recognize my talent and show me respect for it, and to demand more of me (despite my shortcomings) in order to help me improve. For that, I feel indebted to the organization and if I ever were to gain recognition for my accomplishments I would definitely help make Reel Grrls even more well known. I believe that the cause is important, and what Reel Grrls is doing is vital.[33]

QUEEN BEES MIGHT WANNA BE DIRECTORS

Rosalind Wiseman's 2002 best-selling *Queen Bees & Wannabes: Helping Your Daughter Survive Cliques, Gossip, Boyfriends and Other Realities of Adolescence* reveals the ways Alpha girls mastermind elaborate interlocking narratives and dramas, manipulating those around them to appear in their own social storylines.[34] As suggested in Chapter Five, this ability applied to the language of the film set could mean that deep down, Queen Bees "wanna be" Directors. Imagine if Clique Divas were counseled to replace backstabbing and vengeance scenarios with writing, producing, and directing films, the ultimate "Diva" activity? Teenland soap opera redux, anyone? What if the Queen Bee became a filmmaker, and her "minions" became talent and location scouts rather than messengers of trivial rumors? For boys accustomed to the technological helm, it is a learned skill to follow the lead of a girl's vision on a film project. Yet in social situations, boys will often follow the girl-generated script for social structural cues. For a generation raised on Reality TV, what difference lies between acting on cue in elaborate clique schemes and acting out for a girl director on a film set? These are questions to consider as more girls make movies.

In terms of finding one's own voice in the cacophony of internalized "other" voices—social shoulds, celebrity gossip, parents, teachers, normatives, manners, and such —the camera's focus mechanism becomes a metaphoric practice for honing an awareness of one's own unique vision and personal directives. Some girls will, of course, be distracted by the ideas of their collaborators. Time alone with the camera is essential to off-set this, though given the cost of equipment for public schools and non-profit organizations and the need for supervision, this Zen-like experience may be difficult for all to access. Yet moments still occur in group settings when the click beyond the shutter occurs, the Eureka moment, the "Aha—I see things in a different way."

Girls filmmaking initiatives begin with an examination of the visual diet (step one, media literacy/critique); provide girls with digital tools for self-expression (step

two, creative activism and technical literacy); then reward them for their produc- tivity (step three, exhibitions, awards, scholarships as empowerment). Critiquing, naming, and analyzing popular culture is the first step. Making films and videos is the second. Establishing girls' networks of distribution is the third. Most important, teenage girls who graduate from film programs are acknowledged more for what they create, say, and do than for how they look or who their boyfriend might be.

In my experience, when a girl says, "I'm dumb" or "I'm ugly" or "This video I edited sucks," she is trying on tropes of mainstream culture and asking for correc- tives. "Tell me I'm not stupid like some of the girls on TV" underlies a statement such as "I'm dumb." While framed as a potent and disturbing statement, it's a marked request for reassurance. And girls need specifics beyond "That's ridicu- lous." They need a verbal mirror that accurately measures their gifts, without a pat response. They want a mirror more specific to their unique attributes of intel- ligence, talent, and style than the flawed mirrors around them.

What girls have to continue to learn in the filmmaking realm is the value of persistence. While sports training engenders this ethos as well, empowerment efforts must consistently counteract the messages of the mainstream designed to produce consumers rather than directors of girls. There is no end to the reinforce- ments many girls require in the early stages of their film world training. "You'll never make any money at it" is a dirty trick pulled on many young innovators con- sidering art or filmmaking as careers. The fact is, while being a director or an actress may be the most difficult role to attain, a fully trained computer graphics artist, edi- tor, lighting designer, sound technician, digital photographer, or web designer will find employment in her field. It may take networking chutzpah, staying focused, and pulling all-nighters at times, but the closed door is only an illusion. Girls can push it right open with the appropriate amount of talent, self-belief, perseverance, focus, and a willingness to do the math and learn the computer programs.

Access to technology still spells privilege for far more middle- and upper- middle-class students who have better facilities for digital skill building than those living in less-endowed neighborhoods. Scholarships exist for GirlsFilmSchool, Reel Grrls, and some college programs. Many public schools introduce media education through artist residency programs, as administrators continue to make the link between media literacy and overall literacy. Getting the word out and to reach those with potential remains challenging as museums, media art centers, and national girls' organizations including Girls Inc., Girls Clubs, and the Girl Scouts increas- ingly address the need for media outreach programs, especially in multicultural urban environments. Reel Grrls' partnership with Seattle's MetroCenter YMCA has brought diverse girl populations to their programs, with middle-class white girls from Microsoft territory in Bellingham, Washington, collaborating with girls from homeless shelters, Native American girls from a Puget Sound reservation,

and middle-class African American girls from Tacoma. GirlsFilmSchool has made similar diversity commitments through its scholarship program, bringing multicultural girls to the College of Santa Fe campus for three-week summer intensives.

GIRL FILMMAKER STARS

In the early 1990s, Sadie Benning demonstrated how much a 16-year-old girl with a Fisher-Price Pixelvision camera could express about growing up and the emergence of desire. Her low-tech video pieces about gay identity, *Me and Rubyfruit* (1989), *Jollies* (1990), *If Every Girl Had a Diary* (1990), and *A Place Called Lovely* (1991), became favorites at gay and lesbian film festivals and continue to be distributed to largely academic audiences by New York City's Women Make Movies and Chicago's Video Data Bank.[35] These videos, shot on a toy camera in the private universe of Benning's bedroom, employed dolls, toy cars, candy wrappers, and pop tunes to articulate the nascent experiences of teenage love. The intimacy of her kitsch collection of objects proved that a filmmaker doesn't have to stray far from a homemade "set" to translate significant messages onto the screen. Benning's private lair proved a powerful launching site for rebellion against conformity, catapulting her as a teenage art star to the Whitney Biennial and the Metropolitan Museum of Art. In 1992, at the age of 19, Benning was awarded a prestigious MacArthur Fellowship. Her father, James Benning, a professor at CalArts, no doubt encouraged his daughter's creative explorations and championed her early work as worthy of adult recognition and professional-level exhibition and promotion. Due to the controversial nature of Benning's early videos, it is unlikely that many teenage girls will have access to her work outside of museum and art house retrospectives, except perhaps at venues like Reel Grrls. While another Teen Art Star has yet to garner this level of museum and festival attention, part of this resides with the fact that girls as media makers are no longer a rarity, and depictions have even gone big-screen mainstream.

Recent television programs and Indie films have begun to include teenage girl filmmaker/photographer characters, complete with cameras and laptop editing suites. Since seeing is believing, these representational occurrences of girls as filmmakers and photographers are important to note. In addition to Julia Stiles' Ophelia-as-photographer performance in *Hamlet* (2000), the unfolding of Claire Fisher's talent as a photographer on HBO's *Six Feet Under* (see Chapter Eight) appears in detail in several episodes beyond incident quirky glimpses, along with the reactions of family members to evidence of her talent. She begins with her obvious inherited interest, cadavers, then moves on to self-portraiture, moody family portraits, and photo collages, works that appear onscreen as she moves from

high school to college. In *Napoleon Dynamite* (2004, Jared Hess), Tina Majorino provides key comic scenes as the sincere, deadpan Deb, a teenage Glamour Shot photographer who also has a sideline business selling key chains to raise money for college. The faithful film adaptation of *The Sisterhood of the Traveling Pants* (2005) depicts 16-year-old Tibby (Amber Tamblyn) as an aspiring documentarian who conducts video-interviews-in-the-aisles during her boring summer job at a Wal-Mart-like superstore. Tibby is tough, sarcastic, and at first resistant to a younger neighbor Bailey (Jenna Boyd) who wants to become her production assistant on her "Suckumentary" about people leading unfulfilled lives. Impressed by Bailey's "nothing to lose" attitude, Tibby relents and allows her to hold the microphone. In *The Upside of Anger* (2005, Mike Binder) Lavender or "Popeye" (Evan Rachel Wood), the youngest daughter of a woman sinking into alcoholism and depression after the disappearance of her husband, finds solace editing an experimental video on her laptop. She provides the narrative lens on events unfolding in this film within a film, as well as the opening and closing voice-over narration.

These breakthrough examples of teenage girl filmmakers commenting on their worlds through ongoing video and photography projects indicate that girls as media makers are no longer an anomaly but a promising, growing fact of global existence. With increasing access to media programs in schools and the innovative programs mentioned above, the potential for millennial changes in representation abound. A change of consciousness has taken place in potential expressions of Teenage Girl Identity in pop culture, and the possibilities are fluid and endless. Whether girls become filmmakers in adulthood is less important than their achieving mastery over the image systems that often dictate lifestyles and identities. Girls can frame with their own lenses and edit out images that compromise their moral and spiritual existences, welcoming those that inspire them to be larger than life, a Heroine in their own self-created, ever-evolving narrative. A new generation of Indie women is entering the field who may one day challenge the boys' network with a girls' network of their own—or better yet, an equalized, equal-opportunity network where the category of gender becomes secondary to telling a superior visual story. By rewriting the scripts of mainstream culture, Girl Filmmakers continue to redefine what it means to be a self-made Maiden in the USA set in the context of ever-expanding global media networks of digital consumers and producers.

Conclusion: iCelebrity AND Evolving iCons

As viewing and interactive media praxis continue to evolve in the gadget era, the exciting news is that girls are emerging as active shape shifters in this digital culture as Media Mavens, IM-ers, Facebookers, MySpacers, and iPod-ers. Girls increasingly have cell phones and digital cameras with a large majority computer literate by tweenhood. A recent study published by the Pew Internet and American Life Project notes that of teenagers who use the Internet, 57 percent are content creators, due in part to the prodigious popularity of social networking sites, which rely on the creation of a personal web page to become part of the network. Among these, older girls lead the pack in blogging, which requires a high level of tech savvy linked to heavy Internet use.[1] As noted by the study's authors,

> Today's on-line teens live in a world filled with self-authored, customized and on-demand content, much of which is easily replicated, manipulated, and redistributable. The internet and digital publishing technologies have given them the tools to create, remix, and share content on a scale that had previously only been accessible to the professional gatekeepers of broadcast, print, and recorded media outlets.[2]

Of these Content Creators on the Internet, 38 percent of the girls in the 15- to 17-year-old group share self-created content on the web, compared with 29 percent of the boys. Clearly, part of consuming media in the millennium relates definitively to creating media, and as Mary Celeste Kearney points out, these

11.1 ©2007 Kathleen Sweeney, iPod Ad, New York City, ©2006 Yvette Torell, iPod Ad, San Francisco.

girls' activities in cyberspace take place outside the context of computer classes in school, often on home computers, through user-friendly interfaces provided by the companies establishing these sites.[3] The shift in access on the Net has its parallel in the development of FinalCut Pro, which has made editing more of a cut-and-paste operation easy to learn, without the complex keystroke pathways of earlier programs impeding the storytelling. In similar fashion, YouTube provides clear instructions for uploading a Quicktime file to the site, making distribution at that level completely accessible to those who might not be advanced Geek Girls.

As discussed earlier, in the context of pop culture history, teenage girls possess a power collectively to not only create stars through sheer force of their attention, determining who is "cool," but to keep them there, in the spotlight, with their adulation. As Sharon Mazzarella has observed, a continued form of cyber activity for girls has been creating and maintaining fan sites on the web, which include updates and blogs tracking careers.[4] In the land of digital natives, where teenage girls create their own self-portrait-driven web pages on MySpace and Facebook and post clips on YouTube, celebrity obsessions begin to take a backseat. For the self-esteem generation, clearly there's a new terrain of visual fixation. What this means for teenage girls is a potential liberation from the tyranny of corporate brand celebrity culture. In the landscape of social networking sites and YouTube video upload opportunities, Millennial Girls become iCelebrities on their own terms. Whether that means a narcissistic interplay of self-revealing outfits at parties or a true harnessing of a medium that now accesses thousands, if not millions, of potential media activists, viewers, or collaborators resides with the girls at the helm. How they contribute to shifting definitions of Celebrityhood into celebrations of personal female power, vision, and social change through the visual medium remains as wide open as the World Wide Web.

Celebrityhood once defined the domain of a select few who found the access road to movie screen stardom. Reality TV's democratization of celebrity, once novel in its presentation of "regular people's" intimate lives, has become commonplace, paving the way for fascination with weblogs and photo pages on social networking sites. When anyone can be famous, the pedestal on which we perch our celebrities becomes smaller. The era of girls worshiping Uber Celebrity Royalty has perhaps begun to wane, with girls' self-discovery and self-portraiture on the web replacing waiting for the once-in-a-lifetime Cinderella story of being discovered. With cell phones, Blackberries, iPods, and iLife, along with the social networking sites Friendster, MySpace, and Facebook, Millennial Girls have become their own subjects in an iCulture/MyCulture of technology, gadgetry, and Internet savvy. In 2006, *Time Magazine* featured a shiny mirror surface as its Person of the Year,

underscoring the notion of a nation at the cusp of self-stardom, indicating that You, Me, We are all People of the Year, including Teenage Girls. As the accompanying article states,

> It's a story about community and collaboration on a scale never seen before. It's about the cosmic compendium of knowledge Wikipedia and the million-channel people's network YouTube and the online metropolis MySpace. It's about the many wresting power from the few and helping one another for nothing and how that will not only change the world, but also change the way the world changes.[5]

The survival of human culture, freedom of speech, and representation may well depend on the way we present ourselves to that mirror. Media making will be part of that reflecting back. Which filmic narrative will girls pursue: the search for self as American Idol, the creation of new Icons, and/or media leadership for the greater good?

At this point in time, girl participants in the IM, iPod, and MeMedia universe are not navigating the same Generation X issues of self-esteem. They have their own universe, and everyone in it can tune out or tune in to other "Millennial Me"s. The possessive singular pronouns operate, yet the community inherent in the social networking phenomenon marks an important distinction that sets this generation of digital users apart from celebrity worshipers of the 1980s and 1990s. The eye turns inward not just to the self but to the interactive pages of many teenage selves actively recording their lives for all the networks to witness in nanosecond text and image dialogue.

The Master of the Universe sensibility afforded Millennial Girls involves the instant gratification component of the technology. Instant Messenger and cell phone immediacy have empowered them with virtual communities of contact. Physical intimacy issues, computer addiction, and obesity may well be the shadow side of a digitally sped-up culture, but through a couple of keystrokes, this generation of girls wires into a virtual community of thousands of peers, something previous generations could only conjure in front of a microphone or a television screen, with the support of an entire cadre of backers, producers, and a public relations team. This virtual freedom of speech and interconnectivity already affects human consciousness, language, and relationships. By providing a quantifiable awareness of one's place in the context of a much greater community, one enters portals of communication well beyond a roommate or a nuclear family, which itself is expansive. With information services as extensive as Wikipedia, Dictionary.com, Thesaurus.com, UrbanDictionary.com, IMDb, and others, trivia, dates, word meanings, and etymologies can be obtained with a keystroke. Instant communities provide many pathways for meeting social needs, yet aspects of these worlds are based on virtual illusion making. The Internet, with its history of gaming, chat room avatars, and multiple e-mail addresses and domain

names has always been about the power of illusion and its interplay with reality. The impact of this identity playground on girl environments continues to expand with a software resource infrastructure is user-friendly and gender equalizing.

Along with the instant community sensibility comes a generation wired toward shareware. Digital images post freely without credit to the photographer. Just like Wikipedia, fueled by anonymous scribes and scholars, Facebook and MySpace images update without concern for authorship credit. This digital generosity is a concept that can be a little alien to Baby Boomers or Gen X-ers. It's almost utopian; it's almost socialist! But this free flow of images and ideas and blog texts (easily copied, cut, and pasted) keystones the success of the "pass it on and share" fever of the social networking system. It's free. We're free. You're invited. The inclusiveness greatly contrasts the clique mentality of Mean Girls.

In his article "Me Media; The Online Life," John Cassidy chronicles the rise of Facebook from a single dormitory on-line network created at Harvard by Mark Zuckerberg to a national college social network in less than a year.[6] Founded in February 2004, by December 2004, the site had over a million users. What began as an exclusive Harvard networking site, Facebook is now accessible to anyone with a college or high school ID. MySpace and Facebook now provide a telescope into a generation of identity pages. As non-municipal, self-created IDs, they are licenses to create one's own identity in a social space, photo IDs comprised of multiple images that transcend the uniformity of state driver's licenses or government pass-ports, those traditional IDs marred by embarrassingly stiff photographs captured in a single take by a bored functionary. Digital natives took to the concept instantly, more quickly than the previous generation took to establishing e-mail accounts. Part of this streamline caught every college freshman simultaneously as they set up their brand new lives at colleges across the country. In Fall 2005, "Are you on Facebook?" became the question of the day. You had to be a part of the networking system in place. Freshman wanted to count, to be in the know, to be networked. Internet buddies can simply be added to the list. No meeting necessary. You are simply "in," on the list, part of the virtual scene.

As Demetri Martin lampooned on his "Trendspotting" sketch on *The Daily Show* in February 2006, being "friends" in a titular sense with hundreds or thou-sands of people requires little by way of commitment.[7] Cassidy notes, "Facebook's members invariably cite its usefulness for keeping up with friends, but clearly one of the reasons that the site is so popular is that it enables users to forgo the exertion that real relationships entail."[8]

Once Facebook members list someone as a "friend" anyone in the network can post messages and photos on that friend's site. The gatekeeping is limited to deny-ing an individual permission to be a friend, but given the thrill of the quantitative network, most college students say yes unless the requester appears to be a total

stranger, stalker, or high school student. So Facebook is ever evolving, which keeps activity and interest high. Girls in particular constantly update their profiles and photo albums, altering their on-line personae. From a public relations standpoint, this represents an unprecedented forum for filminista distribution of ideas, images, music, and other forms of creativity.

Facebook's "instant popularity," like that of MySpace and Friendster before it, demonstrates what Malcolm Gladwell terms "social epidemics" in his book *The Tipping Point: How Little Things Can Make a Big Difference.*[9] The Internet's speed of connectivity actually assists with social epidemics, capitalizing on rumor through the wired nature of the web to create exponential levels of interrelated computer networks. This means that the Internet, as speculators discovered when the dot. com bubble burst, is a volatile environment for predicting trends, yet unbelievably "overnight" in the way ideas course through it. When a trend becomes that contagious, it can transform human behavior at a mass scale. The phenomenon of social networks disproves initial fears of the Internet being a site of alienation in teenagers, a dropping away from healthy human interactivity to addictive solo gaming or falling prey to predators. In many ways, social networking sites have enhanced connections at the global scale, and girls have been a huge part of the success of the social networking phenomenon. When this applies to political change, as in the case of MoveOn.org's Internet presence in the 2004 and 2006 elections, the force of the networks becomes palpable in conveying environmental issues and human rights abuses and influencing certain kinds of government action due to the visibility and accountability of all public figures whose public records, no longer just word-based, exist in video databases as well.

Anyone can now be "friends" with hundreds, if not thousands, of others, creating a virtual entourage. In this "iSpace" virtual iCelebrities exist without the loss of street privacy; a page contains all the exposure selected for a narrative of self viewed by the list of friends. One is networked, connected, multitasked, but not paparazzied except by one's own digital camera snapping "helicopter shot"[10] self-portraits that can be erased until perfection is achieved—the ultimate self-image. Happy, gorgeous, surrounded by friends at a party, all documented on your own ever-evolving self-image page.

As the self-esteem generation, Millennials are drawn to personal pronouns. The personal pronoun operates in Apple's iLife of iPods, iTunes, iMovie, ... a world to which "I" connect in conjunction with my Mac or PC, a world where "I" am at the center of cool. In the iUniverse life is shared in pod-space with millions of other "I"s. And, interestingly, the iPod "i" is lower case. Not too much ego involved. Despite the personal pronoun hovering in the Apple of the "I," the premise of a whole universe of "I's," living in harmony with movies and music, both self-generates and draws from the cultural treasure box of on-line offerings. MySpace

continues in this linguistic mode, with the possessive pronoun: a space that is mine, yet shared with anyone who joins in to create a page, a presence, a personality. A forum for creatively manufacturing and perfecting a persona also evolves as an arena for quantifying one's social desirability through the sheer numbers of those listed as your friends. For girls, being wired to the social universe at this level of quantification can offset insecurities about the in-crowd. The site statistics record how many friends you have, providing daily proof of one's desirability and connectivity in the posted list of those in your network. That many are removed by six degrees of separation doesn't matter; the hard-core numbers furnish proof that one exists socially. Contrary to the myth of girls as math-phobic, they are seduced by the numbers as much as anyone. And let's face it, self-esteem is a psychological state of self-belief bolstered initially by one's parents and communities. If the Internet serves a role in this movement, what's to critique? If it fosters a certain number of narcissists, every generation has had to grapple with the self-involved. Due to the interactivity of the sites, however, this is unlikely, as social networks are predicated on communing and communicating with a whole host of others. In this universe everyone alternates roles as celebrity or groupie. It's a system for being center stage among many others being center stage, the ultimate youth culture democracy. With party pictures the norm on MySpace and Facebook, by looking at a page, you've been virtually invited to join in by viewing the exuberant documentation. This way the party continues after the fact through participatory viewership.

These communities of self-constructed popularity are not necessarily negative—it takes a village to raise an identity, after all—knowing lots of people, expanding perspectives, posting digital self-portraits, a diversity of connections. It's part of what made the Internet an instantaneous Global Village. In this universe, anyone can be "seen," often by thousands of Internet "viewers," and the out-there bravura of many girls is evident. As chat rooms and avatars proved in the early 1990s, the Internet provides a venue for self-exploration of dress-up and PhotoShop identities in a continuation of the Performing Girl modes explored by Madonna and Cindy Sherman. Creating pages, creating spreads, expands as a digital art form of self-portraiture made available to those with computer access by virtue of the user-friendly interface. Girls, masters of the technology in equal numbers to boys, have proven more willing to update pages and create blogs—in other words, to remain interactive with technology.[11]

For girls, MySpace and Facebook provide a digital mirror that expands beyond the classical two-dimensional mirrors of bathrooms, bedrooms, and hallways. By turning the camera on themselves to create web pages, digital native girls live in an arena of ever-edited exploratory mirror views of themselves. An entire generation of Cindy Shermans! While this may be deemed a further chapter in the culture of self-absorption, this is a two-way mirror culture in that each mirror networks

into thousands of other mirrors-as-self-portraits. The fun play aspect in updating the page and keeping it current means that the reinvention of self moves beyond the static single audience in the hallway mirror to an ever-changing series of self-images as two-dimensional digital self-portraits sent out to the network. With PhotoShop options the self-portrait can be altered to exposure advantage, with black-and-white or sepia settings a click away from experimentation. The self becomes fluid in this networked economy of identity where many "selves" can operate across timeframes, where the self evolves on a daily basis. The self portrait becomes a dialogue with friends that can be viewed by others in the network.

The digital mirror is interactive and dialogic. Compared to the pained or cruel dialogue with the self within the pages of fashion magazines or celebrity rags, MySpace and Facebook creates a very different kind of Internet news service, where pics of friends at parties become currency for the initiated masses. *People Magazine* versus and ever-expanding youth blog of pages and pages of virtual friends. Facebook defies the feared isolation of a technology-based lifestyle, as computer-based communication and documentation provide an adjunct to actual physical celebrations and gatherings. It is one of many conduits of communication including cell phones, Instant Messenger, e-mail, text messaging, and blogging accessed by Millennials Girls.

Much of the bullying in the Girl Worlds described by Rosalind Wiseman and Rachel Simmons comes from a manipulation of a girl's social currency as relational—the notion that without relationships, a girl doesn't have value.[12] The social networking concept offered by MySpace, Friendster, and Facebook capitalizes on this currency by allowing members to accumulate "friends" in the hundreds, all linked to the participant's public web page, filled with digital self-portraits, e-mails from "friends," and a personality profile of likes and dislikes. Facebook has become a way for college and high school students to introduce themselves with an individual profile replete with lists of their favorite musicians, movies, and likes and dislikes, much the same way celebrities appear in profiles on the pages of teen magazines or fan sites.

The precursors to social networking sites are, of course, the cyber-appendages known as cell phones. Talking, texting, amassing a phone book of contacts, these activities, along with Instant Messenger, set the stage for this new form of personal celebrityhood. With their iPods, laptops, and cell phones, teenage girls have in many ways replaced the Mechanical Brides of the 1950s and 1960s depicted in aprons, crooning over their washing machines. Coined in 1951 by Marshall McLuhan in his book *The Mechanical Bride: Folklore of Industrial Man*, the term refers to the ways in which technology has been historically sold through sexualized advertising and the visual alliance of female bodies and gender role narratives with gadgetry and appliances.[13] In magazines and brochures of that era, young housewives and secretaries exclaimed

over the newest in postwar washing machines, telephones, televisions, and type-writers, plugged into their supposed high-tech domestic and office domains, married to their subordinate roles in life as much as they were wired to the electrical socket.[14] Mechanical Maidens now appear with their cell phones and iPods as freely roving tech girls, plugged in yet still mobile, able to talk on the cell phone from a moving car, the woods, the mall, the grocery store, the school campus, or a friend's house. Not wedded to the architecture of wall outlets, the freedom inherent in a cell phone implies that females are no longer tied to the kitchen, the desk, or the switchboard to connect to the newest technology. It also marks a shift away from married women as the arbiters of new technology purchases to teenagers as the pivotal purveyors of the new. High-tech gadgets have transcended gender. Mechanical Brides were promised "freedom from drudgery." Mechanical Maidens are promised the freedom to be ultra-cool. If the appliance era of the 1950s and 1960s depicted the Mechanical Bride enthralled by her space-age kitchen, Millennial Teenagers are the gadget royalty of the high-tech era.

The cell phone functions as an object of desire and being desired. Being connected, having the cell phone emit its special ring tone, indicates that one is in the loop, in the mix. Cell phones, no longer just fun toys with cameras and texting capabilities, have become social necessities. In the 2006 film *Quinceañera*, 14-year-old Magdalena documents her East LA social life with her cell phone camera, receives text messages from her boyfriend Hector, and calls her parents with check-ins about "going to the mall" as cover for meeting with him. When she becomes pregnant and Hector pulls away from her, the break-up is symbolized by her deletion of his photos, messages, and number from her phone. For some girls, the cell phone's instant ability to connect with parents has enhanced their freedom in an era of Missing Girl fear. As a device for documentation and the collection of phone numbers, it represents a portable social lifeline.

iGIRLS

An extension of the now visual urban or suburban scene, which includes hoards of people holding cell phones to their ears as they walk, oblivious to their surround-ings, comes the philosophy of the iPod. "iPod therefore I am." Just as a cell phone became necessery in the 1990s, everyone has to have one. Apple Computer spent under 100 million dollars in two cycles of advertising for the Apple iPod; the rest occurred through word of mouth, making the iPod a hot item since 2001.[15]

Girls with unisex iPods peruse the inner soundtrack to anywhere for a future movie in progress dialed up on a spin of the iPod wheel of music fortune. Everything Mac is girl-friendly, unisex. Utopian. In highly effective banner, billboard, and

television ads, iPod proposes an Everyone iPod iUniverse, where members have amnesia about the $99 to $350 price tag that might limit access to hi-tech Utopia. Yet millions of middle-class teenage girls and their parents are buying them. An iPod is not a Walk*man* or a Disc*man*; it is non-gender specific, it breeds inclusiveness, just like social networks, which feeds its fiscal success story, along with its link back to the computer and its ability to play movies on a small screen. A Filminista can now show her video reel to a job prospect in an elevator or a cab.

Viewing movie content on the Internet has expanded through file compression and DSL networks for excerpted uploads of significant current events, music videos, and personal blog footage. For YouTube, which debuted in 2005 with the tagline "Broadcast Yourself," the wildfire popularity meant millions of viewers within a year.[16] The seeming other-orientation of the titular pronoun is offset by the profusion of personal folders such as "MyVideos," "MyPlaylists," "MyFriends," which, like social networking sites, provide numerical logs of accumulated activity, a progress report which encourages repeat visitation. Given that stats on the site catalogue how many friends one has, the urge to link to as many people as possible becomes palpable. This "coolness equals quantity" equation has helped to enhance the success of the networking inherent in the sites. Every member is measured and rated on how often their videos play, how many friends they have, and so on. For some serious participants, the stress of tracking these ratings resembles the Nielsen Sweeps week of network television. Bottom line: never before in history has a portal opened up for girls to post their films so easily to a global network.

Along with crazy antic clips with titles like "Muffins" and "Shoes," new band videos, *The Daily Show* archives, and other visual clips which achieve popularity through e-mail word of mouth, some of YouTube's most popular video blogs regularly posted on the site have been about teenage girls. According to Ben McGrath in *The New Yorker*, "[W]hat people seemed to like was not pretentious art films with obvious Hollywood aspirations but the confessional blogs of young girls in their bedrooms."[17] Two of the best-known video diary series clips series include LonelyGirl15 and Little Loca. Despite the slick editing and obvious acting of the "Midwestern" teenager onscreen, LonelyGirl15 pulled in the attention of millions of YouTube viewers before being exposed as a Los Angeles confection by Creative Artists Agency. Little Loca, on the other hand, was the creation of a 22-year-old actress named Stevie Ryan who borrowed a friend's video camera to produce her blog. The character Little Loca, a 17-year-old East LA Latina also known as Cynthia, wears large gold hoop earrings and thick dark lipstick as she doles out heavily Hispanic-accented stories of her daily life to background rap music. A straight-A student with a boyfriend named Raul, she proudly keeps her virginity intact, navigates her friends' gang involvements, and keeps her overprotective brother at bay. As a result of the number of hits Ryan received and the loyal

viewership which continues to be devoted to her on-going blog, Ryan has begun to gain attention in Hollywood, all due to a little camcorder and a spunky imagination. Playing a teenage girl clearly has its benefits. That Stevie Ryan shoots, directs, and stars in these videos sets her apart from LonelyGirl15 as another kind of maverick.

While these are some of the most popular characters to gain attention in the first year of YouTube's existence, the openness of the medium to Sadie Benning-style video is clear, even when the diaries are invented. Teenage girl filmmakers have already begun to post their videos on YouTube, along with aspiring musicians, photographers, and artists on MySpace. Girls have gone digital with exhibition opportunities being invented and reinvented, particularly for those with access to cameras. The racial and economic issues of access remain problematic, but as more and more schools incorporate technical literacy into their programs and the funded outreach of Girls Inc., Girls Clubs, Girl Scouts, Reel Grrls, and GirlsFilmSchool continues, more girls will exhibit videos on YouTube and on sites that have yet to be created. Some girls might even catapult themselves to household name recognition and Icon status or simply be part of the "pass it on" wave of the Maiden USA digital revolution. Falling through the digital rabbit hole will no doubt bring new versions of Cyber-Persephones and Techno-Alices to the surface of our Girl screens as Girls continue to be key creators of new media.

Appendix: Resource Lists

TEENAGE GIRL-CENTRIC FILMS

FILMS DIRECTED BY WOMEN SINCE THE 1990S
(A CHRONOLOGICAL SELECTION)

Gas Food Lodging (1991, Allison Anders,* R) [Ione Skye]
Buffy the Vampire Slayer (1992, Fran Rubel Kuzui, PG-13) [Kristy Swanson]

App.1 ©2005 Reel Grrls. Courtesy Reel Grrls, www.reelgrrls.org.

Guncrazy (1993, Tamra Davis, R) [Drew Barrymore]

Just Another Girl on the I.R.T. (1993, Leslie Harris,*R) [Ariyan Johnson]

Mi Vida Loca (1994, Allison Anders,* R) [Angel Aviles, Seidy Lopez]

Little Women (Gillian Armstrong, 1994, PG) [Claire Danes, Winona Ryder, Kirsten Dunst]

The Incredibly True Adventures of Two Girls in Love (1995, Maria Maggenti, R) [Laurel Holloman, Nicole Parker]

Clueless (1996, Amy Heckerling, PG) [Alicia Silverstone]

Harriet the Spy (1996, Bronwen Hughes, PG) [Michelle Trachtenberg]

Manny & Lo (1997, Lisa Krueger,* R) [Scarlett Johansson]

Artemisia (1997, Agnes Merlet,* R) [Valentina Servi]

The Parent Trap (1998, Nancy Meyers, PG) [Lindsay Lohan]

Boys Don't Cry (Kimberly Peirce*, 1999, R) [Hilary Swank, Chloe Sevigny] (Academy Award: Best Actress, Hilary Swank)

But I'm A Cheerleader (Jamie Babbitt,* 1999 R) [Natasha Lyonne]

Slums of Beverly Hills (1999, Tamara Jenkins,*R) [Natasha Lyonne]

Getting to Know You (1999, Lisanne Skyler,* Unrated) [Heather Matarazzo]

The Virgin Suicides (1999, Sofia Coppola,* R) [Kirsten Dunst]

Girlfight (2000, Karyn Kusama,* R) [Michelle Rodriguez]

Love & Basketball (2000, Gina Prince-Bythewood, PG-13) [Sanaa Lathan]

Riding in Cars with Boys (2001, Penny Marshall, PG-13) [Drew Barrymore]

Real Women Have Curves (2002, Patricia Cardoso,* PG-13) [America Ferrara]

Blue Car (2002, Karen Moncrieff,* R) [Agnes Bruckner]

Bend It Like Beckham (2003, Gurinder Chadha* PG) [Keira Knightley]

Whale Rider (2003, Niki Caro,* PG) [Keisha Castle-Hughes] (Academy Award Nomination: Best Actress, Keisha Castle-Hughes)

Thirteen (2003, Catherine Hardwicke,* R) [Evan Rachel Wood] (Academy Award Nomination: Best Supporting Actress, Holly Hunter)

Confessions of a Teenage Drama Queen (2004, Sara Sugarman, PG) [Lindsay Lohan]

The Prince and Me (2004, Martha Coolidge, PG) [Julia Stiles]

Lost in Translation (2004, Sofia Coppola,* R) [Scarlett Johansson] (Academy Award for Best Original Screenplay--Sofia Coppola)

Herbie Fully Loaded (2005, Angela Robinson, G) [Lindsay Lohan]

The Ballad of Jack and Rose (2005, Rebecca Miller, R) [Camilla Belle]

Take the Lead (Liz Friedlander, 2006, PG-13)

Marie Antoinette (2006, Sofia Coppola,* PG-13) [Kirsten Dunst]

The Nativity (2006, Catherine Hardwicke, PG) [Keisha Castle-Hughes]

(*Films also written or co-written by the directors)

Hollywood Films (a chronological selection)

1930s–1950s

Stella Dallas (1937, King Vidor) [Anne Shirley]
Snow White and the Seven Dwarfs (1937, Disney)
The Wizard of Oz (1939, Victor Fleming) [Judy Garland—Academy Award for Best Juvenile Performance]
National Velvet (1944, Clarence Brown) [Elizabeth Taylor]
Mildred Pierce (1945, Michael Curtiz) [Ann Blyth]
Cinderella (1950, Disney)
Peter Pan (1953, Disney)
Gidget (1959, Paul Wendkos) [Sandra Dee]

1960s–1980s

West Side Story (1961, Jerome Robbins and Robert Wise) [Natalie Wood]
Lolita (1962, Stanley Kubrick) [Sue Lyons]
To Sir, With Love (1967, James Clavell)
The Prime of Miss Jean Brodie (1969, Ronald Neame)
The Exorcist (1973, William Friedkin, R) [Linda Blair]
Paper Moon (1973, Peter Bogdanovich, PG) [Tatum O'Neal—Academy Award for Best Supporting Actress]
Taxi Driver (1976, Martin Scorsese, R) [Jodie Foster]
Carrie (1976, Brian De Palma, R) [Sissy Spacek]
Grease (1978, Randal Kleiser, PG)
Fame (1980, Alan Parker, R) [Irene Cara]
Personal Best (1982, Robert Towne)[Mariel Hemingway]
Sixteen Candles (1984, John Hughes, R) [Molly Ringwald]
The Breakfast Club (1985, John Hughes, R) [Molly Ringwald, Ally Sheedy]
Pretty in Pink (Howard Deutch, 1986, PG-13) [Molly Ringwald]
Some Kind of Wonderful (1987, Howard Deutch, PG-13) [Mary Stuart Masterson]
Dirty Dancing (1987, Emile Ardolino, PG-13) [Jennifer Gray]
Mystic Pizza (1988, Donald Petrie, R) [Julia Roberts, Lili Taylor]
Beetle Juice (1988, Tim Burton, PG) [Winona Ryder]
Heathers (1989, Michael Lehman, R) [Winona Ryder]
The Little Mermaid (1989, Disney, Ron Clements/John Musker, G)

1990–1999

Edward Scissorhands (1990, Tim Burton, PG-13) [Winona Ryder]
Mermaids (1990, Richard Benjamin, PG-13) [Winona Ryder, Christina Ricci]

Buffy the Vampire Slayer (1992, Fran Rubel Kuzui) [Kristy Swanson]

The Joy Luck Club (1993, Wayne Wang, PG)

Little Women (1994, Gillian Armstrong, PG) [Claire Danes, Winona Ryder, Kirsten Dunst]

Clueless (1995, Amy Heckerling, PG-13) [Alicia Silverstone]

Dangerous Minds (1995, John N. Smith, R)

Pocahontas (1995, Disney, G)

Scream (1996, Wes Craven, R) [Neve Campbell, Rose McGowan, Courteney Cox, Drew Barrymore]

Harriet the Spy (1996, Bronwen Hughes, PG) [Michelle Trachtenberg]

The Ice Storm (1997, Ang Lee, R) [Christina Ricci]

Scream 2 (1997, Wes Craven, R) [Neve Campbell, Courteney Cox, Sarah Michelle Gellar, Jada Pinkett Smith]

Selena (1997, Gregory Nava, PG) [Jennifer Lopez]

Elizabeth (1998, Shekhar Kapur, R) [Cate Blanchette]

Ever After (1998, Andy Tennant, PG) [Drew Barrymore]

Lolita (Adrian Lyne, 1998, remake, NC-17) [Dominique Swain]

Mulan (1998, Disney, G)

The Parent Trap (1998, Nancy Meyers, PG) [Lindsay Lohan]

A Walk on the Moon (1999, Tony Goldwyn, R) [Anna Paquin]

American Beauty (1999, Sam Mendes, R) [Mena Suvari, Thora Birch]

Anywhere But Here (1999, Wayne Wang, PG-13) [Natalie Portman]

Cruel Intentions (1999, Roger Kumble, R) [Reese Witherspoon, Sarah Michelle Gellar]

Election (1999, Alexander Payne, R) [Reese Witherspoon]

Jawbreaker (Darren Stein, 1999, R) [Rose McGowan, Judy Greer]

She's All That (1999, Robert Iscove, PG-13) [Rachel Leigh Cook]

10 Things I Hate About You (1999, Gil Junger, PG-13) [Julia Stiles]

2000–2007

Almost Famous (2000, Cameron Crowe, R) [Kate Hudson, Anna Paquin]

Bring It On (2000, Peyton Reed, PG-13) [Kirsten Dunst]

Girl, Interrupted (2000, James Mangold, R) [Winona Ryder, Angelina Jolie]

Scream 3 (2000, Wes Craven, R) [Neve Campbell, Courteney Cox, Parker Posey, Emily Mortimer]

X-Men (2000, Brian Singer, PG-13) [Anna Paquin]

Harry Potter & The Sorcerer's Stone (2001, Chris Columbus, PG) [Emma Watson]

The Princess Diaries (2001, Garry Marshall, G) [Anne Hathaway]

Riding in Cars with Boys (2001, Penny Marshall, PG-13) [Drew Barrymore]

Save the Last Dance (Thomas Carter, 2001, PG-13) [Julia Stiles]

Spy Kids (Robert Rodriguez, 2001 PG) [Alexa Vega]

Sugar & Spice (Francine McDougall, 2001, PG-13) [Mena Suvari]

Harry Potter & The Chamber of Secrets (2002, Chris Columbus, PG) [Emma Watson]

The Ring (2002, Gore Verbinski, PG-13) [Amber Tamblyn]

Spy Kids 2: Island of Lost Dreams (Robert Rodriguez, 2002, PG) [Alexa Vega]

White Oleander (2002, Peter Kosminsky) [Alison Lohman]

Matchstick Men (2003, Ridley Scott, PG-13) [Alison Lohman]

Peter Pan (2003, P.J. Hogan, PG) [Rachel Hurd-Wood]

Pirates of the Caribbean: The Curse of the Black Pearl (2003, Gore Verbinski, PG-13) [Keira Knightley]

Spy Kids 3D: Game Over (Robert Rodriguez, 2003, PG) [Alexa Vega]

What a Girl Wants (2003, Dennie Gordon, PG) [Amanda Bynes]

X2: X-Men United (2003, Brian Singer, PG-13) [Anna Paquin]

A Cinderella Story (2004, Mark Rosman, PG) [Hilary Duff]

Confessions of a Teenage Drama Queen (2004, Sara Sugarman, PG) [Lindsay Lohan]

First Daughter (2004, Forest Whitaker, PG) [Katie Holmes]

Harry Potter & The Prisoner of Azkaban (2004, Alfonso Cuaron, PG) [Emma Watson]

The Incredibles (2004, Brad Bird, PG)

Mean Girls (2004, Mark Waters, PG-13) [Lindsay Lohan]

New York Minute (2004, Dennie Gordon, PG) [The Olsen Twins]

The Prince and Me (2004, Martha Coolidge, PG) [Julia Stiles]

13 Going on 30 (Gary Winick, 2004, PG-13) [Jennifer Garner]

The Chronicles of Narnia: The Lion, the Witch and the Wardrobe (2005, Andrew Adamson, PG) [Georgie Henley, Anna Popplewell]

Harry Potter & The Goblet of Fire (2005, Mike Newell, PG) [Emma Watson]

Herbie Fully Loaded (2005, Angela Robinson, G) [Lindsay Lohan]

Ice Princess (2005, Tim Fywell, G) [Michelle Trachtenberg]

Memoirs of a Geisha (2005, Rob Marshall, PG-13) [Zhang Ziyi]

Pirates of the Caribbean: Dead Man's Chest (2005, Gore Verbinski, PG-13) [Keira Knightley]

The Sisterhood of the Traveling Pants (2005, Ken Kwapis, PG) [Alexis Beidel, America Ferrara, Amber Tamblyn]

War of the Worlds (2005, Steven Speilberg, PG-13) [Dakota Fanning]

Charlotte's Web (2006, Gary Winick, G) [Dakota Fanning]

Children of Men (2006, Alfonos Cuaron, R) [Claire-Hope Ashity]

Material Girls (2006, Martha Coolidge, PG) [Hillary Duff]

The Nativity Story (2006, Catherine Hardwicke, PG) [Keisha Castle-Hughes]

The New World (2006, Terrence Malick, PG-13) [Q'Orianka Kilcher]
She's The Man (Andy Fickman, 2006, PG-13) [Amanda Bynes]
Silent Hill (Christophe Gans, 2006, R)
Stephanie Daley (2006, Hillary Brougher, R) [Stephanie Daley]
Take the Lead (Liz Friedlander, 2006, PG-13)
X-Men: The Last Stand (2006, Brett Ratner, PG-13) [Anna Paquin]
Bridge to Terabithia (2007, Gabor Csupo, PG-13) [AnnaSophia Robb]
Harry Potter & The Order of the Phoenix (2007, David Yates, PG) [Emma Watson]
Nancy Drew (2007, Andrew Fleming, PG) [Emma Roberts]
The Golden Compass (2007, Chris Weitz) [Dakota Blue Richards]
Juno (2007, Ivan Reitman) [Ellen Page]

Independent Features
(a chronological selection)

1990–1999

Metropolitan (1990, Whit Stillman, PG-13) [Carolyn Farina]
Gas Food Lodging (1991, Allison Anders, R)* [Ione Skye, Fairuza Balk]
Zebrahead (Anthony Drazan, 1992, R) [N'Bushe Wright]
Guncrazy (1993, Tamra Davis, R) [Drew Barrymore]
Just Another Girl on the IRT (1993, Leslie Harris, R) *[Ariyan Johnson]
Heavenly Creatures (1994, Peter Jackson, R) [Kate Winslet]
Mi Vida Loca (1994, Allison Anders, R) *[Angel Aviles, Seidy Lopez]
The Incredibly True Adventures of Two Girls in Love (1995, Maria Maggenti, R)* [Laurel Holloman, Nicole Parker]
The Secret of Roan Inish (John Sayles, 1994, PG) [Jeni Courtney]
KIDS (1995, Larry Clark, R) [Chloe Sevigny]
Sense and Sensibility (1995, Ang Lee, PG) [Kate Winslet]
Stealing Beauty (1996, Bernardo Bertolucci, R) [Liv Tyler]
Bastard Out of Carolina (1996, Angelica Huston) [Jena Malone, Christina Ricci]
Girls Town (1996, Jim McKay, R) [Lili Taylor]
Welcome to the Dollhouse (Todd Solondz, 1996, R) [Heather Matarazzo]
Artemisia (1997, Agnes Merlet, R)* [Valentina Servi]
Freeway (1997, Matthew Bright, R) [Reese Witherspoon]
Manny & Lo (1997, Lisa Kreuger, R)* [Scarlett Johansson]
Princess Mononoke (1997, Hayao Miyazaki, PG-13)
Buffalo 66 (1998, Vincent Gallo, R) [Christina Ricci]
Desert Blue (1998, Morgan J. Freeman, R) [Christina Ricci, Kate Hudson]

The Opposite of Sex (1998, Don Roos) [Christina Ricci]

Pecker (1998, John Waters, R) [Christina Ricci]

Run Lola Run (1998, Tom Tykwer, R) [Franka Potente]

Boys Don't Cry (1999, Kimberly Peirce, R)* [Hilary Swank—Academy Award, Best Actress, Chloe Sevigny]

But I'm A Cheerleader (1999, Jamie Babbitt, R)* [Natasha Lyonne, Clea DuVall]

Getting to Know You (1999, Lisanne Skyler, NR)* [Heather Matarazzo

The Messenger: The Story of Joan of Arc (Luc Besson, 1999, R) [Milla Jovovich]

Tumbleweeds (Gavin O'Connor, 1999, PG-13) [Kimberly Brown]

2000–2007

Crouching Tiger, Hidden Dragon (2000, Ang Lee, PG-13) [Zhang Ziyi]

Girlfight (2000, Karyn Kusama, R)* [Michelle Rodriguez]

Hamlet (2000, Michael Almyreda, R) [Julia Stiles]

Love & Basketball (Gina Prince-Bythewood, 2000, PG-13) [Sanaa Lathan]

Romeo and Juliet (2000, Baz Luhrman, PG-13) [Claire Danes]

The Virgin Suicides (Sofia Coppola, 2000, R)*[Kirsten Dunst]

Ghost World (2001, Terry Zwigoff, R) [Thora Birch, Scarlett Johansson]

Bend It Like Beckham (2002, Gurinder Chadha, PG)* [Keira Knightley, Parminder Nagra]

Blue Car (2002, Karen Moncrieff, R)* [Agnes Bruckner]

Kiki's Delivery Service ([Disney dubbed version 2002], [Japanese version,1989], Hayao Miyazaki, G)

Real Women Have Curves (2002, Patricia Cardoso, R)*[America Ferrara]

Spirited Away (2002, Hayao Miyazaki, PG)

Girl With A Pearl Earring (2003, Peter Weber, PG-13) [Scarlett Johansson]

Lost in Translation (2003, Sofia Coppola, R) [Scarlett Johansson] (Academy Award for Best Original Screenplay—Sofia Coppola)

Thirteen (Catherine Hardwicke, 2003, R)* [Evan Rachel Wood]

The Holy Girl (Lucretia Martel, 2004, Argentina, R) [Maria Alche]

Kamikaze Girls (2004, Tetsuya Nakashima, Japan) [Kyoko Fukada, Anna Tsuchiya]

Maria Full of Grace (2004, Joshua Marston, R) [Catalina Sandino Morena]

Palindromes (2004, Todd Solondz, R)

Saved! (2004, Brian Dannelly, R) [Jena Malone, Eva Amurri]

Whale Rider (Niki Caro, 2004, PG-13)* [Keisha Castle-Hughes—Academy Award Nomination, Best Actress]

Caterina in the Big City (2005, Paolo Virzi, Italy) [Alice Teghil]

The Ballad of Jack and Rose (2005, Rebecca Miller, R) [Camilla Belle]
Howl's Moving Castle (2005, Hayao Miyazaki, PG)
My Neighbor Totoro ([2005, Disney dubbed version], 1988 [Japanese version], Hayao Miyazaki, G)
Nausicäa of the Valley of the Wind ([2005, Disney dubbed version], 1984, Hayao Miyazaki, PG)
Pride and Prejudice (2005, Joe Wright, PG) [Keira Knightley]
The Upside of Anger (Mike Binder, 2005, R) [Evan Rachel Wood]
Akeelah and the Bee (2006, Doug Atchison, PG) [Keke Palmer]
Half Nelson (2006, Ryan Fleck, R) [Shareeka Epps]
Little Miss Sunshine (2006, Jonathan Dayton/Valerie Feris, R) [Abigail Breslin— Academy Award Nomination, Best Supporting Actress]
Marie Antoinette (2006, Sofia Coppola, PG-13) [Kirsten Dunst]
Paprika (2006, Satoshi Kon, R)
Quinceañera (2006, Richard Glatzer/Wash Westmoreland, R) [Emily Rios]
Stephanie Daley (2006, Hillary Brougher, R) [Amber Tamblyn]
Volver (2006, Pedro Almaldovar, R) [Yohana Cobo]

RESOURCES FOR BUDDING FILMMAKERS

MEDIA LITERACY ORGANIZATIONS AND WEBSITES

About Face, http://www.about-face.org
Center for Media Literacy, http://www.medialit.org
Center for the New American Dream, http://www.newdream.org
Culture of Modeling, http://www.cultureofmodeling.com
Dads and Daughters, http://www.dadsanddaughters.org
Girlistic.com, http://www.girlistic.com
Girls, Women + Media Project, http://www.mediaandwomen.org
Jean Kilbourne, http://www.jeankilbourne.com
Media Awareness Network, http://www.media-awareness.ca
Media Education Foundation, http://www.mediaed.org
Mediascope, http://www.mediascope.org
Mediawatch, http://www.mediawatch.com
Mind on the Media, http://www.mindonthemedia.org
Picturing Women, http://www.picturingwomen.org/home.php
Project Look Sharp!, http://www.ithaca.edu/looksharp/about.php
WAM! Women, Action and the Media, http://www.centerfornewwords.org/wam

First Weekenders Group Movies
http://www.moviesbywomen.com
The First Weekenders Group supports features directed by women the first week-
end they arrive at the box office.

The Fund for Women Artists
P.O. Box 60637, Florence, MA 01062
Phone: 413-585-5968
Fax: 413-586-1303
http://www.womenarts.org

Girls Film Festivals and Media Organizations

Divas Direct/San Diego Girl Film Festival
Renee Herrell, Executive Director
ReneeHerrell@sdgff.org
P.O. Box 632991
San Diego, CA 92163
Phone: 858-531-5390

Girls Eye View
EYEBEAM Atelier
540 W. 21st Street (between 10th and 11th Avenues)
New York, NY 10011
Phone: 212-937-6581
Fax: 212-937-6582
info@eyebeam.org

GirlsFilmSchool
GirlsFilmSchool Director
Moving Image Arts Department
College of Santa Fe
1600 St. Michael's Drive
Santa Fe, NM 87505
Phone: 505-473-6409
Fax: 505-473-6403
http://girlsfilmschool.csf.edu

Girls Go Tech and
Girls Go Film programs
Sponsored by the Girl Scouts
http://www.girlsgotech.org/girlsgofilm.html

Girls Incorporated: Girls Make the Message
Girls Incorporated
120 Wall Street
New York, NY 10005-3902
Phone: 1-800-374-4475
http://www.girlsinc.org

Reel Grrls
915 E Pine Street, #415
Seattle, WA 98122
Phone: 206-393-2085
http://www.reelgrrls.org

Reel Grrls graduate program:
Lila Kitaeff
lila@reelgrrls.org
RG organization:
Malory Graham
malory@reelgrrls.org

Youth Media Programs

Children's Media Project
Lady Washington Firehouse
20 Academy Street
Poughkeepsie, NY 12601
Phone: 845-485-4480
Fax: 845-625-2090
info@childrensmediaproject.org
http://www.childrensmediaproject.org

Do It Your Damn Self!! National Youth Video and Film Festival
The Community Art Center
119 Windsor Street,
Cambridge, MA 02139
Phone: 617-868-7100
info@communityartcenter.org
http://www.selhosting.net/cac/index.html

Downtown Community TV Center (DCTV)
87 Lafayette St.
New York, NY 10013

212-966-4510
info@dctvny.org
http://www.dctvny.org

Future Filmmakers Festival
c/o Cinema/Chicago
30 E. Adams St., Suite 800
Chicago, IL 60603-5628
http://www.chicagofilmfestival.org/FutureFilmmakers

Listen UP!
6 East 32nd St., 8th Floor
New York, NY 10016
Phone: 212-725-7000
http://www.listenup.org
Listen Up! is a national Youth Media Network that helps youth producers and their adult mentors exchange work, share ideas and learn from one another.

New York State Summer School of the Arts
NYSSSA
State Education Department
89 Washington Avenue
Room 866 EBA
Albany, New York 12234
Phone: 518-474-8773
http://www.emsc.nysed.gov/nysssa
Intensive four-week program in filmmaking, computer arts, photography, or video. Open to all New York State students currently enrolled in grades 8 through 12. Held at Ithaca College. For further information, email Judy Powers at NYSSSA@mail.nysed.gov.

Next Gen Programs
Bay Area Video Coalition
2727 Mariposa Street
San Francisco, CA 94110
Phone: 415-861-3282
–and–
1611 Telegraph Avenue
Oakland, CA 94612
Phone: 510-836-2660
http://www.bavc.org/nextgen

Reel Teens Festival
P.O. Box 1246
Woodstock, NY 12477
http://www.reelteensusa.org

Spy Hop Productions
353 West Pierpont Avenue 200B
Salt Lake City, UT 84101
Phone: 801-532-7500
info@spyhop.org

T Tauri Film Festival
195 Peel Road
Locust Grove, AR 72550
Phone: 870-251-1189
ttauri@hughes.net

Tower of Youth
http://www.towerofyouth.org
A strategic project of the World Interdependence Fund to establish an all-teenage
youth membership organization and media corporation in the Sacramento Valley/
Sierra Foothills region of California. The North American All Youth Film and
Education Day, an annual teen video/film festival, is held in Carmichael, CA.
http://www.youthchannel.org

Alternative Media Networks

FreeSpeech TV
http://www.freespeech.org

Squeaky Wheel
http://www.squeaky.org
Squeaky Wheel/Buffalo Media Resources is a grassroots, artist-run media arts
center founded in 1985 to provide and support film, video, computer arts, digital
arts, and audio arts.

Women's Film Festivals and Organizations

Madcat Women's Film Festival
San Francisco, CA
http://www.madcatfilmfestival.org

Movies by Women
http://www.moviesbywomen.com
"The First Weekenders Group supports features directed by women the first weekend they arrive at the box office."
<firstweekendersgroup.moviesbywomen.com>

Ms. Films Festival
c/o Niku Arbabi
2121 Dickson Drive #356
Austin, TX 78704
http://www.msfilms.org

National Museum of Women in the Arts
K. J. Mohr
kmohr@nmwa.org
1250 New York Ave. NW
Washington, D.C. 20005

Reel Venus Film Festival
Grand Central Station
P.O. Box 4344
New York, NY 10163-4344
Phone: 212-714-8375
http://www.reelvenus.com
Melissa Fowler, Festival Director/Curator
melissa@reelvenus.com

Rocky Mountain Women's Film Festival
http://www.reelwomen.org/about.html

San Diego Women's Film Festival
http://www.sdwff.org
Jennifer Hsu
jenniferhsu@sdwff.org
P.O. Box 632996
San Diego, CA 92163

Women in Film and Television
http://www.nywift.org
"Women calling the shots. Since 1977."

Women Make Movies
462 Broadway, Suite 500WS (at Grand Street)
New York, NY 10013
tel: 212-925-0606 fax: 212-925-2052
http://www.wmm.com

ADDITIONAL FILM RESOURCES

Alliance for Community Media in Washington, D.C.
http://www.alliancecm.org

Artists' Television Access
992 Valencia Street (at 21st)
San Francisco, CA 94110
Phone: 415-824-3890
ata@atasite.org
http://www.atasite.org

Bay Area Video Coalition in San Francisco
http://www.bavc.org

California Newsreel
http://www.newsreel.org

C3TV in Cape Cod
http://www.c3tv.org

Current TV, LLC
118 King Street
San Francisco, CA 94107
Phone: 415-995-8200
info@current.tv
http://www.currenttv.com

Downtown Community Television in New York
http://www.dctvny.org

Film Education
http://www.filmeducation.org/contact.html

Girl Geeks: The Source for Women in Computing
http://www.girlgeeks.org

GirlsGoTech: A site sponsored by the Girl Scouts
http://www.girlsgotech.org

Maya Deren's films:
Mystic Fire Video
P O Box 2330
Montauk, NY 11954
http://www.mysticfire.com

New England Film.com
http://www.newenglandfilm.com

New Orleans Video Access Center
http://www.novacvideo.org
911 Media Arts Center in Seattle
http://www.911media.org

Paper Tiger Television
339 Lafayette Street, 3rd Floor
New York, NY 10012
Phone: 212-420-9045
info@papertiger.org
http://www.papertiger.org

Distribution on the Web

http://www.YouTube.com
http://www.ifilm.com
http://www.atomfilms.com
http://www.cameraplanet.com
http://www.dfilm.com

National Girls Organizations

Girls Incorporated
"Inspiring all Girls to be Strong, Smart and Bold"
120 Wall Street

New York, NY 10005-3902
1-800-374-4475
http://www.girlsinc.org/

Girl Scouts of the USA
420 Fifth Avenue
New York, New York 10018-2798
(800) GSUSA 4 U [(800) 478-7248] or (212) 852-8000
http://www.girlscouts.org/

Girls Clubs of America
National Headquarters
1275 Peachtree Street NE
Atlanta, GA 30309-3506
Phone: (404) 487-5700
e-mail (general inquiries): info@bgca.org
http://www.bgca.org

The Lower East Side Girls Clubs of New York City
Art and Media Program for Girls
Phone: (212) 982-1633
http://www.girlsclub.org
The Girls club leadership is a cross-section of women-most who live on the Lower Easr side of Manhattan. The Girls Club holds a special relationship with the women in the girl's lives. The active involvement of mothers, grandmothers, aunts, and other women help build a strong unique support network for the girls and their families.

Publications

BUST (late teens and women)
Editorial offices
P.O. Box 1016
Cooper Station
New York, NY 10276

BUST Subscriptions:
P.O. Box 16775
North Hollywood, CA 91615
http://www.bust.com

Ms. Magazine
Editorial Offices
433 S. Beverly Drive
Beverly Hills, CA 90212
Phone: 310-556-2515
Fax: 310-556-2514
http://www.msmagazine.com
letterstotheeditor@msmagazine.com
contentsuggestions@msmagazine.com

New Moon Magazine for Girls and Their Dreams (tweens and early teens)
https://www.newmoon.org
New Moon® Publishing, Inc.
2 W 1 st St. #101,
Duluth, MN 55802
Phone: 800-381-4743

Resource Books for Girl Filmmakers

Redding, Judith M, and Brownworth, Victoria A. *Film Fatales: Independent Women Directors*. Seattle, WA: Seal Press, 1997.

Vachon, Christine. *A Killer Life: How an Independent Producer Survives Deals and Disasters in Hollywood and Beyond*. New York: Simon & Schuster, 2006.

Vachon, Christine, and Edelstein, David. *Shooting to Kill: How an Independent Producer Blasts Through Barriers to Make Movies that Matter*. New York: Avon Books, 1998.

WOMEN'S RESEARCH INSTITUTIONS AND EDUCATIONAL NETWORKS

The Bernard Center for Research on Women
101 Barnard Hall
Barnard College
3009 Broadway
New York, NY 10027
Phone: 212-854-2067
bcrw@barnard.edu
http://www.barnard.columbia.edu/crow

The National Coalition of Girls Schools
57 Main Street
Concord, MA 01742

(978) 287-4485
ncgs@ncgs.org
http://www.ncgs.org

The Stone Center at Wellesley College
Wellesley Centers for Women
Wellesley College
106 Central Street
Wellesley, MA 02481 USA
Phone: 781-283-2500
wcw@wellesley.edu
http://www.wcwonline.org/w-main.html

Girls' Health Issues

The Museum of Menstruation
http://www.mum.org

Vinnie's Tampon Cases
78 Fifth Avenue #5
New York, NY 10011
Phone: 212-691-6955
vinnie@tamponcase.com

BOOK LISTS FOR GIRLS (SELECTED)

PICTURE BOOKS

Brett, Jan. *Armadillo Rodeo*. New York: G.P. Putnam & Sons, 1995.
Evetts-Secker, Josephine. *Mother and Daughter Tales*. New York: Abbeville Press, 1995.
Evetts-Secker, Josephine. *Father and Daughter Tales*. New York: Abbeville Press, 1997.
Hedlund, Irene. *Mighty Mountain and the Three Strong Women*. Volcano, CA: Volcano Press, 1984.
McCully, Emily Arnold. *The Pirate Queen*. New York: G.P. Putnam & Sons, 1995.
Munsch, Bob. *The Paper Bag Princess*. Buffalo, NY: Annick Press/Firefly Books, 1980.
San Souci, Robert D. *Young Guinevere*. New York: Bantam Doubleday Dell, 1993.

Young Reader Chapter Books

Lansky, Bruce. *Girls to the Rescue* series. New York: Meadowbrook Press, 1995–1999.

Lovelace, Maud Hart. *The Betsy Tacy* books. New York: Harper Collins, 1994 [1940].

Lundgren, Astrid. *Pippi Longstocking* books. New York: Puffin Books, 1977 [1950].

Phelps, Ethel Johnston. *Tatterhood and Other Tales.* New York: The Feminist Press at City University, 1979.

Ragan, Kathleen, ed., & Yolen, Jane. *Fearless Girls, Wise Women, and Beloved Sisters: Heroines in Folktales from Around the World.* New York: W.W. Norton & Co., 2000.

Wilder, Laura Ingalls. *The Little House on the Prairie* books. New York: Harper Trophy, 1994 [1935]. (http://www.littlehousebooks.com/books/)

Tween and Teen Fiction

Blume, Judy. *Are You There God? It's Me, Margaret.* New York: Dell, 1970.

Brashares, Ann. *The Sisterhood of the Traveling Pants* series. New York: Random House, 2001–2005.

Pierce, Tamara, *Song of the Lioness* series. New York: Atheneum Books, 1983.
——*Alanna: The First Adventure* (Book I).
——*In the Hand of the Goddess* (Book II).
——*The Woman Who Rides Like a Man* (Book III).
——*Lionness Rampant* (Book IV).

Pullman Philip
——*The Golden Compass.* New York: Knopf, 1996.
——*The Subtle Knife.* New York: Knopf, 1997.
——*The Amber Spyglass.* New York: Knopf, 2000.

Rowling, J.K. *Harry Potter and the Sorcerer's Stone,* London: Bloomsbury, 1997; New York: Scholastic Press, 1999.
——*Harry Potter and the Chamber of Secrets.* New York: Scholastic, 1999.
——*Harry Potter and the Prisoner of Azkaban.* New York: Scholastic, 1999.
——*Harry Potter and the Goblet of Fire.* New York: Scholastic, 2000.
——*Harry Potter and the Order of the Phoenix.* New York: Scholastic, 2003.
——*Harry Potter and the Half-Blood Prince.* New York: Scholastic, 2005.

Teenage and Adult Fiction

Austen, Jane. *Emma.* New York: Penguin Classics, 2002 [1816].
——*Pride and Prejudice.* [1813].

——Sense and Sensibility. [1811].
——Northanger Abbey. [1817].
Cather, Willa. *My Antonia*. New York: Penguin Books, 1994 [1918].
Chevalier, Tracy. *Girl With the Pearl Earring*. New York: Dutton, 1999.
Danticat, Edwidge. *Breath, Eyes, Memory*. New York: Random House, 1994.
Diamant, Anita. *The Red Tent*. New York: St. Martin's Press, 1997.
Fowler, Connie May. *Before Women Had Wings*. New York: G.P. Putnam & Sons, 1996.
Gibbons, Kaye. *Ellen Foster*. New York: Vintage Books, 1990 [1987].
Goldberg, Myla. *Bee Season*. New York: Doubleday, 2000.
Kidd, Sue Monk. *The Secret Life of Bees*. New York: Viking Penguin, 2002.
Kincaid, Jamaica. *Annie John*. New York: Farrar, Straus, Giroux, 1983.
Kingsolver, Barbara. *The Poisonwood Bible*. New York, HarperCollins, 1999.
McCullers, Carson. *The Member of the Wedding*. New York: Bantam Books, 1977 [1946].
Morrison, Toni. *The Bluest Eye*. New York: Holt, Rhinehart and Winston, 1970.
Robinson, Marilynne. *Housekeeping*. New York: Farrar, Straus, Giroux, 1980.
Simpson, Mona. *Anywhere But Here*. New York: Alfred A. Knopf, 1986.
Strout, Elizabeth. *Amy and Isabelle*. New York: Random House, 1998.
Tartt, Donna. *The Little Friend*. New York: Knopf, 2002.

Adult Coming-of-Age Fiction

Dunant, Sarah. *The Birth of Venus*. New York: Random House, 2003.
Duras, Marguerite. *L'Amant*. Paris: Les Editions de Minuit, 1984.
——*The Lover*. Translated by Barbara Bray. New York: Random House, 1985.
Eugenides, Jeffrey. *Middlesex*. New York: Farrar, Straus, Giroux, 2002.
——*The Virgin Suicides*. New York: Farrar, Straus, Giroux, 1993.
Fitch, Janet. *White Oleander*. New York: Little, Brown & Co., 1999.
Nabokov, Vladimir. *Lolita*. New York: Vintage, 1989 [1955].
Sebold, Alice. *The Lovely Bones*. Boston & New York: Little, Brown, 2002.

Adult Coming-of-Age Graphic Novels

Gloeckner, Phoebe. *The Diary of a Teenage Girl*. Berkeley, CA: Frog Ltd/North Atlantic Books, 2002.
Satrapi, Marjane. *Persepolis: The Story of a Childhood*. New York: Pantheon, 2003.

NOTES

CHAPTER ONE: INTRODUCTION

1. Lynn Hirschberg, "Desperate to Seem 16," *The New York Times Magazine*, September 5, 1999, p. 42–49, 74–79.
2. Sheila Whitely, *Too Much Too Young: Popular Music, Age and Gender*. London & New York: Routledge, 2005, p. 17.
3. Guerrilla Girls, *Bitches, Bimbos and Ballbreakers: The Guerrilla Girls' Illustrated Guide to Female Stereotypes*. New York: Penguin Books, 2003, p. 8.

CHAPTER TWO: NO SECRETS, NO TABOOS: THE WILD WEST OF MILLENNIAL GIRLHOOD

1. Val E. Limburg, "Fairness Doctrine: U.S. Broadcasting Policy," http://www.museum.tv/archives/etv/F/htmlF/fairnessdoct/fairnessdoct.htm.
2. Susan Sontag, "Notes on Camp," in *Against Interpretation and Other Essays*. New York: Farrar, Straus, and Giroux, 1961, p. 289.
3. From the EEOC (Equal Employment Opportunity Commission) website, http://www.eeoc.gov/stats/harassment.html.
4. http://www.pbs.org/wgbh/pages/frontline/shows/navy/tailhook/91.html.
5. Katie Roiphe, *The Morning After: Fear, Sex and Feminism*. Boston: Back Bay Books, 1994.
6. Liz Funk, "Teens Meet Harassment in High School Halls," *Women's eNews*, August 31, 2006, http://www.womensenews.org/article.cfm/dyn/aid/2870.
7. For information about these and other Reel Grrls PSAs, contact them: http://www.reelgrrls.org.
8. Rachel Corbett, "Women Strike Back Online Against Street Harassment," *Women's eNews*, May 9, 2006, http://www.womensenews.org/article.cfm/dyn/aid/2734/.
9. http://www.justyellfire.com/about.php.
10. http://www.justyellfire.com/newsclips.php.

11. Alice Sebold, *Lucky*. New York: Simon & Schuster, 1999.
12. *Clueless* (1995, Amy Heckerling).
13. Rebecca Collins, Marc N. Elliot, Sandra H. Berry, David E. Kanouse, Dale Kunkel, Sarah B. Hunter, and Angela Miu, "Watching Sex on Television Predicts Adolescent Initiation of Sexual Behavior," *Pediatrics*, Vol. 114, No. 3, September 2004, pp. e280–e289.
14. Benoit Denizet-Lewis, "Friends, Friends with Benefits and the Benefits of the Local Mall," *The New York Times Magazine*, May 30, 2004.
15. Rhonda Chittenden, "Teen Oral Sex: It's Sensationalized!" *Sexing the Political: A Journal of Third Wave Feminists on Sexuality*, Vol. 3, No. 1, http://www.sexingthepolitical.com/2004/sextalk.htm.
16. *The New Yorker*, February 8, 1999, cover by Dean Roher.
17. See Georges-Claude Guilbert, *Madonna as Postmodern Myth: How One Star's Self-Construction Rewrites Sex, Gender, Hollywood and the American Dream*. New York: McFarland, 2002; Cathy Schwichtenberg, ed., *The Madonna Connection: Representational Politics, Subcultural Identities, and Cultural Theory*. New York: Perseus Books/Westview Press, 1992.
18. Emily White, *Fast Girls: Teenage Tribes and the Myth of the Slut*. New York: Berkley Publishing, 2002, p. 175.
19. Ibid., p. 125.
20. Ibid.
21. Lauren Greenfield, *Girl Culture*. San Francisco: Chronicle Books, 2002, p. 109.
22. White, *Fast Girls*, p. 117.
23. V-Day website, http://www.vday.org/peace_vmailsplash.html.
24. *This Film Is Not Yet Rated* (2006, Kirby Dick).
25. *The New York Times Magazine*, "Being Thirteen: A Photo Album," May 17, 1998.
26. Alison Adato, "The Secret Life of Teens," *Life*, March 1999, pp. 38–48.
27. Kate Aurthur, "Virginity Lost," *Slate.com*, November 23, 2004, http://www.slate.com/id/2110072.
28. White, *Fast Girls*, p. 53.
29. Ashley D. Grisso and David Weiss, "What Are gUrls Talking About?" in *girl wide web: Girls, the Internet and the Negotiation of Identity*, edited by Sharon Mazzarella. New York: Peter Lang, 2005, pp. 31–49.
30. Sarah Hepola, "Her Favorite Class: 'Sex' Education," *The New York Times*, June 22, 2003, Section 2, p. 1.
31. Ibid.
32. "While Carrie, Samantha, Miranda, and sometimes Charlotte, act in ways that are decidedly feminist (e.g., Miranda's resistance to the demands of work and motherhood or Samantha's refusal to let her sexual experiences be viewed differently from men's), rarely, if ever, are the women or their actions *labeled* as feminist. When a show avoids using the word *feminist*—seemingly because of its still-stigmatized connotations in the age of postfeminism—it is difficult to interpret the show as such." (Beth Montemurro, "Charlotte Chooses Her Choice: Liberal Feminism on *Sex and the City*," *The Scholar & Feminist Online Barnard Center for Research on Women*, New York, Vol. 3, No. 1, Fall 2004, p. 2, http://www.barnard.edu/sfonline/hbo/montemurro_01.htm).
33. *Sex and the City*, Episode 15.
34. Ben Niehart, "OMG! I Love Ellie and Ashley. Craig is Totally HOTTT ...," *The New York Times Magazine*, March 20, 2005, pp. 41–45.
35. Susan Driver, *Queer Girls and Popular Culture: Reading, Resisting, and Creating Media*. New York: Peter Lang, 2007.

36. *This Film Is Not Yet Rated.*
37. American Library Association website. http://www.ala.org/ala/oif/bannedbooksweek/bbwlinks/100mostfrequently.htm.
38. http://www.time.com/time/2005/100books.
39. Boston Women's Health Collective, *Our Bodies Our Selves.* New York: Simon & Schuster, 1993 [1970].
40. Some titles include Mavis Jukes, *It's a Girl Thing*; Joann Loulan, *Period: A Girl's Guide* (see Bibliography).
41. Shelly Stamp Lindsey, "Horror, Femininity and Carries Monstrous Puberty," in *The Dread of Difference*, edited by Barry Keith Grant. Austin, TX: University of Texas Press, 1996, p. 262.
42. *Clueless* (Amy Heckerling, 1995).
43. Gogoi Pallavi, "Smells Like Teen Marketing," *Businessweek*, November 10, 2005, http://www.businessweek.com/innovate/content/nov2005/id20051109_341544.htm.
44. Thanks to Professor David Linton of Marymount Manhattan College for these two examples.
45. http://www.mum.org/visitMUM.htm.
46. http://www.fredflare.com/diary/vinnie.php.
47. Anita Diamant, *The Red Tent.* New York: St. Martin's Press, 1997.
48. Joan Jacobs Brumberg, *The Body Project: An Intimate History of American Girls.* New York: Random House, 1997.
49. http://www.plasticsurgery.org/media/briefing_papers/Plastic-Surgery-for-Teenagers-Briefing-Paper.cfm.
50. Ibid.
51. "Going Bust," *Teen Vogue*, September 2004, pp. 204–205, 234.
52. http://www.plasticsurgery.org/media/briefing_papers/Plastic-Surgery-for-Teenagers-Briefing-Paper.cfm.
53. "Going Bust."
54. http://www.plasticsurgery.org.
55. M.G. Lord, *Forever Barbie: The Unauthorized Biography of a Real Doll.* New York: Walker, 1994, pp. 244–251.
56. http://www.campaignforrealbeauty.com.

CHAPTER THREE: LIPSTICK LOLITAS: THE NEW SEX GODDESSES

1. Jennifer Egan, "James Is a Girl," *The New York Times Magazine*, February 4, 1996, pp. 26–38.
2. *Peter Pan* (2003, P. J. Hogan).
3. Marina Warner, *Alone of All Her Sex: The Myth and the Cult of the Virgin Mary.* New York: Random House/Vintage Books, 1983 [1976], p. 47.
4. Roosevelt's Fair Labor Standards Act of 1938, http://www.dol.gov/esa/whd/flsa.
5. Guerrilla Girls, *Bitches, Bimbos and Ballbreakers: The Guerrilla Girls' Illustrated Guide to Female Stereotypes.* New York: Penguin, 2003. pp. 8–9.
6. "Young, Bad and Beautiful!" *US Weekly*, May 17, 2004, pp. 52–58.
7. Guerrilla Girls, *Bitches, Bimbos and Ballbreakers*, p. 68.
8. Stephen Metcalf, "Lolita at 50: Is Nabokov's Masterpiece Still Shocking?" *Slate.com*, December 19, 2005, http://www.slate.com/id/2132708.
9. Guerrilla Girls, *Bitches, Bimbos and Ballbreakers.*

10. Richard Roeper, "The Jailbait Dilemma: Does Ogling Tweeners Make Us Dirty Old Men?" *Esquire*, May 2004, p. 44.

11. Camille Paglia, *Vamps and Tramps: New Essays*. New York: Vintage Books/Random House, 1994, p. 133.

12. Guerrilla Girls, *Bitches, Bimbos and Ballbreakers*.

13. http://www.pennielane.com/rstory.html.

14. Lauren Greenfield, *Girl Culture*. San Francisco: Chronicle, 2002, p. 118.

15. Sheila Whitely, *Too Much Too Young: Popular Music, Age and Gender*. London & New York: Routledge, 2005.

16. Deep into the 2000s, these issues of *Rolling Stone* are considered collectibles on eBay.

17. *Rolling Stone*, November 2002 (cover).

18. Michelle Chihara, "Two Teens, One Brand, Infinite Possibilities," *Alternet*, January 21, 2002, http://www.alternet.org/story/12255.

19. Amanda Marcotte, "Feminism in an Era of 'Girls Gone Wild,'" *Alternet*, May 5, 2007, http://www.alternet.org/story/51416.

20. Kevin West, "Two Queens," *W Magazine*, May 2006, http://www.style.com/w/feat_story/040506/full_page.html.

21. *Rolling Stone*, August 2004 (cover).

22. *Esquire*, February 2005.

23. Lion's Gate website, http://www.girlwithapearlearringmovie.com.

24. *Vanity Fair*, February 2006 (cover).

25. *Entertainment Weekly*, December 17, 2004 (cover).

26. *Vanity Fair*, January 2006 (cover).

27. *Interview Magazine*, June 2006 (cover).

28. Jean Baudrillard, *Simulations*. Semiotext[e], 1983, p. 3.

29. Laura Mulvey, "Visual Pleasure and Narrative Cinema," in *Visual and Other Pleasures*, Bloomington and Indianapolis: Indiana University Press, 1989 [1971], p. 19.

30. bell hooks, "Good Girls Look the Other Way," in *Reel to Real: Race, Sex and Class at the Movies*, London & New York: Routledge, 1996, p. 10.

31. Mulvey, "Visual Pleasure and Narrative Cinema," p. 19.

32. Camille Paglia, *Sexual Personae: Art and Decadence from Nefertiti to Emily Dickinson*. New York: Vintage, 1992, p. 9.

33. http://www.youtube.com/watch?v=GKfsZ35tOLI.

34. Mulvey, "Visual Pleasure and Narrative Cinema," p. 14.

35. John Berger, *Ways of Seeing*. London: British Broadcasting Corporation and Penguin, 1972, p. 63.

36. Paglia, *Vamps and Tramps*, p. 9.

37. Egan, "James Is a Girl."

38. Whitely, *Too Much Too Young*.

39. Lynn Hirschberg, "Desperate to Seem 16," *The New York Times Magazine*, September 5, 1999, pp. 42–49, 74–79 (cover story).

40. Susan Sontag, "Notes on Camp," in *Against Interpretation and Other Essays*. New York: Farrar, Straus, and Giroux, 1961, p. 279.

41. Jennifer Baumgardner and Amy Richards, *Manifesta: Young Women, Feminism and the Future*. New York: Farrar, Straus, and Giroux, 2000, p. 141.

42 David Graham, "Gothic Lolitas: Goth Girls Just Wanna Have Fun," http://www.lilith-ezine.com/articles/gothic/gothic_lolitas.html. See also the excellent photography book by Masayuki Yoshinaga and Ishikawa Katsuhiko, *Gothic + Lolita*. New York & London: Phaidon, 2007.

CHAPTER FOUR: REIGNING TWEENS AND ALTERNATIVE TWEENDOMS

1. Sharon Lamb and Lyn Mikel Brown, *Packaging Girlhood: Rescuing Our Daughters from Marketers' Schemes*. New York: St. Martin's Press, 2006, p. 5.

2. Lauren Greenfield, *Girl Culture*. San Francisco: Chronicle Books, 2002.

3. Julia Boorstin, "Disney's 'Tween Machine," *Fortune Magazine*, September 29, 2003, http://money.cnn.com/magazines/fortune/fortune_archive/2003/09/29/349896/index.htm.

4. Peggy Orenstein, "What's Wrong with Cinderella," *The New York Times Magazine*, December 24, 2006, http://www.peggyorenstein.com/articles/2006_princesses.html.

5. Robert Munsch, *The Paper Bag Princess*. Ontario & New York: Firefly Books, 2002 [1980].

6. Michelle Chihara, "Two Teens, One Brand, Infinite Possibilities," *Alternet*. January 21, 2002, http://www.alternet.org/story/12255.

7. *US Weekly*, May 17, 2004 (back cover).

8. *Little Miss Sunshine* (2006, Jonathan Dayton and Valerie Faris).

9. This archive contains multiple articles on the twins, including "Update on Mary-Kate Olsen Anorexia," June 29, 2004, http://www.moono.com/news/news00348.html.

10. Alex Williams, "Before Spring Break, The Anorexic Challenge," *The New York Times, Sunday Styles*, April 2, 2006, p. 1.

11. This concept was articulated by Bonnie Bainbridge Cohen in a workshop on anatomy and movement conducted at the Trisha Brown Dance Studio, New York City, Spring 2006.

12. http://www.babyphat.com/aboutus.php.

13. American Association of University Women, *Shortchanging Girls, Shortchanging America*, http://www.aauw.org/research/sgsa.cfm.

14. Gerard J. Tortora and Sandra R. Grabowski, *Principles of Anatomy and Physiology*. New York: John Wiley & Sons, 2002, pp. 384–385.

15. Joseph Chilton Pearce, *Evolution's End: Claiming the Potential of our Intelligence*. San Francisco: Harper, 1992, pp. 21–22.

16. http://www.hbo.com/docs/programs/thin/synopsis.html.

17. See Orenstein, "What's Wrong with Cinderella."

18. Lisa Belkin, "The Making of the 8-Year Old Woman," *The New York Times Magazine*, December 24, 2000, p. 40.

19. Ibid.

20. M.G. Lord, *Forever Barbie: The Unauthorized Biography of a Real Doll*. New York: Walker, 1994, p. 6.

21. Ibid.

22. Ibid., p. 6.

23. Ibid., p. 207.

24. Ibid., p. 48.

25. Ibid., p. 71.

26. Ibid.

27. Ibid., p. 73.

28. Marcelle Karp and Debbie Stoller, *The Bust Guide to the New Girl Order*. New York & London: Penguin, 1999, p. 188.

29. Women Make Movies, http://www.wmm.com.

30. Reel Grrls, http://www.reelgrrls.org.

31. See Lynda Hass, "Eighty-Six the Mother," in *From Mouse to Mermaid: The Politics of Film, Gender and Culture*. Indianapolis: Indiana University Press, 1995, pp. 193–211.

32. Joseph Campbell, *The Hero with a Thousand Faces*. Princeton, NJ: Princeton University Press, 1978 [1949].

33. See Amy Aidman, "Disney's *Pochantas*: Conversations with Native American and Euro-American Girls," in *Growing Up Girls: Pop Culture and the Construction of Identity*, edited by Sharon Mazzarella. New York: Peter Lang, 2001 [1999].

34. Lord, *Forever Barbie*, p. 172.

35. AAUW, 1991, http://www.aauw.org/research/sgsa.cfm.

36. Pearce, *Childhood's End*, p. 165.

37. http://www.snopes.com/disney/films/lionking.htm and http://www.animatedbuzz.com/WB/39.html are a couple of examples of site discussions about Disney's subliminal images.

38. Jessica Winter, "Sex and the Single Squaw," *The Village Voice*, December 19, 2005, http://www.villagevoice.com/film/0551,Winter,71142,20.html.

39. Margaret Talbot, "The Auteur of Anime: A Visit with the Elusive Genius Hayao Miyazaki," *The New Yorker*, January 17, 2005, p. 67.

40. Susan Napier, *Anime from Akira to Howl's Moving Castle: Experiencing Contemporary Japanese Animation*. New York: Palgrave Macmillan, 2005 [2001], p. 157.

41. Talbot, "The Auteur of Anime," p. 70.

42. John Markoff, "The Rise and Swift Fall of Cyber Literacy," *The New York Times*, March 13, 1994, http://query.nytimes.com/gst/fullpage.html?res=9E06E2D7123DF930A25750C0A962958260.

43. See the appendix for titles, authors, and dates of books mentioned.

44. The first book was published in 2001, by Delacorte Books for Young Readers, followed by *The Second Summer of the Sisterhood* (2004), *Girls in Pants: The Third Summer of the Sisterhood* (2005), and *Forever Blue: The Fourth Summer of the Sisterhood* (2007).

CHAPTER FIVE: MEAN GIRLS IN OPHELIA LAND

1. Mary Pipher, *Reviving Ophelia: Saving the Selves of Adolescent Girls*. New York: Ballantine, 1994.

2. AAUW, http://www.aauw.org/research/sgsa.cfm.

3. Ibid.

4. Margaret Mead, *Coming of Age in Samoa*. New York: William Morrow, 1928; New York: Quill/Morrow, 1961.

5. AAUW, http://www.aauw.org/research/sgsa.cfm.

6. Tamar Lewin, "Boys Are No Match for Girls in Completing High School," *The New York Times*, April 19, 2006, p. A12, http://www.nytimes.com/2006/04/19/education/19graduation.html.

7. Pipher, ibid, p. 12.

8. Jennifer Baumgardner and Amy Richards, *Manifesta: Young Women, Feminism and the Future*. New York: Farrar, Straus, and Giroux, 2000, p. 179.

9. The Ophelia Project website: http://www.opheliaproject.org/

10. William Shakespeare, *The Tragedy of Hamlet, Prince of Denmark*, Act I Scene iii, in *The Riverside Shakespeare*, Boston: Houghton Mifflin, 1974, p. 1147.

11. Camille Paglia, *Vamps and Tramps: New Essays*. New York: Vintage, 1994, p. 135.

12. CNN Interactive web posted August 5, 1996, http://www.cnn.com/US/9608/05/klaas.sentence/index.html.

13. http://www.pollyklaas.org.

14. http://www.cbsnews.com/stories/2002/10/01/48hours/main523875.shtml.

15. Reuters, August 17, 2006, http://msnbc.msn.com/id/14392957.

16. Susan J. Douglas and Meredith Michaels, *The Mommy Myth: The Idealization of Motherhood and How It Has Undermined All Women*. New York: Free Press, 2004, p. 92.

17. Megan's Law, named for eight-year-old victim Megan Kanka of New Jersey, was instituted in 1994 as a means to alert neighborhoods to the presence of a convicted sex offender.

18. Amber Alerts began in 1996 after the murder and rape of nine-year old Amber Hagerman of Texas as general public alerts via national and local media outlets of a confirmed child abduction.

19. *Little Children* (2006, Todd Field).

20. Daniel Bergner, "The Making of a Cyber Molester," *The New York Times Magazine*, January 23, 2005, pp. 26–33, 58–61.

21. Child Molestation Research and Prevention Institute, http://childmolestationprevention. org.

22. Alice Sebold, *Lucky*. New York: Simon & Schuster, 1999, p. 58.

23. BBC News, "Mixed Reaction to Columbine Film," October 21, 2002, http://news.bbc.co.uk/1/ hi/entertainment/film/2346659.stm.

24. This was again the case for *People* cover story of April 30, 2007, following the Virginia Tech massacre of April 16, 2007.

25. Rosalind Wiseman, *Queen Bees & Wannabes: Helping Your Daughter Survive Cliques, Gossip, Boyfriends and Other Realities of Adolescence*. New York: Three Rivers Press, 2002.

26. Jackson Katz's article "More Than a Few Good Men," as well as several videos on masculinity (http://www.jacksonkatz.com); Michael Gurian's books such as *The Wonder of Boys*. New York: Jeremy P. Tarcher/Penguin/Putnam, 1996 (http://www.michaelgurian.com).

27. AAUW, http://www.aauw.org/research/sgsa.cfm.

28. http://www.boxofficemojo.com/movies/?id=elephant.htm.

29. Lewin, "Boys Are No Match for Girls."

30. Rachel Simmons, *Odd Girl Out: The Hidden Culture of Aggression in Girls*. New York: Harcourt Brace, 2002, p. 135.

31. http://www.lifetimetv.com/movies/originals/oddgirlout.php.

32. Simmons, *Odd Girl Out*, p. 2.

33. *People*, August 18, 2002 (cover and pp. 50–55).

34. Julie Scelfo, "Bad Girls Gone Wild," *Newsweek*, June 13, 2006, http://www.msnbc.msn.com/ id/8101517/site/newsweek.

35. Margaret Talbot, "The Maximum Security Adolescent," *The New York Times Magazine*, 2000, p. 46.

36. http://www.courttv.com/archive/trials/grossberg/070998.html.

37. http://www.injersey.com/news/prom/story/1,1466,127036,00.html.

38. Douglas and Michaels, *The Mommy Myth*, p. 169.

39. Ibid.

40. Women Make Movies, http://www.wmm.com.

41. Karen Sherarts and Suzanne Stenson, *Baby Love Study Guide*, ITVS, 1997.

42. Douglas and Michaels, *The Mommy Myth*, pp. 178–181.

43. *Heathers* (1989, Michael Lehman).

44. Janet Maslin, "Eye Candy: Teen Queens of Mean," *The New York Times*, February 19, 1999, http://movies2.nytimes.com/mem/movies/review.html?res=9C05E2DB163DF93AA25751C0 A96F958260.

45. Wiseman, *Queen Bees & Wannabes*. Ibid

46. Margaret Talbot, "Girls Just Want to Be Mean," *The New York Times Magazine*, February 24, 2002, pp. 24–29, 40, 58. Cover headline: "Mean Girls and the New Movement to Tame Them."

47. Virginia Heffernan, "Anchor Woman: Tina Fey Rewrites Late-Night Comedy," *The New York Times*, November 3, 2003, http://www.newyorker.com/archive/2003/11/03/031103fa_fact.

48. Ben Niehart, "OMG! I Love Ellie and Ashley. Craig is Totally HOTTT …" *The New York Times Magazine*, March 20, 2005, pp. 41–45.

49. Wiseman, *Queen Bees & Wannabes*, p. 4.

50. Ibid., p. 122.

51. http://www.billboard.com.

52. Wiseman, *Queen Bees & Wannabes*, p. 244.

53. Susan J. Douglas, "The ERA as Catfight," in *Where the Girls Are: Growing Up Female With the Mass Media*. New York: Times Books/Random House, 1994, pp. 221–244.

54. Simmons, *Odd Girl Out*, p. 101.

55. Sherrie Inness, ed., *Action Chicks: New Images of Tough Women in Popular Culture*. London & New York: Routledge, 2004.

56. Lyn Mikel Brown, *Raising Their Voices: The Politics of Girls' Anger*, Cambridge, MA: Harvard University Press, 1998, p. 117.

57. Wiseman, *Queen Bees & Wannabes*, p. 125.

58. Ibid.

59. Emily White, *Fast Girls and the Myth of the Slut*, pp. 133–135.

60. http://www.outwardbound.org.

61. Alice Sebold, *The Lovely Bones*. Boston & New York: Little, Brown & Co., 2002, p. 59.

CHAPTER SIX: OUT OF THE GENDER BOX: TITLE IX AMAZONS, BRAINIACS AND GEEK GIRLS

1. Susan J. Douglas, *Where the Girls Are: Growing Up Female with the Mass Media*. New York: Times Books/Random House, 1994, p. 120.

2. Lyn Mikel Brown, *Raising Their Voices: The Politics of Girls' Anger*. Cambridge, MA: Harvard University Press, 1998, p. 6.

3. For more on Ani DiFranco, see her open letter to *Ms. Magazine*, http://www.columbia.edu/~marg/ani/letter.html and her website: http://www.righteousbabe.com.

4. http://www.grammy.com.

5. Alanis Morissette, "Right Through You," from *Jagged Little Pill*, 1995.

6. Alanis Morissette, "You Oughta Know," from *Jagged Little Pill*, 1995.

7. Alanis Morissette, "Right Through You," from *Jagged Little Pill*, 1995.

8. Alanis Morissette, "Hands Clean," from *Under Rug Swept*, 2002.

9. *Rolling Stone*, Vol. 778, January 28, 1998.

10. Missy Elliot's home page: http://www.missy-elliott.com/index_site.html, www.billboard.com.

11. TLC, "Unpretty," ©1999 on *Fanmail*.

12. See the "Unpretty" video on YouTube: http://www.youtube.com/watch?v=4ejX0q3s0yY.

13. Donna Freydkin, "Lilith Fair: Lovely, Lively and Long Overdue," *CNN Interactive*, July 28, 1998, http://www.cnn.com/SHOWBIZ/Music/9807/28/lilith.fair.

14. See http://www.lilithfair.com for more history.

15. Akin Ojumu. *Guardian Unlimited*, November 6, 2003, http://arts.guardian.co.uk/news/story/0,,1086231,00.html#article.

16. http://www.aliciakeys.com.

17. Camille Paglia, *Sexual Personae: Art and Decadence from Nefertiti to Emily Dickinson*. New York: Vintage, 1992, p. 267.

18. Alex Williams, "Up to Her Eyes in Gore and Loving It," *The New York Times, Sunday Styles*, pp. 1–2.

19. These rounded figures are for domestic theatrical release and do not include international or DVD release statistics. All box office statistics found on http://www.imdb.com.

20. See U.S. Department of Labor, Education Amendments, http://www.dol.gov/oasam/regs/statutes/titleix.htm.

21. From the official websites of Venus and Serena Williams: http://www.venuswilliams.com and http://www.serenawilliams.com.

22. Henry Fountain, "Where the Noise Is Not So Joyful," *The New York Times*, September 11, 2005, http://www.nytimes.com/2005/09/11/weekinreview/11basic.html?ex=1284091200&en=cad63f1454a5f7fc&ei=5088&partner=rssnyt&emc=rss.

23. Richard Schickel, "Gender Bender," *Time*, June 24, 1991, pp. 52–56 (cover story headline: "Why *Thelma and Louise* Strikes a Nerve").

24. Sherrie Inness, "Boxing Gloves and Bustiers," in *Action Chicks: New Images of Tough Women in Popular Culture*. London & New York: Routledge, 2004, p. 3.

25. Mary Celeste Kearney, *Girls Make Media*. London & New York: Routledge, 2006, p. 259.

26. "Prophecy Girl," Season One, *Buffy the Vampire Slayer*, The WB Network, 1997–2003, Created by Joss Whedon.

27. Based on *The New Yorker* cartoons by Charles Addams; remake 1991, Barry Sonnenfeld.

28. Peggy Orenstein, *SchoolGirls Young Women, Self-Esteem, and the Confidence Gap*. New York: Doubleday, 1994.

29. Donna Haraway, *Simians, Cyborgs and Women: The Reinvention of Nature*. London & New York: Routledge, 1991.

30. Mark Dery, "Hacking Barbie's Voice Box: Vengeance Is Mine!" *New Media*, May 1994, http://www.levity.com/markdery/barbie.html.

31. M.G. Lord, *Forever Barbie: The Unauthorized Biography of a Real Doll*. New York: Walker, 1994, p. 216.

32. Michael Kaplan, "Tracking Snowclones Is Hard, Let's Go Shopping," March 6, 2006, http://itre.cis.upenn.edu/~myl/languagelog/archives/002892.html.

33. http://sniggle.net/barbie.php.

34. Whitney Chadwick, *Women, Art and Society*. London & New York: Thames & Hudson, 2002 [1990], p. 109.

CHAPTER SEVEN: SUPERNATURAL GIRLS: WITCHES, WARRIORS, AND ANIMÉ

1. A version of this chapter originally appeared as "Supernatural Girls," *Afterimage*, Spring 2006.

2. Marcelle Karp and Debbie Stoller, *The Bust Guide to the New Girl Order*. New York & London: Penguin, 1999, p. 188.

3. For a view into Evangelical "counterbrainwashing" of children, which includes banishing Harry Potter books, see the 2006 documentary *Jesus Camp* by Rachel Grady and Heidi Ewing, http://www.jesuscampthemovie.com.
4. The first date listed is the Japanese release; second date is U.S. release. With international distribution now taken over by Disney/Pixar, Miyazaki's more recent films have been released to the U.S. market soon after their Japanese release.
5. For further discussion of "gender in flux," see Judith Butler, *Gender Trouble: Feminism and the Subversion of Identity*. New York & London: Routledge, 1990.
6. Sandy Yang, "Girl Power Make Up the Beginning of Shoujo in the US," *Akadot*, November 25, 2000, http://www.akadot.com/article.php?a=30.
7. Joyce Millman, "Supergirls and Little Women," *Salon.com*, Issue #7, February 10–23, 1996, http://www.salon.com/07/features/tvgirls2.html.
8. Sarah Banet-Weiser, "Girls Rule!: Gender, Feminism, and Nickelodeon," *Critical Studies in Media Communication*, Vol. 21, No. 2, June 2004, pp. 119–139. See also Rebecca C. Hains (forthcoming), "Inventing the Teenage Girl: The Construction of Female Identity in Nickelodeon's *My Life as a Teenage Robot*," *Popular Communication*, Vol. 5, No. 3.
9. From opening credits of *Buffy the Vampire Slayer*, The WB Network, 1997–2001; UPN, 2001–2003.
10. See Rhonda Wilcox, *Why Buffy Matters: The Art of Buffy the Vampire Slayer*. London & New York: I.B. Tauris, 2005.
11. *Buffy the Vampire Slayer*, Season One, The WB Network, 1997–2003, Created by Joss Whedon.
12. Eleanor Roosevelt, "This Is My Story," *US Diplomat and Reformer* (1884–1962), http://www.quotationspage.com/quote/137.html.
13. *Sabrina the Teenage Witch*, Season One, ABC-TV, 1996–2003.
14. Hagrid in *Harry Potter and the Chamber of Secrets*, Chapter 7.
15. Christine Schoefer, "Harry Potter's Girl Trouble," January 12, 2000, http://www.salon.com/books/feature/2000/01/13/potter/index.html.
16. Liesl Schillinger, *Wired*, April 24, 2007, http://www.wired.com/culture/lifestyle/multimedia/2007/04/ss_raves?slide=4.
17. Wilcox, *Why Buffy Matters*, p. 69.
18. See *Jesus Camp* (2006, Rachel Grady and Heidi Ewing).
19. Rogue to Wolverine in *X-Men* (2000, Brian Singer).
20. Jen Yu to Yu Shu Lien in *Crouching Tiger, Hidden Dragon* (2000, Ang Lee).
21. Carmen Cortez in *Spy Kids* (2001, Robert Rodriguez).
22. Ibid.
23. Violet Parr in *The Incredibles* (2004, Brad Bird).
24. Elastigirl to Violet in *The Incredibles* (2004, Brad Bird).
25. *Joan of Arcadia* (2003–2005, CBS-TV).
26. Susan Napier, *Anime from Akira to Howl's Moving Castle: Experiencing Contemporary Japanese Animation*. New York: Palgrave Macmillan, 2005, p. 149.
27. Ibid., p. 246.
28. Ibid., p. 156.
29. Joseph Campbell, *The Hero with a Thousand Faces*. Princeton, NJ: Princeton University Press, 1978 [1949].
30. Napier, *Anime from Akira to Howl's Moving Castle*, p. 36.
31. See Guerrilla Girls, *Bitches, Bimbos and Ballbreakers: The Guerrilla Girls' Guide to Female Stereotypes*, New York & London: Penguin Books, 2003.

CHAPTER EIGHT: GRRLS VERSUS WOMYN: GENERATION BLENDING

1. *Harry Potter and the Sorcerer's Stone* (2001, Chris Columbus).
2. Debbie Stoller, *The Bust Guide to the New Girl Order.* New York & London: Penguin Books, 1999, p. 185.
3. Selected works by Mary Daly include *Beyond God the Father: Toward a Philosophy of Women's Liberation.* Boston: Beacon Press, 1985; *Gyn/Ecology, the Metaethics of Radical Feminism.* Boston: Beacon Press, 1990; *Webster's First New Intergalactic Wickedary of the English Language* (with Jane Caputi and Sudie Rakusin). San Francisco: Harper, 1994.
4. http://www.michfest.com.
5. See Reena Mistry, "Madonna and Gender Trouble," http://www.theory.org.uk/madonna.htm.
6. Susan J. Douglas, *Where the Girls Are: Growing Up Female with the Mass Media.* New York: Times Books/Random House, 1994.
7. Daly, *Webster's First New Intergalactic Wickedary.*
8. Judith Thurman, "Reckless Perfectionism," *The New Yorker*, March 17, 2003, p. 114.
9. See Lynda Nead, *The Female Nude: Art, Obscenity and Sexuality.* London & New York: Routledge, 1992.
10. "Miwa Yanagi Deutsches Bank Collection," The Chelsea Art Museum, New York, May 5–August 25, 2007, http://chelseaartmuseum.org.
11. Amalia Jones, *Cindy Sherman: A Retrospective.* London: Thames and Hudson, 1997, p. 39.
12. Peter Galassi, "The Complete Untitled Film Stills," catalogue essay, http://www.moma.org/exhibitions/1997/sherman/index.html.
13. See Linda Nochlin, *Woman, Art and Power and Other Essays.* New York: Harper & Row, 1988.
14. http://www.guerrillagirls.com.
15. http://www.guerrillagirls.com/posters/unchained.shtml.
16. Marcia Tucker, "Bad Girls," exhibition catalogue, New York: New Museum of Contemporary Art and Cambridge, MA: MIT Press, 1994, p. 18.
17. Deborah Solomon, "Art Girls Just Wanna Have Fun," *The New York Times*, January 30, 2000, http://www.contemporaryartproject.com/cap/Othercontent/Cecily3.htm.
18. Catherine Driscoll, "Girl Culture, Revenge and Global Capitalism: Cybergirls, Riot Grrls, Spice Girls," *Australian Feminist Studies*, Vol. 14, No. 29, 1999, p. 176.
19. Mark Starr and Marsha Brant, "It Went Down to the Wire and Thrilled Us All," *Newsweek*, July 19, 1999, pp. 44–54 (cover story headline: "Girls Rule! Inside the Amazing World Cup Victory").
20. Recording Industry Association of America, http://www.riaa.com/gp/database/default.asp.
21. Driscoll, "Girl Culture, Revenge and Global Capitalism," p. 176.
22. Marcelle Karp and Debbie Stoller, *The Bust Guide to the New Girl Order.* New York & London: Penguin, 1999, p. 186.
23. Ibid., p. 188.
24. Laura Greenfield, *Girl Culture.* San Francisco: Chronicle, 2002, p. 118.
25. See James Clifford "Traveling Cultures," *Cultural Studies*, University of North Carolina at Chapel Hill, 1992.
26. Greenfield, *Girl Culture*, p. 90.
27. Ibid., p. 91.
28. Ibid., p. 93.
29. Ibid., p. 149.
30. Ibid., p. 150.
31. http://www.elliebrown.com.

32. E-mail correspondence with the artist, Winter 2007.

33. *Elle Magazine*, February 2001.

34. *Absolutely Fabulous*, Season One, episode 6, BBC-TV, 1992.

35. John Markoff, "The Rise and Swift Fall of Cyber Literacy," *The New York Times*, March 13, 1994, http://query.nytimes.com/gst/fullpage.html?res=9E06E2D7123DF930A25750C0A962958260.

36. *Business Week*, "Why Oprah Opens Readers' Wallets," October 10, 2005,http://www.businessweek.com/magazine/content/05_41/b3954059.htm.

37. See Oprah's Book Club archive: http://www2.oprah.com/obc_classic/obc_main.jhtml.

38. Ivan Waterman, "TV Boss Bans Huston's Child Abuse Film," *The Independent* (London), May 19, 1996. http://findarticles.com/p/articles/mi_qn4158/is_19960519/ai_n14054602

39. Emily Rems, "Girl Uncorrupted," *Bust*, Summer 2004, p. 46.

CHAPTER NINE: THE GIRL GAZE: INDIES, HOLLYWOOD, AND THE CELLULOID CEILING

1. "The Celluloid Ceiling: Behind-the-Scenes Employment of Women in the Top 250 Films of 2003," Martha M. Lauzen, Ph.D., School of Communication, San Diego State University, San Diego, CA 92182, 619.594.6301, © 1998–2004. All rights reserved. www.moviesbywomen.com/marthalauzenphd/stats2005.html.

2. "The Celluloid Ceiling: Behind-the-Scenes Employment of Women in the Top 250 Films of 2004," Martha M. Lauzen, Ph.D., School of Communication, San Diego State University, San Diego, CA 92182, 619.594.6301, © 2005. All rights reserved.

3. From the American Medical Association website, http://www.ama-assn.org.

4. See Christine Vachon, *Shooting to Kill: How and Independent Producer Blasts Through Barriers to Make Movies That Matter*. New York: Avon Books, 1998; and *A Killer Life: How an Independent Producer Survives Deals and Disasters in Hollywood and Beyond*. New York: Simon & Schuster, 2006.

5. Nancy Hass, "The New Old Girls Network, Running Hollywood Studios," *The New York Times*, April 24, 2005, p. 2, p. 13.

6. Rhonda Wilcox, *Why Buffy Matters: The Art of Buffy the Vampire Slayer*. London & New York: I.B. Tauris, 2005.

7. Hass, "The New Old Girls Network."

8. According to the Internet Movie Database, IMDb, a $50 million return on a $15 million budget, http://www.imdb.com/title/tt0110367/business.

9. http://www.imdb.com/title/tt0185937/business.

10. Lauzen, "The Celluloid Ceiling." Statistics on cinematographers have been gathered annually since 1998.

11. For more on this issue see a review of Channel 4's documentary about women cinematographers, "Lipstick on the Lens," http://www.channel4.com/film/reviews/feature.jsp?id=151905 &cs=1.

12. Eileen Kowalski, "Tina Hirsch," *Variety*, November 14, 2001, http://www.variety.com/article/VR1117855804.html?categoryid=1013.

13. All of this information obtained from the Internet Movie Database, IMDb, http://www.imdb.com.

14. For a chronicle of the crucial turning-point years of development of the Indie scene from the mid-1980s to mid-1990s, see John Pierson's *Spike, Mike, Slackers & Dykes: A Guided Tour across*

a Decade of Independent Cinema. New York: Hyperion/Miramax Books, 1995. This book is not, however, a homage to women directors of the era, who gain cursory mention. Rather, it follows the tradition of highlighting the work of male amateurs such as Jim Jarmusch, Steven Soderbergh, Spike Lee, Hal Hartley, and Kevin Smith.

15. See Sundance Institute website, http://institute.sundance.org, for more about these programs.
16. Rosa Linda Fregoso, "Hanging Out with the Homegirls? Allison Anders' *Mi Vida Loca*," *Cineaste*, Vol. 21, No. 3, Summer 1995, pp. 36–38.
17. Martha Southgate, "Leslie Harris: Not Just Another Girl on the IRT," *Essence*, April 1993, http://www.findarticles.com/p/articles/mi_m1264/is_n12_v23/ai_13521518.
18. Eileen Kelly, "The Female Gaze," *Salon.com*, January 30, 2003, http://dir.salon.com/story/mwt/feature/2003/01/30/gaze/index.html.
19. For a thorough discussion of the portrayal of young Latinas in recent films, see Jillian M. Báez, "Towards a Latinidad Feminista: The Multiplicities of Latinidad and Feminism in Contemporary Cinema," *Popular Communication*, Vol. 5, No. 2, 2007, pp. 109–128.
20. http://www.rottentomatoes.com/m/1158195-marie_antoinette and http://bigscreenlittlescreen.net/2006/10/20/marie-antoinette-a-quotational-reference.
21. See Judith M. Redding and Victoria A. Brownworth, *Film Fatales: Independent Women Directors*. Seattle, WA: Seal Press, 1997.
22. http://www.moviesbywomen.com.
23. And the winners are Barbara Kopple, 1975, 1990; Maria Florio and Victoria Mudd, 1985; Barbara Trent, 1992; Susan Raymond, 1993; Freida Lee Mock, 1994; Deborah Oppenheimer, 2000; Zana Briski, 2005, http://www.oscar.com.
24. And the winners are Claire Wilbur, 1975; Lynn Littman and Barbara Myerhoff, 1976; Jacqueline Phillips Shedd, 1978; Cynthia Scott, 1983; Marjorie Hunt, 1984; Vivienne Verdon-Roe, 1986; Sue Marx and Pamela Conn, 1987; Debra Chasnoff, 1991; Geraldine Wurzburg, 1992; Margaret Lazarus, 1993; Jessica Yu, 1996; Donna Dewey and Carol Pasternak, 1997; Keiko Ibi, 1998; Susana Hannah Hadary, 1999; Tracy Seretean, 2000; Sarah Kernochan and Lynn Appelle, 2001; Maryann DeLeo, 2003; Ruby Yang, 2006, http://www.oscar.com.
25. From Kids with Cameras website, http://www.kids-with-cameras.org/mission.

CHAPTER TEN: GIRLS MAKE MOVIES: OUT OF THE MIRROR AND THROUGH THE LENS

1. A version of this article appeared as "Grrls Make Movies: The Emergence of Women-Led Film Initiatives for Girls," *Afterimage*, Winter 2005. Most of the quotes from program directors and teenage girl participants throughout this chapter were gleaned from e-mail interviews conducted by the author in the Summer and Fall of 2005.
2. Compare impact of images on http://www.nyfa.com and http://www.spyhop.org with http://www.reelgrrls.org and http://www.girlsfilmschool.csf.edu.
3. Mary Celeste Kearney, *Girls Make Media*. London & New York: Routledge, 2006.
4. Ibid., p. 289.
5. From e-mail interview with author, Summer/Fall 2005.
6. Ibid.
7. Barrie Thorne, *Gender Play: Boys and Girls in School.* New Brunswick, NJ: Rutgers University Press, 1993, pp. 111–134.

8. From e-mail interview with author, Summer/Fall 2005.
9. Ibid.
10. http://www.reelgrrls.org includes additional statistics about girls and media.
11. From e-mail interview with author, Summer/Fall 2005.
12. Lawrence H. Summers, "Remarks at NBER conference on Diversifying the Science & Engineering Workforce," January 14, 2005, http://www.president.harvard.edu/speeches/2005/nber.html.
13. From e-mail interviews with the author, Summer/Fall 2005.
14. Ibid.
15. Ibid.
16. Ibid.
17. Ibid.
18. Ibid.
19. Ibid.
20. Ibid.
21. Ibid.
22. Ibid.
23. Ibid.
24. For contact information about films produced in these programs, see the appendix.
25. From e-mail interviews with the author, Summer/Fall 2005.
26. Ibid.
27. For information about this film, see the VillaVillaCola website, http://www.villavillacola.com/Website/GNFabout.htm.
28. From e-mail interviews with the author, Summer/Fall 2005.
29. Ibid.
30. From email interview with the author, December 2006.
31. Ibid.
32. Tess's songs can be heard on MySpace, www.myspace.com/intisaar.
33. From e-mail interview with the author, December 2006.
34. Rosalind Wiseman, *Queen Bees & Wannabes: Helping Your Daughter Survive Cliques, Gossip, Boyfriends and Other Realities of Adolescence.* New York: Three Rivers, 2002.
35. Women Make Movies, http://www.wmm.com; Video Data Bank, http://www.vdb.org.

CHAPTER ELEVEN: CONCLUSION: ICELEBRITY AND EVOLVING ICONS

1. Amanda Lenhart and Mary Madden, "Teen Content Creators and Consumers," *Pew Internet and American Life Project*, November 2, 2005, p. iv.
2. Ibid., p. 1.
3. Mary Celeste Kearney, *Girls Make Media.* London & New York: Routledge, 2006, p. 290.
4. Sharon Mazzarella, "Claiming a Space" in *girl wide web: Girls, the Internet and the Negotiation of Identity,* edited by Sharon Mazzarella. New York: Peter Lang, 2005, pp. 141–160.
5. Lev Grossman, "Time's Person of the Year: You," *Time Magazine*, http://www.time.com/time/magazine/article/0,9171,1569514,00.html.
6. John Cassidy, "Me Media," *The New Yorker*, May 15, 2006, pp. 50–59.
7. See Demetri Martin, "Trendspotting: Social Networking," on *The Daily Show*, Comedy Central, February 2006, YouTube, http://www.youtube.com/watch?v=VpcvR1tIBfQ.

8. Cassidy, "Me Media," p. 55.

9. Malcolm Gladwell, *The Tipping Point: How Little Things Can Make a Big Difference*. New York: Back Bay Books/Little, Brown, 2002 [2000].

10. Alex Williams, "Here I Am Taking My Own Picture," *The New York Times*, Sunday Styles, February 29, 2006.

11. Lenhart and Madden, "Teen Content Creators and Consumers."

12. Rosalind Wiseman, *Queen Bees & Wannabes: Helping Your Daughter Survive Cliques, Gossip, Boyfriends and Other Realities of Adolescence*. New York: Three Rivers Press, 2002; Rachel Simmons, *Odd Girl Out: The Hidden Culture of Aggression in Girls*. New York: Harcourt Brace, 2002.

13. Marshall McLuhan, *The Mechanical Bride: Folklore of Industrial Man*, Corte Madera, CA: Gingko Press, 2001 [1951].

14. Ellen Lupton, *Mechanical Brides: Women and Machines from Home to Office*. New York: Cooper Hewitt National Museum of Design/Princeton Architectural Press, 1993.

15. "According to the advertising-tracking firm of TNS Media Intelligence, Apple spent twenty-four and a half million dollars to launch the device, and forty-five and a half million dollars between January and September of 2004. ... Apple's expenditures were relatively modest, and surprisingly traditional: only two hundred and six thousand dollars went for Web ads, and ninety per cent of last year's total went for television, with the broadcast networks receiving twenty-five million dollars and cable just under eighteen million. Yet the real reason that the iPod has more or less cornered the digital music-player market is far simpler: the product was brilliantly conceived and executed. Word-of-mouth and promotion did the rest."(Ken Auletta, "The New Pitch." *New Yorker*, March 28, 2005, http://www.newyorker.com/fact/content/articles/050328fa_fact).

16. Joshua Davis, "The Secret World of LonelyGirl," *Wired*, December 2006, pp. 232–239.

17. Ben McGrath, "It Should Happen to You: The Anxieties of YouTube," *The New Yorker*, October 16, 2006, p. 87.

Bibliography

BOOKS

Allende, Isabel. *Daughter of Fortune*. New York: HarperCollins, 1999.

Allison, Dorothy. *Bastard Out of Carolina*. New York: Penguin Books, 1993.

Anzaldua, Gloria. *Borderlands/La Frontera* San Francisco, CA: Spinsters/aunt lute, 1987.

Austen, Jane. Emma. New York: Penguin Classics, 2002 [1816].

———. *Northanger Abbey*. New York: Bantam Books, 1999 [1817].

———. *Pride and Prejudice*. New York: Oxford University Press, 2004 [1813].

———. *Sense and Sensibility*. London: Penguin Classics, 1995 [1811].

Barthes, Roland. *Mythologies*. Paris: Editions du Seuil, 1980 [1957].

———. *S/Z*. Paris: Editions du Seuil, 1979 [1970].

Baudrillard, Jean. *Simulations*. Translated by Paul Foss, Paul Patton and Philip Beitchman. Cambridge, MA: MIT Press: Semiotext[e], 1983.

Baumgardner, Jennifer, and Richards, Amy. *Manifesta: Young Women, Feminism and The Future*. New York: Farrar, Straus and Giroux, 2000.

Bell, Elizabeth, Haas, Lynda, and Sells, Laura. *From Mouse to Mermaid: The Politics of Film Gender and Culture*. Bloomington, IN: University of Indiana Press, 1995.

Benjamin, Walter. *Illuminations: Essays and Reflections*. Edited by Hannah Arendt. New York: Harcourt Brace Jovanovich, 1968.

Berger, John. *Ways of Seeing*. London: British Broadcasting Corporation and Penguin Books, Ltd, 1972.

Bettleheim, Bruno. *The Uses of Enchantment: The Meaning and Importance of Fairy Tales*. New York: Vintage Books, 1975.

Blessing, Judith. *Rrose is a Rrose is a Rrose: Gender Performance in Photography*. New York: Guggenheim Museum Publications, 1997.

Blume, Judy. *Are You There God? It's Me, Margaret*. New York: Dell, 1970.

Boston Women's Health Collective. *Our Bodies Our Selves*. New York: Simon and Schuster, 1993 [1971].

Brashares, Ann. *The Sisterhood of the Travelling Pants*. New York: Random House, 2001.

Brown, Lynn Mikel. *Raising Their Voices: The Politics of Girls' Anger.* Cambridge, MA: Harvard University Press, 1998.

Brumberg, Joan Jacobs. *The Body Project: An Intimate History of American Girls.* New York: Random House, 1997.

Butler, Judith. *Gender Trouble: Feminism and the Subversion of Identity.* New York & London: Routledge, 1999 [1990].

Butor, Michel. *Les Mots Dans La Peinture.* Paris: Flammarion, 1969.

Campbell, Joseph. *The Hero With a Thousand Faces.* New Jersey: Princeton University Press, 1949.

Cather, Willa. *My Antonia.* New York: Penguin Books, 1994 [1918].

Chadwick, Whitney. *Women, Art and Society.* London & New York: Thames and Hudson, 2002 [1990].

Chevalier, Tracy. *Girl with the Pearl Earring.* New York: Dutton, 1999.

Christiansen, Keith and Mann, Judith. *Orazio and Artemsia Gentileschi.* New York: The Metropolitan Museum of Art and New Haven: Yale University Press, 2001.

Cixous, Helene and Clement, Catherine. *The Newly Born Woman.* Minneapolis, MN: The University of Minnesota Press, 1986 [1975].

Cruz, Amada; Smith, Elizabeth A.T. and Jones, Amalia. *Cindy Sherman: A Retrospective.* London: Thames and Hudson, 1997.

Daly, Mary. *Beyond God the Father: Toward a Philosophy of Women's Liberation.* Boston: Beacon Press, 1985.

———. *Gyn/Ecology, the Metaethics of Radical Feminism.* Boston: Beacon Press, 1990.

———. *Websters' First New Intergalactic Wickedary of the English Language.* (with Jane Caputi and Sudie Rakusin) San Francisco: Harper, 1994.

Danticat, Edwidge. *Breath, Eyes, Memory.* New York: Random House, 1994.

de Beauvoir, Simone. *Le Deuxieme Sexe.* Paris: Editions Gallimard, 1980 [1949].

Delaney, Janice, Mary Jane Lupton and Emily Toth. *The Curse: A Cultural History of Menstruation.* New York: Dutton, 1976.

De Lauretis, Teresa. *Alice Doesn't: Feminism, Semiotics, Cinema.* Bloomington, IN: Indiana University Press, 1984.

Derrida, Jacques and Spivak, Gayatri, trans. *Of Grammatology.* Baltimore, MD: The Johns Hopkins University Press, 1997 [1974].

Diamant, Anita. *The Red Tent.* New York: St. Martin's Press, 1997.

Douglas, Susan J. *Where the Girls Are: Growing Up Female with the Mass Media.* New York: Times Books/Random House, 1994.

Douglas, Susan J. and Michaels, Meredith W. *The Mommy Myth: The Idealization of Motherhood and How it has Undermined all Women.* New York: Free Press, 2004.

Duras, Marguerite. *L'Amant.* Paris: Les Editions de Minuit, 1984.

———. *The Lover.* Translated by Barbara Bray. New York: Random House, 1985.

Dunant, Sarah. *The Birth of Venus.* New York: Random House, 2003.

Eisenstein, Sergei. *The Film Sense.* New York: Harcourt Brace, 1942.

Elium, Jeanne & Elium, Don. *Raising a Daughter: Parents and the Awakening of a Healthy Woman.* Berkeley, CA: Celestial Arts, 1994.

Ensler, Eve. *The Vagina Monologues: The V-Day Edition.* New York: Villard/Random House, 2001.

Eugenides, Jeffrey. *Middlesex.* New York: Farrar, Straus, Giroux. 2002.

———. *The Virgin Suicides.* New York: Farrar, Straus, Giroux, 1993.

Fisher, David E. and Fisher, Marshall Jon. *Tube: The Invention of Television.* Washington, DC: Counterpoint, 1996.

Fisherkeller, Joellen. *Growing Up with Television: Everyday Learning among Young Adolescents.* Philadelphia, PA: Temple University Press, 2002.

Fitch, Janet. *White Oleander.* New York: Little, Brown & Co., 1999.

Foucault, Michel. *L'Usage des Plaisirs.* Paris: Editions Gallimard, 1984.

Fowler, Connie May. *Before Women Had Wings.* New York: G.P. Putnam & Sons, 1996.

Fraser, Antonia. *Marie Antoinette: The Journey.* New York: Anchor Books/Doubleday, 2001.

Freidan, Betty. *The Feminine Mystique.* New York: W.W. Norton & Co., 1997 [1963].

Freire, Paolo. *Pedagogy of the Oppressed.* New York & London: Continuum International Publishing Group, 2005 [1970].

Freud, Sigmund. *Dora: An Analysis of a Case of Hysteria.* New York: Simon & Schuster, 1997 [1963].

———. *The Interpretation of Dreams* (trans. A.A. Brill). New York & London: Penguin Classics, 2006 [1899].

———. *Totem and Taboo* (trans. A.A. Brill). New York: Prometheus Books, 1999 [1918].

Gadon, Elinor. *The Once and Future Goddess.* San Francisco: HarperSanFrancisco, 1989.

Gibbons, Kaye. *Ellen Foster.* New York: Vintage Books, 1990 [1987].

Gilligan, Carol. *In a Different Voice: Psychological Theory and Women's Development.* Cambridge, MA & London, England: Cambridge University Press, 1993 [1982].

Gladwell, Malcolm. *The Tipping Point: How Little Things Can Make a Big Difference.* New York: Back Bay Books/ Little, Brown & Co., 2002 [2000].

———. *Blink: The Power of Thinking Without Thinking.* New York: Little, Brown & Co., 2005.

Gloeckner, Phoebe. *The Diary of a Teenage Girl.* Berkeley, CA: Frog Ltd/North Atlantic Books, 2002.

Goldberg, Myla. *Bee Season.* New York: Doubleday, 2000.

Grant, Barry Keith, ed. *The Dread of Difference: Gender and the Horror Film.* Austin: University of Texas Press, 1996.

Graves, Robert. *The Greek Myths, Vols 1-2.* London: Penguin Books, 1955.

Greenfield, Lauren. *Fast Forward: Growing Up in the Shadow of Hollywood.* New York: Alfred A. Knopf/Melcher Media, 1997.

———. *Girl Culture.* San Francisco: Chronicle Books, 2002.

Greer, Germaine. *The Female Eunuch.* New York: Farrar, Straus, Giroux, 2001 [1970].

Grosz, Elizabeth. *Space, Time and Perversion: Essays on the Politics of the Body.* New York & London: Routledge, 1995.

Guerrilla Girls. *Bitches, Bimbos and Ballbreakers: The Guerrilla Girls' Illustrated Guide to Female Stereotypes.* New York: Penguin Books, 2003.

———. *The Guerrilla Girls' Bedside Companion to the History of Western Art.* New York: Penguin Books, Inc., 1998.

Hall, Nor. *The Moon and The Virgin: Reflections on the Archetypal Feminine.* New York: Harper & Row, 1980.

Hancock, Emily. *The Girl Within.* New York: Fawcett Columbine Books, 1989.

Haraway, Donna J., Simians. *Cyborgs and Women: The Reinvention of Nature.* London & New York: Routledge, 1991.

Hiaasen, Carl. *Team Rodent: How Disney Devours the World.* New York: The Library of Contemporary Thought/Ballantine Books, 1995.

hooks, bell. *Reel to Real: Race, Sex and Class at the Movies.* London & New York: Routledge, 1996.

———. *Yearning: Race, Gender and Cultural Politics.* Boston: South End Press, 1990.

Inness, Sherrie, ed. *Action Chicks: New Images of Tough Women in Popular Culture.* London & New York: Routledge, 2004.

Irigaray, Luce. *Ce Sexe Qui N'En Est Pas Un.* Paris: Les Editions de Minuit, 1977.
———. *I love to you: Sketch of a Possible Felicity in History* (trans. Alison Martin). New York & London: Routledge, 1996.
———. *Speculum de l'Autre Femme.* Paris: Les Editions de Minuit, 1974.
Jukes, Mavis. *It's a Girl Thing: How to Stay Healthy, Safe and in Charge.* New York: Borzoi/Knopf, 1996.
Jung, C.G. *The Collected Works, Vol 14: Mysterium Coniuntionis.* Princeton, NJ: Princeton University Press, 1977 [1960].
———. *The Collected Works, Vol 12: Psychology and Alchemy.* Princeton, NJ: Princeton University Press, 1980 [1968].
———. *The Collected Works, Vol 9: The Archetypes and the Collective Unconscious.* Princeton, NJ: Princeton University Press, 1990 [1959].
Karp, Marcelle and Stoller, Debbie. *The Bust Guide to the New Girl Order.* New York & London: Penguin Books, 1999.
Karr, Mary. *The Liar's Club.* New York: Penguin Books, 1995.
Katz, Melissa R. and Orsi, Robert A. *Divine Mirrors: The Virgin Mary in the Visual Arts.* New York: Oxford University Press, 2001.
Kaysen, Susanna. *Girl, Interrupted.* New York, Random House, 1994.
Kearney, Mary Celeste. *Girls Make Media.* London & New York: Routledge, 2006.
Kidd, Sue Monk. *The Secret Life of Bees.* New York: Viking Penguin, 2002.
Kilbourne, Jean. *Can't Buy My Love: How Advertising Changes the Way We Think and Feel.* New York: Touchstone Books, 1999.
Kilbourne, Jean and Levin, Diane. *So Sexy So Soon: The Sexualization of Childhood.* New York: Ballantine, 2008.
Kincaid, Jamaica. *Annie John.* New York: Farrar, Straus, Giroux, 1983.
Kingsolver, Barbara. *The Poisonwood Bible.* New York: HarperCollins, 1999.
Kracauer, Siegfried. *Theory of Film: The Redemption of Physical Reality.* New York: Oxford University Press, 1960.
Kruger, Barbara, and Linker, Kate. *Love for Sale: The Words and Pictures of Barbara Kruger.* New York: Harry N. Abrams, 1990.
Lamb, Sharon, and Brown, Lyn Mikel. *Packaging Girlhood: Rescuing Our Daughters from Marketers' Schemes.* New York: St. Martin's Press, 2006.
Lippard, Lucy. *Mixed Blessings: New Art in a Multicultural America.* New York: The New Press, 1990.
Lipper, Joanna. *Growing Up Fast.* New York: Picador, 2003.
Lord, M.G. *Forever Barbie: The Unauthorized Biography of a Real Doll.* New York: Walker & Co., 1994.
Lupton, Ellen. *Mechanical Brides: Women and Machines from Home to Office.* New York: Cooper Hewitt National Museum of Design/Princeton Architectural Press, 1993.
Mazzarella, Sharon, ed. *Girl Wide Web: Girls, the Internet and the Negotiation of Identity.* New York: Peter Lang, 2005.
Mazzarella, Sharon, and Pecora, Norma Odom, eds. *Growing Up Girls: Popular Culture and the Construction of Identity.* London & New York: Peter Lang Publishing, 1998.
McCullers, Carson. *The Member of the Wedding.* New York: Bantam Books, 1977 [1946].
McLuhan, Eric and Zingrone, Frank, ed. *Essential McLuhan.* New York: Basic Books, 1995.
McLuhan, Marshall. *The Mechanical Bride: Folklore of Industrial Man.* Corte Madera, CA: Gingko Press, 2001 [1951].

———. *Understanding Media*. Cambridge, Massachusetts and London, England: The MIT Press, 1994 [1964].

McRobbie, Angela. *Feminism and Youth Culture*. London & New York: Routledge, 2000 [1991].

Mead, Margaret. *Coming of Age in Samoa*. New York: William Morrow, 1928, New York: Quill/Morrow, 1961.

Morrison, Toni. *The Bluest Eye*. New York: Holt, Rhinehart and Winston, 1970.

Mulvey, Laura. *Visual and Other Pleasures*. Bloomington, IN: Indiana University Press, 1989.

Munsch, Robert. *The Paper Bag Princess*. Ontario & New York: Firefly Books, 2002 [1980].

Murdock, Maureen. *The Heroine's Journey*. Boston: Shambala Books, 1990.

Museum of Contemporary Art, Chicago and The Museum of Contemporary Art, Los Angeles. *Cindy Sherman: Retrospective*. London: Thames & Hudson, 2001 [1997].

Nabokov, Vladimir. *Lolita*. New York: Vintage, 1989 [1955].

Napier, Susan J. *Animé from Akira to Howl's Moving Castle: Experiencing Contemporary Japanese Animation*. New York: Palgrave MacMillan, 2005 [2001].

National Museum of Women in the Arts. *Italian Women Artists from Renaissance to Baroque*. Milan: Skira, 2007.

Nead, Lynda. *The Female Nude: Art, Obscenity and Sexuality*. London & New York: Routledge, 1992.

Nochlin, Linda. *Woman, Art and Power and Other Essays*. New York: Harper & Row, 1988.

Orenstein, Peggy. *SchoolGirls: Young Women, Self-Esteem, and the Confidence Gap*. New York: Doubleday, 1994.

Paglia, Camille. *Sexual Personae: Art and Decadence From Nefertiti to Emily Dickinson*. New York: Vintage Books, 1992.

———. *Vamps and Tramps: New Essays*. New York: Vintage Books/Random House, 1994.

Pearce, Joseph Chilton. *Evolution's End: Claiming the Potential of our Intelligence*. San Francisco: Harper, 1992.

Pierson, John. *Spike, Mike, Slackers & Dykes: A Guided Tour Across a Decade of Independent Cinema*, New York: Hyperion/Miramax Books, 1995.

Pipher, Mary. *Reviving Ophelia: Saving the Selves of Adolescent Girls*. New York: Ballantine Books, 1994.

Postman, Neil. *Amusing Ourselves to Death: Public Discourse in the Age of Show Business*. New York & London: Viking Penguin Books, 1985.

Potter, Giselle. *Lucy's Eyes and Margaret's Dragons: The Lives of the Virgin Saints*. San Francisco, CA: Chronicle Books, 1997.

Propp, Vladimir. *Morphology of the Folktale*. Austin, TX: University of Texas Press, 1968.

Redding, Judith M. and Brownworth, Victoria A. *Film Fatales: Independent Women Directors*. Seattle, WA: Seal Press, 1997.

Renov, Michael, and Suderburg, Erika, eds. *Resolutions: Contemporary Video Practices*. London and Minneapolis: University of Minnesota Press, 1996.

Robinson, Marilynne. *Housekeeping*. New York: Farrar, Straus, Giroux. 1980.

Roiphe, Katie. *The Morning After: Fear, Sex and Feminism*. Boston: Back Bay Books, 1994.

Rowling, J.K. *Harry Potter and the Sorcerer's Stone*. London: Bloomsbury, 1997; New York: Scholastic Press, 1999.

———. *Harry Potter and the Chamber of Secrets*. New York: Scholastic, 1999.

———. *Harry Potter and the Prisoner of Azkaban*. New York: Scholastic, 1999.

———. *Harry Potter and the Goblet of Fire*. New York: Scholastic, 2000.

———. *Harry Potter and the Order of the Phoenix*. New York: Scholastic, 2003.

————. *Harry Potter and the Half-Blood Prince*. New York: Scholastic, 2005.

Sapphire. *Push*. New York: Knopf, 1996.

Satrapi, Marjane. *Persepolis: The Story of a Childhood*. New York: Pantheon, 2003.

Sebold, Alice. *The Lovely Bones*. Boston & New York: Little, Brown & Co., 2002.

————. *Lucky*. New York: Simon & Schuster, 1999.

Shakespeare, William. *The Riverside Shakespeare*, Boston: Houghton Mifflin, 1974.

Shandler, Sara. *Ophelia Speaks: Adolescent Girls Write about their Search for Self*. New York: HarperPerennial, 1999.

Shlain, Leonard. *The Alphabet Versus the Goddess: The Conflict Between Word and Image*. New York: Viking Penguin, 1998.

Sherman, Cindy. *The Complete Untitled Film Stills*. New York: The Museum of Modern Art, 1997.

Shuttle, Penelope and Peter Redgrove. *The Wise Wound: Menstruation and Everywoman*. London: Harper Collins Publishers, 1978.

Silverman, Kaja. *The Acoustic Mirror: The Female Voice in Psychoanalysis and Cinema*. Bloomington, IN: University of Indiana Press, 1988.

Simmons, Rachel. *Odd Girl Out: The Hidden Culture of Aggression in Girls*. New York: Harcourt Brace, 2002.

Simpson, Mona. *Anywhere But Here*. New York: Alfred A. Knopf, 1986.

Sontag, Susan. *On Photography*. New York: Farrar, Straus, Giroux, 1973.

————. *Against Interpretation and Other Essays*. New York: Farrar, Straus, Giroux, 1961.

Strout, Elizabeth. *Amy and Isabelle*. New York: Random House, 1998.

Tartt, Donna. *The Little Friend*. New York: Knopf, 2002.

The New Museum of Contemporary Art, New York. *Bad Girls*, exhibition catalogue, New York: New Museum of Contemporary Art and Cambridge, MA: MIT Press, 1994.

Thorne, Barrie. *Gender Play: Girls and Boys in School*. New Brunswick, NJ: Rutgers University Press, 1999 [1993].

Tortora, Gerard J. and Grabowski, Sandra. *Principles of Anatomy and Physiology*. New York: John Wiley & Sons, Inc., 2002.

Trinh, T. Minh-ha. *Woman Native Other: Writing Postcoloniality and Feminism*. Bloomington, IN: University of Indiana Press, 1989.

Turkle, Sherry. *Life on the Screen: Identity in the Age of the Internet*. New York: Simon and Schuster, Inc., 1995.

Ussher, Jane M. *Fantasies of Femininity: Reframing the Boundaries of Sex*. New Brunswick, NJ: Rutgers University Press, 1997.

Vachon, Christine. *A Killer Life: How an Independent Producer Survives Deals and Disasters in Hollywood and Beyond*. New York: Simon & Schuster, 2006.

Vachon, Christine, and Edelstein, David. *Shooting to Kill: How an Independent Producer Blasts Through Barriers to Make Movies that Matter*. New York: Avon Books, 1998.

von Franz, M.L. *Shadow and Evil in Fairy Tales*. Dallas, TX: Spring Publications, Inc., 1987 [1974].

Walker, Barbara G. *The Woman's Encyclopedia of Symbols and Sacred Objects*. New York: Harper & Row, 1988.

————. *The Woman's Encyclopedia of Myths & Secrets*. San Francisco: Harper & Row, 1983.

Ware, Susan. *Still Missing: Amelia Earhart and the Search for Modern Feminism*. New York: W.W. Norton & Co., 1993.

Warner, Marina. *Alone of All Her Sex: The Myth and the Cult of the Virgin Mary*. New York: Random House/Vintage Books, 1983 [1976].

———. *Joan of Arc: The Image of Female Heroism*. New York: Random House/Vintage Books, 1982 [1981].

White, Emily. *Fast Girls: Teenage Tribes and the Myth of the Slut*. New York: Berkley Publishing, 2002.

Whitely, Sheila. *Too Much Too Young: Popular Music, Age and Gender*. London & New York: Routledge, 2005.

Wilcox, Rhonda. *Why Buffy Matters: The Art of Buffy the Vampire Slayer*. London & New York: I.B. Tauris, 2005.

Willis, Sarah. *Some Things That Stay*. New York: Farrar, Straus and Giroux, 2000.

Wiseman, Rosalind. *Queen Bees & Wannabes: Helping Your Daughter Survive Cliques, Gossip, Boyfriends and Other Realities of Adolescence*. New York: Three Rivers Press, 2002.

Wolf, Naomi. *The Beauty Myth: How Images of Beauty Are Used Against Women*. New York: Doubleday, 1991.

———. *Promiscuities: The Secret Struggle for Womanhood*. New York: Ballantine Books, 1998 [1997].

Wolf, Sylvia. *Julia Margaret Cameron's Women*. New Haven: Yale University Press, 1998.

Woodman, Marion. *The Pregnant Virgin: A Process of Psychological Transformation*. Toronto: Inner City Books, 1985.

Wurtzel, Elizabeth. *Bitch: In Praise of Difficult Women*. New York: Doubleday, 1998.

Yates, Frances. *The Art of Memory*. Chicago: The University of Chicago Press, 1980 [1966].

Yoshinaga, Masayuki and Katsuhiko, Ishikawa. *Gothic + Lolita*. New York & London: Phaidon Press, 2007.

JOURNAL ARTICLES, NEWSPAPER AND MAGAZINE ARTICLES, PAPERS, AND CHAPTERS

Adato, Allison. "The Secret Lives of Teens." *Life Magazine*, March 1999, pp. 38–48.

American Association of University Women. "Shortchanging Girls, Shortchanging America." Washington, DC: American Association of University Women, 1994 [1991].

Anderson, Eric. "Young, Bad and Beautiful!" *US Weekly*, May 17, 2004.

Aurthur, Kate. "Bringing Up Baby Into an R-Rated World," *The New York Times*, April 2, 2006.

———. "Virginity Lost," *Slate.com*, November 23, 2004. http://www.slate.com/id/2110072/

———. "When God Was Less Controversial," *The New York Times*, May 8, 2005.

Banet-Weiser, Sarah. "Girls Rule!: Gender, Feminism, and Nickelodeon." *Critical Studies in Media Communication*, Vol. 21, No. 2, June 2004, pp. 119–139.

Bankowsky, Katya. "Contenders." *Filmmaker: The Magazine of Independent Film*, Summer 2000, pp. 60–65, 112.

Baumgarten, Marjorie. "Just Another Girl on the IRT." *Austin Chronicle*, April 16, 1993. http://www.austinchronicle.com.

Becker, Carol. "The Education of Young Artists and the Issue of Audience." Chapter 4 in *Between Borders: Pedagogy and the Politics of Cultural Studies*. London & New York: Routledge, 1994, pp. 101–111.

Belkin, Lisa. "The Making of an 8-Year-Old Woman." *The New York Times Magazine*, December 24, 2000.

Benfer, Amy. "A Teen Sex Guru Speaks." *Salon.com*, January 21, 2001. http://archive.salon.com/mwt/fearure/2001/01/10/teen_sex/print.html

Bergner, Daniel. "The Making of a Cyber Molester." *The New York Times Magazine*, January 23, 2005, pp. 26–33, 58–61.

Binelli, Mark. "Confessions of a Teenage Drama Queen." *Rolling Stone*, August 19, 2004. p. 59 (cover story).

Boorstin, Julia. "Disney's 'Tween Machine," *Fortune Magazine*, September 29, 2003. http://money.cnn.com/magazines/fortune/fortune_archive/2003/09/29/349896/index.htm

Bright, Susie. "Monica: The Beauty and the Brains." *Ms. Magazine*, June 1999. http://www.msmagazine.com/jun99/monica-bright.asp

Brubach, Holly. "Heroine Worship: The Age of the Female Icon." *The New York Times Magazine*, pp. 55–57 (cover story).

Cassidy, John. "Me Media." *The New Yorker*, May 15, 2006, pp. 50–59.

Cave, Damien. "Weren't You Famous? Reality TV: The Humiliation that Keeps on Giving." *The New York Times*, May 1, 2005.

Chagollan, Steve. "The Myth of the Native Babe: Hollywood's Pocahontas." *The New York Times*, November 27, 2005.

Chihara, Michelle. "Two Teens, One Brand, Infinite Possibilities." *Alternet*, January 21, 2002. http://www.alternet.org/story/12255/

Chittenden, Rhonda. "Teen Oral Sex: It's Sensationalized!" *Sexing the Political: A Journal of Third Wave Feminists on Sexuality*, Vol 3, No. 1, www.sexingthepolitical.com/2004/sextalk.htm

Clifford, James. "Traveling Cultures." *Cultural Studies*, University of North Carolina at Chapel Hill, 1992.

Collins, Clayton. "Pitches to Tweens Target Parents, Too." *The Christian Science Monitor*, April 28, 2006, p. 11.

Corbett, Rachel. "Women Strike Back Online Against Street Harassment." *Women's eNews*, May 9, 2006. http://www.womensenews.org/article.cfm/dyn/aid/2734/

Creswell, Toby. "Love That Teen Spirit," November 29, 2003, http://www.smh.com.au/articles

Davis, Joshua. "The Secret World of LonelyGirl." *Wired*, December 2006, pp. 232–239.

Dawn, Randee. "New York's Lower Eastside Girls Club Nurtures the Next Generation of Young Female Filmmakers," *Hollywood Reporter*, July 2004, http://www.hollywoodreporter.com

Dean, Cornelia. "Theorist Drawn into Debate 'That Will Not Go Away.'" *The New York Times*, April 12, 2005, p. D2.

Dean, Katie. "Film School for Girls' Eyes Only," *Wired.com*, June 17, 2002, http://www.wired.com/culture/lifestyle/news/2002/06/53171

Denby, David. "High School Confidential." *The New Yorker*, May 31, 1999, pp. 94–98.

Denizet-Lewis, Benoit. "Friends, Friends With Benefits and the Benefits of the Local Mall." *The New York Times Magazine*, May 30, 2004 (cover story).

Dery, Mark. "Hacking Barbie's Voice Box: Vengeance is Mine!" *New Media*, May 1994. http://www.levity.com/markdery/barbie.html

Dieckmann, Katherine. "The Girls are Alright." *The Village Voice Literary Supplement*, October 1998. http://villagevoice.com/vls/158,,757,21.html

Dizon, Kristin. "Reel grrls: Program teaches young women the art of filmmaking." *Seattle Post-Intelligencer Reporter*, April 13, 2004. http://seattlepi.nwsource.com/movies/168757_reelgrrls13.html

Driscoll, Catherine. "Girl Culture, Revenge and Global Capitalism: Cybergirls, Riot Grrls, Spice Girls." *Australian Feminist Studies*, Vol. 14, No. 29, 1999.

Early, Frances H. "Staking Her Claim: Buffy the Vampire Slayer as Transgressive Woman Warrior." *Journal of Popular Culture*, Winter 2001, Vol 35, No. 3, pp. 11–27.

Egan, Jennifer. "James is a Girl." *The New York Times Magazine*, February 4, 1996, pp. 26–38 (cover story).

Egan, Tracie. "A Star Osbourne." *Bust*, Winter 2003, pp. 44–49 (cover story).

Elber, Lynn. "Ugly Betty." *The Seattle Times*, May 16, 2007. http://seattletimes.nwsource.com/html/television/2003707799_ferrera.html

Fountain, Henry. "Where the Noise is Not So Joyful." *The New York Times*, September 11, 2005.

Fregoso, Rosa Linda. "Hanging Out with the Homegirls? Allison Anders' Mi Vida Loca." *Cineaste*, Vol. 21, No. 3 (Summer 1995): 36–38.

Freydkin, Donna. "Lilith Fair: Lovely, Lively and Long Overdue," *CNN Interactive*, July 28, 1998. http://www.cnn.com/SHOWBIZ/Music/9807/28/lilith.fair/

Friedman, Josh. "Directing Gender Buzz," *Los Angeles Times*, February 19, 2007. http://moviesby-women.com/press_20070219_latimes.php

Funk, Liz. "Teens Meet Harassment in High School Halls." Women's eNews, August 31, 2006, http://www.womensenews.org/article.cfm/dyn/aid/2870

Garfield, Bob. "You Tube vs. Boob Tube." *Wired*, December 2006, pp. 222–227, 266.

Gladwell, Malcolm. "Brain Candy: Is pop culture dumbing us down or smartening us up?" *The New Yorker*, May 17, 2005.

Glave, Michelle Pentz. "Girls, Cameras and the Art of Filmmaking," Santa Fe New Mexican, June 23, 2002.

Godwin, Jennifer. "Mary Kate and Ashley: Jailbait No More." *Eonline.com*, June 11, 2004, http://www.eonline.com/News/Items/0,1,14296,00.html

Goldstein, Patrick. "Movies Are All Going Back to High School." *Los Angeles Times*, April 20, 1998.

Gorney, Cynthia. "Teaching Johnny the Appropriate Way to Flirt." *The New York Times Magazine*, June 13, 1999, pp. 42–47, 67–68, 80–83.

Graham, David. "Gothic Lolitas: Goth Girls Just Wanna Have Fun." *Lilith e-zine*. http://www.lilith-ezine.com/articles/gothic/gothic_lolitas.html Retrieved June 5, 2007 (no publication date).

Gross, Jane. "In Quest for Perfect Look, More Girls Choose the Scalpel." *The New York Times*, November 29, 1998, p. B1, 56.

Hack, Susan. "Tampax Nightmares." *Salon.com*, July 22, 1998. http://www.salon.com/wlust/feature/1998/07/22feature2.html

Hains, Rebecca. "Inventing The Teenage Girl: The Construction of Female Identity in Nickolodeon's *My Life as a Teenage Robot*." *Popular Communication*, 2007, Vol. 5, No. 3. pp. 191–213.

Hall, Stephen S. "The Smart Set." *The New York Times Magazine*, June 4, 2000 (cover story).

Hall, Stuart. "Minimal Selves." in *Identity: The Real Me*, ICA Document 6, 1988.

———. "New Ethnicities." *Black British Cultural Studies*. Eds. Houston A. Baker, Manthia Diawara, and Ruth H. Lindeborg. Chicago, IL: University of Chicago Press, 1996, pp. 163–172.

Hanley, Robert. "Woman Gets 15 Years in Death of Newborn at Prom." *The New York Times*, October 30, 1998, B1, 5.

Harrington, Maureen. "Braver Than They Knew." *People Magazine*, pp. 50–55 (cover story).

Hass, Nancy. "Hollywood's New Old Girls' Network." *The New York Times*, April 24, 2005.

Hatcher, Candy. "Empowered Young Women are Passing it On." *Seattle Post-Intelligencer*, February 4, 2002, p. 1.

Hayt, Elizabeth. "Evoking the Fitful Passage to Womanhood." *The New York Times*, May 10, 1998. p. 50.

Heath, Chris. "Christina Aguilera: Inside the Dirty Mind of a Pop Princess." *Rolling Stone*, November 14, 2002. pp. 50–55 (cover story).

———. "Spice Girls: Too Hot to Handle." *Rolling Stone*, July 10–24, 1997, p. 74 (cover story).

Heffernen, Virginia. "Anchor Woman: Tina Fey rewrites late-night comedy." *The New York Times*, November 3, 2003.

Hepola, Sarah. "Her Favorite Class: 'Sex' Education." *The New York Times*, June 22, 2003, Section 2, p. 1.

Herman-Giddens, ME, Slora, EJ , Wasserman, RC, Bourdony, CJ, Bhapkar, MV, Koch, GG and Hasemeir. CM. 1997. "Secondary Sexual Characteristics and Menses in Young Girls Seen in Office Practice: A Study from the Pediatric Research in Office Settings Network." *Pediatrics* Vol. 99, No. 4, pp. 505–512.

Hershman, Lynn. "The Fantasy Beyond Control: Lorna and Deep Contact." *Art and Design 9*, November–December 1994, pp. 32–37.

Hirschberg, Lynn. "Desperate to Seem 16." *The New York Times Magazine*, September 5, 1999, 42–49, 74–79 (cover story).

Holden, Stephen. "A New Rule: The Beautiful Are the Bad." *The New York Times*, January 13, 1999, p. 13.

hooks, bell. "Engaged Pedagogy," from *Teaching to Transgress: Education as the Practice of Freedom*. London & New York: Routledge, 1994, pp. 13–22.

Jesella, Kara. "Going Bust," *Teen Vogue*, September 2004, p. 204, 234.

Johnson, Marilyn. "Nice Girls Finish First." *Life Magazine*, March 1999, p. 50 (cover story).

Jones, Chris. "Scarlett Johansson: A Charming and Amusing Story." *Esquire*, February 2005. pp. 64–71 (cover story).

Julien, Isaac, and Mercer, Kobena. "Introduction: De Margin and De Center." *Screen*, Vol. 29, No. 4, Autumn 1988.

Kaplan, Michael. "Tracking Snowclones is Hard, Let's Go Shopping," March 6, 2006. http://itre.cis.upenn.edu/~myl/languagelog/archives/002892.html

Kelly, Eileen. "The Female Gaze." *Salon.com*, January 30, 2003. http://dir.salon.com/story/mwt/feature/2003/01/30/gaze/index.html

Kornblum, Janet. "Teens hang out at MySpace." *USA TODAY*, January 8, 2006. http://www.usatoday.com/tech/news/2006-01-08-myspace-teens_x.htm?csp=34

Korzeniowski, Paul. "Cell Phones at School: Nuisance or Necessity?" *TechNewsWorld*, November 11, 2006. http://www.technewsworld.com/story/education/54192.html)

Kowalski, Eileen. "Tina Hirsch." *Variety*, November 14, 2001. http://www.variety.com/article/VR1117855804.html?categoryid=1013&cs=1

Kuczynski, Alex. "Teenage Magazines Mostly Reject Breast Enlargement Ads." *The New York Times*, August 13, 2001, p. C1.

Lacy, Emily. "Cellular Phones as Sexual Objects and Human Implosion." *Eyebeam Journal: Dissecting Art and Technology*, February 22, 2005. www.eyebeam.org/journal/archives/2005/cellular_phones_as_sexual_objects.html

Lane, Anthony. "Illustrated Life." *The New Yorker*, November 15, 2004, pp. 116–117.

Last, Jonathan V. "Live. Young. Girls." *The Daily Standard*, December 3, 2004.

LeBlanc, Adrian Nicole. "Hollywood Elementary." *The New York Times Magazine*, June 4, 2006, pp. 42–49, 66, 70–71, 73.

Lemire, Christy. " 'Twixt teen and vamp," *theage.com.au*, May 11, 2004, http://www.theage.com.au/articles/2004

Lenhart, Amanda, and Madden, Mary. "Teen Content Creators and Consumers." Pew Internet and American Life Project, November 2, 2005.

Lewin, Tamar. "Boys Are No Match for Girls in Completing High School." *The New York Times*, April 19, 2006, p. A12.

Limburg, Val E. "Fairness Doctrine: U.S. Broadcasting Policy." http://www.museum.tv/archives/etv/F/htmlF/fairnessdoct/fairnessdoct.htm

Longman, Jere. "Show Time for Reluctant Soccer Superstar." *The New York Times*, June 11, 1999.

Loos, Ted. "And Aviva Will be Played By…." *The New York Times*, April 6, 2005.

Lyons, Charles. "The Audience Speaks Spanish but Not at the Multiplex," *The New York Times*, April 2, 2006.

Marcotte, Amanda. "Feminism in the Era of 'Girls Gone Wild," *Alternet*, May 5, 2007. http://www.alternet.org/story/51416.

Marcus, Greil. "Raising the Stakes in Punk Rock." *The New York Times*, June 18, 2000.

Markoff, John. "The Rise and Swift Fall of Cyber Literacy." *The New York Times*, March 13, 1994. http://query.nytimes.com/gst/fullpage.html?res=9E06E2D7123DF930A25750C0A962958260

Maslin, Janet. "Eye Candy: Teen Queens of Mean," *The New York Times*, February 19, 1999. http://movies2.nytimes.com/mem/movies/review.html?res=9C05E2DB163DF93AA25751C0A96F958260

Mazzarella, S. R., and Pecora, N. "Revisiting Girls' Studies: Girls Creating Sites for Connection and Action." *Journal of Children and Media*, Vol. 1, No. 2, 2007.

McCabe, Janet. "Claire Fisher on the Couch: Discourses of Female Subjectivity, Desire and Teenage Angst in Six Feet Under" *The Scholar and Feminist Online*, Issue 3.1, Published by the Barnard Center for Research on Women, 2004.

McClure, Wendy. "Teenage Daydream: Why are today's screen teens, like, so mature?" *BUST*, December 2004, p. 26.

McGrath, Ben. "It Should Happen to You: The Anxieties of YouTube." *The New Yorker*, October 16, 2006, pp. 86–95.

McGrath, Charles. "Being 13: It's Not the Way It Used to Be—Except That It Is." *The New York Times Magazine*. May 17, 1998, pp. 29–30 (cover story).

Metcalf, Stephen. "Lolita at 50: Is Nabokov's Masterpiece Still Shocking?" *Slate.com*, December 19, 2005. http://www.slate.com/id/2132708/

Mifflin, Lawrie. "Giving Fairy Tales a Feminist Twist." *The New York Times*, June 22, 1999.

Miller, Laura. "Sex AND THE Single POST-Feminist." *Salon.com*, February 26, 1997. http://www.salon.com/feb97/badgirl970226.html

Millman, Joyce. "Why Must I Be a Teenage Vampire Slayer in Love?" *Salon.com*, June 8, 1998.

———. "Super Girls and Little Women." *Salon.com*, January 25, 1996. http://www.salon.com/07/features/tvgirls.html

Montemurro, Beth. "Charlotte Chooses Her Choice: Liberal Feminism on Sex and the City" in *The Scholar & Feminist Online Barnard Center for Research on Women,* New York. Vol. 3, No. 1, Fall 2004. http://www.barnard.edu/sfonline/hbo/montemurro_01.htm

Natoli, Cori Anne. "Tearful Drexler get 15-year sentence for prom killing." Asbury Park Press, October 30, 1998. http://www.injersey.com/news/prom/story/1,1466,127036,00. html

Newman, Bruce. "Can't Read the Classic? See the Teen Movie." *The New York Times*, February 28, 1999, pp. 21–22.

Newsome, Victoria. "Young Females as Super Heroes: Superheroines in the Animated Sailor Moon." *FemSpec* "Girl Power," Vol. 5.2 (online only, no date), http://www.femspec.org/samples/sailor-moon.html

Niehart, Ben. "OMG! I Love Ellie and Ashley. Craig is Totally HOTTT…." *The New York Times Magazine*, March 20, 2005, pp. 41–45.

Noe, Denise. "All About Polly Klaas and Richard Allen Davis." http://www.crimelibrary.com/serial_killers/predators/klaas/9.html

Norris, Chris. "The Genies Are Out of the Bottle." *The New York Times*, July 3, 2005.

O'Hehir, Andrew. "Spirited Away." *Salon.com*, September 25, 2002. http://dir.salon.com/story/ent/movies/review/2002/09/25/spirited/index.html

Orenstein, Peggy. "One Hundred Years of Adolescence." *The New York Times Book Review*, October 5, 1997.

———. "What's Wrong with Cinderella." *The New York Times Magazine*, December 24, 2006. http://www.peggyorenstein.com/articles/2006_princesses.html

Owen, David. "Title IX Babies." *The New Yorker*, May 15, 2006, pp. 44–49.

Packard, George. "Film School Open to Girls," *Operating Cameraman*, Spring–Summer 1999.

Pallavi, Gogoi. "Smells Like Teen Marketing" *Businessweek*, November 10, 2005. http://www.business-week.com/innovate/content/nov2005/id20051109_341544.htm

Pareles, Jon. "Britney Grows Up, Very Carefully." *The New York Times*, May 14, 2000, p. 1, 34.

Pearse, Emma, "Appeal of All-Girls' Clubs Growing Nationally," *WeNews*, July 2, 2004. http://www.womensenews.org/article.cfm/dyn/aid/1895/context/archive

Peretz, Evgenia. "Confessions of a Teenage Movie Queen." *Vanity Fair*, February 2006 (cover story).

Pollitt, Katha. "Not Just Bad Sex." *The New Yorker*, October 4, 1993.

Power, Elizabeth. "The Cinematic Art of Nympholepsy: Movie Star Culture as Loser Culture in Vladimir Nabokov's Lolita." *Criticism*, Winter 1999. http://www.findarticles.com/p/articles/mi_m2220/is_1_41/ai_56905046

Pressler, Jessica. "School, Sleepovers, Red Carpet Dreams," *The New York Times*, February 12, 2006.

Ramsay, Carolyn. "The Olsens Inc." *Los Angeles Times*, January 30, 2000.

Reiss, Spencer, "His Space." *Wired*, July 2006, pp. 142–147, 164.

Rems, Emily. "Girl, Uncorrupted: Jena Malone is talkin' 'bout her Jena-ration." *BUST*, Summer 2004, pp. 42–47 (cover story).

Rivero, Yeidy M. "ABC's Not-So-Ugly Betty." *Ms. Magazine*, Winter 2007. http://www.alternet.org/stories/46928/

Roadman, Jenna. "How To Make Your Own Pop Princess." *Portland Mercury News*, September 8, 2004. http://www.portlandmercury.com/portland/Content?oid=32041&category=23483

Roeper, Richard. "The Jailbait Dilemma: Does Oogling Tweeners Make us Dirty Old Men?" *Esquire*, May 2004, pp. 44–46.

Saroyan, Strawberry. "Is Child Stardom No Longer a Life Sentence?" *The New York Times*, November 27, 2005.

Schickel, Richard. "Gender Bender." *Time*, June 14, 1991 (cover story).

Schiff, Stacy. "Know It All: Can Wikipedia Conquer Expertise?" *The New Yorker*, July 31, 2006, pp. 36–43.

Scott, A.O. "Blessed Restraint," *The New York Times Magazine*, April 10, 2005.

———. "Revenge of the Nerds," *The New York Times*, May 8, 2005.

Sheffield, Rob. "Hot, Ready and Legal! Lindsay Lohan." *Rolling Stone*, August 19, 2004 (cover story).

Smith, Dinitia. "Now It's Women's Turn to Make It in the Ring." *The New York Times*, October 1, 2000, p. 13.

Soltan, Rita. "The Tween Market: Keeping Our Collections Attractive, Practical And Effective," *MLA Forum*, Vol. III, No. 1, February 24, 2004. http://www.mlaforum.org/volumeIII/issue1/Article2Tweens.html

Southgate, Martha. "Leslie Harris: Not Just Another Girl on the IRT." *Essence*, April 1993. http://www.findarticles.com/p/articles/mi_m1264/is_n12_v23/ai13521518

Starr, Mark, and Brant, Martha. "Inside the World Cup Victory." *Newsweek*, pp. 46–54 (cover story).

Steinhauer, Jennifer. "Pow! Slam! Thank You, Ma'am." *The New York Times*, November 5, 2000, p. 5.

St. John, Warren. "They're Not Just Saying Ah." *The New York Times*, Sunday Styles, October 2, 2005, p. 13.

Strauss, Neil. "The Hit Girl: Christina Aguilera." *Rolling Stone*, July 6–20, 2000, pp. 80–86, 151 (cover story).

Summers, Lawrence H. "Remarks at NBER conference on Diversifying the Science & Engineering Workforce," January 14, 2005, http://www.president.harvard.edu/speeches/2005/nber.html

Sweeney, Jennifer Foote. "The Virginity Hoax." *Salon.com*, January 8, 2001. http://www.salon.com/mwt/feature/s001/01/08/virginity_pledge/index.html

Sweeney, Kathleen. "Grrls Make Movies: The Emergence of Women-Led Filmmaking Initiatives for Girls." *Afterimage*, Winter 2005. pp. 37–42.

———. "Maiden USA: Representations of Teenage Girls in the 90s." *Afterimage*, Winter 1999, pp. 10–13.

———. "Supernatural Girls." *Afterimage*, Spring 2006, pp. 13–16.

Talbot, Margaret. "The Auteur of Anime: A Visit with the Elusive Genius Hayao Miyazaki." *The New Yorker*, January 17, 2005, pp. 64–75.

———. "Girls Just Want to Be Mean." *The New York Times Magazine*, February 24, 2002, pp. 24–29, 40, 58.

———. "The Maximum Security Adolescent." *The New York Times Magazine*, pp. 40–47, 58–60, 88, 96 (cover story).

Tapley, Kristopher. "New Crop of Message Films, Very Different Message." *The New York Times*, April 9, 2006.

Thurman, Judith. "Dressed for Excess: Marie Antoinette, Out of the Closet." *The New Yorker*, September 25, 2006, pp. 136–143.

Udovitch, Mim. "The Olsen Juggernaut." *The New York Times Magazine*, May 27, 2001, pp. 22–25.

Valby, Karen, "Breakouts: Lindsay Lohan." *Entertainment Weekly*, December 17, 2004 (cover story).

Van Ness, Elizabeth, "Is a Cinema Studies Degree the New M.B.A.?" *The New York Times*, March 6, 2005.

Vineberg, Steve. "Yes, She's a Vampire Slayer. No, Her Show Isn't Kid Stuff." *The New York Times*, October 1, 2000.

Wadler, Joyce. "Turning a Corner: A Model at Size 12." *The New York Times*, August 11, 2001, p. 1.

Walker, Rob. "The Brand Underground." *The New York Times Magazine*, July 30, 2006, pp. 23–33, 52–55.

West, Kevin. "Two Queens." *W Magazine*, May 2006. http://www.style.com/w/feat_story/040506/full_page.html

Williams, Alex. "Before Spring Break, The Anorexic Challenge." *The New York Times*, Sunday Styles, April 2, 2006, p. 1.

———. "Here I Am Taking My Own Picture," *The New York Times*, Sunday Styles, February 29, 2006.

———. "Up to Her Eyes in Gore, And Loving It." *The New York Times*, Sunday Styles, pp. 1–2.

Williams, Linda, and Rich, B. Ruby. "The Right of Re-Vision: Michelle Citron's *Daughter Rite*," in Nichols, Bill, ed. *Movies and Methods, Volume II*. Berkeley, CA: University of California Press, 1985, pp. 359–369.

Winter, Jessica. "Sex and the Single Squaw," *The Village Voice*, December 19, 2005. http://www.vil-lagevoice.com/film/0551,Winter,71142,20.html

Yazigi, Monique P. "A Sweet 16-Going-On 25-Party." The New York Times, February 7, 1999, p. 1.

Zacharek, Stephanie. "Modern and mythical sexuality in 'Buffy the Vampire Slayer,'" Salon.com, November 9, 2002.

Index

mediated youth

Sharon R. Mazzarella
General Editor

Grounded in cultural studies, books in this series will study the cultures, artifacts, and media of children, tweens, teens, and college-aged youth. Whether studying television, popular music, fashion, sports, toys, the Internet, self-publishing, leisure, clubs, school, cultures/activities, film, dance, language, tie-in merchandising, concerts, subcultures, or other forms of popular culture, books in this series go beyond the dominant paradigm of traditional scholarship on the effects of media/culture on youth. Instead, authors endeavor to understand the complex relationship between youth and popular culture. Relevant studies would include, but are not limited to studies of how youth negotiate their way through the maze of corporately-produced mass culture; how they themselves have become cultural producers; how youth create "safe spaces" for themselves within the broader culture; the political economy of youth culture industries; the representational politics inherent in mediated coverage and portrayals of youth; and so on. Books that provide a forum for the "voices" of the young are particularly encouraged. The source of such voices can range from in-depth interviews and other ethnographic studies to textual analyses of cultural artifacts created by youth.

For further information about the series and submitting manuscripts, please contact:

SHARON R. MAZZARELLA
Communication Studies Department
Clemson University
Clemson, SC 29634

To order other books in this series, please contact our Customer Service Department at:

(800) 770-LANG (within the U.S.)
(212) 647-7706 (outside the U.S.)
(212) 647-7707 FAX

Or browse online by series at WWW.PETERLANG.COM